Art
Marketing
Sourcebook
for the fine artist

ArtNetwork

Art Marketing Sourcebook for the Fine Artist, Second Edition

Copyright © September 1995 by ArtNetwork
Printed and bound in the United States of America
Second Edition

Published by *ArtNetwork*
PO Box 1268, 18757 Wildflower Dr
Penn Valley , CA 95946
916/432-7630 916/432-7633 Fax

ArtNetwork is a publishing company connecting fine artists to artworld professionals. In addition to publishing art marketing books and newsletters, ArtNetwork sponsors seminars and private consultations. To be listed in future editions, send appropriate materials to the address noted above.

Cover Design by Richard Moore

**Publisher's Cataloging in Publication
(Prepared by Quality Books Inc.)**

Art marketing sourcebook for the fine artist / compiled by Constance Smith. – 2nd ed.
 p. cm.
 Includes index.
 ISBN 0-940899-26-4

1. Art–Marketing–Directories. I. Smith, Constance, 1949-

N8353.A78 1995 700'.68'8
 QB195-20323

About the Editor

Constance Smith has been promoting fine artists and writing and publishing art marketing books for over twelve years. Her active professional networking has made her familiar with all facets of the artworld and an expert in finding niches for all types of artwork. The founder of *ArtNetwork*, she has published the *Encyclopedia of Living Artists* for nine years. She lectures throughout the United States and Canada and conducts private consultations.

Acknowledgements

As the editor I wish to thank all the artists who have called *ArtNetwork* and commended us for the services we are providing to them. To contact the 500,000 active artists in the United States is no easy task! As our name implies, we want to build a network amongst artists to communicate ideas that will enable them to succeed and keep their career going strong. Thanks also to the many artworld professionals who took their time to respond to our questionnaires. Without them this book would not be possible.

Disclaimer

While the publisher and editor have made every reasonable attempt to obtain accurate information and verify same, with such a large volume of references, occasional address and telephone number changes are inevitable, as well as other discrepancies. We assume no liability for errors or omissions in editorial listings. Should you discover any changes, please use the form at the back of this book to write to us so that corrections may be made in future editions.

Talking to many people each day within the artworld—artist, buyer and seller—I can see that one of the most important aspects of marketing in this heavily competitive age is niche marketing. The second edition of this long-trusted guide includes a very important new section—Specialty Markets. These specialty market listings will help you find just those people who deal directly with your style or medium of artwork.

This book contains researched data that would be very difficult to obtain in any other way. Contacting the national markets listed within this book can be easy for you, even if you don't have a fax machine, modem or computer.

We do not claim to have listings of every artworld professional in our book. This, in fact, is not our intention. We want to list only those companies and individuals who voluntarily indicate that they are opening their doors to fine artists and want to review their work.

We compiled this book by sending out question-naires to artworld professionals on our extensive mailing lists. We told them that upon answering the questions and returning the form, the information would be published, free of charge, in a book which fine artists would be able to reference. They were informed that they would be receiving calls and slides from various artists and would be able to make connections with much new talent. Some companies wished to list their logos and/or accent their listing with bold type. We have accommo-dated their desires with a small charge; otherwise no one has paid to be in this book, nor are listings necessarily endorsed by *ArtNetwork*.

The resources in this book are your connection to the professional artworld. Use them wisely!

We are most interested in your thoughts about the directory and its format, as well as your comments on ease-of-use. If there is information you would like to see in future editions, we would be most appreciative if you would let us know by filling out the form at the back of the book.

Constance Smith, Editor

Reference books are a vital part of an artist's business library. Our aim in producing this book was to give fine artists the opportunity to spend more time creating and less time searching for leads—i.e. simplify the marketing process for them.

Following this idea, we've tried to make the format simple to read, with plenty of space to jot down notes as you proceed through the various sections. You need to **read**, highlight, circle, and finally (and most importantly) contact people in the various categories. Call the organizations and people that you deem important. Network.

Yes, you indeed need to **read** this book—all sections of the book! You will be amazed at what you learn from this process! You will discover things you didn't know existed which will lead to new marketing ideas for your artwork.

For the second section of the book, we sent questionnaires asking for information we thought an artist would want to know about a particular gallery, publisher, museum, etc. Listings are exactly as the company noted them in their reply; i.e. if a question went unanswered, we have left it out.

After you have perused this book and marked all over the columns with your personal comments, it's time to start calling, verifying names and addresses and interest in reviewing slides/photos. When you send your samples, be sure they are of the highest quality. If this part looks sloppy, you've lost out on all your previous work. Try to present your work 'smarter' than another artist, perhaps with a clever, eye-catching or beautiful folder. You need to stand out above the crowd, not only with your artwork, your style, but your presentation.

Remember, SASE means 'self-addressed, stamped envelope.' When someone requests this, be sure to accommodate them! It will be a strong point against you if you don't, and you might not receive your materials back.

Good luck, and stay with it!

Table of Contents

Specialty Markets

Book Publisher

TFH Publications
1 TFH Plaza, Neptune City, NJ 07753
908/988-8400

Competitions

Animals in Art
School of Veterinary Medicine Library
Louisiana State U, Baton Rouge, LA 70803
504/346-3172
March.

Art Show at the Dog Show
Joe Miller
11301 W 37th N #A, Wichita, KS 67205
316/722-6181 (eve)

National Anti-Vivisection Society
53 Jackson Blvd #1552, Chicago, IL 60604
312/427-6065

Exhibitions

Animal Art Studio
100 Naughbright Rd, Long Valley, NJ

Birds in Art
Leigh Yawkey Woodson Art Museum
700 N 12th St, Wausau, WI 54401-5007
715/845-7010
Sept-Oct.

Massachusetts Audubon Society
PO Box 236, S Wellfleet, MA 02663
508/349-2615

Society of Animal Artists
MacArthur Beach State Park, North Palm Beach, FL
212/741-2880
March-April.

Society of Animal Artists
Cleveland Museum of Natural History/Ellen Walters
1 Wade Oval Dr, University Cir, Cleveland, OH 44106
216/231-4600

Society of Animal Artists
315 N Stadium Way, Tacoma, WA

ZooArts Festival
National Zoological Park, Washington, DC
Sept 30-Oct 1.

Galleries

Animalia Gallery
403 Water St, PO Box 613, Saugatuck, MI 49453
616/857-3227

Cat's Paw Gallery
31 Race St, Jim Thorpe, PA 18229
717/325-4041
Annual competition.

Coast Gallery
The Lodge, 17 Mile Dr, Pebble Beach, CA 93953
408/624-2002

Magazines

American Birds
Susan Drennan
700 Broadway, New York, NY 10003
212/979-3000

Bird Talk
Julie Rach
Box 6050, Mission Viejo, CA 92690
714/855-8822

Birder's World
44 E 8th St #410, Holland, MI 49423

Cats Magazine
Tracy Copeland
Box 290037, Port Orange, FL 32129
904/788-2770

Reptile & Amphibian Magazine
Erica Ramus
Rt 61 Highway RD 3 Box 3709, Pottsville, PA 17901
717/622-6050
Works with wildlife artists who have limited edition prints or sculptures that deal with herpetology.

Mail Order Catalogs

The Artful Fish
PO Box 40, Santa Cruz, CA 95063-0040
408/426-7707

Cats, Cats & More Cats
Rte 17M, PO Box 270, Monroe, NY 10950
914/782-4141

Coldwater Creek
2 Coldwater Creek, Sandpoint, ID 83864
800/262-0040

Hep Cat Inc
2605A Fessey Park Rd, Nashville, TN 37204
615/386-9705

Animals/General

Mail Order Catalogs (cont.)

National Wildlife
1400 16th St NW, Washington, DC 20036-2266
800/432-6564

Your Pet
30 Lincoln Plz #6D, New York, NY 10023
212/489-1416

Mailing Lists

Carousel Press
PO Box 6061, Albany, CA 94706
510/527-5849
Mailing lists of zoo stores.

Direct Media List
Box 4565, 200 Pemberwick Rd, Greenwich, CT 06830
203/532-1000
Various mailing lists.

Museum

Dog Museum
Walter Dunn
1721 S Mason Rd, St Louis, MO 63131
314/821-3647

Organizations

ASPCA Animal Watch
Dave McMichael
424 E 92nd St, New York, NY 10128
212/876-7700

Audubon Artists
32 Union Square E, #612, New York, NY 10003
Have an annual exhibition.

Cat Writers Association
9 Marshall Ave, Guilford, CT 06437-3516
203/453-1929
Annual art competition.

Pet Industry Trade Show
Pet Industry Distributors Association/Gale
5024R Campbell Blvd, Baltimore, MD 21236
410/931-8100

Publisher

Quay Publications International
PO Box 2737, Matthews, NC 28106
800/346-7514 704/847-8545
Cards and prints featuring birds and horses as well as all breeds of dogs and cats.

Shows

American Dog Art Contest
Billie McFadden
20 Dogwood Dr, Flemington, NJ 08822
908/782-0298
November.

Midwest Pet Fair and Animal Art Show
770 E 6th St, St Paul, MN 55106
612/731-7921
Over 30,000 attend/May.

Book

So...You Draw Horses? The Equine Artist's Marketing Guide and Source Directory by Betsy Lieger-Linamen
PO Box 2704, Gaithersburg, MD 20886
301/840-1210
$25ppd/1992.

Book Illustrations

Simon & Schuster
1230 6th Ave, New York, NY 10010
212/698-7000

Storey Communications
Cathy Graney
105 Schoolhouse Rd, Pownal, VT
802/823-5810

Exhibitions

Washington Thoroughbred Breeders Association
PO Box 88258, Seattle, WA 98138
206/226-2620
August.

Galleries

Cross Gate Gallery
219 E High St, Lexington, KY 40507
606/233-3856

Equine Art Gallery
1438 SW Park, Portland, OR
503/243-5633

Klausner/Cooperage Equine Gallery
Barbara Klausner
500 4th Ave, Louisville, KY 40202
502/584-1616

Magazines

American Cowboy
PO Box 12830, Wichita, KS 67277
316/946-0600

Arabian Horse World
824 San Antonio Ave, Palo Alto, CA 94303
415/856-0500

Art of the West
Vicki Stavig
15612 Highway 7 #235, Minnetonka, MN 55345
612/935-5850

California Horse Review
PO Box 1238, Rancho Cordova, CA 95741-1238
916/687-7107

Chronicle of the Horse
John Strassburger
Box 46, Middleburg, VA 22117
703/687-6341

Equine Images
Susan Laman
900 Central Ave #19, PO Box 916, Ft Dodge, IA 50501
800/247-2000

Equus
Fleet Street Publications/Richard Elias
656 Quince Orchard Rd, Gaithersburg, MD 20878
301/977-3900

Horse and Horseman
Bob Arsenault
3429 Camino Capistrano, Capistrano Beach, CA 92624
714/493-2101

Horse and Rider
Cowles Magazines
12265 W Bayaud #300, Lakewood, CO 80228
303/914-3000

Horse Illustrated
Audrey Pavia
PO Box 6050, Mission Viejo, CA 92690
714/855-8822

Horse Play
Lisa Kaiser
PO Box 130, Gaithersburg, MD 20877
301/840-1866

Horse Show Magazine
AHSA Inc/Noreen Dworkin
220 E 42nd St, New York, NY 10017-5876
212/972-2472 ext 251

Informart
1727 E 2nd St, Casper, WY 82601
307/237-1659

Polo
656 Quince Orchard Rd, Gaithersburg, MD 20878
301/977-0200

Tack N Togs Magazine
PO Box 2400, Minnetonka, MN 55343
612/931-0211

Western Horseman
PO Box 7980, Colorado Springs, CO 80933
719/633-5524
Has art section with Western art.

Animals/Equine

Mailing Lists

Mail Marketing Inc
201/387-1010
"Hunter" and "Sport Horse Magazine" subscribers.

Museums

American Quarter Horse Heritage Center Museum
James May
2601 I-40 E, Amarillo, TX 79104
806/376-5181

Appaloosa Museum
PO Box 8403, Moscow, ID 83843
208/882-5578

Arabian Horse Center
12000 Zuni St, Westminster, CO 80234
303/450-4710

International Museum of the Horse
Barbara Dietrich
4089 Iron Works Pike, Lexington, KY 40511
606/259-2746
Twice a year they have "Art at the Park."

Kentucky Derby Museum
David Wagner
PO Box 3513, Louisville, KY 40201
502/637-7097

Museum of the Horse
PO Box 40, Ruidoso Downs, NM 88346
505/378-4142

Trotting Horse Museum
PO Box 590, 240 Matin St, Goshen, NY 10924
914/294-6330

Organizations

American Academy of Equine Arts
22655 Harrisburg Rd, Lexington, KY 40504
606/276-5318
Equifest.

American Horse Council
1700 K St NW #300, Washington, DC 20006
202/296-4031
Has a Horse Industry Directory for $20.

American Horse Show Association
220 E 42nd St #409, New York, NY 10017-5876
212/972-2472

American Royal Association
1701 American Royal Ct, Kansas City, MO 64102
816/221-9800

Equine Medical Center
Tom Walker
PO Box 1938, Leesburg, VA 22075
703/771-6800
Auction.

Horse Artists Association
3706 N Tucson Blvd, Tucson, AZ 85716
602/327-6180
Annual auction. Send 32¢ SASE for information on jurying process or to become part of organization.

Jamestown New Horizons
Bonnie Genanger
15350 Old Jamestown Rd, Florissant, MO 63034-1944
314/741-5816
August charity auction, sponsored to assist riding instruction for the disabled.

Monmouth Park
Phillip Iselin
PO Box MP, Oceanport, NJ 07757
908/222-5100
Annual auction held during racing season.

New York Racing Association
PO Box 90, Jamaica, NY 11417
718/641-4700
It is common for artists to set up and paint at this track.

Saratoga Association for Retarded Citizens
Beverly Kantrowitz
517 Broadway, Saratoga Springs, NY 12855
518/587-6378
Two major horse-related charity functions annually.

Vinceremose Riding Center
Ruth Menor
8765 Lake Worth Rd, Lake Worth, FL 33467
407/433-5800
Benefit auction.

Wild Horse Sanctuary
Nadine Marshall
141 Vista View Dr, Cloverdale, CA 95425
707/996-6677
Annual benefit.

Youngs Paso Fino Ranch
Barbara Young
8075 NW State Rd 326, Ocala, FL 32675
904/867-5305
Charitable functions.

Publishers

Austin Productions Inc
Pam Pierce
815 Grundy Ave, Holbrook, NY 11741
516/981-7300
Sculpture.

Equine Products Ltd
Mike Polyak
Box 23567, Pittsburgh, PA 15222
412/232-4500
Pays a flat fee of $200 plus some product. Is especially interested in Christmas (equine) themes as it is 60% of their business; gift wrap, ornament work, etc.

Franklin Mint
Rt 1, Franklin Center, PA 19091

Horsey Source
Connie Essig
135 Washington Sq, Washington, IL 61571
309/444-2222
Cards, stationery, shirts, preferably black and white artwork.

Jasper Publications
Dale Mountain
PO Box 725, Rhinebeck, NY 13572
Horses and dogs, calendars and t-shirts; sells some prints in her shop.

Leanin Tree
Edward Trumble
PO Box 9500, Boulder CO 80301
303/530-1442
Cards, etc.

Michael Alden Associates
PO Box 26097, New Orleans, LA 70186-6097
504/241-2670

Pomegranate Publications
Katie Burke
PO Box 808022, Rohnert Park, CA 94975
707/586-5500
Calendars, etc.

R&D Packaging Co
Don Runyan
703 Broadway #500, Vancouver, WA 98660
360/576-1155
Western gift wrap.

Saratoga Collection
PO Box 430, Averill Park, NY 12018
800/722-8060

Toh-Atin Gallery
Antonia Clark
145 W 9th St, Durango, CO 81301
800/525-0384

Walter Lee
Pike Industrial Pk, 450 Pike Rd, Huntington Valley, PA 19006
215/947-1608
Sculpture.

School

American Academy of Equine Art
PO Box 1315, Middleburg, VA 22117
703/687-6701

Shows

Equine Images Art Show
Central Sierra Arts Council
48 S Washington St, PO Box 335, Sonora, CA 95370
209/532-2787

Video

Nikki Pelley
PO Box 8664, Riverside, CA 92515
908/688-3236
"Keeping Your Western Heritage & Getting Your Craft to Market."

Animals/Wildlife

Contests

Duck Stamp Competition
New Hampshire Fish and Game Department
2 Hazen Dr, Concord, NH 03301
603/271-3211

Wildlife Photographer of the Year
PO Box 660, Bristol BS99 1XR England

Galleries

Addi Galleries
400 Jefferson St, San Francisco, CA 94109
415/776-1180

Ambassador Wildlife Gallery
3640 Ashley Phosphate Rd, N Charleston, SC
803/552-0078

American Heritage Gallery
2516 Ponce De Leon Blvd, Coral Gables, FL 33134
800/572-2628 305/442-6717

Gallery Jamel
630 Old Line Centre, Waldorf, MD 20602
301/870-6570

J N Bartfield Gallery
30 W 57th St, New York, NY 10019
212/245-8890

Landmarks Gallery
231 N 76th St, Milwaukee, WI 53213
414/453-1620

Mongerson Wunderlich
704 N Wells, Chicago, IL 60610
800/275-2691

Nature Trail
5672 Calle Real, Goleta, CA 93117
805/964-2244

Robert Miller
306 N Milwaukee St, Milwaukee, WI 53202
414/278-7424

Sportsman Specialities
PO Box 217, Youngblood, PA 15697
412/834-2768

Sportsman's Galleria
John Latham
432 Bayou Blue Rd, Houma, LA 70364
504/868-5733

Western Wildlife Gallery
4 Embarcadero Center, San Francisco, CA 94111
415/398-4845

Wild Wings
PO Box 451, Lake City, MN 55041
612/345-5355

Wildlife Gallery
Patrick Dugan
172 Bedford St, Stamford, CT 06901
203/324-6483

Magazines

Sporting Classics
PO Box 23707, Columbia, SC 29224
803/736-2424

Tiger Tribe
Hilary Granfield
1407 E College St, Iowa City, IA 52245-4410
319/351-6698

US Art
220 S 6th St #500, Minneapolis, MN 55402-4502
612/339-7571

Wildlife Art News
PO Box 16246, Minneapolis, MN 55416-0236
800/221-6547 612/927-9056 8
Publishes an annual show guide of 125 wildlife shows across the nation for $10—a must for marketing wildlife art. Call Linnea Addison at 800/626-0934.

Museums

Ward Museum of Wildfowl Art
Jane Rollins
909 S Schumaker Dr, Salisbury, MD 21801
410/742-4988
Annual competition with show in May.

Wildlife Art News
800/221-6547
Publishes an annual yearbook that has a list of wildlife art collections at museums.

Organizations

National Wildlife Federation
8925 Leesburg Pike, Vienna, VA 22184
703/790-4000

Noxubee National Wildlife Refuge
Rt 1 Box 142, Brooksville, MS 37939
601/323-5548

Rocky Mountain Elk Foundation
PO Box 8249, Missoula, MT 59807-8249
800/225-5355

Southern California Wildlife Artists Association
Larry Wagner
PO Box 33757, Granada Hills, CA 91394
818/366-8800

Wildlife Art News
800/221-6547
Has an extensive list of wildlife organizations in their annual yearbook.

Publishers

Art Resources International
0 Fields Ln , Brewster, NY 10509
914/277-8888

Foundation Fine Arts Ltd
Christopher Law
39101 Hood Canal Dr NE, Hansville, WA 98340
800/545-2529 206/698-0396

National Wildlife Galleries Inc
Lissa Robinson
11000-33 Metro Pkwy, Ft Myers, FL 33912
800/DUCK-ART 813/939-7518

Steiner Prints
Robert Steiner
315 Cornwall St, San Francisco, CA 94118
415/387-9754

Shows

Institute of Natural Science
#2 Box 532, Woodstock, VT 05091
802/457-2779
Sept-Oct.

Journey into the Wild
Wildlife Foundation
6211 Hwy 51 S, Hazelburst, WI 54531-9743
715/356-4496

Michigan Wildlife Habitat Foundation
Tricha
6425 S Pennsylvania #9, Lansing, MI 48911-5975
517/882-3630
Spring & Fall festivals.

Mosquito Hill Nature Artfest
Rogers Rd, New London, WI 54961
414/779-6433
3-5,000 attendance. Original works only.

National Wildlife Art Show
Anita Harnett
PO Box 7728, Shawnee Mission, KS 66207
913/888-6927
8,500 attendance. $400,000 in sales.

Northwest Rendezvous Show
Kimball Art Center
PO Box 1478, Park City, UT 84060
800/279-0140
August.

Pacific Rim Wildlife Art Show
PO Box 11225, Tacoma, WA 98411
206/383-3523
Annually in late September.

Slide Reference

Wildlife Photographer
Denver
PO Box 368, Bozeman, MT 59771
406/586-4106
Rents slide usage of wildlife art.

Architectural/Historical

Government Buildings

The Russell Senate Building
Sponsors shows. Call a US Senator to sponsor your work.

State Government Buildings
Call the executive director of your state arts council to help you to get your artwork into state government buildings.

Government Programs

Art in Architecture
 GSA
 Room 1300, 18th & F Sts NW, Washington, DC 20405
 202/708-5082
Write for information about their slide registry.

Art in Embassies
 US Department of State/May Hollis Hughes
 Room B258, Washington, DC 20520
 202/647-5723
Show your work around the world by 'loaning' it to various embassies.

Highway Department

The highway department of your home state usually publishes a tourist information and state publicity magazine. The editors often like to commission home state artists to illustrate various tourist attractions. Call your state highway department to find the person in charge of your state's magazine.

Magazines

Architectural Conservators
 410/377-4187

Architectural Digest
 6300 Wilshire Blvd, Los Angeles, CA 90036
 213/965-3700

ID Handbook
 201/592-7007
New York City area listings that interior designers use.

Interior Design Buyers Guide
 Cahners Publication
 249 W 17th St, New York, NY 10011
 212/645-0067
Annual list of suppliers.

The Magazine of Small Luxury Hotels
 Illustrated London New Group
 20 Upper Ground, London SE1 9PF England
If you want to sell your work to luxury hotels, here's the list!

Progressive Architecture
 600 Summer St, Stamford, CT 06904
 203/348-7531

Public Art Review
 2324 University Ave W #102, St Paul, MN 55114

Residential Interiors
 1515 Broadway, New York, NY 10036

Newsletter

Sales Prospector
 Box 9079, Waltham, MA 02254
 617/899-1271
Bi-monthly newsletter with information on major construction projects around the nation. Different volumes for various areas of the country. University libraries often subscribe.

Organizations

American Historical Association
 400 A St SE, Washington, DC 20003
 202/544-2422
Annual convention.

American Hotel and Motel Association
 1201 New York Ave NW #600, Washington, DC 20005
 202/289-3100

American Institute of Architects
 3200 Park Center Dr #110, Costa Mesa, CA 92626
 714/557-7796

American Institute of Architects/AIA
 200 Lexington Ave #600, New York, NY 10016
 212/683-0023
Trade association for architects.

American Institute of Architects
 Ron Baum
 4131 Woodland Park Ave N, Seattle, WA 98103
 206/632-7332

American Society of Interior Designers/ASID
 602/952-8513

Hotel Sales & Marketing Association
 1300 L St NW #800, Washington, DC 20005
 202/789-0089
Annual convention.

Institute of Business Designers/IBD
 602/528-4300

International Furnishings & Design Association/IFDA
602/941-4635

International Interior Design Association/IIDA
Maggy Mendoza
8687 Melrose Ave #M54, W Hollywood, CA 90069
310/657-0244

International Society of Interior Designers/ISID
602/273-6210

National Trust for Historic Preservation
1785 Massachusetts Ave NW, Washington DC 20036
202/673-4000

Society of American Historical Artists
1377 K St NW #870, Washington, DC 20005

Publications

The Guild
Designer's Source of Artists and Artisans
Kraus Sikes Inc
228 State St, Madison, WI 53703
608/256-1990
Sourcebook in which artists can advertise.

Publisher

Art Post Gallery
1452 Waukegan Rd, Carillon Sq, Glenview, IL 60025

Real Estate Agents

Demetri Publishing
11250 Kirkland #A, Kirkland, WA 98033
206/822-5324
Sells prints to real estate agents.

Reference Directories

Who's Who in the Lodging Industry
American Hotel & Motel Association
1201 New York Ave NW, Washington, DC 20005
202/289-3157

Referral Service

Artist Index
Robin Klitzke
2832 36th Ave S, Minneapolis, MN 55406
612/946-5816
Matches architects, interior designers, contractors and any interested member of the public with skilled regional artists. $25 fee for artists wishing to be listed.

Shows

The Exhibit Review
Phoenix Communications
PO Box 5808, Beaverton, OR 97006-0808
800/235-3324 503/244-8745
Over 8,000 show listings organized into 45 industry categories. Look in here for Realtors' Shows, Home Shows, and Furniture and Accessory Shows, Floral Shows, etc.

Karel Exposition Management
3800 S Ocean Dr, Miami Beach, FL 33022
305/454-7777
Sponsors nationwide shows.

Trade Show Exhibiting by Diane Weintraub
McGraw Hill
800/722-4726
$29.95 + shipping.

Automotive

Galleries

Cars the Star
Philip Schroeder
420 W 7th St, Kansas City, MO 64105-1407
816/221-1957

Old Master Auto Gallery
15438 Hawthorne Blvd, Lawndale, CA 90260
310/679-2525

Magazines

American Motorcyclist
Greg Harrison
Box 6114, Westerville, OH 43081-6114
614/891-2425

Auto Racing Digest
990 Grove St, Evanston, IL 60201
708/491-6440

Automobile Magazine
120 E Liberty, Ann Arbor, MI 48104
313/994-3500

Circle Track Magazine & Car Craft
6420 Wilshire Blvd, Los Angeles, CA 90048
213/782-2000

Collision Magazine
PO Box M, Franklin, MA 02038
508/528-6211
New car dealers are their audience.

High Performance Mopar & High Performance Pontiac
299 Market St, Saddle Brook NJ 07662
201/712-9300

Mercedes Benz Star
1235 Pierce St, Lakewood, CO 80214
303/235-0116

Motor Magazine
645 Stewart Ave, Garden City, NY 11530
516/227-1303

Old Cars
700 E State St, Iola, WI 54945
715/445-2214

Racing Cars
Box 1341, Marion, IN 46952

Sports Car International
3901 Westerly Pl #120, Newport Beach, CA 92660
714/828-6190

Mailing Lists

Media Management Group
666 Plainsboro Rd #508, Plainsboro, NJ 08536
609/275-0050
Has a list of Corvette enthusiasts.

Dan Poynter
PO Box 2206, Santa Barbara, CA 93118-7206
805/968-7277
Lists of automobile magazines.

Museums

Petersen Automotive Museum
6060 Wilshire Blvd, Los Angeles, CA
213/930-2277

San Diego Auto Museum
619/231-2886

Virginia Museum of Transportation
Pat Sissen
303 Norfolk Ave, Roanoke, VA
703/342-5670
Kemper A Dobbins Annual Transportation Art Exposition.

Organizations

Automotive Fine Arts Society/AFAS
Ken Eberts
PO Box 613, Temecula, CA 92593
818/992-4353
Annual shows, including The Pebble Beach Annual which attracts many celebrities.

Publisher

Williams Company
6129 Airways Blvd, Chattanooga, TN 37421
615/892-1328

Shows

Canning Enterprises
PO Box 400, Maywood, CA 90270
213/587-5100

Competitions

EAA Sport Aviation Art Competition
Experimental Aircraft Association/Joan Mueller
PO Box 3065, Oshkosh, WI 54903-3065
414/426-4800

Rocky Mountain Air Fair
Walt Barbo
303/780-5802
In October at the Denver Convention Center.

Direct Mail

Aviation Books
25133 Anza Dr #E, Santa Clarita, CA 91355
800/423-2708

Tailwinds
42 Digital Dr, Novato, CA 94949
800/992-7737

Galleries

Accents Collectors Gallery
45 E Main St, Ashland, OR 97520
800/752-2933

Aero Art
1011 N Pantona Rd, Tucson, AZ
520/296-5871

Air Nostalgia
420 S Main, Grapevine, TX 76051
817/481-9005

Airport Galleries
Box 26, Dallas, TX 78235
214/352-1204

Av-Art Connection
PO Box 393, Aledo, TX 76008
817/244-1471

Aviation Arts Gallery
Steve Ornelaw
533 S Coast Hwy, Laguna Beach, CA
714/494-4304

CollectAir Gallery
Steve Remington
2555 Robert Fowler Way, San Jose, CA 95148
408/259-3360

Federal Galleries
1527 3rd St N, Jacksonville Beach, FL 32250
904/247-1119

Heritage Aviation Art
12819 SE 38th St #211, Bellevue, WA 98006-1395
206/747-7429

New Masters Gallery
PO Box 7009, Carmel, CA 93921
408/625-1511

Nostalgic Aviator
1012 Hollywood Way, Burbank CA
818/558-7870

Sky's the Limit
1128 Main St, Oregon City, OR
503/650-0787

Southern Comfort Gallery
2813 E Cervantes, Pensacola, FL 32503
800/659-6165

Virginia Bader Fine Arts Ltd
1305 King St, Alexandria, VA 22314
703/548-4440

Magazines

Aviation Art
Challenge Publications
7950 Deering Ave, Canoga Park, CA 91304
818/887-0550

Aviation International News
81 Kenesha, Danbury, CT
203/798-2400

Flying Magazine
500 W Putnam Ave, Greenwich, CT 06830

Sport Aviation
PO Box 3086, Oshkosh, WI 54903-3086
414/426-4800

US Art
12 S 6th St #500, Minneapolis, MN 55402
612/339-7571
September 1992 has a special edition on aviation art.

Mailing Lists

Dan Poynter
PO Box 2206, Santa Barbara, CA 93118-2206
805/968-7277
Mailing lists of aviation magazines.

Aviation

Museums

Champlin Fighter Museum
4636 Fighter Aces Dr, Mesa, AZ 85205
602/830-4540

Combat Air Museum
PO Box 19142, Topeka, KS 66619
913/862-3303

Cradle of Aviation Museum
Mitchel Field, Garden City, NY 11530
516/572-0410

International Women's Air and Space Museum/IWASM
26 N Main St, PO Box 465, Centerville, OH 45459
513/433-6766

Intrepid Sea-Air-Space Museum
W 46th and 12th Aves, New York, NY 10036
221/245-0072

Kalamazoo Aviation History Museum
3101 E Milham Rd, Kalamazoo, MI 49002
616/382-6555

Mid-Atlantic Air Museum
Harrisburg International Airport, Middletown, PA 17507
610/874-1000

Museum of Flight
9404 E Marginal Way, Seattle, WA 98108
206/764-5720

Naval Aviation Museum
904/452-3604

New England Air Museum
Bradley International Airport, Windsor Locks, CT 06096
203/623-3305

Pima County Air Museum
520/574-0462

Planes of Fame
909/597-3514

San Diego Aerospace Museum
2001 Pan American Plz, Balboa Park, CA 92101
619/234-8291

Shannon Air Museum
PO Box 509, Fredericksburg, VA 22401
703/373-4431

Victory Air Museum
Polidori Airfield, Rt 2, Mundelein, IL 60060
708/949-6626

Organizations

American Aviation Historical Society
2333 Otis, Santa Ana, CA 92704
714/549-4818

American Society of Aviation Artists
Luther Gore
1805 Meadowbrook Heights Rd, Charlottesville, VA 22901
804/296-9771
Publishes "Aerobrush Magazine."

Experimental Aircraft Association
PO Box 3086, Oshkosh, WI 54903-3086
414/426-4800 414/426-4818/gift store
Holds world's largest aviation event in July-Aug, a "Fly-In" convention.

Publishers

Eagle Editions
PO Box 1830, Sedona, AZ 86336
602/284-1412

Gray Stone Press
205 Louise Ave, Nashville, TN 37203
615/327-9497

Greenwich Workshop
1 Greenwich Pl, Shelton, CT 06484
203/371-6568

Hadley House Publishers
11001 Hampshire Ave S, Bloomington, MN 55438
612/943-8474

Military Gallery
821 E Ojai Ave, Ojai, CA 93023
805/640-0057

Somerset House Ltd
10688 Haddington #900, Houston, TX 77043
713/932-6847

Spofford House
PO Box 1, Spofford, NH 03462
800/222-6788
Publishes "Aeroprint Magazine" to which aviation art collectors subscribe.

Wild Blue
John Redding
PO Box 50608, Phoenix, AZ 85076-0608
602/893-7754

Exhibits

bASE.ARTS
PO Box 78154, San Francisco, CA 94107
415/821-4989
E-Mail base @ well.sf.ca.us./Compuserve 71742,2615

Gallery of Art
Eastern Washington U/Richard Twedt
Cheney, WA 99004
509/359-2493
Annual show of computer-generated art.

New Voices New Visions
Interval Research Corporation
1801 Page Mill Rd Bldg C, Pal Alto, CA 94304
415/855-0780

U of Puget Sound
Betty Ragan
1500 N Warner, Tacoma, WA 98416
206/756-3721

Virtual Reality
Meckler Conferences
20 Ketchum, Westport, CT 06880
203/226-6967
Held in various parts of the country at various times.

Gallery

Pulse Art Gallery
494 Broadway, New York, NY 10012

Magazines

Amiga World
80 Elm St, Peterborough, NH 03458
They are building a reference file of artists.

Arts Line Magazine
Alice Smith
600 University St #2505, Seattle, WA 98101-3110
206/528-2085

Computer Artist Magazine
Steven Porter
10 Tara Blvd 5Fl, Nashua, NH 03062-2801

Computer Graphics World
Gary Pfitzer
10 Tara Blvd 5Fl, Nashua, NH 03062-2801

Computer Pictures Magazine
701 Westchester Ave, White Plains, NY 10604

IICS
Interactive Society
PO Box 6211, Malibu, CA 90264

Macworld
501 Second St, San Francisco, CA 94017
415/243-0505

New Media
901 Mariners Island Blvd #365, San Mateo, CA 94404
415/573-5170

Personal Publishing
191 S Gary Ave, Carol Stream, IL 60188
708/665-1000

Publish Magazine
Michael Sullivan
501 Second St, San Francisco, CA 94107
415/243-0600

Step by Step Electronic Design
6000 N Forest Park Dr, Peoria, IL 61614-3592
309/688-8800

VERBUM
PO Box 189, Cardiff, CA 92007
619/944-9977

Mail Order

Media Magic
PO Box 598, Nicasio, CA 94946
800/882-8284

Organizations

International Design by Electronics Association/IDEA
2200 Wilson Blvd #102-153, Arlington, VA 22201
800/466-1163

National Computer Graphics Association/NCGA
2722 Merrilee Dr #200, Fairfax, VA 22031
703/698-9600

YLEM: Artists Using Science and Technology
PO Box 749, Orinda, CA 94563
415/856-9593

Shows

Seybold Seminars
Softbank Exposition and Conference Co
PO Box 5856, Santa Monica, CA 94402-0856
800/488-2883

SIGGAPH
The Association of Computing Machinery
401 N Michigan Ave, Chicago, IL 60611
312/321-6830

Surtex
George Little Management
2 Park Ave #1100, New York, NY 10016-5748
800/272-7469 212/686-6070

Environmental

Directories

Conservation Directory
1400 16th St NW, Washington, DC 20036-2266
$21.95ppd.

Eco-Networker Directory
Patti Grimes
PO Box 2929, Vista, CA 92085
619/726-3755
$20.95.

Museum

Delaware Agricultural Museum
866 N DuPont Hwy, Dover, DE
302/734-1618

Organizations

Many artists these days are 'co-oping' with a non-profit organization to aid the organization and promote their own work.

Artists Representing Environmental Arts
500 E 83rd St, New York, NY 10028
212/288-7650

Children of the Green Earth
Box 95219, Seattle, WA 98145

Environmental Defense Fund
257 Park Ave S, New York, NY 10010
212/505-2100

Independent Environmental Artists Network
227 Montrose Pl #C, St Paul, MN 55104-5651

National Parks and Conservation Association
Laurie Nelson
PO Box 25354, Woodbury, MN 55125
612/735-8008

Wilderness Society
900 17th St NW, Washington, DC 20006-2596
202/833-2300

Publications

Earth
21027 Crossroads Cir, Waukesha, WI 53186

In Business
JG Press Inc
419 State Ave, Emmaus, PA 18049
610/967-4135

National Green Pages
Co-op American
1612 K St NW #600, Washington, DC 20006
202/872-5307
$6.95ppd for a book with 1400 listings of environmentally responsible businesses.

State of the World
World Watch Institute
1776 Massachusetts Ave NW, Washington, DC 20035
202/452-1999
$14.95ppd.

Resources

Garbage: The Practical Journal for the Environment, Old House Journal Corp
2 Main St, Gloucester, MA 01930
800/274-9909

National Association of Professional Environmental Communicators
Stephanie Wright
PO Box 8352, Chicago, IL 60661
312/902-7100

Shows

Arts for the Parks
National Park Academy/Images of America
PO Box 608, Jackson Hole, WY 83001
800/451-2211 800/553-2787 307/733-2787
Annual competition of the National Park system. $25,000 first prize, great sales and publicity. June 1 deadline.

EarthFair
619/272-7370 619/496-6666
Annual festival held in Balboa Park (San Diego) in April with art exhibits.

Health & Harmony Festival
Wishing Well Productions
PO Box 7040, Santa Rosa, CA 95407
707/575-WELL(9355)

New Visions Gallery
1000 N Oak, Marshfield, WI 54449
715/387-5562
"Culture and Agriculture," an annual exhibit.

Stony Brook Gallery
31 Titus Mill Tr, Pennington, NJ 08534
609/737-7592

Yosemite Renaissance
PO Box 313, Yosemite National Park, CA 95389
Annual competition with deadline in September.

Book

Erotic Art by Living Artists
ArtNetwork Press
PO Box 1268, Penn Valley, CA 95946
$19.95ppd.

Catalogs

Adam & Eve
PO Box 800, Carrboro, NC 27510

AMOK
PO Box 861867, Terminal Annex, Los Angeles, CA
90086-1867

Blazer Art Books
584 Chapel St, New Haven, CT 06511-6920

Elysium Book Nook
814 Robinson Rd, Topanga, CA 90290-9672

Eve's Garden
119 W 57th St 4Fl, New York, NY 10019-2303
212/757-8651

Gaia Catalog
1400 Shattuck Ave, Berkeley, CA 94709

Internaturally Events Unlimited
PO Box 203, Pequannock, NJ 07440

Last Gasp
PO Box 410067, San Francisco, CA 94141-0067
415/824-6636

Lawrence Research Group Inc
PO Box 319005, San Francisco, CA 94131
415/952-7844

Leather Masters
969 Park, Los Angeles, CA 95126

Left Bank Distribution
4142 Brooklyn Ave NE, Seattle, WA 98105

Open Enterprises/Good Vibrations
Joani Blank
1210 Valencia, San Francisco, CA 94110
415/550-7399

Pandora Book Peddlers
885 Belmont Ave, North Haledon, NJ 07508-2567

Playboy/The Catalog
PO Box 1554, Elk Grove Village, IL 60009-1554

Red Rose Gallerie
2251 Chestnut St, PO Box 280140, San Francisco, CA
94123

Secret Passions
PO Box 8870, Chapel Hill, NC 27515

Stamford Collection
PO Box 1160, Long Island City, NY 11101

Tools for Exploration
4460 Redwood Highway #2, San Rafael, CA 94903

Vernons Specialties
386 E Moody St, Waltham, MA 02154-5260
619/894-1744

Whole Sex Catalog
Sally Stubbs
133 Beedle Dr #2, Ames, IA 50010

World Resource Guide
601-1755 Robson St, Vancouver BC, Canada V6G 3B7

Galleries

Apropos Gallery
1016 E Las Olas Blvd, Ft Lauderdale, FL 33301
305/524-2100

Best Artists Gallery
147 Wooster St, New York, NY 10012

Fantasy Emporium
13237 Montfort Dr, Dallas, TX 75240

Ganymede Gallery
PO Box 66, Boston, MA 02199

Griffin Gallery
130 2nd St, Miami Beach, FL 33139
305/534-0303

Metropolis Contemporary Art Gallery
105 University St, Seattle, WA 98101
206/682-6077

Rita Dean Gallery
548 5th Ave, San Diego, CA 92101
619/338-8153

Second Story Gallery
89 Yesler Way, Seattle, WA 98104-2545
206/682-9331

SOCO Gallery
101 S Coombs, Napa, CA 94559

Erotica

Westbeth Gallery
55 Bethune St, New York, NY 10028

Works Search
PO Box 728, Jenison, MI 49429

Magazines

Alternative Lifestyles Directory
Winter Publishing
PO Box 80099, S Dartmouth, MA 02748-0099

American Nudist
Ron York
4425 S Pleasant Hill Rd, Kissimmee, FL 32741

Archives of Sexual Behavior
Richard Green
233 Spring St, New York, NY 10013

Bad Attitude
PO Box 110, Cambridge, MA 02139

Club Erotique
Box 350 Falls Station, Niagara Falls, NY 14303

Ecstasy Journal
402 W Matilija, Ojai, CA 93023

Eidos Magazine
Brenda Loew Tatelbaum
PO Box 96, Boston, MA 02137

Elysium Growth Press
Ed Lange
5438 Fernwood Ave, Los Angeles, CA 90027

Erotic Fiction Quarterly
Richard Hiller
Box 4958, San Francisco, CA 94101

Erotic Letters
9171 Wilshire Blvd #300, Beverly Hills, CA 90210

Erotic Visions
PO Box 203, New York, NY 10013

Gallery Magazine
Michael Monte
401 Park Ave S, New York, NY 10016

Ganymede Press
1735 Maryland Ave, Baltimore, MD 21201

Journal of Sex Research
Paul Abramson
Box 208, Mt Vernon, IA 52314

Libido
Jack Hafferkamp
PO Box 146721, Chicago, IL 60614

Off Our Backs
2423 18th St NW 2Fl, Washington, DC 20009

Pan Erotic Review
David Steinberg
Box 2992, Santa Cruz, CA 95063

Penthouse
Joe Brooks
1965 Broadway, New York, NY 10023

Playboy
680 N Lake Shore Dr 15Fl, Chicago, IL 60611

Sex Guide
PO Box 642, Scottsdale, AZ 85252

Sex Over Forty
Paul Fleming
PO Box 1600, Chapel Hill, NC 27515

Sex Roles: A Journal of Research
Phyllis Katz
233 Spring St, New York, NY 10013

Sexual Perspectives
Sally Stubbs
133 Beedle Dr #2, Ames, IA 50010

SEXY Newsletter
Cindy Moog
2511 N Kentucky Ave #10, Evansville, IN 47711

Tantra Magazine
Susanna Andrews
PO Box 79, Torreon, NM 87061-0079
505/384-2292

Yellow Silk
Lily Pond
PO Box 6374, Albany, CA 94706

Mailing Lists

ArtNetwork
PO Box 1268, Penn Valley, CA 95946
Send SASE for brochure.

Publishers

Asbury Park Press
Myrna Lippman
3601 Highway 66, Neptune, NJ 07754
908/922-6000

Brazen Grafix
Chris Reed
8516 W Lake Mead Blvd #102, Las Vegas, NV 89128

Brazen Images
269 Chatterton Pkwy, White Plains, NY 10606
914/949-2605

Comstock Cards
Patti Wolf
600 S Rock Blvd #15, Reno, NV 89502
702/856-9400

Crystal Greeting Card Co
5672 Lincoln Dr, Edina, MN 55436
612/935-4499

Great Path Publishing
PO Box 882, Freeland, WA 98249
800/858-5063

No! No! Greetings
PO Box 221, Norco, CA 91760

Skylight
PO Box 1434, Venice, CA 90294

US Fine Arts Ltd
PO Box 704, Huntington Beach, CA 92648
800/669-5317

Ethnic/African-American

Book Distributor

African Marketplace
Chimbuko Tembo
2560 W 54th St, Los Angeles, CA 90043
213/295-9799
Sells calendars and greeting cards of interest to minorities and African-Americans.

Book Publishers

Art Sensation
Jerome Gray
2806 26th St NE, Washington, DC 20018
202/635-9337

Beacon Press
Sarah Eisenman
25 Beacon St, Boston, MA 02108
617/742-2110

Catalogs

Art in the Dark
Galerie 500 Collection
500 9th St SE, Washington, DC 20003
202/543-9200
Screen saver. $49.45ppd.

Art X-Pressions
5904 N College Ave, Indianapolis, IN 46220
317/257-5448

Essence by Mail
PO Box 62, Hanover, PA 17333-0062
800/882-8055

Festivals

Black Expo USA
Washington, DC Convention Center
408/892-2815
July.

Harambee African American Arts Festival
Kuumba House, Houston, TX
713/524-1079

Indiana Black Expo Inc
314 N Meridian St, Indianapolis, IN 46208
317/925-2702
June/July.

International Festival
City of Lawton Arts & Humanities
PO Box 1054, Lawton, OK 73502
405/581-3500
Held annually in September. Work must relate to ethnic group.

National Black Arts Festival
Wainwright/Smith Associates
68 E 7th St, New York, NY 10003
212/777-5218
August.

Seaway National Bank Art Fair
Renee Oliver
645 E 87th St, Chicago, IL 60619
312/602-4051
Original work by black artists, 5-10,000 attendees in August.

Galleries

Abstractions
Jeffrey Mayo
166-33 89th Ave #12F, Jamaica, NY 11432
718/523-6685

ACA Gallery
41 E 57th St 7Fl, New York, NY 10022
212/644-8300

Alitash Kebede Gallery
Alitash Kebede
964 N La Brea Ave, Los Angeles, CA 90038
213/874-6269

Art for Community
772 N High St #102, Columbus, OH 43215
614/294-4200

Articles Gallery
Box 241377, Omaha, NE 68124
402/393-6198

Aswad International Graphics
Charles Dorsey
1539 Centinela, Inglewood, CA 90302
310/677-8283

Barnes Blackman Gallery
1501 Elgin Ave #B, Houston, TX 77004
713/520-0059

Black Art Group International
1259 S Wabash, Chicago, IL 60605
312/427-7600

Black Art Plus
51 Parsons Ave, Columbus, OH 43215
614/469-9980

Black Heritage Gallery
5408 Alameda Rd, Houston, TX 77004
713/529-7900

Bomani Gallery
Asaki Bomani
251 Post St 6Fl, San Francisco, CA 94108-5004
415/296-8677

Ebony Expressions
2319 B W Edison Ave, Tulsa, OK
918/583-2669

Elijah Pierce Gallery
867 Mt Vernon Ave, Columbus, OH 43203
614/252-KING

Evan Tibbs Collection
1910 Vermont Ave NW, Washington, DC 20001
202/234-8164

G R N'Namdi
161 Townsend, Birmingham, MI 48012
810/642-2700

H&N Gallery
65 Reade St, New York, NY 10007
800/662-0793 516/563-1211
Limited editions, prints.

Isobel Neal Ltd
Isobel Neal
200 W Superior St # 200, Chicago, IL 60610-3532
312/944-1570

June Kelly Gallery
June Kelly
591 Broadway 3Fl, New York, NY 10012
212/226-1660

Kenkeleba Gallery
214 E Second St, New York, NY 10009
212/674-3939

Lithos Gallery
Linda Thomas
630B Del Mar, St Louis, MO
314/862-0674

Malcolm Brown Gallery
Ernestine Brown
20100 Chagrin Blvd, Cleveland, OH 44122-4947
216/751-2955

Michael Sampson Gallery
144 E 3rd St, Dayton, OH 45402
513/228-ARTS

Mosadi Collection
Earnest Bonner
624 E 17th Ave, Denver, CO 80203
303/863-0701

Nautilus
5900 N Port Washington Rd, Milwaukee, WI 53217
414/963-0717

Sande Webster Gallery
Sande Webster
2018 Locust St, Philadelphia, PA 19103-5614
215/732-8850

Savacau Gallery
Byrma Graham
240 E 13th St, New York, NY 10003
212/473-6904

Shades of Color Gallery
316 NE Thompson St, Portland, OR 97212
503/288-3779

Sherry Washington Gallery
1274 Library St, Detroit, MI
313/961-4500

Surya Gallery
227 N 9th St, Lincoln, NE 68508
402/474-2559

Third World Art Exchange
2016 N Hillhurst Ave, Los Angeles, CA 90027
213/666-9357

Us Art Gallery
Uokes Ra
RR 1 Box 153A, Billingsly, AL 36006
205/269-2550

Wendell Street Gallery
Constance Brown
17 Wendell St, Cambridge, MA 02138-1816
617/864-9294

Grants

National Black Programming/NBPC
929 Harrison Ave #104, Columbus, OH 43215
614/299-5355
Funding is available for production on African-American history and culture intended to be broadcast nationally on public television.

Richard Florsheim Art Fund
University of Southern Florida/August Freundlich
PO Box 3033, Tampa, FL 33620-3033
Assists older American artists of merit with mounting exhibitions, books, etc. with awards from $5,000-$20,000.

Ethnic/African-American

Museums

African American Museum
PO Box 15053, Dallas, TX 75315

Chattanooga Afro-American Museum
Bessie Smith African-American Building
200 E Martin Luther King Blvd, Chattanooga, TN
37403
615/267-1076
African-American Cultural Arts Festival, an annual art fair in August.

Museum of African-American Art
4005 Crenshaw Blvd 3Fl, Los Angeles, CA 90008
213/294-7071

National Afro-American Museum and Cultural Center
1350 Brush Row Rd, Wilberforce, OH 45384
513/376-4944

Organizations

African-American Cultural Center
213/299-6124

African-American History and Cultural Society
Jule Anderson
Fort Mason Center Bldg C, San Francisco, CA 94123
415/441-0640
4 exhibits per year.

African-American Museum Association
Joycelyn Hubbuch
PO Box 548, Wilberforce, OH 45384-0540
513/376-4611

African-American Museum Association
PO Box 150153, Dallas, TX 75315-0153
214/565-9026

Afro-American Cultural Center
Harry Harrison
401 N Myers St, Charlotte, NC 28202
704/374-1565

American Association of Black Owned Galleries
240 E 13th St, New York, NY 10003
212/473-6904

Black Arts Alliance
Angela Brown
1157 Navasota, Austin, TX 78702
512/477-9660

Black Cultural Affairs Board
Portland State U/Charles Stademeyer
PO Box 750, Portland, OR 97207
503/725-4646

Black Dimension In Art
Margaret Cunningham
409 Schenectady St, Schenectady, NY 12307
518/346-1027

Black United Fund of Oregon
PO Box 12406, Portland, OR 97212
503/282-7973

Black Women Artists
154 Crown St, Brooklyn, NY 11225

Coastal Center for the Arts
2012 Demere Rd, St Simons Island, GA 31522
912/634-0404
Open to US Afro-American artists.

Commission on Black Affairs
State Capitol Bldg, Room 106, Salem, OR 97310
503/378-5336

Long Island Black Artist Association
Maxine Townsend-Broderick
PO Box 141, Hempstead, Long Island, NY 11550
718/526-6056

National Conference of Artists
409 7th St NW, Washington, DC 20004
202/393-3116

World Arts Foundation
Michael Grice
PO Box 12384, Portland, OR 97212-2384
503/222-1457

YMI Cultural Center Gallery
Margaret Fuller
PO Box 7301, Asheville, NC 28802
704/252-4614

Publications

ABBWA Journal
PO Box 10548, Marina Del Rey, CA 90295

African-American Review
Indiana State U, English Dept, Terre Haute, IN 47809
812/237-2788

American Visions
PO Box 614, Mt Morris, IL 61054
800/998-0864

Black Enterprise Magazine
130 5th Ave, New York, NY 10011
212/242-8000

Catalogue of African and Afro-American Collections
Howard U/Gallery of Art
2455 7th St NW, Washington, DC 20059
202/806-7047

Class Magazine
900 Broadway 8Fl, New York, NY 10003
212/677-3055

Colors
Anthony Porter
2608 Blaisdell Ave S, Minneapolis, MN 55408-1505
612/874-0494

Ebony Magazine & Jet Magazine
Mr Bennett
820 S Michigan Ave, Chicago, IL
312/322-9250

International Review of African-American Art
Juliet Bowles
Hampton U Virginia Museum
804/727-5308

Northstar News
Brenda Richardson
800 S Wells St #551, Chicago, IL 60607
312/431-3310

Publishers

Affordable Black Art
5146 Fourth Ave, Los Angeles, CA 90043
213/299-8082

American Fine Art Editions Inc
7034 Main St, Scottsdale, AZ 85251
602/990-1200

American Vision Gallery
625 Broadway, New York, NY 10012
212/226-0610

Angel Graphics
PO Box 530, Fairfield, IA 52556
800/354-8362

Art to Art
5327 Knotty Oaks Tr, Houston, TX 77045
713/433-5708
Distributor.

Bojay Ltd
PO Box 2576, Winter Park, FL 32790
407/645-4617

Double J Art & Frame
PO Box 66304, Baltimore, MD 21239
410/433-2137

Essence Art
1708 Church St, Holbrook, NY 11741
516/589-9420

Ethnic Reams
1341 Plowman Ave, Dallas, TX 75203
214/946-3772

Ethnic Visions
5195 Cinderlane Pkwy #U-603, Orlando, FL 32808
407/298-1966

Frederick Douglass Designs
1033 Folger St, Berkeley, CA 94710
510/204-0950

Golden Enterprises of Denver
11001 Albion Dr, Thornton, CO 80233
303/450-5464

Images of Color
5500 Greenville Ave #107, Dallas, TX 75206
214/265-0061

International Black Art
1431 S LaBrea, Los Angeles, CA 90019
213/939-0843
Distributor of prints as well as retailer of original work.

Market Art Publishing
PO Box 1125, 5610 SW Freeway, Pt Arkansas, TX 78373
713/781-6595

Melanin Graphics
2315 Hollins St #303, Baltimore, MD 21223
410/233-0772
Distributor.

Positive Black Images
PO Box 775, Bethesda, MD 20584
301/421-4549

Renaissance Design
35 Paisley Pk, Dorchester, MA 02124
617/265-2902

Things Graphic and Fine Arts
1522 14th St, Washington, DC 20005
202/667-4028

Ethnic/African-American

Vargas & Associates
Lee Thomas
4461 Nicole Dr, Lanham, MD 20706
301/731-5175
Distributor and publisher.

Victorias Fox
2458D Wesley Chapel Rd, Decatur, GA 30035
404/981-2298

Wanda Wallace Associates
PO Box 436, Inglewood, CA 90306

Reference Books

African-American Writer's Survival Handbook: How and Where to Get Published by LaRita Pryor
1,200 listings of publishers, book clubs, etc.

Big Black Book
Unlimited Creative Enterprises
PO Box 400476, Brooklyn, NY 11240
718/638-9223
Directory listing black-owned businesses, $5.

Black Books Guide/BBG
PO Box 5368, Newport News, VA 23605
Monthly publication distributed via black bookstores.

Directory of People of Color in the Visual Arts
College Art Association/CAA
275 7th Ave, New York, NY 10001
212/691-1051
72 pages, 750 listings, $9.

Guide to Multi-Cultural Resources
Highsmith Press
W5527 Highway 106, PO Box 800, Fort Atkinson, WI 53538-0800
414/563-9571
Lists hundreds of community organizations, $49.

Profile of Black Museums by African-American Museums Association

Success Guide: The Guide to Black Resources
Success Source
1949 E 105th St #100, Cleveland, OH 44106
216/791-9330
Guides for several cities.

USA Guide to Black America by Marcella Thun

Writing for the Ethnic Market
Writers Connection Press
PO Box 24770, San Jose, CA 95154
408/445-3600
Locates book publishers who need book covers.

Rep

Gwendolyn Henry-Jones
11249 S Longwood, Chicago, IL 60643

Shows

ABPsi-NCC
Association of Black Psychologists
Nayla Cooper
PO Box 55999, Washington, DC 20040-5999
213/295-0231
Conventions allow exhibit space. Location of convention varies each year.

Coalition of Black Meeting Planners
8630 Fenton St, Silver Springs, MD 20910
202/628-3952
Annually in April.

Denver Black Arts Festival
PO Box 300577, Denver, CO 80205
Deadline to apply is in June, festival is in mid-July.

Multi-Cultural Publishers Exchange Conference
916/889-4438
October.

National Black Arts Festival
236 Forsyth St, Atlanta, GA 30303
404/730-7315
Bi-annual event held June-July 1996.

National Black Media Coalition
38 New York Ave NE, Washington, DC 20002
202/387-8155
Annual conference in October.

Universities

North Carolina Central U
NCCU National Visual Artists File/Rosie Thompson
PO Box 19555, Durham, NC 27707
919/560-6391
Seeks slides, videos, catalogues, books, resumés, bibliographies for its recently established African-American visual artists file.

Pratt Community College
Gene Wineland/Gallery Director
Hwy 61, Pratt, KS 67124
316/672-5641 ext 191
Exhibits a contemporary African-American artist during the Black History Month (February).

Galleries

Arts & Antiques of Asia
chí-lin
17 Lake St, Meredith, NH 03253
135 Eastman Rd, Iaconia, NH 03246 (mailing address)
603/279-8663 603/527-1115
Specializing in contemporary Chinese prints.

Denise Amato Gallerie
123A NW 2nd St, Portland, OR
503/223-9502

Museum

Wing Luke Asian Museum
407 7th Ave S, Seattle, WA 98104
206/623-5124

Organizations

Asia Society Galleries
Margo Machida
725 Park Ave, New York, NY 10021
212/288-6400

Asian-American Art Alliance
PO Box 879, Canal St Station, 339 Lafayette St,
New York, NY 10013
212/979-6734

Asian-American Arts Centre
26 Bowery, New York, NY 10013
212/233-2154

Asian-American Renaissance
1564 Lafond Ave, St Paul, MN 55104
612/641-4040

Asian Art Council
1219 SW Park Ave, Portland, OR 97205

Center for US-China Arts Exchange
423 W 118th St #1E, New York, NY 10027
212/280-4648

China Institute
212/744-8181

Chinese Artists Association
1278 California St, San Francisco, CA 94109

Chinese Contemporary Painting Gallery
2758 36th Ave, San Francisco, CA 94116

Chinese Culture Foundation of San Francisco
Julie Chung
750 Kearny St, San Francisco, CA 94108
415/986-1822

Chinese Culture Institute
Doris Chu
276 Tremont St, Boston, MA 02116
617/542-4599
Has a gallery.

Chinese Photographers Association
101 First St, Box 238, Los Altos, CA 94022-0238

Commission on Asian-American Affairs
501 S Jackson #301, Seattle, WA 98104
206/464-5820

Consul General of the PR of China in San Francisco
1450 Laguna St, San Francisco, CA 94115
415/563-1718

U.S. Pan-Asian American Chamber of Commerce
1329 18th St NW, Washington, DC 20016
202/638-1764

Publisher

Avatar
617/466-9838
Wholesaler and retailer of contemporary Chinese artwork, publisher of prints and posters.

Ethnic/Hispanic & Latin American

Galleries

Aldo Castillo Gallery
Aldo Castillo
3513 N Lincoln 2Fl, Chicago, IL 60657
312/525-2536

B Lewin Galleries
210 S Palm Canyon Dr, Palm Springs, CA 92262
619/325-7611

Carla Stellweg Gallery
87 E Houston St, New York, NY 10012
212/431-5556

Chac Mool
125 N Robertson Blvd, Los Angeles, CA 90048
310/550-6792

El Bohio
605 E 9th St, New York, NY 10009
212/533-6835

Elite Fine Art
3140 Ponce de Leon Blvd, Coral Gables, FL 33134
305/448-3800

Galeria Las Americas
912 E 3rd St #402, Los Angeles, CA 90013
213/613-1347

George Belcher Gallery
340 Townsend, San Francisco, CA 94107
415/543-1908

Institution of Creative Art
Francisco Torregrosa
7080 Hollywood Blvd #321, Los Angeles, CA 90026
213/962-9879

Jose Galvez Gallery
743 N 4th Ave, Tucson, AZ 85705
602/624-6878

Latin American Masters
264 N Beveriy Dr, Beverly Hills, CA 90210
310/271-4847

Mary-Anne Martin Gallery
23 E 73rd St, New York, NY 10021
212/288-2213

New Latino Gallery
Gustavo Valdes Jr
1020 Madison Ave 3Fl, New York, NY 10021
212/439-6115

Vista Gallery
Nanni Herrera
1020 Madison Ave, New York, NY
212/439-6115

Organizations

Association of Hispanic Arts/AHA
Jane Arce-Bello
173 E 116 St 2Fl, New York, NY 10029
212/860-5445
Publishes a quarterly newsletter.

Chicano Humanities and Arts Council/CHAC
PO Box 2512, Denver, CO 80201
303/477-7733
Publications, workshops, information.

Contemporary Hispanic Artists
516/277-0387

Hispanic Chamber of Commerce
221 E 9th St #203, Austin, TX 78701
512/476-7502

Hispanic Society of America
613 W 155 St, New York, NY 10032
212/926-2234

US Hispanic Chamber of Commerce
1030 15th St NW #206, Washington, DC 20005
202/842-1212

Periodical

Latin American Art
7824 E Lewis Ave, Scottsdale, AZ 85252
602/947-8423
Coming out with an annual directory listing galleries, consultants, etc.

Reps

Abe Tomás Hughes II
Latin American Art Consultant
PO Box 1865, La Jolla, CA 92038-1865
619/454-7876
Rua General Oscar Miranda, 30, Porto Alegre, RS
90440-160 Brazil
011/55-51-331-0397

Mountain Wind
Roger Hernandez
PO Box 570, New York, NY 10029
212/534-6004

Phyllis Needleman
50 E Bellevue Pl #2505, Chicago, IL 60611
312/642-7929

Books

Encyclopedia of the American Indian, Sixth Edition
by Barry Klein

Minnesota Native Artists Directory
1433 E Franklin Ave, Minneapolis, MN 55404
612/870-7173
$69.95ppd.

Galleries

American Indian Contemporary Arts
685 Market St #250, San Francisco, CA 94105
415/495-7600

Minneapolis American Indian Center
1530 E Franklin Ave, Minneapolis, MN 55404
612/871-4555

Organizations

American Indian Community House Gallery/Museum
Joanna Osburn-Bigfeather
404 Lafayette 2Fl, New York, NY 10543
212/598-0100 ext 241
Has a slide registry.

American Indian Cultural Center/AICC
Georgena Counts
2122 S Pacific Highway, Talent, OR 97540
Has gallery space available.

Artists Registry/ATLATL
Carla Roberts
203 N Central #104, Phoenix, AZ 85004
602/253-2731
Resources, seminars and referral services. Publishes a newsletter, "Native Arts Update," edited by Wendy Weston-Ben.

Indian Arts and Crafts Association
122 LaVeta NE #B, Albuquerque, NM 87108
505/265-9149

Minority Business Development Agency
Herbert C Hoover Bldg, 14th and Constitution Ave NW, Washington, DC 20230
202/482-1936

National Center of the American Indian
953 E Juanita Ave, Mesa, AZ 85204
602/831-7524

National Minority Supplier Development Council
15 W 39th St 9Fl, New York, NY 10018
212/944-2430

Native American Indian Information & Trade Center/ NA²IITC
Fred Snyder
PO Box 27626, Tucson, AZ 85726-7626
602/622-4900
Has a Native American postcard deck, Native American Directory, Fair Guide, gallery space; sponsors powwow with craft shows, and gives financial aid.

SW Association for Indian Arts
509 Camino De Los Marquez #1, Santa Fe, NM 87501
505/983-5220
Sponsors annual Santa Fe art shows in August and May.

Periodicals

Santa Fe & Taos Arts
535 Cordova Rd #241, Santa Fe, NM 87501

Publishers

Market Direct Greeting Cards
2665 N Indian Ridge Dr, Tucson, AZ 85715

Native American Images
PO Box 746, Austin, TX 78767
800/252-3332 512/472-3049

RT Computer Graphics Inc
602 San Juan de Rio, Rio Rancho, NM 87124
505/891-1600
Native American and Southwest clip art.

Spirit Vision Publishers
PO Box 2074, Round Rock, TX 78680
512/218-0300

White Door Publisher
Mark Quale
PO Box 427, New London, MN 56273
612/796-2209

Shows

Colorado Indian Market
Western Art Roundup
PO Box 17187, Boulder, CO 80308
303/447-9967
Western art invitational in July.

Lawrence Indian Arts Show
Kansas University Museum of Anthropology, Lawrence, KS 66045
913/864-4245
Sept-Oct.

Twin Cities Indian Art Market
Hyatt Regency, Minneapolis, MN
612/370-1234
Held early May.

Ethnic/Various

Austrian

Austrian Cultural Institute
Wolfgang Waldner
11 E 52nd St, New York, NY 10022
212/759-5165

Bulgarian

Nelly's Art Gallery
225 N Michigan, Chicago, IL
312/565-1602

Caribbean

Pan American Gallery
3303 Lee Pkwy #111, Dallas, TX 75219
214/521-3584

Caribbean Cultural Center/VARRCRC
408 W 58th St, New York, NY 10019
212/307-7420

Haitian

Galerie Lakaye
1550 N Curson Ave, Los Angeles, CA 90046
213/850-6188

Haitian Art News
Fred Lambrou
5440 N Ocean Dr #1506, Singer Island, FL 33404

Le Jardin Culturel Art Gallery
225-09 Linden Blvd, Cambria Heights, NY 11411
718/712-9377

Japanese

Japanese American Cultural Center
George Doizaki Gallery
244 S San Pedro St, Los Angeles, CA 90012-3895
213/628-2725

Japantown Art Workshop
Dennis Taniguchi
1840 Sutter St #102, San Francisco, CA 94115
415/922-8700
Gallery space.

Japan Foundation
2425 W Olympic Blvd #620E, Santa Monica, CA
90404-4034
310/449-0027

Japanese Artists Association
80 Amsterdam Ave, New York, NY 10023

Russian

Galeria Alyonushka
504 DeGroff St, Sitka, AK 99835
907/747-5757

Scandinavian

American-Scandinavian Foundation
Lynn Carter
725 Park Ave, New York, NY 10021
212/879-9779

Sons of Norway Gallery
1455 W Lake St, Minneapolis, MN 55408
612/827-3611

Ukranian

Ukranian Art Center
4315 Melrose Ave, Los Angeles, CA 90029
213/668-0172

Ukranian Institute of America
Slava Gerulak
2 E 79th St, New York, NY 10021
212/288-8660

Art Distributor

Art Alley
Don Monson
579 Fairfield Ln, Louisville, CO 80027
303/666-9728

Art Publishers

Applejack Limited Editions
PO Box 1527, Manchester Center, VT 05255

Art Beats
33 River Rd, Coss Cob, CT 06807
800/338-3315

International Graphics
Postfach 1257, 76339 Eggenstein, Germany

Catalog

Waterford Gardens
Elaine
74-E Allendale Rd, Salle River, NJ 07458
201/327-0721

Gallery

Meredith Long & Co
2323 San Felipe, Houston TX 77019
713/523-6671

Magazines

American Horticulturist
7931 E Boulevard Dr, Alexandria, VA 22308
703/768-5700

Florist
William Golden
Box 2227, Southfield, MI 48037
810/355-9300

Flowers & Garden
Kay Olson
700 W 47th St #310, Kansas City, MO 64112
816/531-5730

Garden Supply Retailer
1 Chilton Way, Radnor, PA 19089
610/964-4275

Horticulture
98 N Washington St, Boston, MA 02114
617/742-5600

Museum

Museum of Floral Arts
Chicago Botanic Garden/Roger Vandiver
PO Box 400, Glencoe, IL 60022
708/835-5440

Shows

American Orchid Society
Jennifer
6000 S Olive Ave, W Palm Beach, FL 33405-9974
407/585-8666
Has directory of nationwide societies for possible exhibition venues for $20.

American Rock Garden Society
2100 S Monroe St, Denver, CO 80210
Annual art show with great exposure in the Vail area.

Azalea Festival Art Show
Lori Malhoit
PO Box 722, Palatka, FL 32177
904/325-8750
Held in March. $8,000 in prizes.

Chicago Botanic Garden
Roger Vandiver
PO Box 400, Glencoe, IL 60022
708/835-5440
Hosts an annual Business of Art conference, along with other shows.

Colorado Garden and Home Show
303/696-6100
Held in February. Has an artists' section.

Dixon Gallery and Gardens
Memphis, TN
901/761-5250
Sanctioned by the Garden Club of America. Held in April.

Lansing Art Gallery
425 S Cesar Chavez Ave, Lansing, MI 48933
517/374-6400
Annual "Botanical Images" competition.

National Capital Orchid Society
Ruth Lazarowitz
1513 Gingerwood Ct, Vienna, VA 22182
703/759-5914
October exhibition.

San Francisco Orchid Society
415/665-2468

Sunset Magazine
Lists flower shows throughout the nation.

Healing

Magazines

Health Care Week
1515 Broadway, New York, NY 10026

Hospital Audiences Inc
220 W 42nd St, New York, NY 10036

Medical Imaging Magazine
207 Highpoint Ave, Portsmouth, RI 02871
401/683-7470

Well-Being Magazine
833 W 1st, San Diego, CA 92101
800/727-4777

Organizations

Arts in the Hospitals
Wayne Fitzgerald
Box 510, Richmond, VA 23298-0510
804/225-4706

Courage Art Publishing
Fran Bloomfield
3915 Golden Valley Rd, Golden Valley, MN 55422
612/520-0585
Has an annual 'Art Search' for its Christmas/Holiday cards.

Guild Association of Children's Hospital and Medical Center
3713 NE 45th, Seattle, WA 98105
206/526-2156/7
Prints 450,000 Christmas cards. Competition submissions due in January.

Healing Legacies
PO Box 5605, Burlington, VT 05402

Healing Through the Arts
PO Box 411, Wayland, MA 01778
617/868-1908
$2,000 to artists exploring the use of art in a healing capacity.

Health Care Convention and Exhibitors Association
5775 Peachtree-Dunwoody Rd #500G, Atlanta, GA 30342
404/252-3663
Annual convention.

Medical Illustrators Association
Premiere Productions/Linda Johnson
1819 Peachtree St #620, Atlanta, GA 30309
800/454-7900 404/350-7900
Has an annual directory.

National Expressive Therapy Association
1164 Bishop St, #124, Honolulu, HI 96813
808/524-5411

Organization for Artists Trained in Health Care/OATH
Pamela Rogow
5500 Wissahickon Ave #805C, Philadelphia, PA 19144
215/849-5790
Puts together temporary and traveling shows.

Society for the Arts in Healthcare
216/841-9723
Has an annual conference.

Shows

Art as a Healing Force
Linda Samuels
PO Box 820, Bolinas, CA 94924
415/868-0634
Slide resource library.

Breast Cancer Action Group
PO Box 5605, Burlington, VT 05402
802/863-3507

The Fine Arts for the Healing Arts
LaSalle Nursing Alumni, Union Bldg Ballroom,
LaSalle U,1900 W Olney Ave, Philadelphia, PA
215/533-2236
Annual show and auction.

North River Gallery
Ralph Ivery
384 Main St, Catskill, NY 12414
518/943-1455
Statewide art shows held within the Mental Health Services showrooms.

Galleries

Jewish Community Center
Sandy Schneider
75738 Forbes Ave, Pittsburgh, PA 15217
412/521-8011 ext 228
Send slides and SASE for review for exhibition.

Jewish Community Center of Cleveland
Carol Kranitz
3505 Mayfield Rd, Cleveland Heights, OH 44118
216/382-4000 ext 233

Jewish Community Center of St Paul
Kevin Olson
1375 St Paul Ave, St Paul, MN 55116
612/698-0751

Michael Hittleman Gallery
Michael Hittleman
8797 Beverly Blvd #302, Los Angeles, CA 90048
213/655-5364

Magazines

Commentary
165 E 56th St, New York, NY 10022
212/339-6000

Hadassah Magazine
50 W 58th St, New York, NY 10019
212/355-7900

Jewish Book Council
15 E 26th St, New York, NY 10010
212/532-4949

Jewish Daily Forward
45 E 33rd St, New York, NY 10016
212/889-8200

Jewish Times Outlook
Box 10674, Charlotte, NC 28234
704/372-3296

Jewish Week American Examiner
1501 Broadway #505, New York, NY 10036
212/921-7822

Judaism
15 E 84th St, New York, NY 10028
212/879-4500

Lith
250 W 57th St #2432, New York, NY 10107
212/757-0818

National Jewish Monthly
1640 Rhode Island Ave, Washington, DC 20036

Museums

Magnes Museum
2911 Russell St, Berkeley, CA 94705

National Council of Jewish Women
Landsman Gallery/Melissa Killeen
PO Box 9236, Cherry Hill, NJ 08003
609/346-3278
Has an annual art show.

National Museum of American Jewish History
55 N 5th St, Philadelphia, PA 19106
215/923-3811

Rosenthal Judaica Collection
Alex Rosenthal
260 47th St, Brooklyn, NY 11220
718/439-6900
Sells mass-market and exclusive numbered pieces.

Organizations

American Jewish Art Club
Irma Rosenberger
10124 Peach Pkwy, Skokie, IL 60076
708/675-2977
Mostly used by local artists to exhibit.

Art Judaica Education Foundation
Nacha Leaf
25900 Greenfield Rd #209, Oak Park, MI 48237
810/968-6541
For artists whose work is educating.

Jewish Community Center
Joan Cavar
4800 E Alameda Ave, Denver, CO 80222
303/399-2660

Jewish Community Center
PO Box 81980, Pittsburgh, PA 15217
412/521-8010
Annual art show.

National Council on Art in Jewish Life
Julius Schatz
15 E 84th St, New York, NY, 10028
212/879-4500

Northwest Jewish Arts
Etona Dyhan
8606 35th Ave NE, Seattle, WA 98115
206/526-8073

Union of American Hebrew Congregations
Department of Synagogue Management/Joe Bernstein
838 Fifth Ave, New York, NY 10021
212/249-0100

Marine

Book Publishers

Cornell Maritime Press Inc
Box 456, Centreville, MD 21617
410/758-1075

International Marine
Molly Mulhern
PO Box 220, Camden, ME 04843
207/236-4837

Contest

SeaFood Leader
Mary Dittrich
5305 Shilshole Ave NW #200, Seattle, WA 98107
Holds an annual call for entries for free publicity and exhibition of artwork in their trade publication to the seafood industry.

Corporation

Bank & Trust Co
225 Franklin St, Boston, MA
Over 200 works of art relating to ships.

Direct Mail

Artful Fish
PO Box 40, Santa Cruz, CA 95063-0040
800/525-6777

Festivals

Charleston Maritime Festival
211 Meeting St, Charleston, SC 29401
803/723-1748
September 1996.

International Boat Builders Conference
CMC/Tina Sanderson
200 Connecticut Ave, Norwalk, CT 06856-4990
203/852-0500

Marine Art Exhibit
Newport Visual Arts Center
777 W Beach St, Newport, OR 97365
Month of June.

Marine Art Expo
PO Box 223519, Carmel, CA 93922
408/625-4145
Jan-Apr in Hawaii.

Marine Art Fair
1313 Broadway St, Marine on St Croix, MN 55047
612/433-3636
September.

Marine Arts Festival
PO Box 590, Mendocino, CA 95460
707/937-2709
July.

White Lake Maritime Festival
White Lake Rotary Club
124 Hanson, Whitehall, MI 49461
616/893-4585
Held in August. 10,000 expected.

Galleries

Clipper Ship Gallery
10 W Harris Ave, La Grange, IL 60525
708/352-2778

Confederation Centre of the Arts
902/628-6129

Kirsten Gallery
5320 Roosevelt Way NE, Seattle, WA 98105
206/522-2011

Moorings Gallery
PO Box 490, 575 Main St, Mahone Canyon, NS
Canada B0J 2E0
902/624-6208

Mystic Marine Gallery
39 Greenmanville Ave, Mystic, CT 06355
203/572-8524
Has an annual competition in the Fall with a June deadline.

Port 'N Starboard
53 Falmouth Rd, Falmouth, ME 04105
207/781-4214

Sportsman's Edge Ltd
Alfred King
136 E 74th St, New York, NY 10021

Wilson Gallery
129 Newbury St, Boston, MA 02116
617/236-7845

Magazines

Clearwater Navigator
112 Market St, Poughkeepsie, NY 12603
914/454-7673

Goldbergs Marine
201 Meadow Rd, Edison, NJ 08818
908/819-7400

International Marine Publishing
Paula Blanchard
207/236-6039

Sailing Magazine
125 E Main St, Pt Washington, WI 53074
414/284-3494

Mailing Lists

George-Mann Assoc
20 Lake Dr, Box 930, Highstown, NJ 08520
609/443-1330

Karen Gamow
14618 Tyler Foote Rd, Nevada City, CA 95959
916/292-3727
300 names of nautical stores in tourist areas for $65.

Museum

American Merchant Marine Museum
Kings Point, NY
516/773-5000

Organizations

American Cetacean Society
PO Box 2639, San Pedro, CA 90733
310/548-6279
Protects marine mammals.

American Society of Marine Artists/ASMA
1461 Cathy's Ln, N Wales, PA 19454
215/283-0888

Center for Marine Conservation
1725 DeSalles St NW, Washington, DC 20036
202/429-5609
A mail order catalog that carries many poster reproductions of animals and marine life.

Coast Guard Art Program
Salmagundi Club/Mr George Gray
47 Fifth Ave, New York, NY 10003
212/255-7740
Accepted marine artists are given a card allowing entry to US Coast Guard installations to sketch, paint, and photograph unclassified USCG activities for the purpose of completing works of art for the US Coast Guard Collection.

Cousteau Society
870 Greenbriar Cir #402, Chesapeake, VA 23320
804/523-9335

International Society of Marine Painters
Jerry McClish
PO Box 13, Oneco, FL 34264
813/758-0802
Has a newsletter entitled "Seascaper."

Whale and Dolphin Conservation Society
191 Weston Rd, Lincoln, MA 01773
617/259-0423

Whooping Crane Conservation Association
3000 Meadowlark Dr, Sierra Vista, AZ 85635
318/234-6339

Wildlife Art News
PO Box 16246, Minneapolis, MN 55416-0236
800/626-0934
Has an annual yearbook which lists shows for the entire year as well as museums having shows.

Publishers

Chandler Mill
PO Box 477, N Pembroke, MA 02358
617/294-1687

Dauphin Island Art Center
Nick Colquitt
1406 Cadillac Ave, Box 699, Dauphin Island, AL 36528
Distributor and retailer for marine and nautical decorative art.

Pilothouse Art
2442 NW Market #237, Seattle, WA 98107

Portside Gallery
1900 Fairfax Rd #12, Annapolis, MD 21401
410/268-4769

Water Colors
2808 Kenloth Dr, Orlando, FL 32923
800/3-COLOUR

Miniatures

Exhibitions

Georgia Miniature Art Society
Dana Terpin
3455 Childers Rd, Roswell, GA 30075
404/993-2236

Galleries

El Dorado Fine Arts Gallery
Carol Fuller-DuBois
2504 W Colorado Ave, Colorado Springs, CO 80904
719/634-4075
International show held in Apr-May.

Long Beach Island Gallery
2001 Long Beach Blvd, Surf City, NJ 08008
609/494-4232
December show.

Seaside Gallery
2716 Virginia Dare Tr S, Nags Head, SC 27959
800/828-2444
May show.

White Oak Gallery
Wally Grewe
3929 W 50th, Edina, MN 55424
612/461-2416
Annual exhibition.

Organizations

Laramie Art Guild
PO Box 874, Laramie, WY 82070
Annual exhibition held in September.

Miniature Art Society of America
1595 N Peaceful Ln, Clearwater, FL 34616

Miniature Art Society of Florida
Jack Spregue
623 Royal Dornosh Ct, Tarpin Springs, FL 34689

Miniature Art Society of Florida Inc
Doris Liverman
PO Box 867, Dunedin, FL 34697-0867

Miniature Art Society of Montana
918 Avenue F, Billings, MT 59102

Miniature Art Society of New Jersey
Art on the Avenue Gallery/Pearl Mason
648 Bloomfield Ave, Verona, NJ 07044

Miniature Sculpture Association
Glenn Johnson
PO Box 327, Wayland, MA 01778

Miniature Showcase
Kalmbach Publications/Geri Willems
PO Box 1612, Waukesha, WI 53187,
800/558-1544 414/796-8776
Publishes a monthly newsletter, "Nutshell News," on various books on miniatures.

Miniatures Society of Washington DC
Margaret Wisdom
5812 Massachusetts Ave NW, Bethesda, MD 20816

Raleigh Miniatures Guild
Nancy Kirby
5519 Parkwood Dr, Raleigh, NC 27612

Tennessee Art League
Joanne Seigenthaler
3011 Poston Ave, Nashville, TN 37203
615/298-4072

Shows

Albuquerque Art Museum
2000 Mountain Rd NW, Albuquerque, NM 87103
505/243-7255
Annual show.

American Art in Miniature
Gilcrease Museum/Paula Eliot
1400 Gilcrease Museum Rd, Tulsa, OK 74127
918/596-2700
November.

Gateway to the Rockies
Marion Golden
373 Lima St, Aurora, CO 80010

Soho Gallery
23 Palafox Pl, Pensacola, Fl 32501
904/435-7646
Annual show "It's A Small World" with deadline in November.

Organizations

American Society of Portrait Painters
PO Box 230216, Montgomery, AL 36123-0216
800/622-7672 334/270-9020
Annual portraits festival.

Caricaturist Network
Buddy Rose
PO Box 181147, Dallas, TX 75214
214/412-4363

Portrait Institute
Box 510, Georgetown, CT 06829
203/438-1109
Holds an annual seminar in March.

The Portrait Institute
John Howard Sanden
130 W 57th St, New York, NY 10019

Portrait Society of Atlanta
Nancy Honea
361 Navarre Dr, Stone Mountain, GA 30087
404/469-4616

Reps

Artist's Son Gallery
130 King St, Rte 3A, Cohasset, MA 02025
617/383-1841

Faces West Portraits
PO Box 82, Pacific Grove, CA 93950-0082
408/373-5727

Michelle Broadfoot
1560 SW 6th Ave, Boca Raton, FL 33486
407/367-1339

Portrait Brokers of America
36B Church St, Birmingham, AL 35213
205/879-1222

Portrait Center of America
985 Park Ave, New York, NY 10028
212/879-5560

The Portrait Group
Paschal Young
Box 1800, Charleston, SC 29402

Portraits Chicago
Kathleen Vanella
PO Box 303, Lake Forest, IL 60045

Portraits South
Anne Pace
4008 Barrett Dr #106, Raleigh, NC 27609
919/782-1610
Photos only (no slides).

Primarily Portraits
Karen Spiro
3 Lehman Ln, Philadelphia, PA 19144
215/843-6034

Postage Stamps

Contests

Conservation Stamp Contest
5400 Bishop Blvd, Cheyenne, WY 82006
307/777-4541

Informart
Stamp Print Department
1727 E 2nd St, Casper, WY 82601
307/237-1659
A magazine which has listings you will want to research.

Stamp Guides

Federal Migratory Bird Hunting & Conservation Stamp Contest
US Dept of Interior, Fish and Wildlife Service
1849 C St NW #2058, Washington, DC 20240
202/208-4354
Entry fee is $50. This stamp program has raised over $400 million since 1934 to preserve nearly 4 million acres of wetlands.

Minister of Posts and Telecommunications
Stamps & Correspondence Promotion
Postal Bureau, Ministry of Posts and Telegraph
Kasumigaseki 1-3-2 Chiyoda-ky Tokyo, 100-90 Japan
Has an annual contest.

Native Species Stamp Contest
Department of Fish and Game
916/327-5961

Stamps & Coins
Mordechai
460 W 34th St 10Fl, New York, NY 10001
212/629-7979
Agent to foreign governments for postage stamps.

US Postage Stamps
Citizens Stamp Advisory Committee/Cindy Tackett
Postmaster General, 475 L'enfant Plaza SW #5700,
Washington DC 20260
202/268-2000
Acceptance is by a committee of 11 people. They award approximately $1,500 per commission. They also keep a talent-bank file of resumés (they have about 4,000 subjects on backlog).

Wildlife Art News
PO Box 16246, Minneapolis, MN 55416-0236
800/626-0934
Has an extensive directory on federal, state and conservation stamps available for $5.

Though the olden (and golden) days have passed when painters and sculptors were supported by the church system, churches of all denominations still commission artists to create new works. When a new church is built, new artworks are needed. Search out the national headquarters of churches and religious organizations and their art or architecture committee to find out where their new churches or renovations are occurring.

Art Publisher

Bartons & Cotton
Carol White
1405 Parker Rd, Baltimore, MD 21227

Inspirationart & Scripture
Lisa Edwards
PO Box 5550, Cedar Rapids, IA 52406-5550
800/728-5550 319/366-8286

Marks Collection
1590 N Roberts, Kennesaw, GA 30144
800/849-3125 404/425-7982
Christian fine art. Send only photos (no resumé) for review.

Master Peace Collection
PO Box 1010, Siloam Springs, AR 72761
800/944-8000

Artist-in-Residence Program

Pacific School of Religion
Dean's Office, Berkeley, CA
510/848-0528

Wesley Theological Seminary
Center for Arts & Religion/Elly Sparks Brown
4500 Massachusetts Ave NW, Washington, DC 20016
202/885-1000

Book Publisher

Augsburg Fortress Publishers
Ellen Maly
426 S 5th St, PO Box 1209, Minneapolis, MN 55440
612/330-3408

Crossway Books/Good News Publishers
Arthur Guye
1300 Crescent St, Wheaton, IL 60187
708/682-4300

David C Cook
Randy Made
850 N Grove Ave, Elgin, IL 60120
708/741-2400

Pacific Press Publishing Association
Merwin Stewart
1350 N Kings Rd, Nampa, ID 83687
208/465-2592

Galleries

Big Art Productions
Natalya Melnikoff
1069 S Hayworth Ave, Los Angeles, CA 90035
213/937-6645

Gallery Genesis
Ronald Zawilla
4201 S Archer, Chicago, IL 60632
312/247-2454
Serves clergy and private collectors.

Maritain Gallery
127 W Loveland Ave, Loveland, OH 45140
513/683-1152
Spiritual work.

Sanctuary Art
5225 SW 166th Ave, Beaverton, OR 97007
503/642-3404

Sloane Gallery of Art
1612 17th St, Denver, CO 80202
303/595-4230

St Anthony's Gallery
450 N Academy, Greenville, SC 29601
803/370-2086

Theosophical Society Art Gallery
PO Box 270, Wheaton, IL 60189-0270

Magazines

Charisma Magazine & New Man Magazine
600 Rinehart Rd, Lake Mary, FL 32746
407/333-0600

Church Herald
616/698-7071

Moody Magazine
820 N La Salle Blvd, Chicago, IL 60610
312/329-4000

New Catholic World
201/825-7300

Preaching Magazine
PO Box 7728, Louisville, KY 40257
502/899-3119

Mailing Lists

Bernice Bush Co
15052 Springdale St, Huntington Beach, CA 92649
714/891-3344

Religious

Museums

American Interfaith Institute
401 N Broad St, Philadelphia, PA 19108
215/238-5313

Bill Graham Center Museum
500 E College Ave, Wheaton College, Wheaton, IL 60187
708/752-5909

Cathedral Heritage Foundation
Spiritual Art Gallery/Kim Klein
429 W Muhammad Ali Blvd #100, Louisville, KY 40202
502/583-3100

Catholic Museum of America
Christina Cox
645 Fifth Ave #1202, New York, NY 10022
212/752-3785

Organizations

Catholic Artists of the 80's
M Beaudette
101 W 15th St, New York, NY 10011

Catholic Art Society
PO Box 4429, New York, NY 10163-4429

Chapel Art Center
Saint Anselm College
87 Saint Anselm Dr, Manchester, NH 03102-1310
603/641-7000

Christian Artisans Guild
760 Bristol Ferry Rd, Portsmouth, RI 02871

Christian Booksellers Association/CBA
2620 Venetucci Blvd, Colorado Springs, CO 80909
719/576-7880
Holds a convention every summer.

Christians in the Arts Networking Inc
PO Box 242, Atlington, MA 02174
617/646-1541

Christians in the Visual Arts/CIVA
Box 18117, Minneapolis, MN 55418-0117
612/378-0606

Evangelical Christian Publishers Association
3225 S Hardy Dr #101, Tempe, AZ 85282
602/966-3998
Various Bible and book fairs throughout the country.

Interfaith Forum on Religion, Faith and Architecture
1777 Church St NW, Washington, DC 20036
Has a slide registry for its annual juried show which awards certificates of merit to 13 winners and has an exhibit of these works. Offers referrals to church officials across the country.

Liturgical Art Guild Of Ohio
3322 Sciontangy Dr, Columbus, Oh 43212

Religious Arts Guild
Jackie Jay
25 Beacon St, Boston, MA 02108
617/742-2100
Offers a scholarship.

San Diego Pentecostal Center
Mary Ann Fallon
PO Box 85728, San Diego, CA 92186-5728
619/490-8290
Has a slide registry of religious and spiritual works.

St Peter's Church
Tanya Gresh/Exhibition Committee
619 Lexington Ave, New York, NY 10022
212/935-2200

United Church of Christ
Dorothy Clarkton
132 W 31st St, New York, NY 10001
212/870-3271
Has a gallery.

Retreat

Pathways
5140 E State Rd 45, Bloomington, IN 47408
812/330-9333

School

School of Sacred Arts
133 W Fourth St, New York, NY 10012
212/475-8048

Show

Christian Fine Arts Exhibition
Civic Center Gallery
808 N Montgomery, Farmington, NM 87401
505/327-0363
Annual Christian fine arts exhibit held in April each year.

Advertising

Kraus Sikes Inc
228 State St, Madison, WI 53703
800/969-1556
Annual directory of architects around the country showing the work of sculptors.

Sculpture Magazine
1050 17th St NW #250, Washington, DC 20036
202/785-1144

Awards

National Sculpture Society
1177 Ave of the Americas, New York, NY 10036
212/764-5645
Must be under 35 years of age.

NEA Sculpture Fellowship
1100 Pennsylvania Ave NW #729, Washington, DC 20506
202/682-5448
Deadline in February.

Competition

Annual Indoor/Outdoor Competition
Caldwell Arts Council
PO Box 1613, Lenoir, NC 28465
704/754-2486
In its tenth year. August deadline.

Consultants

Francoise Yohalem
10834 Antique Ter #203, Rockville, MD 20852
301/816-0518

Images Sculptural Concepts
Joan Starr
165 Avery Pl, Westport, CT 06880
203/222-0040

Sardi Snyder
Art Resource Network
68 Commerce Dr, Farmingdale, NY 11735
516/753-0451

Exhibitions

Art Shows
PO Box 245, Spokane, WA 99210-0245
509/838-5847
Holds an International Sculpture Expo in July 1996. Best of show $10,000; 200 exhibitors; $350 for booth.

Burlington County College Annual Exhibition
Pemberton, NJ 08068
609/894-9311 ext 212
Stays up for one year. Juried in February. Stipend provided.

Kingston Arts Council
PO Box 3554, Kingston, NC 28502
919/527-2517

Outdoor Sculpture Exhibit
Art Broker/Karen Briede
220 N Hancock, Miller Beach, IN 46403
219/938-3652
June-Aug with sales booths.

Outdoor Sculpture Search
City of Los Altos Arts Committee/Brian McCarthy
1 N San Antonio Rd, Los Altos, CA 94022
415/948-0482
Invites artists to loan their work for display throughout the city for 1-2 years.

Sculpture in the Park
Mayfair/Cindy Ornstein
2020 Hamilton St, Allentown, PA 18104
610/437-6900
Month-long; no entry fee; stipends to $1,000; deadline January.

Foundries

Excalibur Bronze Sculpture Foundry
85 Adams St, Brooklyn, NY 11201
718/522-3330

Fine Arts
4975 Waldon Rd, Clarkston, MI 48348
810/391-3010

Fine Arts & Metal
825 N 10th St, San Jose, CA
408/292-7628

Modern Art Foundry Inc
18-70 41st St, Long Island City, NY 11105
718/728-2030

Paul King Foundry
92 Allendale Ave, Johnson, RI 02919
401/231-3120

Sculpture House Casting Inc
155 W 26 St, New York, NY 10001
212/645-9430

Tallix Inc
175 Fishgill Ave, Beacon, NY 12508
914/838-1111

Sculpture

Galleries

A New Leaf Gallery
1286 Gilman St, Berkeley, CA 94706
510/525-7621
Contemporary art for outer spaces.

Herr-Chambliss Fine Arts Gallery
718 Central Ave, Hot Springs Natl Park, AR 71902
501/624-7188
Cutting edge sculpture.

Out of Sight Gallery
1511 Chicago Ave, Evanston, IL 60201
708/328-1808
Cooperative gallery.

Philip Bareiss Contemporary Exhibitions
Susan Strong
Box 2739, Taos, NM 87571
505/776-2284

Sculptors Gallery
164 Mercer St, New York, NY

Shidoni Gallery
Box 250, Tesuque, NM 87574
505/988-8001

Tory Folliard Gallery
233 N Milwaukee St, Milwaukee, WI 53202
414/273-7311
Specializing in sculpture.

Valley Bronze of Oregon
PO Box 999, Cannon Beach, OR 97110
503/436-2118

Woodlot Gallery
Christopher and Janet Graf
5215 Evergreen Dr, Sheboygan, WI 53081
414/458-4798
Largest outdoor sculpture collection in the Midwest.

Magazines

Public Art Review
2324 University Ave W, St Paul, MN 55114-1802
612/641-1128

Sculpture Review
1177 Ave of the Americas 15Fl, New York, NY 10036
212/764-5645

Sculpture/Sculpture Maquette
1050 17th St NW #250, Washington, DC 20036
202/785-1144

Mailing Lists

ArtNetwork
916/432-7630
Slide registries of art councils percentage of arts programs.

Museums

Weisman Art Museum/U of Minnesota
Jerome Sculpture Plaza
333 E River Rd, Minneapolis, MN 55455
612/625-9686

Organizations

14 Sculptors Gallery
Esther Grillo
168 (rear) Mercer St, New York, NY 10014
212/966-5790

Federation of Modern Painters and Sculptors
Haim Mendleson
234 W 21st St, New York, NY 10011
212/568-2981

Grants Pass Community Sculpture Association
Tina Stafford
980 SW 6th St #14, Grants Pass, OR 97526

Holdenville Society of Painters and Sculptors
Dorothy Buyers
418 S Echo, Holdenville, OK 74848
405/379-5481

International Sculpture Center
1050 17th St NW #250, Washington, DC 20036
202/785-1144

Johnson Atelier Technical Institute of Sculpture
60 Ward Ave Ext, Mercerville, NJ 08619
609/890-7777

Kansas Sculptors Association
James Patti
2030 Ousdahl, Lawrence, KS 66046
913/843-0419

Knoxville International Sculpture
Ingrid Fassbender
439 W Oakdale, Chicago, IL 60657

National Sculpture Society
1177 Ave of the Americas 15Fl, New York, NY 10036
212/764-5645

New England Sculptors Association/NESA
37 Atkinson Ln, Sudbury, MA 01776
508/443-5104

Northwest Stone Sculptors Association
5580 S Langston Rd, Seattle, WA 98178-3566

Pacific Rim Sculptors Group
Connie Tell
593 Arkansas St, San Francisco, CA 94107
415/285-6431
$40 per year.

Pen & Brush Inc
16 E 10th St, New York, NY 10003
212/475-3669

Peninsula Sculptors Guild
1870 Ralston Ave, Belmont, CA 94002
415/594-1577

Renegade Sculpture Associates
1800 Rees Rd, San Marcos, CA 92069

Santa Barbara Sculptors' Guild
PO Box 2273, Santa Barbara, CA 93120

Sculpture Center
12206 Euclid Ave, Cleveland, OH 44106
216/229-6527

Sculpture Center Inc
Marian Griffiths
167 E 69th St, New York, NY 10021
212/879-3500
Has a gallery and school.

Sculpture Chicago
Karen Paluzzi
20 N Michigan Ave #400, Chicago, IL 60602
312/456-7140
A public art organization that sponsors competitive exhibitions and seminars. They do public art programming.

Sculptor's Guild Inc
110 Greene St, New York, NY 10012
212/431-5669

Sculptor's Guild of San Diego
1800 Rees Rd, San Marcus, CA 92069
619/238-0522

Sculpture Outdoors
220 Locust St #27-D, Philadelphia, PA 19106

Sculpture Space
Sylvia de Swaan
12 Gates St, Utica, NY 13502
315/724-8381

SOS
National Institute for the Conservation of Cultural Property
3200 K St NW #602, Washington DC 20007
800/421-1381 202/625-1495

Southeast Sculpture Association
PO Box 3005, Vero Beach, FL 32964

Southern Association of Sculptors
Tim Murray
Univ of Alabama, Huntsville, AL 35805
205/895-6114

Texas Sculpture Association
Dottie Shiplash
2360 Laughlin Dr, Dallas, TX 75228
214/320-0828

Tri State Sculptor's Guild
Joel Haas
3215 Merriman Ave, Raleigh, NC 27607

Tryon Painters and Sculptors
208 Melrose Ave, Tryon, NC 28782
704/859-8322

Washington Sculptor's Group
Mary Frank
5814 Ruatan St, Berwyn Heights, MD 20740

Wisconsin Painters & Sculptors
1112 Smith St, Green Bay, WI 54302-1431
414/432-8550

Parks

621 Gallery
621 Industrial Dr, Tallahassee, FL 32310
904/224-6163
Progressive non-profit institute.

Abilene Outdoor Sculpture
Cultural Affairs Council
PO Box 2281, Abilene, TX 79604
915/677-7241
Texas artists annual exhibit.

Aerie Art Garden
71-225 Aerie Dr, Palm Desert, CA 92260
619/568-6366
Call for tour information.

Ann Norton Sculpture Garden
Sylvia Prim
253 Barcelona Rd, W Palm Beach, FL 33401
407/832-5328

Sculpture

Arboretum of the Horticulture Center in Fairmont Park
Marsha Moss
220 Locust St #27-D, Philadelphia, PA 19106
215/925-3384
54-acre park.

Bradley Palmer State Park
Asbury St, Beverly, MA 01983
508/887-5931

Contemporary Sculpture at Chesterwood
Paul Ivory
PO Box 827, Stockbridge, MA 01262-0827

Gardens of Art
2900 Sylvan St, Bellingham, WA 98226
206/671-1069

Grounds for Sculpture
18 Fairgrounds Rd, Hamilton, NJ 08619
609/586-0616

La Quinta Sculpture Park
Bernardo Gouthier/Thomas Vetal
PO Box 1566, 57325 Madison St, La Quinta, CA 92253
619/564-6464
They have a gallery that sells works to the public as well as to corporations. They represent 75 artists from all parts of the country. Send slides/photos by mail for consideration anytime during the year.

Laumeier Sculpture Park
12580 Rott Rd, St Louis, MO 63127
314/821-1209

Lookout Sculpture Park
Susanne Wibroe
55 E 93rd St, New York, NY 10128
212/851-4050

Lookout Sculpture Park
RD 1 Box 102, Damascus, PA 18425
717/224-6300
Susanne Wibroe
1077 Lakeville St, Petaluma, CA 94952
707/762-6502
Residencies available to artists submitting proposals to create outdoor sculpture projects at sites in California and Pennsylvania. Artists who work with environmental or media issues preferred. Send slides, videos, proposals, letters of interest and SASE.

Manhattan Psychiatric Center Sculpture Garden
Wards Island, New York, NY 10035
212/369-0500

Max Hutchinsons Sculpture Fields
PO Box 94, Kenoza Lake, NY 12750

Norwich Sculpture Park
Charlotte Newson
16 Aylsham Rd, Norwich, Norfolk, England NR3 3HG
Also has residencies and workshops.

Quietude Garden Gallery
Amy Medford
24 Fern Rd, E Brunswick, NJ 08816
908/257-4340

River Gallery Sculpture Garden
400 E 2nd St, Chattanooga, TN 37403
615/267-7353

Sho-En
Lewis Weinberg
PO Box 2010, Ramona, CA 92065-0930
619/789-7079
Beautiful location in the desolate hills near San Diego. Be sure you have driving instructions before you go. Plan a picnic in this quiet spot.

Skokie Sculpture Garden
9356 Ewing, Evanston, IL 60203
708/673-1463

Stone Quarry Hill Art Park
Carol Jeschke
3883 Stone Quarry Rd, Cazenovia, NY 13035
315/655-3196
75-acre park.

Storm King Art Center
Mountainvile, NY
914/534-3190
Largest outdoor park of contemporary monumental sculpture in the word; 35 years old; 400 acres.

Tempe Art Center Sculpture Garden and Artspark
PO Box 549, Tempe, AZ 85281-0549
602/968-0888

Toronto Sculpture Garden
PO Box 65, Station Q, Toronto, Ontario Canada
M4T 2L7

Reproductions

Cain Studios
PO Box 1649, Gainesville, FL 32602-1649
904/378-3223

Franklin Mint
Louise Ternay
Franklin Center, PA 19091-0001
Miniatures.

Resources

Artesia Press
Michael Edge
PO Box 21, Springfield, OR 97477
503/746-0094
Foundry and books: "The Art of Patina" and "Art Bronze Foundries."

Brad's Sculpture Supply
375 S Owasso Blvd, Roseville, MN 55113
612/486-9142

Civic Designs Commission
Robert MacLeod
Abel Wolman Municipal Bldg, Holiday and Lexington Sts, Baltimore, MD 21202
410/396-4290
Provides a packet that lists upcoming public art commissions.

Contemporary Patination by Ron Young
Sculpt Nouveau
625 W 10th Ave, Escondido, CA 92025
800/728-5787

Encyclopedia of Sculpture Techniques by John Mills
Watson-Guptill
800/ART-TIPS

Inventory of American Sculpture
National Museum of American Art
Smithsonian Institute, Washington, DC 20560
202/786-2384

Stone Sculpture Supplies
PO Box 17656, San Diego, CA 92128
619/489-1424

West Michigan U
Carol Rhodes, Sculpture Tour Administrator
Kalamazoo, MI 49008
616/387-2433
Annual exhibition of large-scale outdoor sculpture. Stipends and housing provided.

Slide Registries

Guild Register of Public Art
Kraus Sikes Inc
228 State St, Madison, WI 53703
800/969-1556
Listings of over 400 artists experienced in working in the public arena.

National Slide File
National Museum of American Art/Smithsonian
Washington, DC 20560
202/786-2384
Has a database of more than 50,000 American sculptures in public and private collections, including indoor and outdoor work.

Sculpture Source
International Sculpture Center
1050 17th St NW #250, Washington, DC 20036
202/785-1144
Computerized visual registry and referral services. This system refers hundreds of artists annually to a wide range of international arts professionals.

Sports/General

Bookstores

SportsBooks
 8302 Melrose Ave, Los Angeles, CA 90048
 213/651-2334
 Sports books.

SportsBooks
 Paul Hass
 5224 Fort Royal Rd, Springfield, VA 22151
 703/321-8660

Distributors

Namestreet
 9478 Aberdare Dr, Indianapolis, IN 46256
 800/892-0158
 Distributor of prints.

National Sports Distributors
 Pro Sport Art
 9 Jordan St, San Rafael, CA 94901
 800/892-1299

Expos

International Sport Summit
 E J Krause & Associates/Peter Cantor
 301/986-7800
 February in Atlanta, GA. Publishes a directory, "Who's Who in International Sport."

World Sports Expo
 National Sporting Goods Association
 1699 Wall St, Mt Prospect, IL 60056-5780
 708/439-4000
 July in Chicago. Also has mailing lists.

Galleries

Cross Gate Gallery
 219 E High St, Lexington, KY 40507
 606/233-3856

Drummond Gallery
 Coeur d'Alene Resort, Coeur d'Alene, ID 83814
 208/667-7732

Landmarks Gallery
 231 N 76th St, Milwaukee, WI 53212
 414/453-1620

Maser Galleries
 Pittsburgh, PA
 412/687-0885

Magazines

Anglers Art
 Box 148, Plainfield, PA 17081
 717/243-9721
 Angling books and prints.

Baseball Digest
 Jack Kuenster
 990 Grove St, Evanston, IL 60201
 708/491-6440

Basketball Digest & Bowling Digest
 Vince Aversano, Editor
 990 Grove St, Evanston, IL 60201
 708/491-6440

BC Outdoors
 George Will
 202-1132 Hamilton St, Vancouver, BC Canada
 V6B 2S2
 604/687-1581

Bicycling
 33 E Minor St, Emmaus, PA 18049
 610/967-5171

Bowlers Journal
 2005 S Michigan Ave #1430, Chicago, IL 60604
 312/341-1110

Focus on Sports
 222 E 46th St, New York, NY 10017
 212/661-6860

Game & Fish Publications
 Allen Hansen
 2250 Newmarket Pkwy, Marietta, GA 30067
 404/953-9222

Metrosports Magazines
 695 Washington St, New York, NY 10014
 212/627-7040

Spitball, The Literary Baseball Magazine
 6224 Collegevue Pl, Cincinnati, OH 45224
 Has a column entitled "Brushes with Art."

Sports Afield
 Hearst Corp
 250 W 55th St, New York, NY 10019
 212/649-4308

Sports Card Magazine
Greg Ambrosius
700 E State St, Iola, WI 54990
715/445-2214

Women's Sports & Fitness
2025 Pearl St, Boulder, CO 80302
303/440-5111

Mailing Lists

List Services Corporation
6 Trowbridge Dr, PO Box 516, Bethel, CT 06801
203/743-2600
Sport club catalog of 65,000 buyers.

Museums

National Art Museum of Sport
Germaine Glidden
U of New Haven, New Haven, CT 06516
203/932-7000

National Art Museum of Sport
University Pl, 850 W Michigan St, Indianapolis, IN
46202-5198
317/274-2339

National Baseball Hall of Fame & Museum
Art Collection/Howard Talbot
PO Box 590, NY 13326

Publishers

Bill Goff Inc
Bill Goff
PO Box 977, Kent, CT
203/927-1411
Publishes baseball art and other sports art. Sells 95% to private collectors and 5% to corporate collectors.

Romark Publishing
Mr Kelleher
11 Torrey St, Brockton, MA 02401
800/372-5632

Sierra Sun Editions
Ravel Buckley
305 Glen Ridge Way, El Dorado Hills, CA 95630
916/933-3228

Signature
12190$\frac{1}{2}$ Ventura Blvd #375, Studio City, CA 91604
800/677-2787

Sport Images
Bigg Duff
14920 Stony Plain Rd #202, Edmonton, Alberta Canada
T5P 3X8
403/484-7696

Sports Collectors Warehouse
11345 Slater Ave #113, Santa Ana, CA 92708
714/545-2329

Sportsman's Edge Ltd
Alfred King
136 E 74th St, New York, NY 10021
212/249-5010

Rep

Artistry in Sports
James Garone
4320 A1A, St Augustine, FL 32084
904/471-9985
Works with several foundations that want sports art.

Sport Centers/Athletic Clubs

Try these types of centers in your local area for exhibitions and commissions.

Eastend Athletic Club
St George Hotel/Ilsey Korey
43 Clark St, Brooklyn Heights, NY
718/625-0500

Galleries

Golf Gifts and Gallery
880 Oak Creek Dr, Lombard, IL 60148
708/953-9087

Golfing Gallery
11200 Kirkland Wy, Kirkland, WA
206/242-PUTT

Magazines

Golf Journal
George Earl
Golf House, Far Hills, NJ 07931
908/234-2300

Mail Order Catalog

Par Excellence
24 Wexford Rd, Brampton, Ontario, Canada L6Z 2V8
800/561-4653

Mailing Lists

Action Markets
908/531-2212
Various golf lists.

Millard Group Inc
10 Vose Farm Rd, Peterborough, NH 03458
603/924-9262
Golf enthusiasts.

Publishers

Cypress Classics
PO Box 1844, Pebble Beach, CA 93953

Golf Gallery
219 Eisenhower Ln S, Lombard, IL 60148
708/953-9087

Golf Shop Collection
PO Box 14609, Cincinnati, OH 45250
513/241-7789

Rivers
1030 Century Bldg, Pittsburgh, PA 15222
800/544-0580 412/261-5350

Schiftan
406 W 31st St, New York, NY 10001
800/255-5004 212/532-1984/5

Tee-Mark Ltd
Harvey Plummer
PO Box 410765, Charlotte, NC 28241
704/588-4038

Stores

Look for stores or country clubs in your area for sales as well as exhibition possibilities.

Golf Town
25 W 32nd St, New York, NY
212/563-0506

New York Golf Center
131 W 35th St, New York, 10001
212/564-2255

World of Golf
147 E 47th St, New York, NY
212/755-9398

Abstract

American Abstract Artists
Irene Rousseau
41 Sunset Dr, Summit, NJ 07901
Organization.

American Abstract Painters
Beatrice Riese
470 W End Ave #9D, New York, NY 10024
212/874-0747
Organization; you must be sponsored by a member to gain entry.

Corporate Artworks Ltd
Denise Ripenger
1300 Remington Rd #11, Schaumburg, IL 60173
708/843-3636
Rep.

Eduard de A Art Gallery
7466 Beverly Blvd, W Hollywood, CA 90036
213/935-0992

Hoffman Enterprises
PO Box 335, Palmyra, WI 53156
Rep.

International Art Placement
Christopher Hoffman
PO Box 1058, Portland, OR 97055
800/688-4960

International Graphics
Postfach 12 57, 76339 Eggenstein Germany
Publisher.

Joan T Washburn Gallery
20 W 57th St, New York, NY 10019
212/397-6780

Animation

Animation Art Guild
330 W 45th St #9D, New York, NY 10036
212/765-3030

Animation Art Resources
118 N Third St, Philadelphia, PA 19106
215/925-2009

Mice Ducks & Wabbits
42-36 235th St, Douglaston, NY 11363
800/229-MICE 718/279-3861

Book Arts

American Academy of Bookbinding
PO Box 1590, Telluride, CO 81435
303/728-3886

Center for Book Arts
626 Broadway 5Fl, New York, NY 10012
212/460-9768

Chicago Center for Book & Paper
Barbara Lazarus Metz
218 S Wabash Ave, Chicago, IL 60604-2316
312/431-8612
Workshops and classes.

Idaho Center for the Book
Tom Trusky
Boise State U, Boise, ID 83725

Journal of Artists' Books
Brad Freeman
324 Yale Ave, New Haven, CT 06515
Reviews, interviews, artists' statements, "smart" and "graphically advanced," $7.

Letterpress Resource Handbook
Briar Press
364 Long Hill Rd E, Briarcliff, NY 10510
Listings and descriptions of resources, supplies, associations, publications, schools and museums; 80 ppgs, $15ppd.

Mid-America Print Council
1016 W Washington, South Bend, IN 46601

Minnesota Center for Book Arts
Hollis Stauber
24 N 3rd St, Minneapolis, MN 55401
612/338-3634
Offers week-long residencies in schools.

Page Two Inc
PO Box 77167, Washington, DC 20013
800/821-6604
Quarterly newsletter with lots of info.

Women's Studio Workshop/WSW
PO Box 489, Rosendale, NY 12498
914/658-9133
Residencies; November 15 deadline.

Yolla Bolly Press
PO Box 15, Covelo, CA 95428
Offers apprenticeship programs for book artists.

Styles

Children

American Victorian Museum
PO Box 328, 431 Broad St, Nevada City, CA 95959
916/265-5804
Annual Teddy Bear Convention in April.

Bradford Exchange
9333 Milwaukee Ave, Chicago, IL 60648
708/581-8205
Publisher.

Crystal McKenzie
Uche
30 E 20th St, New York, NY 10003
212/598-4567

Every Picture Tells A Story
7525 Beverly Blvd, Los Angeles, CA 90036
213/932-6070
Book publisher.

Hyperion Books for Children
114 Fifth Ave, New York, NY 10011
212/633-4420
Book publisher.

Lovelace Family Ltd
Kimberly Frost
2824 International Cir, Colorado Springs, CO 80910
800/745-1682
Publishes turn-of-the-century style, often related to children.

Pemberton & Oakes
Patricia Kendall
113 E Cabrillo St, Santa Barbara, CA 93101
805/963-1371
Publisher.

Pinx-A-Card
PO Box 1168, Studio City, CA 91604
805/498-7521
Publisher.

Posterservice Originals Publishing
255 Northland Blvd, Cincinnati, OH 45246
513/577-7100
Publisher.

Scott Editions
9640 S Vermont Ave, Los Angeles, CA 90044
800/540-4278 213/757-8247
Publisher.

Tender Heart Treasures
10525 J St, Omaha, NE 68127-1090
800/443-1367
Direct mail company.

Copier Art

International Society of Copier Artists/ISCA
Louise Neaderland
759 President St #2H, Brooklyn NY 11215
718/638-3264 914/687-7769

Impressionism

Lavon Fine Art
620 Hwy 9, Freehold, NJ 07728
908/780-0800

Newman & Saunders Galleries
120 Bloomingdale Ave, Wayne, PA 19087
610/293-1280

Oklahoma Society of Impressionists
2616 E 22nd Pl, Tulsa, OK 74114

Landscape

Enduring Visions
Lauren Hutton
600 W Cummings Park #3500, Woburn, MA 01801
617/935-2135
Publisher.

Military

Military Market Magazine
6883 Commercial Dr, Springfield, VA 22159-0210
703/750-8676

Red Lancer Fine Art
Robin Bates
PO Box 8056, Mesa, AZ 85214
602/964-9667
Publisher of 19th century and European battle scenes.

Vladimir Arts
5401 Portage Rd, Kalamazoo, MI 49002
800/678-8523 616/327-7998
Publisher.

Murals

Bob Jenny
2327 N Andrews Ave, Ft Lauderdale, FL 33311
305/522-4261
Specializing in oversize murals.

Grandes Illusions Studios
Karina Cavat/Kenneth Gore
264 Bowery 4Fl, New York, NY 10012
212/966-5301

John Goodno Art Competition
404 9th St #202, Huntington, WV 25701

Murals (cont.)

Mural Conservancy of LA
PO Box 86244, Los Angeles, CA 90086-0244
213/481-1186

National Society of Mural Painters
215 W 57th St, New York, NY 10019

Precita Eyes Mural Arts Center
348 Precita Ave, San Francisco, CA 94110
415/285-2287

St Lucie Mural Society
Susan Cassens
PO Box 593, 218 Orange Ave, Ft Pierce, FL 34954
407/595-0026

Music

ArtNetwork
916/432-7630
Mailing lists of record companies.

Drive Entertainment
10351 Santa Monica Blvd #404, Los Angeles, CA
90025-6937
Publisher.

Hedgerow House
6401 E Rogers Circle, Boca Raton, FL 33487-2647
407/998-0756
Publisher.

Jazz Ambassador Magazine/JAM
Mike Matheny
PO Box 36181, Kansas City, MO 64111-6181
816/333-1277
Magazine.

Mitchell Beja Inc
1180 E 92nd St, Brooklyn, NY 11236
718/649-1617
Publishes jazz prints.

Music Sales Corp
257 Park Ave S 20Fl, New York, NY 10010
Magazine.

Rising Star Music Publishers
710 Lakeview Ave NE, Atlanta, GA 30308
404/872-1431
Mailing lists.

Naive

Mary Pratyor Gallery
26 S Main St, Greenville, SC 29601
803/235-1800

Neon

Museum of Neon Art
704 Traction, Los Angeles, CA 90013-0184
213/617-1580

Political

Creative Time City Wide
Susan Kennedy
131 W 24th St, New York, NY 10011
Sponsors outdoor projects of a political nature.

Stockholm Art Windows
Marie Odenstrand
Selen-Odenstrand AB, Box 2316, 103 17 Stockholm,
Sweden
Issue-based artists to display on windows around the city.

Syracuse Cultural Workers
PO Box 6367, Syracuse, NY 13217
315/474-1132
Publishers of politically-oriented art.

Realism

Aesthetics Realism
Marcia Rackow
141 Greene St, New York, NY 10012
212/777-4490
Has a gallery space.

American Society of Classical Realism
Gary Christensen
1313 5th St SE #126D, Minneapolis, MN 55414
612/379-3908
Publishes a beautiful quarterly journal.

Galerie Michael
430 N Rodeo Dr, Beverly Hills, CA 90210
310/273-3377

Katharine Rich Perlow Gallery
560 Broadway, New York, NY 10012
212/941-1220

Massey Fine Arts
PO Box 1258, 5290 McNutt #208, Santa Teresa, NM
88008
505/589-0770

Parkersburg Art Center
220 8th St, PO Box 131, Parkersburg, WV 26101
304/485-3859
Annual competition.

Tampa Realistic Artists
Faye Culp
705 Swann Ave, Tampa, FL 33606
813/251-3780

Textiles

Books

Art Fabric Mainstream by Mildred Constantine and Jack Lenor Larsen
Farrar Strauss Publishers
212/741-6900

Beyond Craft: The Art of Fabric by Mildred Constantine and Jack Lenor Larsen
Van Nostrand Reinhold Publishers
212/254-3232

Fiberarts Design Book edited by Kate Mathews
Lark Books
800/284-3388

Handbook for Textile Artists by Peggy Schofield
5761 Olympic St, Vancouver, BC Canada V6N 1Z7
604/263-5590
Lists sources for fabrics, dyes, books, magazines, schools and organizations.

Surface Designers Art
Lark Books
800/284-3388
$45.00.

The Textile Design Book by Karin Herstorp and Eva Kohlmark
Lark Books
800/284-3388
$22.95.

Textile Design by Carol Joyce
Watson-Guptill
800/ART-TIPS
$39.95.

Wallpaper and the Artist by Marilyn Oliver Hapgood

Classes

Look into your local community college adult schedule for textile design classes.

Break into the World of Textile Design
Image West Design Studio
PO Box 613, San Anselmo, CA 94979-0613
415/258-0342

Fabric Design as a Profession
Seida Rothman
510/549-3051

Textile Detective
Box 422, Andover, MA 01810
508/475-8790
Provides teachers' directories to the craft arena as well as a couple of short reports.

Magazines

Computer Graphics World Magazine
Dec '92 issue has an article entitled "An Art Unto Itself" by Barbara Robertson with an overview of the market and how artists create designs for fabric companies.

Fiberarts
50 College St, Asheville, NC 28801
800/284-3388 704/253-0468

Interiors Magazine
July 1994 has a complete listing of 346 manufacturers of contract textiles and wall coverings.

International Tapestry Journal
Shawn Marcus
4145 SW Corbett, Portland, OR 97201-4201
503/796-1234
Quarterly/$35 a year.

Manufacturers

Bagindd Prints
Arnold Reimer
2171 Blount Rd, Pompano Beach FL 33069
305/971-9000 305/973-1000
Manufacturer of hand-painted and silk-screened designer wallcoverings and fabrics. Their clients are interior designers.

Image Crafters
Brian Goldojarb
3328 Losee Rd, N Las Vegas, NV 89030
702/657-1660
Wallpaper and fabric manufacturer.

JC Prints Ltd
Sol Adam
444 W Jericho Turnpike, Huntington NY 17743
516/692-2900
Manufacturer of wallpaper.

J Josephson Inc
Cheryl McPherson
20 Horizon Blvd, S Hackensack, NJ 07606
201/440-7000
Manufacturer of wallcoverings.

Pattern People
Michael Copeland
10 Floyd Rd, Derry, NH 03038
603/432-7180
Designs wallcoverings and textiles with classical elegance and exciting new color themes for all ages. Artwork must be designed for repeat format; send SASE.

Prelude Designs
Madalyn Grano
10 Waldo Ave, White Plains, NY 10606
914/949-0096
Designs for juvenile wallpaper and fabric market.

Rainbow Creations
Steve Thomas
216 Industrial Dr, Ridgeland, MS 39157
601/856-2158

Studio 38 Design Center
Andrea Reda
38 William St, Amityville, NY 11701
516/789-4224
Wallpaper for national clients.

Organizations

International Tapestry Network/ITNET
PO Box 203228, Anchorage, AK 99520-3228
A non-profit organization to connect tapestry artists globally. Overall objective is the advancement of tapestry as an art form, educatinf the public, writing articles for magazines, and providing historic and contemporary information to the public.

NW Fiber Network
PO box 10007, Eugene, OR 97440
503/484-9220
Has a slide registry.

Pittsburgh Center for the Arts
Catherine McConnell
6426 Jackson St, Pittsburgh, PA 15206
412/361-0455
Fiber Art International Show.

Suncoast Fiber Guild
Ruth Miller
13906 Cherry Creek Dr, Tampa, FL 33618
904/961-8334

Tapestry Forum
Shannock Looms
10402 NW 11th St, Vancouver, WA 98615

Textile Arts Centre
Gina Alicea
916 W Diversey, Chicago, IL 60614
312/929-5655
Gallery space. Sponsors competitive exhibitions, has a fiber art library, slide registry, classes and a newsletter.

Resources

AVL Loom Inc
601 Orange St, Chico, CA 95928
916/893-4915
Tool vendors for textile design trade.

Computer Design Inc
2880 E Beltline NE, Grand Rapids, MI 49505
616/361-1139
Design software for apparel and textile industries.

HighTex Systems
1129 Folsom St, San Francisco, CA 94103
415/861-5230
Textile computer program.

Info Design Inc
104 W 40th St 8Fl, New York, NY 10018
212/921-2727
Scans designs and prints out on fabric.

Modacad
1954 Kotner Ave, Los Angeles, CA 90025
310/312-6632

Shows

Fiber Arts Festival
Alto Modo
211 E Palace, Santa Fe, NM 87501
505/982-0084
At the state fairgrounds in Albuquerque in mid-November.

National Fiber Arts Competition and Exhibition
Fiber National
PO Box 1485, Dalton, GA 30722-1485
706/278-0168

Visionary

You might want to read the article in the March/April 1994 issue of "Informart Magazine" (307/237-1659) on visionary art.

Catalogs

Pacific Spirit
Whole Life Products
1334 Pacific Ave, Forest Grove, OR 97116
503/357-1566
Catalog of mystical things.

Pyramid Books and the New Age Collection
PO Box 3333, Chelmsford, MA 01824-0933
800/333-4220
Catalog of New Age items.

Contest

Illustrators of the Future
PO Box 3190, Los Angeles, CA 90078
213/466-3310
No entry fee; send SASE for prospectus.

Conventions

American Association for Advancement of Science
1333 H St NW, Washington, DC 20005-4792
202/326-6400
February.

World Science Fiction Convention
PO Box 2430, Winnipeg, Manitoba Canada R3C 4A7

Exhibitions

ConFrancisco
712 Bancroft Rd #1993, Walnut Creek, CA 94598
$100,000 auction of originals; 150 artists display; September.

Association of Science Fiction and Fantasy Artists/ASFFA
400 members.

Mythical Realism Exhibition
312/951-8466
May-Jun. Call Brandywine Fantasy Gallery for details.

World Science Fiction Society
Southern California Institute for Fan Interests
PO Box 8442, Van Nuys, CA 91409
818/366-3827

Festivals

Brussels International Festival of Fantasy, Science Fiction & Thriller Films
Avenue de la Reine 144, Koninginelaan, Bruxelles 1210 Belgium

North American Science Fiction Convention/NASFC
Dragon Con
PO Box 47696, Atlanta, GA 30362-0696
404/925-0115
Held each July.

Gallery

Mysterium
PO Box 1836, Boulder, CO 80306-1836

Shasta Gallery
416 N Mt Shasta Blvd, Mt Shasta, CA 96067
916/926-5499

Magazines

Author Services Inc
403 Canyon Rd, Santa Fe, NM 87501
505/983-1588

The Quest
PO Box 270, Wheaton, IL 60189-0270
800/669-9425
Reviews submissions throughout the year.

Rising Star
47 Byledge Rd, Manchester, NH 03104
603/623-9796
Reports in newsletter format on markets for artists who produce works falling into the science fiction and fantasy genre. $1.50/make payable to Scott E Green.

Science Fiction and Fantasy Review & Quantum
D Douglas Fratz
8217 Langport Ter, Gaithersburg, MD 20877

Organization

National Academy of Fantasy Art
Hap Henriksen
PO Box 1310, Kountze, TX 77625

Publishers

Narada Productions
Connie Gage
4650 N Point Washington Rd, Milwaukee, WI 53212
414/961-8350
New Age record company.

Quicksilver Productions
Pam Weathers
PO Box 340, Ashland, OR 97520
503/482-5343
Publishes astrological calendars.

US Games Systems Inc
Stuart Kaplan
179 Ludlow St, Stamford, CT 06902
203/353-8400
Publisher of deck cards, including Tarot.

Valley of the Sun Publishing
Jason McKean
Box 38, Malibu, CA 90265

Competitions

Buffalo Bill Art Show and Sale
Cody Country Chamber of Commerce/Diane Estest
836 Sheridan Ave, PO Box 2777, Cody, WY 82414
307/587-2297

Governor's Invitational Western Art Show & Sale
PO Box 2477, Cheyenne, WY 82003
307/778-7202
July.

Museum of Northwest Colorado
Bear River Western Historical Art Exhibit/Frances Reust
590 Yampa Ave, Craig, CO 81625
303/824-6360
Held in December.

National Cowboy Hall of Fame
1700 NE 63rd St, Oklahoma City, OK 73111
405/478-2250
June.

Wild West Art Show
Big Horn Galleries
1167 Sheridan Ave, Cody, WY 82414
800/505-CODY
Jun-Jul.

Exhibitions

Arts in Olde Town
PO Box 654, Arvada, CO 80002
303/431-3928 303/424-0313 (Sarah)

Custer County
Box 1284, Miles City, MT 59301
406/232-0635
Western Art Roundup, Apr-Jul annually.

Westfest
Copper Mountain Resort
800/437-1218

Wildlife & Western Art Show
Southern California Wildlife Artists Association
PO Box 33757, Granada Hills, CA 91394
714/284-9399

Galleries

Adobe East Gallery
445 Springfield Ave, Summit, NJ 07901
908/273-8282
Southwestern art.

Coyote Woman Gallery
160 E Main St, Harbor Springs, MI 49740
616/526-5889
Southwestern art amongst others.

Overland Gallery of Fine Art
687 E Lake St, Wayzata, MN 55391
612/476-8324

Red Men Hall
Box 608, Highway 40, Empire, CO 80438
303/569-3243

SW Indian Foundation
PO Box 86, Gallup, NM 87302-0001
505/863-9568
Has a sales catalog.

Toh-Atin Gallery
PO Box 2329, Durango, CO 81302-2329
800/525-0384

Museums

CM Russell Museum
PO Box 634, 400 13th St N, Great Falls, MT 59403
406/717-8787
Annual Western art auction held each March.

Cowboy Artists of America Museum/CAA
PO Box 1716, Kerrville, TX 78009
210/896-2553

Phippen Museum of Western Art
PO Box 1642, 4701 N Us Hwy 89, Prescott, AZ 86302
602/778-1385

Organizations

Cowboy Artists of America
TM Watson
PO Box 396, Blue Spring, MO 64013
816/224-2244

National Academy of Western Art
1700 NE 63rd St, Oklahoma City, OK 73111

Society of Western Artists
Lola Nelson
PO Box 3742, Pinedale, CA 93650-3742

Society of Western Artists
Sylvia Hittenberger
3416 Del Monte St, San Mateo, CA 94403

Western

Trails West Art Association
Sue Cox
8700 Vancouver Mall Dr #20, Vancouver, WA 98662
206/256-6963

Western Art Association
Diane Legare
PO Box 893, 406 N Pearl St, Ellensburg, WA 98926
509/962-2934
National Western art show and auction. Held each May.

Publishers

Heritage West
11201 Richmond Ave #102, Houston, TX 77082
713/531-5151

Leanin Tree
Box 9800, 6055 Longlow Dr, Boulder CO 80301
305/530-1442

Louis Fine Art
3852 28th St SE, Grand Rapids, MI 49512
800/752-4558 616/942-7120

Spirit Vision Publishers
PO Box 2074, Round Rock, TX 78680
512/218-0300

Career Development

There is an abundance of assistance for women developing their businesses. Ask your local Chamber of Commerce for leads in your area.

American Women's Economic Development Corp
New York, NY 800/222-2933
Long Beach, CA 310/983-3747
Irvine, CA 714/474- AWEO
CT 203/326-7914
Washington, DC 202/857-0091
Train and educate women to manage their own businesses.

National Women's Business Counsel
202/205-3850
Federal advisory panel in Washington, DC.

National Association for Female Executives
212/477-2200

SBA Office of Women's Business Ownership
Betsy Meyers
202/205-6673
Call for the office nearest you.

Department of Commerce/Minority Business Development Administration
202/482-1684
Call for the office nearest you. Mostly for minority women.

Small Business Center
Janet Weigel
212/760-7250
Offers a special eight-week career development program to women in the fine arts and other creative fields. Several workshops and individual counseling, all for $100.

Exhibits

City of Crystal Lake
NW Area Arts Council
PO Box 597, Crystal Lake, IL 60014
815/459-2020 ext 334
Annual Women's Works Art Exhibit.

Galleries

A Room of Her Own: The Gallery for Women Artists
195H N 4th St, Columbus, OH 43201
614/291-3639

Artemis
700 N Carpenter, Chicago, IL 60622
312/226-7323

Matrix Gallery
1725 I St, Sacramento, CA 95814
916/441-4818

Muse Gallery
60 N 2nd St, Philadelphia, PA 19106-4505
215/627-5310
A cooperative women's gallery.

Women Made Gallery
4646 N Rockwell, Chicago, IL 60625
312/588-4317

Museum

National Museum of Women in the Arts
Krystyna Wasserman
1250 New York Ave NW, Washington, DC 20005
202/783-7364

On-Line

World's Women On-Line
Muriel Magenta
602/965-4483
Electronic art networking is being developed that will offer the opportunity for women to exhibit their artwork in Beijing at a gallery and all over the world through INTERNET.

Organizations

Associated Women Artists
La Velle Dixon
2128 Hollywood Dr, Pueblo, CO 81005-2706
719/543-6402

Atlanta Women's Art Collective
Chantal Gadd
206 Degress Ave, Atlanta, GA 30307
404/584-8177

Canadian Women's Art Caucus
Regroupement des Femmes, Center of Fine Arts
Univ. of British Columbia, Vancouver, BC, Canada
V6T 1W5

Career Arts for Women
114 E 2nd St, Fond Du Lac, WI 54935

Chicago Women's Caucus for the Art
Sherry Rabbino
700 N Carpenter St 3Fl, Chicago, IL 60622
312/226-2105

Connecticut Women Artists
Carmela Venti
78 Great Neck Rd, Waterford, CT 06385

Women

Dallas Women's Caucus for Art
Bonnie Wilber
5804 Goliad Ave, Dallas, TX 75206

Feminists in the Arts
Pam McAllister
Box 40-1043, Brooklyn, NY 11240

Houston's Women's Caucus for Art
Lin Swanner
1413 Westheimer, Houston, TX 77006

Money For Women
2854 Coastal Hwy, St Augustine, FL 32095

National Assoc of Women Artists
Bldg 41 Union Sq W, New York, NY 10003
212/675-1616
Send SASE for application.

San Francisco Women Artists Gallery
Joyce Peters
370 Hayes St, San Francisco, CA 94102
415/552-7392

Western Women in the Arts
Alice Smith
Box 48, Hill City, SD 57745

Wild Woman Artisan's Guild
Kim Barrett
2402 University Ave #510, St Paul, MN 55114
612/920-0265

Wisconsin Women in the Arts
Carla Bodette
8700 S 15th St, Oak Creek, WI 53154

WomanKraft
Linn Lane
388 S Stone Ave, Tucson, AZ 85701-2318
602/629-9976

Women & Their Work
1137 W 6th St, Austin, TX 78704

Women in Design
Anne Richardson-Daniel
1875 Oak Tree Dr, Eagle Rock, CA 90041

Women in Design
Sherry Russo
400 W Madison #2400, Chicago, IL 60606
312/648-1874

Women in the Arts Foundation
Roberta Crown
1175 York Ave, New York, NY 10021
212/751-1915

Women's Art Registry of Minnesota/WARM
Vicki MacNabb
2402 University Ave W, St Paul, MN 55114
612/649-0059

Women's Caucus for the Arts
Moore College of Art
20th and Parkway, Philadelphia, PA 19103
215/854-0922

Women's Interart Center
Ronnie Geist
549 W 52 St, New York, NY 10019
212/246-1050

Women's Studio Workshop
PO Box 489, Rosendale, NY 12472
914/658-9133

Photographers

New York Foundation for the Arts
Catalogue Project
155 Ave of the Americas, New York, NY 10013
212/366-6900 ext 232
Awards grants of $5,000 to New York state women photographers 40 years of age and older who will have solo or two-person shows for production of catalog.

Publication

Gallerie Publications
2901 Panorama Dr, N Vancouver, BC Canada
V7G 2A4
604/929-8706

Resources

The Company of Women
Melinda Little
PO Box 2526, Kearneysville, WV 25430
800/937-1193
Direct mail catalog for women's products.

Women's Business Network Directory
800/48-WOMEN
Includes state organizations and assistance networks.

Book club

WoodWorkers Book Club
800/937-0963

Exhibitions

Mid-South Woodcarvers Exhibition
N Alabama Woodcarvers Association/Dick Brewer
205/772-0411

Festival

Blackduck Woodcarvers Festival
Jim Schram
Pennington Rt Box 221, Blackduck, MN 56630-0221
218/835-4669
Annual exhibition in July.

Gallery

Northwest Gallery of Fine Woodworking
202 First Ave S, Seattle, WA
206/625-0542

Organizations

Affiliated Woodcarvers Ltd
PO Box 10408, Bettendorf, IA 52722
319/359-9684
Promotes the fine art of woodcarving/$10 membership per year; one show annually in June.

LA Woodworkers' Organization
PO Box 66751, Los Angeles, CA 90066
310/398-5931
Publishes "Woodworker West." $2 for sample issue, $10 per year.

Woodworkers' Association
Jerry Wagers
4996 Ridgeview Dr, Las Vegas, NV 89120

Wood Turning Center
Albert LeCoff
Box 25706, Philadelphia, PA 19144
215/844-2188
Stages international exhibitions and conferences. Has lending program with their resource library.

chapter **2**

Dealers

Consultants, Reps, Dealers & Brokers

One of the most common questions we receive from fine artists at ArtNetwork is, "Where can I find a rep?" Finding an active art rep can be a dream come true for a fine artist. Not all people, however, who assist fine artists refer to themselves as art rep. There are other professionals who are a type of art rep, yet they are often overlooked:
• Art advisors - generally consult with artists, outline marketing plans, give marketing direction and advice.
• Art managers - are often paid by the hour. They might do a specific type of job for the artist (bookkeeping, managing their contacts, or writing contracts and grant requests).
• Publicist - usually hired by the hour or project for promotion purposes for an exhibition or museum opening. Often well-known artists will hire a publicity agency when they are having a gallery or museum opening. (See "ArtNetwork Yellow Pages" for list of publicity firms.)
How to locate these types of artworld professionals:
• Right here in this section of Art Marketing Sourcebook, Second Edition!
• Local Yellow Pages under 'art consultants' or 'art galleries.'
• Keep your eyes open for articles in magazines. They often refer to reps in various parts of the country.
• Art Business News 203/356-1745.
• Decor 314/421-5445.
• Local art newspapers.
• National art magazine ads and articles
Before you send a full package of information to any of the people you locate, you should first call or at least send a query letter and SASE asking them whether they are in fact interested in seeing more of your work. Add them to your mailing list. Over time and continued promotion to them, you might awaken their faculties to your artwork!

Consultants

Administrative Arts
 Brenda Harris
 PO Box 547935, Orlando, FL 32854-7935
 407/578-1266

Jean Apgar
 2513 Knight Ave, Rockford, IL 61101
 815/968-9285

Art America
 134 Spring St #504, New York, NY 10012
 212/226-1000
 Has an annual directory listing some consultants and reps.

Art for Cruise Ships
 Denise Shaw
 2 Wooster St, New York, NY 10013

Art Smart
 Carol Grape
 2453 Amsterdam Rd, Villa Hills, KY 41017
 606/341-4592

ArtBiz
 Susan Joy Sager
 RR 2 Box 1255 River Rd, Hinckley, Clinton Bridge,
 Clinton, ME 04927
 207/453-4641
 Career counseling, business seminars, bookstore with business books.

Artists Career Planning Service
 Po Lowenberg
 50 E 3rd St #4A, New York, NY 10003
 212/460-8163
 For artists living in New York.

ArtNetwork
 18757 Wildflower Dr, Penn Valley, CA 95946
 914/432-7630
 Has a mailing list that comes on pressure sensitive labels of over 3000 reps, consultants, brokers and dealers for $195.

Katherine Carter
 PO Box CS, San Leo, FL 33574
 212/903-4650
 Consultant, works both in New York and Florida.

Michelle Carter
 4790 Irvine Blvd #105, Irvine, CA 92720
 714/544-9181
 Consultant.

Chicago Artists Coalition/CAC
 11 E Hubbard St 7Fl, Chicago, IL 60611
 312/670-2060
 Has a list of reps and consultants in the Chicago area for $2.30.

Creative Artists Network
 PO Box 30027, Philadelphia, PA 19103
 215/546-7775
 A non-profit organization that selects emerging artists in various media and assists them in a two-year program, helping promote them and showing them the ins and outs of the business.

Fabri Creations
 Karen Perry
 110 Mast Rd, Falmouth, ME 04105
 207/797-4288
 Conducts workshops on press kits and getting publicity.

Fine Art Trade Guild
 Scott Siemers
 16-18 Empress Pl, London SW6 1TT England
 Helps business in the USA establish links in England.

Consultants, Reps, Dealers & Brokers

Larry Harris
Box 142, La Veta, CO 81055-0142
719/742-3146
Specialty is art shows.

Richard Harrison
PO Box 625, Laurel, FL 34272

Patricia Holm
192 Connecticut St, San Francisco, CA 94107
415/621-3981

Peter Homestead & Assoc Inc
505 Wolcott Ave, Beacon, NY 12508
914/831-7178

International Art Placement
41610 SE Coalman Rd, Sandy ,OR 97055
Works with abstract artists.

Cay Lang
1506 62nd, Emeryville, CA 94608
510/653-1655

Carroll Michels
516/329-9105
Consultant.

Michigan Guild of Artists
118 N 4th Ave, Ann Arbor, MI 48104-1402
313/662-3382
Has seminars and short-course workshops on booth design, marketing, slides, mock jury, corporate art and more.

National Directory of Consulting in the Arts
NASAA Publications
1010 Vermont Ave #920, Washington, DC 20005
202/347-6352
The Referral section lists consultants recommended by state arts agencies around the nation. $20ppd.

Reneé Phillips
200 E 72nd St #26-L, New York, NY
212/794-0324
Consultant.

Constance Smith
PO Box 1268, Penn Valley, CA 95946
914/432-7630
Consultant and author.

Society of Photographers' and Artists' Representatives/ SPAR
60 E 42nd St #1166, New York, NY 10651
212/779-7644
Directory $37.

Will Torphy
765 Rand Ave #306, Oakland, CA 94610
213/937-8777
Works both in Los Angeles and the Bay Area.

Sue Viders
2651 S Kearney, Denver, CO 80222
800/999-7013
Free phone consultations sponsored by Color Q printing.

Sylvia White
2022 Broadway St #B, Santa Monica, CA 90404
310/451-2700

Gallery Consultants

Nina Pratt
116 Pinehurst Ave #F-65, New York, NY 10033
212/795-6131
Has books and newsletter.

LJ Bury
21310 Windrush Ct #34, Sterling, VA 20165
800/343-3444 703/430-8167
Has books and newsletters.

Wineries

Several California wineries have great art collections and support artists in various ways with exhibition venues.

Hess Collection
707/257-0101

Clos Pegase
707/942-4981

Robert Mondavi
Margaret Biever-Mondavi
707/963-9611

Codorniu Napa
Marsha Jane
707/224-1668

Rochioli Winery
707/433-2305

❖ **Corporate Art Source**

Jean Belt
2960-F Zelda Rd, Montgomery, AL 36106
205/271-3772 Telephone/Fax

Independent Art Advisor/Fine Art Consultant
Year our company was established: 1984
We are a member of: NACAM
We work with: Fine artists.
We are seeking both new and established talent.
Types of companies we work with:

Offices	Hotel/Motel	Medical
Residential	Public Spaces	

Styles we deal in:

Abstract	Animals	Classic
Conceptual	Contemporary	Figurative
Impressionism	Landscape	Minimal
Modernism	Realistic	Representational
Southwestern	Stylistic	Surrealism
Traditional	Visionary	

Media we deal in:

Acrylic	Bronze	Ceramic
Clay	Collage	Glass
Installations	Mixed Media	Oil
Paper Sculpture	Pastel	Photography
Pottery	Prints	Sculpture
Silkscreen	Watercolor	

Target market:

Individuals	Corporations	Architects
Developers	Interior Designers	

To contact us: Arrange a personal interview to show portfolio/send slides by mail for consideration/provide resumé, business card, brochure, statement, etc.

❖ **Arizona Art Company**

Letitia Mackey
6615 N Scottsdale Rd, Scottsdale, AZ 85250
602/789-7997 602/789-8404 Fax

Fine Art Consultant/Art Dealer
Year our company was established: 1993
We work with: Fine and decorative artists.
We are actively seeking new talent.
Types of companies we work with:

Offices	Hotel/Motel	Medical
Stores/Showrooms		

Styles we deal in:

Abstract	Classic	Contemporary
Equestrian	Figurative	Impressionism
Landscape	Modernism	Southwestern
Sport	Surrealism	

Media we deal in: All
Target market:

Corporations	Architects	Developers
Interior Designers		

Number of artists presently represented: 20
Geographical limitations to artists we represent: None
Advice for the artist interested in working with us: Great opportunity for wide range of exposure.
To contact us: Submit portfolio for review.

❖ **Art Connects**

John Sheridan
1290 Hopkins #30, Berkeley, CA 94702
510/527-4912 510/527-5912 Fax

Independent Art Advisor/Fine Artist Representative
Commercial Artist Representative/Independent
Year our company was established: 1988
We work with: Mostly fine, as well as some commercial and decorative artists.
We are seeking both new and established talent.
Types of companies we work with:

Offices	Hotel/Motel	Medical
Realtors	Stores/Showrooms	

Styles we deal in:

Abstract	Alternative	Animals
Classic	Contemporary	Ethnic
Figurative	Impressionism	Landscape
Marine	Minimal	Modernism
Naive	POP	Portraits
Realistic	Representational	Surrealism
Traditional		Western

Media we deal in:

Acrylic	Airbrush	Bronze
Ceramic	Charcoal	Clay
Collage	Colored Pencil	Computer Art
Drawing	Glass	Marble
Mixed Media	Oil	Pastel
Pen & Ink	Photography	Prints
Sculpture	Silkscreen	Watercolor

Target market:

Galleries	Individuals	Corporations
Architects	Developers	Interior Designers

Number of artists presently represented: 100+
Commission taken: to 40%
Geographical limitations to artists we represent: None, emphasis in San Francisco Bay Area, however
Advice for the artist interested in working with us: Have clear photos of work available; have clear desire to have work promoted.
To contact us: Arrange a personal interview to show portfolio/query with resumé/send slides by mail for consideration.
Type/style of artwork has the best chance of being purchased by our clients in the next two years: Landscapes in impressionist style; florals; marines; abstracts on paper.

Consultants, Reps, Dealers & Brokers

❖ **Lee & Lou Productions Inc**
8522 National Blvd #108, Culver City, CA 90232
310/287-1542 310/287-1814 Fax

Artist Agent/Commercial Artist Representative
Year our company was established: 1981
We work with: Commercial artists
We are seeking both new and established talent.
Types of companies we work with:
Designers Advertising agencies
Styles we deal in:
Automotive Realistic
Media we deal in:
Acrylic Airbrush Collage
Computer Art Drawing Mixed Media
Oil Photography
Target market:
Art directors Designers
Number of artists presently represented: 14
Commission taken: 25%
Geographical limitations to artists we represent: West coast
Advice for the artist interested in working with us: Be on time; update samples.
To contact us: Submit portfolio for review.
Type/style of artwork has the best chance of being purchased by our clients in the next two years: Computer

❖ **Corporate Art Portfolio**
Dublene C Hayes
6392 Santa Rita Ave, Garden Grove, CA 92645
714/373-8077

Independent Art Advisor/Artist Agent
Fine Art Consultant
Year our company was established: 1989
We work with: Fine, commercial and decorative artists.
We are not seeking new talent at this time.
Types of companies we work with:
Offices Schools Hotel/Motel
Medical Residential Public Spaces
Stores/Showrooms
Styles we deal in:
Abstract Conceptual Contemporary
Impressionism Representational
Media we deal in:
Acrylic Collage Colored Pencil
Fibre Arts Mixed Media Paper Sculpture
Pastel Watercolor
Target market:
Individuals Corporations Art Publishers
Architects Interior Designers
Number of artists presently represented: 7
Commission taken: 50%
Geographical limitations to artists we represent:
Worldwide

Advice for the artist interested in working with us: Learn and understand wholesaling; exposure of artist and interest of buyers can take up to a year.
To contact us: Query with resumé/send slides by mail for consideration/provide resumé, business card, brochure, statement, etc.
Type/style of artwork has the best chance of being purchased by our clients in the next two years: Original, representation, contemporary

❖ **Advance Design**
John Crespo
3524 Monogram Ave, Long Beach, CA 90808
310/425-6321 Telephone/Fax

Independent Art Advisor/ Artist Agent
In-House Corporate /Fine Art Consultant/Art Critic
Fine Artist Representative
Commercial Artist Representative
Year our company was established: 1984
We work with: Fine, commercial and decorative artists.
We are actively seeking both new and established talent.
Types of companies we work with:
Advertising agencies Pre-press production
Styles we deal in:
Abstract Animals Aviation
Classic Conceptual Contemporary
Figurative Impressionism Landscape
Latin American Minimal Modernism
Naive POP Portraits
Realistic Representational Sport
Stylistic Surrealism Wildlife
Media we deal in:
Acrylic Airbrush Charcoal
Collage Colored Pencil Computer Art
Drawing Marker Mixed Media
Oil Paper Sculpture Pastel
Pen & Ink Photography Prints
Sculpture Silkscreen Watercolor
Target market:
Individuals Corporations Developers
Interior Designers
Primary activities in representing artists: Involving artists in a variety of shows and promotional projects
Number of artists presently represented: 8
Commission taken: 15%
Geographical limitations to artists we represent: None
Advice for the artist interested in working with us:
Never reject a low-budget job if it offers an advantage.
To contact us: Query with samples/send slides by mail for consideration.
Type/style of artwork has the best chance of being purchased by our clients in the next two years: Computer, watercolor, cartoon, pastel, airbrush, sketch and others.

❖ Mardine Davis

850 N Poinsettia Pl #5, Los Angeles, CA 90046
213/937-9656 213/937-5676 Fax

Independent Art Advisor/Fine Art Consultant
Year our company was established: 1990
We work with: Fine and decorative artists.
We are actively seeking new talent.
Types of companies we work with:

Offices	Medical	Restaurants
Stores	Film and TV studios for set decorating	

Styles we deal in:

Abstract	Contemporary	Ethnic
Impressionism	Landscape	Naive
Representational	Traditional	

Media we deal in:

Acrylic	Ceramic	Clay
Collage	Fibre Arts	Mixed Media
Oil	Paper Sculpture	Photography
Prints	Sculpture	Silkscreen

Target market:

Corporations	Interior Designers

Primary activities in representing artists: I obtain projects, then find artwork that is appropriate. I do not limit myself to any specific artist or source.
Advice for the artist interested in working with us: Send a few photographs of work that is representative of available artwork.
To contact us: Query with samples/provide resumé, business card, brochure, statement, etc.
Type/style of artwork has the best chance of being purchased by our clients in the next two years: Abstract or representational works on paper

❖ Artistic Connections

Jennifer Sarkisian
1021 S Hill St, Oceanside, CA 92054-5004
619/721-4940 619/439-5622 Fax

Affiliated with Gallery/Fine Artist Representative
Artist Agent
Year our company was established: 1991
We work with: Fine and decorative artists.
We are actively seeking new talent.
Types of companies we work with:

Offices	Hotel/Motel	Residential
Publishers		

Styles we deal in: All
Media we deal in:

Bronze	Oil	Pastel
Watercolor		

Target market:

Galleries	Individuals	Corporations
Art Publishers	Book Publishers	Developers
Interior Designers		

Primary activities in representing artists: Developing portfolio, promotion of artist in various markets

Number of artists presently represented: 4
Commission taken: 30%
Geographical limitations to artists we represent: U.S.
Advice for the artist interested in working with us: Stay positive in spite of possible rejections; remember that art is an industry; supply and demand will determine acceptance in many cases. A professional portfolio, perseverance and positive attitude are a **must**.
To contact us: Submit portfolio for review/send slides by mail for consideration/provide resumé, business card, brochure, statement, etc.
Type/style of artwork has the best chance of being purchased by our clients in the next two years: Realism; also a portion of proceeds toward a cause, organization or foundation is good in the public eye.

❖ Final Touches

Marc Rosen
8454 Whelan Dr, San Diego, CA 92110
619/469-1312 Telephone/Fax

Independent Art Advisor/Fine Art Consultant
Artist Agent/Art Broker/Art Dealer
Year our company was established: 1985
We are a member of: ISID
We work with: Fine, commercial and decorative artists.
We are seeking both new and established talent.
Types of companies we work with:

Offices	Hotel/Motel	Medical
Residential	Restaurants	Public Spaces
Stores/Showrooms		

Styles we deal in:

Abstract	Conceptual	Contemporary
Impressionism	Landscape	Representational
Southwestern	Sport	Traditional
Wildlife	Western	

Media we deal in:

Acrylic	Airbrush	Bronze
Collage	Installations	Oil
Paper Sculpture	Pastel	Photography
Prints	Sculpture	Silkscreen
Watercolor		

Target market:

Galleries	Individuals	Architects
Developers	Interior Designers	

Number of artists presently represented: 10
Commission taken: 25-50%
Geographical limitations to artists we represent: Nationwide
To contact us: Send slides by mail for consideration/ query with samples/provide resumé, business card, brochure, statement, etc.
Type/style of artwork has the best chance of being purchased by our clients in the next two years: Landscape, abstract art, flowing movement—not geometrics

Consultants, Reps, Dealers & Brokers

❖ Freda Scott

1015B Battery St, San Francisco, CA 94111
415/398-6121

Commercial Artist Representative
Year our company was established: 1980
We are a member of: SPAR
We work with: Commercial artists
We are seeking both new and established talent.
Types of companies we work with:

Ad agencies	Designers

Media we deal in:

Acrylic	Airbrush	Collage
Colored Pencil	Computer Art	Pastel
Pen & Ink	Photography	Watercolor

Target market:

Corporations	Ad agencies	Designers

Number of artists presently represented: 13
Commission taken: 25%
Geographical limitations to artists we represent: None
Advice for the artist interested in working with us: Need to be familiar with the needs of art directors and the market themselves
To contact us: Arrange a personal interview to show portfolio/query with resumé/query with samples/send slides by mail for consideration/provide resumé, business card, brochure, statement, etc.
Type/style of artwork has the best chance of being purchased by our clients in the next two years: No particular style—realistic, impressionistic—look at ads!

❖ Electric Ave

Sharon Traux
1625 Electric Ave, Venice, CA 90291
310/396-3162 Telephone/Fax

Artist Agent/Art Dealer/PR projects
Year our company was established: 1988
We work with: Fine artists.
We are seeking established talent mostly through referrals.
Types of companies we work with:

Offices	Residential	Restaurants
Public Spaces	Educational Facilities	

Styles we deal in:

Abstract	Contemporary	Figurative
Landscape	Minimal	Realistic

Media we deal in:

Acrylic	Bronze	Installations
Oil	Pastel	Pen & Ink
Photography	Prints	Sculpture
Silkscreen	Watercolor	

Target market:

Individuals	Museums	Corporations
Architects	Developers	

To contact us: Query with resumé.

❖ Leslie Art Inc

Stan Sherwin
PO Box 6693, Woodland Hills, CA 91365
818/999-9228 818/999-0833 Fax

Fine Art Consultant/Artist Agent
Year our company was established: 1965
We work with: Fine, commercial and decorative artists.
We are seeking both new and established talent.
Styles we deal in:

Classic	Fantasy	Figurative
Impressionism	Landscape	Naive
Nostalgia	Realistic	Representational
Stylistic	Surrealism	Traditional
Western		

Media we deal in:

Acrylic	Bronze	Marble
Oil	Sculpture	

Target market:

Galleries	Museums	Corporations
Art Publishers	Book Publishers	Architects
Interior Designers		

Commission taken: 50%
Geographical limitations to artists we represent: International
Advice for the artist interested in working with us: Send slides and photos of best work for consideration.
Type/style of artwork has the best chance of being purchased by our clients in the next two years: Representational, figurative, landscape, floral, still-life

❖ McGrath & Braun Art Consultants

Mauve McGrath
919 Broadway, Denver, CO 80203
303/893-0449 303/893-8130 Fax

Independent Art Advisor/Fine Art Consultant/Art Broker
Year our company was established: 1987
We work with: Decorative artists.
We are seeking both new and established talent.
Types of companies we work with:

Offices	Hotel/Motel	Medical
Public Spaces		

Styles we deal in:

Abstract	Animals	Contemporary
Landscape	Realistic	Representational
Southwestern	Sport	Stylistic
Traditional		

Media we deal in: All
Target market:

Corporations	Architects	Developers

Commission taken: 50%
To contact us: Send slides by mail for consideration.

❖ **Mona Berman Fine Arts**
Mona Berman
78 Lyon St, New Haven, CT 06511
203/562-4720 203/787-6855 Fax

Independent Art Advisor/Fine Art Consultant
Year company was established: 1979
We are a member of: New England Appraisers Association
We work with: Fine artists.
We are seeking both new and established talent.
Types of companies we work with:

Offices	Medical	Residential

Styles we deal in:

Abstract	Classic	Contemporary
Ethnic	Landscape	Modernism
Portraits	Realistic	Representational
Traditional		

Media we deal in:

Acrylic	Ceramic	Charcoal
Clay	Collage	Drawing
Fibre Arts	Glass	Mixed Media
Oil	Paper Sculpture	Pastel
Photography	Pottery	Prints
Sculpture	Silkscreen	Watercolor

Target markets:

Individuals	Corporations	Architects
Interior Designers		

Number of artists presently represented: 125
Commission taken: 50%
Geographical limitations to artists we represent: None
Advice for the artist interested in working with us: Send SASE, slides with retail price list, resumé
Review policy: Send slides by mail for consideration/ provide resumé, business card, brochure, statement, etc.
Type/style of artwork which has the best chance of being purchased by our clients in the next two years: Realistic, landscape, Oriental

❖ **International Portfolio**
Marcia Mayne
1820 Clydesdale Pl NW #405, Washington, DC 20009
202/588-9309 202/332-2802 Fax

Fine Artist Representative/Art Dealer
Independent Curator
Year our company was established: 1992
We work with: Fine artists
We are seeking established talent mostly through referrals/primarily black artists.
Types of companies we work with:

Residential	Galleries	Public Spaces
Commercial office		

Styles we deal in:

Abstract	Classic	Contemporary
Ethnic	Figurative	Latin American
Naive	Representational	Traditional

Media we deal in:

Acrylic	Bronze	Mixed Media
Oil	Photography	Sculpture

Target market:

Galleries	Individuals	Book Publishers
Architects		

Primary activities in representing artists: Arrange exhibitions, primarily through galleries, curate exhibitions in public spaces, sell to individuals, architects and interior designers. Provide publicity.
Number of artists presently represented: 10
Commission taken: 20-30%
Geographical limitations to artists we represent: None
Advice for the artist interested in working with us: This is a team effort; we expect artists to have their portfolio properly prepared, slides properly labelled, resumés up-to-date, etc.
To contact us: Query with samples.
Type/style of artwork has the best chance of being purchased by our clients in the next two years: Representational, contemporary, abstract, sculpture

❖ **Creations International Gallery**
Victoria Haer
48 E Granada Blvd, Ormond Beach, FL 32176
904/673-8778

Gallery Advisor/Affiliated with Gallery/Art Dealer
Fine Art Consultant/Artist Agent
We work with: Fine, commercial and decorative artists.
We are seeking both new and established talent.
Types of companies we work with:

Churches	Offices	Facilities
Hotel/Motel	Medical	Residential

Styles we deal in:

Abstract	Animals	Classic
Conceptual	Contemporary	Fantasy
Figurative	Landscape	Marine
Realistic	Stylistic	Surrealism
Traditional	Wildlife	

Media we deal in: All except installations
Target market:

Galleries	Individuals	Museums
Corporations	Art Publishers	Book Publishers
Architects	Developers	Interior Designers

Number of artists presently represented: 10
Commission taken: 30%
Geographical limitations to artists we represent: None
To contact us: Query with resumé/provide resumé, business card, brochure, statement, etc.
Type/style of artwork has the best chance of being purchased by our clients in the next two years: Unique in style/identifiable/all media

Consultants, Reps, Dealers & Brokers

❖ Local Color
Arlene Howard
4 Misty Ridge Manor NW, Atlanta, GA 30327
404/256-3491 Telephone/Fax

Independent Art Advisor/Fine Art Consultant
Year our company was established: 1989
We work with: Fine artists
We are seeking established talent mostly through referrals.
Types of companies we work with:

Offices	Hotel/Motel	Medical
Residential	Public Spaces	

Styles we deal in:

Abstract	Conceptual	Contemporary
Ethnic	Figurative	Landscape
Modernism	Naive	Representational
Southwestern	Visionary	Western

Media we deal in:

Acrylic	Bronze	Ceramic
Clay	Collage	Fibre Arts
Glass	Pastel	Pottery
Prints	Sculpture	Silkscreen
Watercolor		

Target market:

Corporations	Architects	Developers

Type/style of artwork has the best chance of being purchased by our clients in the next two years: Originals on paper and canvas, fine craft, folk art

❖ Livingston Galleries Ltd
Beth Wotkyns
51-666 Kamehameha Hwy, Kaaiwa, HI 96730
808/237-7165 808/237-7220 Fax

Affiliated with Gallery/Fine Art Consultant
Art Dealer
Year our company was established: 1985
We work with: Fine artists.
We are seeking both new and established talent.
Types of companies we work with:

Offices	Residential	Restaurants

Styles we deal in:

Abstract	Conceptual	Contemporary
Ethnic	Figurative	Impressionism
Landscape	Marine	Modernism
Naive	Portraits	Realistic
Representational	Surrealism	Traditional
Wildlife	Western	

Media we deal in:

Acrylic	Bronze	Ceramic
Collage	Colored Pencil	Drawing
Glass	Mixed Media	Oil
Pastel	Pen & Ink	Photography
Prints	Sculpture	Silkscreen
Watercolor		

Target market:

Individuals	Corporations

Primary activities in representing artists: Monthly featured artist with reception
Number of artists presently represented: 40
Commission taken: Varies by artist
Advice for the artist interested in working with us: Do not contact us unless your work is excellent and you are a master of your chosen medium.
To contact us: Arrange a personal interview to show portfolio/submit portfolio for review/query with resumé/send slides by mail for consideration.
Type/style of artwork has the best chance of being purchased by our clients in the next two years: Our clients have and will continue to purchase a broad spectrum of styles. Quality is our main criterion.

❖ Corporate Art Services
Ellen Ripp
1090 Johnson Dr, Buffalo Grove, IL 60089
708/215-4900 708/215-4776 Fax

Affiliated with Gallery/Fine Art Consultant
Corporate Art Consultant
Year our company was established: 1964
We are a member of: SPAR
We work with: Fine, commercial and decorative artists.
We are seeking both new and established talent.
Types of companies we work with:

Offices	Facilities	Hotel/Motel
Medical	Restaurants	Public Spaces
Stores/Showrooms		

Styles we deal in:

Abstract	Animals	Contemporary
Ethnic	Impressionism	Landscape
Latin American	Minimal	Naive
Realistic	Representational	Southwestern
Sport	Traditional	Wildlife
Western		

Media we deal in: All
Target market:

Corporations	Architects	Developers
Interior Designers		

Primary activities in representing artists: We are four art consultants showing work on a weekly basis.
Number of artists presently represented: Several hundred
Commission taken: Varies
Geographical limitations to artists we represent: None
Advice for the artist interested in working with us: Be patient; our projects take several months to consummate.
To contact us: Send slides by mail for consideration.

❖ **Orea Art**
Jay Fahn
300 W Grand Ave, Chicago, IL 60610
312/245-5245 Telephone/Fax

Art Dealer
Year our company was established: 1987
We are a member of: SPAR
We work with: Fine artists.
We are seeking both new and established talent.
Types of companies we work with:

Offices	Educational Facilities	Medical
Residential		

Styles we deal in:

Animals	Eskimo	Inuit
NW Coast Indian	Wildlife	

Media we deal in:

Drawing	Fibre Arts	Glass
Installations	Marble	Prints
Sculpture	Silkscreen	Wood

Target market:

Individuals	Corporations	Developers
Interior Designers		

Number of artists presently represented: 100
Commission taken: Inquire
Geographical limitations to artists we represent: Must be Inuit, Eskimo or Northwest Coast Tribal affiliated
To contact us: Query with samples.
Type/style of artwork has the best chance of being purchased by our clients in the next two years: Sculpture, masks, jewelry

❖ **Suzanne Love**
3050 N Allen Ave, Chicago, IL 60618
312/342-8283 312/862-3002 Fax

Fine Art Consultant
Year our company was established: 1993
We work with: Fine, commercial and decorative artists.
We are seeking both new and established talent mostly through referrals.
Types of companies we work with:

Offices	Hotel/Motel	Medical
Residential	Public Spaces	Corporations

Styles we deal in:

Abstract	Conceptual	Contemporary
Figurative	Impressionism	Landscape
Minimal	Modernism	Stylistic
Traditional		

Media we deal in:

Acrylic	Bronze	Ceramic
Charcoal	Clay	Collage
Drawing	Fibre Arts	Glass
Mixed Media	Oil	Paper Sculpture
Pastel	Pen & Ink	Photography
Pottery	Prints	Sculpture
Watercolor		

Target market:

Individuals	Corporations	Architects
Developers	Interior Designers	

Number of artists presently represented: 20
Commission taken: I buy the art from artists at their wholesale price.
Geographical limitations to artists we represent: Midwest states, east coast is good, no California art.
Advice for the artist interested in working with us: Must be able to deliver on time, no erotic art, no garish colors or color combinations, looking for high quality.
To contact us: Send slides by mail for consideration.
Type/style of artwork has the best chance of being purchased by our clients in the next two years: Works on paper, acrylic, abstract, lithographs, sculpture, serigraphs, high quality posters, actually a very broad range of media.

❖ **Accent Art**
Robert Galitzn
166 Hilltop Ln, Sleepy Hollow, IL 60118
708/426-8842 708/426-8846 Fax

Fine Artist Representative/Art Dealer
Year our company was established: 1986
We work with: Fine and decorative artists.
We are seeking both new and established talent.
Types of companies we work with:

Offices	Medical	Residential
Public Spaces	Stores/Showrooms	

Styles we deal in:

Abstract	Classic	Contemporary
Impressionism	Landscape	Modernism
Realistic	Representational	Traditional

Media we deal in:

Acrylic	Bronze	Collage
Colored Pencil	Drawing	Fibre Arts
Mixed Media	Oil	Paper Sculpture
Pastel	Prints	Silkscreen
Watercolor		

Target market:

Galleries	Corporations	Architects
Interior Designers		

Number of artists presently represented: 100
Commission taken: 20 - 45%
Geographical limitations to artists we represent: Midwest (Chicago, IL) and three-hour radius.
To contact us: Query with resumé/send slides by mail for consideration.
Type/style of artwork has the best chance of being purchased by our clients in the next two years: Abstract, landscape

Consultants, Reps, Dealers & Brokers

❖ William Blackwell & Associates
638 S Governor St, Iowa City, IA 52240
800/366-5208 319/338-1247 Fax

Artist Agent/Distributor
Year our company was established: 1979
We work with: Fine and decorative artists.
We are seeking established talent mostly through referrals.
Types of companies we work with: The Trade
Styles we deal in:
Representational Traditional
Media we deal in:
Drawing Prints (especially etchings)
Watercolor
Advice for the artist interested in working with us: Learn something about the business side of art before deciding what work is to be offered.
To contact us: Telephone for guidelines.

❖ Artemis Inc
Sandra Trapper
4715 Crescent St, Bethesda, MD 20816
301/229-2058 301/229-2186 Fax

Independent Art Advisor/Fine Art Consultant
Art Broker/Art Dealer/Fine Art Appraiser
Year our company was established: 1990
We are a member of: American Society of Appraisers
We work with: Fine and decorative artists.
We are seeking both new and established talent.
Types of companies we work with:
Commercial Residential Restaurants
Public Spaces
Styles we deal in:

Abstract	Animals	Classic
Conceptual	Contemporary	Equestrian
Ethnic	Figurative	Impressionism
Landscape	Latin American	Marine
Minimal	Modernism	Portraits
Realistic	Representational	Southwestern
Stylistic	Surrealism	Traditional

Media we deal in:

Acrylic	Bronze	Ceramic
Charcoal	Clay	Collage
Colored Pencil	Computer Art	Drawing
Fibre Arts	Glass	Installations
Marble	Mixed Media	Oil
Paper Sculpture	Pastel	Pen & Ink
Pottery	Prints	Sculpture
Silkscreen	Watercolor	

Target market:

Collectors	Corporations	Architects
Interior Designers		

Number of artists presently represented: 200
Commission taken: 50%
Geographical limitations to artists we represent: None

Advice for the artist interested in working with us:
Present slides/photos of work with a retail price list and biographical information.
To contact us: Send slides by mail for consideration/ provide resumé, business card, brochure, statement, etc.

❖ Galerie Mourlot
Marjorie Javan
14 Newbury St, Boston, MA 02116
617/536-0040 617/241-7659 Fax

Fine Art Consultant affiliated with gallery
We work with: Fine artists.
We are seeking both new and established talent.
Types of companies we work with:
Offices Medical Residential
Styles we deal in:

Abstract	Conceptual	Contemporary
Figurative	Impressionism	Landscape
Marine	Modernism	Naive
New Age	Realistic	Representational
Surrealism	Traditional	

Media we deal in:

Acrylic	Bronze	Collage
Computer Art	Drawing	Fibre Arts
Glass	Mixed Media	Oil
Pastel	Photography	Prints
Sculpture	Silkscreen	Watercolor

Target market:

Individuals	Museums	Corporations
Architects	Developers	Interior Designers

Number of artists presently represented: 20+
Commission taken: 50%
Geographical limitations to artists we represent: None
To contact us: Send slides by mail for consideration.
Type/style of artwork has the best chance of being purchased by our clients in the next two years: Both contemporary and traditional, landscape, etc.

❖ Lysographics Fine Arts
Esther Lyss
722 S Meramec, St Louis, MO 63105
314/726-6140 314/726-6141 Fax

Independent Art Advisor/Fine Art Consultant
Fine Artist Representative/Artist Agent/Art Broker
Year our company was established: 1970
We work with: Fine, commercial and decorative artists.
Types of companies we work with:
Offices Hotel/Motel Medical
Residential Restaurants Public Spaces
Stores/Showrooms
Styles we deal in: All
Media we deal in: All

Target market:

Galleries	Individuals	Museums
Corporations	Art Publishers	Book Publishers
Architects	Developers	Interior Designers

To contact us: Query with samples/send slides by mail for consideration.

❖ RMB Enterprises

RM Bush
11469 Olive Blvd #265, St Louis, MO 63141
314/432-5824 Telephone/Fax

Independent Art Advisor/Fine Art Consultant
Fine Artist Representative/Art Broker/Art Dealer
Year our company was established: 1986
We work with: Fine artists.
We are seeking both new and established talent.
Types of companies we work with:

Offices	Residential	Stores/Showrooms

Styles we deal in:

Classic	Figurative	Impressionism
Landscape	Marine	Naive
Realistic	Representational	Southwestern
Surrealism	Traditional	Wildlife
Western		

Media we deal in:

Acrylic	Bronze	Ceramic
Clay	Drawing	Glass
Marble	Oil	Pastel
Pen & Ink	Prints	Sculpture
Watercolor		

Target market:

Individuals	Corporations	Architects
Developers	Interior Designers	

Number of artists presently represented: 50
Commission taken: 40%
Geographical limitations to artists we represent: None
To contact us: Query with resumé/send slides by mail for consideration.
Type/style of artwork has the best chance of being purchased by our clients in the next two years: Impressionism/realism

❖ Visual Art Access

Michael S Bell
Box 2880, Santa Fe, NM 87504
505/820-0121 505/820-0038 Fax

Fine Artist Representative
Year our company was established: 1987
We work with: Fine, commercial and decorative artists.
We are seeking both new and established talent.
We work with: Individual artists and art groups
Styles we deal in: All
Media we deal in: All
Target market: All

Number of artists presently represented: 80-120
Commission: I charge a fee/no commission. Call or write for brochure.
Geographical limitations to artists we represent: U.S. only
Advice for the artist interested in working with us: I am interested in helping artists who prefer career independence.
To contact us: Query with resumé.
Type/style of artwork has the best chance of being purchased by our clients in the next two years: Almost anything that is carefully, thoughtfully, well-made.

❖ Mary Craig International Art

PO Box 825, Moorestown, NJ 08057
609/439-1698

Art Dealer
Year our company was established: 1989
We are a member of: SPAR
We work with: Fine artists.
We are actively seeking new talent.
Types of companies we work with:

Offices	Medical	Residential
Public Spaces		

Styles we deal in:

Abstract	Conceptual	Contemporary
Figurative	Portraits	Realistic

Media we deal in:

Acrylic	Pastel	Photography
Silkscreen		

Target market:

Individuals	Museums	Corporations

To contact us: Provide resumé, business card, brochure, statement, etc.

❖ Art Directions

Isabella Pizzano
38 Wilcox Dr, Mountain Lakes, NJ 07046-1148
201/263-1420

Independent Art Advisor/Fine Art Consultant
Fine Artist Representative/Art Dealer
Year our company was established: 1988
We work with: Fine, commercial and decorative artists.
We are seeking both new and established talent.
Types of companies we work with:

Churches	Offices	Hotel/Motel
Medical	Residential	Restaurants

Styles we deal in:

Abstract	Animals	Classic
Contemporary	Impressionism	Landscape
Realistic	Representational	Sport
Traditional		

Consultants, Reps, Dealers & Brokers

Media we deal in:

Acrylic	Bronze	Ceramic
Clay	Collage	Computer Art
Fibre Arts	Glass	Marble
Mixed Media	Oil	Paper Sculpture
Pastel	Photography	Pottery
Prints	Sculpture	Silkscreen
Watercolor		

Target market:

Individuals	Corporations	Architects
Developers	Interior Designers	

Number of artists presently represented: 100's
Commission taken: 30-40-50%
Geographical limitations to artists we represent: Tri-state area, mostly New Jersey
To contact us: Arrange a personal interview to show portfolio/query with samples.
Type/style of artwork has the best chance of being purchased by our clients in the next two years: Monoprints, monotypes, limited edition prints, posters, ceramic, three-dimensional wall sculpture.

❖ Leader Associates

Bernice Leader
7 Nottingham Rd, Wayne, NJ 07470
201/696-1836

Independent Art Advisor
Year our company was established: 1987
We are a member of: NACAM
We work with: Fine artists.
We are seeking both new and established talent.
Types of companies we work with:

Churches	Offices	Medical
Residential		

Styles we deal in:

Abstract	Contemporary	Impressionism
Landscape	Marine	Modernism
Realistic	Religious	Representational
Sport		

Media we deal in:

Acrylic	Ceramic	Clay
Collage	Colored Pencil	Fibre Arts
Glass	Mixed Media	Oil
Paper Sculpture	Pastel	Photography
Pottery	Prints	Sculpture
Silkscreen	Watercolor	

Target market: Corporations Other
Number of artists presently represented: 105
Commission taken: 40-50%
Advice for the artist interested in working with us: Patience.
To contact us: Query with samples/send slides by mail for consideration.
Type/style of artwork has the best chance of being purchased by our clients in the next two years: Cheap and cheerful.

❖ Designer Collection/Interior Fine Art

Elaine Violyn Luzine
PO Box 22, Guilderland, NY 12084
518/456-2913

Fine Art Consultant/Art Dealer/Independent
Year our company was established: 1984
We work with: Fine and decorative artists.
We are seeking both new and established talent.
Types of companies we work with:

Offices	Residential

Styles we deal in:

Abstract	Contemporary	Marine
Realistic	Sport	

Media we deal in:

Acrylic	Oil	Pastel
Prints	Watercolor	

Target market:

Individuals	Corporations	Architects

Type/style of artwork has the best chance of being purchased by our clients in the next two years: Sporting and floral

❖ Value of Art

William Warmus
PO Box 30, Lansing, NY 14882
607/533-7688 607/533-9095 Fax

Fine Art Consultant/Appraiser
Year our company was established: 1977
We work with: Fine artists.
Types of companies we work with:

Offices	Residential	Private collectors

Styles we deal in:

Abstract	Conceptual	Contemporary
Figurative	Minimal	Modernism
Representational		

Media we deal in:

Acrylic	Glass	Mixed Media
Oil	Sculpture	

Target market:

Galleries	Individuals	Museums

Advice for the artist interested in working with us: We can provide appraisals for artists and collectors. We publish a newsletter tracking market prices.

❖ Burns Fine Art

Zinnia
568 Broadway #1001, New York, NY 10012
212/219-8444 212/219-8456 Fax

Fine Art Consultant/Fine Artist Representative
Art Dealer
Year our company was established: 1983
We work with: Fine artists.
We are actively seeking new talent.

Types of companies we work with:

Offices Hotel/Motel Medical
Residential

Styles we deal in:

Abstract	Conceptual	Contemporary
Landscape	Representational	Traditional

Media we deal in:

Acrylic	Bronze	Collage
Computer Art	Drawing	Installations
Mixed Media	Oil	Pastel
Pen & Ink	Photography	Prints
Sculpture	Silkscreen	Watercolor

Target market:

Individuals	Corporations	Architects
Interior Designers		

Primary activities in representing artists: Sale of work
Number of artists presently represented: 200
Commission taken: 40%
Geographical limitations to artists we represent: None
To contact us: Send slides by mail for consideration.
Type/style of artwork has the best chance of being purchased by our clients in the next two years: Traditional, abstract and photography

❖ Cohen & Associates

30 E 20th St #304, New York, NY 10003
212/475-2759

**Fine Artist Representative/Artist Agent
Art Broker/Art Dealer
Year our company was established:** 1990
We work with: Fine, commercial and decorative artists.
We are seeking both new and established talent.
Types of companies we work with: Stores/Showrooms
Styles we deal in:

Contemporary	Figurative	Portraits
Sport		

Media we deal in:

Bronze	Ceramic	Glass
Photography	Pottery	Sculpture
Other		

Target market:

Individuals	Corporations	Interior Designers

Primary activities in representing artists: Marketing sales
Number of artists presently represented: 15+
Commission taken: 10-30%
Geographical limitations to artists we represent: Mostly in the Northeast
Advice for the artist interested in working with us:
Looking for contemporary American potters and glassblowers who produce clean, marketable work. The creativity should not exceed the skill put into the pieces.
To contact us: Provide resumé, business card, brochure, statement, etc.
Type/style of artwork has the best chance of being purchased by our clients in the next two years: Small bronze and glass sculpture; colorful but tasteful ceramic dinnerware.

❖ Smart Art Consultants

Catherine Drillis
531 E 20 St #6B, New York, NY 10010
212/254-8334

**Independent Art Advisor/Art Critic/Artist Agent
Year our company was established:** 1992
We work with: Fine artists.
We are seeking both new and established talent.
Types of companies we work with:

Residential	Commercial

Styles we deal in:

Abstract	Classic	Contemporary
Equestrian	Fantasy	Figurative
Impressionism	Landscape	Minimal
Modernism	POP	Portraits
Realistic	Representational	Southwestern
Stylistic	Surrealism	Traditional
Wildlife	Western	

Media we deal in:

Acrylic	Airbrush	Charcoal
Collage	Colored Pencil	Computer Art
Drawing	Mixed Media	Oil
Pastel	Pen & Ink	Photography
Prints	Silkscreen	Watercolor

Target market: Individuals
Primary activities in representing artists: Negotiating prices and payment schemes, writing contracts for reproduction and copyright, preparing exhibitions, etc.
Number of artists presently represented: 12
Commission taken: 30%
Geographical limitations to artists we represent: None
Advice for the artist interested in working with us: We buy art for lush-end collectors, primarily to furnish their homes, though sometimes their offices. Top prices paid for exceptional work.
Type/style of artwork has the best chance of being purchased by our clients in the next two years:
Size: 3x5' Subject: Any Style: Any

❖ Walt Burton Photo Dealer

4032 Egbert Ave, Cincinnati, OH 45220
513/961-3860 Telephone/Fax

Fine Art Consultant/Art Dealer/Independent Publisher of limited edition original photographic portfolios.
Year our company was established: 1965
We are a member of: SPAR + others
We work with: Fine artists only
We are seeking established talent mostly through referrals.
Types of companies we work with:

Corporations	Individuals	Galleries

Styles we deal in:

Aviation	Classic	Erotic
Figurative	Pictorialism	Portraits
Western		

Media we deal in: Only original photographic prints
Target market:

Galleries Individuals Corporations
Private collectors

Number of artists presently represented: 2
Commission taken: None; buy outright all my inventory.
Geographical limitations to artists we represent: None
Advice for the artist interested in working with us: Call first.

❖ Art Dynamics

H R Jaffie
PO Box 1624, Allentown, PA 18105
610/434-3841

Independent Art Advisor/Fine Art Consultant
Art Broker/Art Business Management and Marketing
Advisor to artists
Year our company was established: 1987
We are a member of: Allied Member ASID, Women's Caucus for Art, CAA
We work with: Fine artists (all 2- and 3-D); decorative artists (all media/upscale museum/gallery quality); art business management and marketing advisor to artists.
We welcome both new and established talent.
Types of companies we work with:

Offices Medical Residential
Public Spaces Architects Developers
Interior Designers Art Publishers Museums
Corporations Individuals Galleries

Styles we deal in:

Abstract Animals Aviation
Classic Conceptual Contemporary
Figurative Landscape Marine
Minimal Modernism Portraits
Realistic Representational Sport
Stylistic Surrealism Traditional
Western

Media we deal in: All
Primary activities in representing artists: We provide business management and marketing advisory services to artists on a consulting basis. We evaluate content and style of business materials and offer suggestions to help the artist prepare and present a professional image of him/herself and his/her portfolio, business material and documents.
Commission taken: Fee based on consulting services; % sales on commissions; 10% brokerage fee. Additional information and details upon request.
Advice for the artist interested in working with us: We supply any style of art the client is interested in. Act like a business person.
To contact us: Send slide/tear sheets/photos by mail which you do not need back.
Type/style of artwork has the best chance of being purchased by our clients in the next two years: Landscapes (all styles), abstracts (all media on canvas or paper)

❖ Pennamenities Fine Arts

Deborah A Miller
RD #2 Box 1080, Schuylkill Haven, PA 17972
717/754-7744 Telephone/Fax

Gallery Advisor/Fine Art Consultant/Appraiser
Fine Artist Representative/Artist Agent/Art Dealer
Year our company was established: 1988
We work with: Fine artists.
We are selectively seeking both new and established talent.
Types of companies we work with:

Residential Restaurants

Styles we deal in:

Abstract Contemporary Figurative
Impressionism Landscape Minimal
Modernism Naive Portraits
Realistic Representational Traditional

Media we deal in:

Acrylic Charcoal Colored Pencil
Drawing Marker Mixed Media
Oil Pastel Pen & Ink
Photography Prints Watercolor

Target market:

Galleries Individuals Museums
Corporations Art Publishers Interior Designers

Primary activities in representing artists: Establishing gallery exhibits and marketing
Number of artists presently represented: 40
Commission taken: Varies
To contact us: Send slides by mail for consideration with resumé, price list and SASE for return of materials.

❖ Cumberland Gallery

Carol Stein
4107 Hillsboro Cir, Nashville, TN 37216
615/297-0296

Fine Art Consultant/Fine Art Representative
Art Dealer
Year our company was established: 1981
We work with: Fine artists.
We are seeking both new and established talent.
Types of companies we work with:

Offices Medical Residential
Restaurants Public Spaces

Styles we deal in:

Abstract Conceptual Contemporary
Fantasy Landscape Minimal
Realistic Representational Stylistic
Surrealism Visionary

Media we deal in:

Acrylic Bronze Charcoal
Collage Colored Pencil Drawing
Glass Mixed Media Oil
Pastel Pen & Ink Photography
Prints Sculpture Silkscreen
Watercolor

Target market:

| Individuals | Museums | Corporations |
| Architects | Developers | Interior Designers |

Number of artists presently represented: 55
Commission taken: 50%
Geographical limitations to artists we represent: U.S.
Advice for the artist interested in working with us:
Present slides, resumé (current only) and price list for consideration.
To contact us: Send slides by mail for consideration/ provide resumé, business card, brochure, statement, etc.
Type/style of artwork has the best chance of being purchased by our clients in the next two years: Contemporary, both abstract and realist.

❖ **Select Art**
Paul Adelson
10315 Gooding Dr, Dallas, TX 75229
214/353-0011 214/350-0027 Fax

Fine Artist Representative/Art Dealer
Year our company was established: 1986
We work with: Fine artists.
We are seeking both new and established talent.
Types of companies we work with:

| Offices | Hotel/Motel | Medical |
| Residential | Public Spaces | |

Styles we deal in:

| Abstract | Contemporary | Landscape |
| Representational | | |

Media we deal in:

Acrylic	Bronze	Charcoal
Collage	Colored Pencil	Glass
Marble	Oil	Pastel
Pen & Ink	Photography	Sculpture
Watercolor		

Target market:

| Individuals | Corporations | Architects |
| Interior Designers | | |

Number of artists presently represented: 30
Commission taken: 50%
Geographical limitations to artists we represent: None
Advice for the artist interested in working with us: Do what you say you are going to do!
To contact us: Send slides by mail for consideration with SASE.
Type/style of artwork has the best chance of being purchased by our clients in the next two years: Abstract and photography

❖ **Two Ravens**
Brent Buhler, Chuck Reasoner
22833 Bothell-Everett Hwy #1278, Bothell, WA 98021
206/778-0826 206/778-1412 Fax

Independent Art Advisor/Fine Artist Representative
Artist Agent
Year our company was established: 1990

We work with: Fine artists and illustrators.
We are seeking both new and established talent.
Types of companies we work with:

| Public Spaces | Publishers | Individuals |
| Stores/Showrooms | | |

Styles we deal in:

Expressionism	Impressionism	Latin American
Native American	NW Native	Southwestern
Western		

Media we deal in:

Acrylic	Colored Pencil	Oil
Prints	Watercolor	Limited Editions
Functional Wood Art		

Target market:

| Galleries | Individuals | Art Publishers |
| Book Publishers | Architects | Interior Designers |

Primary activities in representing artists: Independent art advisor, promotional work, marketing, fine art publishing
Number of artists presently represented: 6
Commission taken: Varies, depending on project
To contact us: Arrange a personal interview to show portfolio/query with resumé/send slides by mail for consideration.
Type/style of artwork has the best chance of being purchased by our clients in the next two years: Western, native, wildlife, realism, expressionism, impressionism.

❖ **Nikki Bender and Company**
2330 N 55th St, Milwaukee, WI 53210
414/873-5300 414/873-6886 Fax

Independent
Year our company was established: 1994
We work with: Fine artists.
Types of companies we work with:

| Offices | Hotel/Motel | Medical |
| Restaurants | Public Spaces | |

Styles we deal in:

Abstract	Animals	Classic
Contemporary	Equestrian	Ethnic
Impressionism	Landscape	Marine
Naive	Realistic	Representational
Sport	Traditional	Wildlife
Western		

Media we deal in:

Acrylic	Airbrush	Ceramic
Charcoal	Clay	Collage
Colored Pencil	Fibre Arts	Glass
Installations	Mixed Media	Oil
Paper Sculpture	Pastel	Photography
Pottery	Prints	Sculpture
Silkscreen	Watercolor	

Target market:

| Corporations | Architects | Interior Designers |
| Healing Spaces | | |

To contact us: Send slides by mail for consideration.
I put together collections of art to create well-being for people and spaces through art and color.

Corporations Collecting Art

To locate more corporations collecting art, keep an eye on your local newspaper! Check out your local businesses to see if they want to lease or buy pieces for their new offices.

ARTnews International Directory of Corporate Art Collectors

ARTnews
48 W 38th St, New York, NY 10018
212/398-1690
$109.95+ shipping.

ArtNetwork

PO Box 1268, 18757 Wildflower Dr, Penn Valley, CA 95946
916/432-7630
Mailing list on labels of over 900 corporations collecting art for $75.

❖ **BankAmerica Gallery**

South Coast Metro Center, 555 Anton Blvd #4055,
Costa Mesa, CA 92626
714/433-6000

❖ **Munger, Tolles & Olson**

355 S Grand Ave #2500, Los Angeles, CA 90071
213/683-9100 213/687-3702 Fax

Year corporate collection started: 1970
Number of pieces in collection to date: 180
Number of pieces purchased annually: 10-20
Status of collection: Ongoing
Source of artwork collected:
Emerging artists Established artists Consultant
Dealer Gallery
Style of artwork collected: All
Medium of artwork collected: All
To contact our corporation: Send slides by mail for consideration/send SASE for submission guidelines.

❖ **BankAmerica Corporation Art Collection**

Bonnie Earls-Solari
PO Box 37000, San Francisco, CA 94137
415/622-1265 415/622-2387 Fax

Year corporate collection started: 1979
Number of pieces in collection to date: 18,000
Number of pieces purchased annually: Varies
We have a corporate gallery open for public viewing.
 Hours are: In San Francisco: Mon-Fri 8-5
 In Costa Mesa: Mon-Fri 11-4
Status of collection: Ongoing
Source of artwork collected:
Emerging artists Established artists Consultant
Dealer Gallery Auction
Style of artwork collected: All
Medium of artwork collected: All except airbrush, marble and paper sculpture
Trends we see in corporate art collecting: Plateaued
To contact our corporation: Send SASE for submission guidelines.
Specific time of year to contact corporation: Anytime

❖ BKM Total Office Today

222 Pitkin St, East Hartford, CT 06108
203/528-9981 203/528-1843 Fax

Outside Consultant: Rosalie Zetoff
157 Balfour Dr, West Hartford, CT
203/521-9044

We have a corporate gallery open for public viewing.
Source of artwork collected:
Established artists Consultant Dealer
Gallery
Style of artwork collected:
Abstract Impressionism Landscape
Marine Realistic Representational
Medium of artwork collected:
Acrylic Mixed Media Pastel
Prints Watercolor
Trends we see in corporate art collecting: Posters
To contact our corporation: Arrange a personal interview
to show portfolio/send slides by mail for consideration.
Specific time of year to contact corporation: Anytime

❖ Stevenson & Wilkinson

James Kortan
100 Peachtree St NW #2400, Atlanta, GA 30303-6801
404/522-8888

❖ Playboy Enterprises Inc

Barbara S Hoffman
680 N Lake Shore Dr, Chicago, IL 60611
312/751-8000 312/751-2818 Fax

Year corporate collection started: 1953
Number of pieces in collection to date: 5,000
Number of pieces purchased annually: 5-10
We have a corporate gallery open for public viewing.
 Hours are: By appointment
We have a corporate photo library.
Status of collection: Ongoing
Source of artwork collected:
Emerging artists Established artists
Style of artwork collected: Our collection of art is made
up of art which was commissioned for *Playboy Magazine*
and almost all styles are included.
Medium of artwork collected:
Acrylic Airbrush Bronze
Charcoal Collage Colored Pencil
Drawing Fibre Arts Mixed Media
Oil Paper Sculpture Pastel
Pen & Ink Photography Prints
Sculpture Watercolor
To contact our corporation: Send 3mm slides of work by
mail for consideration to Kerig Pope, Managing Art
Director. Any work added to the collection first has to
appear in the magazine.
Specific time of year to contact corporation: Anytime

❖ Warner Norcross & Judd LLP

Jack B Combs
111 Lyon St NW, Grand Rapids, MI 49503

Year corporate collection started: 1966
Number of pieces in collection to date: 62
Number of pieces purchased annually: 2-3
Status of collection: Ongoing
Source of artwork collected:
Emerging artists Galleries
Style of artwork collected:
Abstract Figurative Landscape
Representational
Medium of artwork collected:
Acrylic Drawing Mixed Media
Oil Pastel Photography
Silkscreen Watercolor

❖ Federal Reserve Bank of Minneapolis

Christine Power
250 Marquette Ave, Minneapolis, MN 55480

Year corporate collection started: 1972
Number of pieces in collection to date: 350
Number of pieces purchased annually: Varies
Status of collection: Ongoing
Source of artwork collected:
Emerging artists Consultant Dealer
We purchase from artists who live and work in the Ninth
Federal Reserve District: Minnesota, North & South
Dakota, Montana, Wisconsin and the Upper Peninsula of
Michigan.
Style of artwork collected:
Abstract Figurative Landscape
Realistic Representational Traditional
Western
Medium of artwork collected:
Acrylic Airbrush Bronze
Charcoal Colored Pencil Drawing
Fibre Arts Mixed Media Oil
Pastel Pen & Ink Photography
Prints Sculpture Silkscreen
Watercolor
To contact our corporation: Submit portfolio for review/
send slides by mail for consideration.

Corporations Collecting Art

❖ Lutheran Brotherhood

Richard L Hillstrom
625 4th Ave S, Minneapolis, MN 55415
612/340-8072 612/340-8447 Fax

Year corporate collection started: 1982
Number of pieces in collection to date: 600
Number of pieces purchased annually: Around 35
We have a corporate gallery open for public viewing.
 Hours are: Mon-Fri 10-4
Status of collection: Ongoing
Source of artwork collected:
Gallery Auction
Style of artwork collected: Religious
Medium of artwork collected:

Charcoal	Drawing	Pastel
Pen & Ink	Prints	Watercolor

Specific time of year to contact corporation: Anytime

❖ Chase Manhattan Bank

Manuel E Gonzalez
1 Chase Manhattan Plz, New York, NY
212/552-4794 212/552-0695 Fax

Year corporate collection started: 1959
Number of pieces in collection to date: 13,200
We do not have a corporate gallery.
We have a corporate art library.
Status of collection: Ongoing
Source of artwork collected:

Emerging artists	Established artists	Consultant
Dealer	Gallery	Auction

Style of artwork collected: All
Medium of artwork collected: All

❖ Port Authority of New York & New Jersey

Saul S Wenegrat
1 World Trade Center, New York, NY 10048
212/435-3325 212/435-3382 Fax

Year corporate collection started: 1969
Number of pieces in collection to date: 1,500
Number of pieces purchased annually: 25
We have a corporate gallery open for public viewing 24 hours a day.
Status of collection: Ongoing
Source of artwork collected:

Emerging artists	Established artists	Consultant
Dealer	Gallery	Auction

Style of artwork collected:

Abstract	African-American	Aviation
Ethnic	Figurative	Landscape
Latin American	Marine	Realistic
Representational	Surrealism	

Medium of artwork collected:

Acrylic	Bronze	Collage
Drawing	Fibre Arts	Installations
Marble	Mixed Media	Oil
Pastel	Photography	Prints
Sculpture	Silkscreen	Watercolor

Trends we see in corporate art collecting: Functional art and installations
To contact our corporation: Send slides by mail for consideration/send SASE for submission guidelines.
Specific time of year to contact corporation: Anytime

❖ Progressive Corporation

Toby Lewis
6300 Wilson Mills Rd, Mayfield Village, OH 44143
216/461-5000

In the middle of major renovation and are reviewing slides.

❖ Hobart Brothers Company

Peter C Hobart
Hobart Square, Troy, OH 45373
513/332-4272 513/332-4249 Fax

Year corporate collection started: 1965
Number of pieces in collection to date: 25
Number of pieces purchased annually: 1
Annual collection budget: $10,000-$15,000
We have a corporate sculpture gallery open for public viewing.
We have a corporate art library.
Status of collection: Ongoing
Source of artwork collected:
Emerging artists Established artists
Style of artwork collected:
Abstract Realistic
Medium of artwork collected: Sculpture
Trends we see in corporate art collecting: A growing trend with more knowledge and professionalism
To contact our corporation: Send slides by mail for consideration.
Specific time of year to contact corporation: Fall

Corporations Collecting Art

❖ **Blount Inc**
Gail Parrick
4909 SE International Wy, Portland, OR 97222
503/653-4478 503/653-4201 Fax

Year corporate collection started: 1960's
Number of pieces in collection to date: 200+
Number of pieces purchased annually: Varies
Status of collection: Ongoing
Source of artwork collected:
Emerging artists Established artists Gallery
Style of artwork collected:

Abstract	African-American	Classic
Fantasy	Figurative	Historic
Impressionism	Landscape	Marine
Naive	New Age	Nostalgic
Realistic	Representational	Southwestern
Surrealism	Traditional	Visionary
Western	Wildlife	

Medium of artwork collected:

Acrylic	Bronze	Charcoal
Collage	Colored Pencil	Drawing
Fibre Arts	Installations	Mixed Media
Oil	Paper Sculpture	Pastel
Pen & Ink	Photography	Prints
Sculpture	Silkscreen	Watercolor

Trends we see in corporate art collecting: Multi-dimensional works rather than 2-dimensional.
To contact our corporation: Send slides by mail for consideration.
Specific time of year to contact corporation: Anytime

❖ **United States Tobacco Manufacturing Co Inc**
David Wright
800 Harrison St, Nashville, TN 37203
615/271-2349 615/271-2285 Fax

Year corporate collection started: 1974
Number of pieces in collection to date: 1,000
Number of pieces purchased annually: 10-100
We have a corporate gallery open for public viewing.
 Hours are: Mon-Sat 9-4
We have a corporate art library.
Status of collection: Ongoing
Source of artwork collected:
Consultant Dealer Auction
Style of artwork collected: Tobacco-related antiques
Medium of artwork collected:
Advertising Art Drawing Lithography
Sculpture
Specific time of year to contact corporation: Anytime

❖ **University of VA Health Science Center**
Margaret Price
Charlottesville, VA 22908
804/924-9452

❖ **Microsoft Corporation**
Deborah Paine, Art Collection Administrator
1 Microsoft Wy, Redmond, WA 98052-6399
206/936-5029 206/936-7329 Fax

Outside Advisors: Margery Aronson
2231 1st Ave N, Seattle, WA 98109
206/285-6936 206/285-9129 Fax

Year corporate collection started: 1987
Number of pieces in collection to date: 1500+
Status of collection: Ongoing
Source of artwork collected:
Emerging artists Established artists Consultants
Dealers Galleries
Style of artwork collected:

Abstract	African-American	Classic
Contemporary	Ethnic	Figurative
Impressionism	Landscape	Latin American
Narrative	Native American	New Age
Realistic	Representational	

Medium of artwork collected:

Acrylic	Bronze	Charcoal
Collage	Colored Pencil	Drawing
Fibre Arts	Glass	Installations
Mixed Media	Oil	Paper Sculpture
Pastel	Pen & Ink	Photography
Prints	Sculpture	Silkscreen
Watercolor		

To contact our corporation: Send SASE to arts administrator for submission guidelines.
Specific time of year to contact corporation: Anytime

Interior Designers

It's a good idea to look in your local area for interior designers. Once you get acquainted with how to deal with them, you can expand your horizons to other parts of the state, then country. Interior designers can sell a lot of artwork for you, almost acting like an agent.

American Society of Interior Designers/ASID

National Headquarters
730 Fifth Ave, New York, NY 10019
212/586-7111

Membership is 12,000 nationwide. They rent mailing lists by state or region at $60 per M (thousand). Call this number also to find out the number of your local chapter of the ASID, who might also publish a directory.

ASID New York Headquarters

950 Third Ave, New York, NY 10022
212/421-8765

Has a membership directory for the NY Metropolitan Chapter, listing some of the most respected designers in the country.

❖ **Natalie Craig Interior Design**

Natalie Craig
39120 Argonaut Wy #175, Fremont, CA 94538
510/657-5606 510/656-4969 Fax

Our firm uses living artists' work in various projects throughout the year: Fine art originals, posters, prints, etc.
Source of artwork:

Emerging artists	Established artists	Consultants
Dealers	Auction	

Our clients are:

Corporations	Restaurants	Medical facilities
Offices	Private individuals	

We are actively seeking both new and established artists.
Particular style of artwork generally desired: Contemporary
Particular medium of artwork generally desired:

Painting	Sculpture	Glass
Fabric		

Artists can contact us by: Submitting portfolio for review.

❖ **Art's Yours**

Jasmine Tjorda
4339 Balboa St, San Francisco, CA 94121
415/379-9436 Telephone/Fax

Our firm uses living artists' work in various projects throughout the year.
Source of artwork: Emerging artists
Our clients are:
Medical facilities Education facilities Private individuals
We are actively seeking new artists for various projects.
We keep artists' slides on file for possible future projects.
Particular style of artwork generally desired: Socially aware
Particular medium of artwork generally desired: Installations/mixed media/oils
Artists can contact us by: Calling to arrange a personal interview to show their portfolio or submitting a portfolio for review.

❖ Glenn Design Co

Nancy Glenn
44 Sunshine Ave, Sausalito, CA 94965
415/331-5700 415/331-5701 Fax

Our firm uses living artists' work in various projects throughout the year: Fine art originals, posters, prints, etc.
Source of artwork:

Emerging artists	Established artists	Consultants
Dealers	Galleries	Auction

Our clients are:

Corporations	Offices	Private individuals

We are actively seeking both new and established artists.

❖ Julie Madsen Interiors

Julie Madsen
12323 Parker Cir, Omaha, NE 68154
402/496-3529 402/496-3530 Fax

Our firm uses living artists' work in various projects throughout the year: Fine art originals, posters, prints, etc.
Source of artwork: Gallery
Our clients are: Private individuals
We are actively seeking both new and established artists.
Artists can contact us by: Send slides/photos which can be filed until needed.

❖ The Art Group

Beverly Moscillo
Colonial Way Plz, Pelham, NH 03076
603/635-9058 603/635-9056 Fax

Our firm uses living artists' work in various projects throughout the year: Fine art originals, posters, prints, etc.
Source of artwork:

Emerging artists	Established artists	Consultants
Dealers	Galleries	Auction

Our clients are:

Stores.	Corporations	Restaurants
Medical facilities	Offices	Hotel/Motel
Private individuals		

We are actively seeking both new and established artists.
We review unsolicited slides from artists.
We keep artists' slides on file for possible future projects.
Particular style of artwork generally desired: Varied
Particular medium of artwork generally desired: Various
Artists can contact us by: Submitting a portfolio for review.

❖ Starbuck Designers Inc

John Starbuck/Sallie Starbuck
733 Georgetown Dr, Nashville, TN 37205
615/356-4407 615/356-4998 Fax

Our firm uses living artists' work in various projects throughout the year: Fine art originals, posters, prints, etc.
Source of artwork:

Emerging artists	Established artists	Consultants
Dealers	Galleries	Auction

Our clients are:

Corporations	Medical facilities	Offices
Schools	Hotel/Motel	Private Individuals

We are actively seeking both new and established artists.
We review unsolicited slides from artists.
We keep artists' slides on file for possible future projects.
Particular style of artwork generally desired: Transitional, traditional and contemporary
Particular medium of artwork generally desired:

Oil	Watercolor	Acrylic
Mixed Media	Sculpture	Crafts
Original Furniture		

Artists can contact us by: Calling to arrange a personal interview to show their portfolio/submit a portfolio for review.

Design Centers

Within design centers there are often interior designers and other resources through which artists can sell their work. Become acquainted with showrooms at your local design centers. Some artists have an exhibit space here; some have a "bulletin board" where they advertise their work. Be innovative and see what you can come up with! The following listings are alphabetical by state, then city within the state.

Arizona Design Center
Kelly Hardage
3600 E University Dr, Phoenix, AZ 85034
602/232-0032

Design Center South
23811 Aliso Creek Rd, Laguna Beach, CA 92677
714/643-2929

Los Angeles Merchandise Mart
1933 S Broadway, Los Angeles, CA 90014
213/749-7911

Pacific Design Center
Richard Norfolk
8687 Melrose Ave, Los Angeles, CA 90069
213/657-0800

Canyon Creek Design Center San Diego
6455 Lusk Blvd, San Diego, CA 92121
619/452-SDDC

Contract Design Center
600 Townsend St, San Francisco, CA 94103
415/864-8541

Design Pavilion at 200 Kansas
JoAnn Avery
200 Kansas St, San Francisco, CA 94103
415/522-2290

Design Pavilion at 251 Rhode Island
JoAnn Avery
251 Rhode Island, San Francisco, CA 94103

Galleria Design Center
101 Henry Adams St, San Francisco, CA 94103
415/846-1500

Showplace Square
Laura Stephan
2 Henry Adams St #450, San Francisco, CA 94103

Showplace Square South
235-299 Kansas St, San Francisco, CA 94103
415/552-7475

Showplace Square West
550 Fifteenth St, San Francisco, CA 94103
415/626-8257

Denver Design Center
Kathy Golding
595 S Broadway, Denver, CO 80209
303/733-2455

Denver Merchandise Mart
Darrell Hare
451 E 58 Ave, Denver, CO 80216
303/292-MART

Washington Design Center
300 D St SW, Washington, DC 20024
202/554-5053

Design Center of the Americas
1855 Griffin Rd, Dania, FL 33004
305/920-7997

Miami Decorating & Design District
3930 NE 2nd Ave, Miami, FL 33137
305/573-8116

Miami Decorating/Design District Plaza 1
3841 NE Second Ave, Miami, FL 33137
305/573-8116

Miami Decorating/Design District Plaza IV
3901 NE Second Ave, Miami, FL 33137
305/573-8116

Miami International Mart
777 NW 72 Ave, Miami, FL 33133
305/261-2900

Atlanta Decorative Arts Center
Jeffrey Portman
351 Peachtree Hills Ave NE #244, Atlanta, GA 30305
404/231-1720

Atlanta Merchandise Mart
240 Peachtree St NW, Atlanta, GA 30303
404/220-3000

Piedmont Center
10 Piedmont Ctr, Atlanta, GA 30305
404/841-3667

Merchandise Mart
470 Merchandise Mart, Chicago, IL 60654
312/527-4141

Boston Design Center
One Design Center Pl, Boston, MA 02210
617/338-5062

Michigan Design Center
1700 Stutz Dr, Troy, MI 48084
313/649-4772

International Market Square
275 Market St, Minneapolis, MN 55405
612/338-6250

Saint Louis Design Center
Sharon Perry
917 Locust, Saint Louis, MO 63101
314/621-6446

Commerce & Design Building
201 W Commerce St, High Point, NC 27260
919/884-1404

International Home Furnishings Center
210 E Commerce St, High Point, NC 27261
919/889-6144

Market Square
305 W High St, High Point, NC 27260
919/889-4464

Architects & Designers Building
Katherine Flaherty
150 E 58 St, New York, NY 10155
212/644-6555

Art & Design Building
1059 3rd Ave, New York, NY 10021
212/758-0012

Decorative Arts Center
305 E 63 St, New York, NY 10021
212/838-7736

Decorator's Center Building
315 E 62 St, New York, NY 10021
212/682-4737

Fine Arts Building
Joan Battaglia
232 E 59th St, New York, NY 10022
212/759-6935

International Showcase
225 Fifth Ave, New York, NY 10010
800/235-3512

Manhattan Art & Antiques Center
Stephen Roedler
1050 Second Ave, New York, NY 10022
212/355-4400

Marketcenter
230 Fifth Ave, New York, NY 10001
212/532-4555

New York Design Center
200 Lexington Ave, New York, NY 10016
212/679-9500

New York Merchandise Mart
41 Madison Ave, New York, NY 10010
212/686-1203

St Paul's Mart
1117 Pendleton St, Cincinnati, OH 45210
513/579-1922

Ohio Design Center
23533 Mercantile Rd, Cleveland, OH 44122
216/831-1245

Design Center at Montgomery Park
Glen Robins
2701 NW Vaughn St, Portland, OR 97210
503/228-7275

Marketplace Design Center
2400 Market St, Philadelphia, PA 19103
215/561-5000

Dallas Home Furnishings Mart
2100 N Stemmons Fwy, Dallas, TX 75207
214/760-2852

Decorative Center of Houston
5120 Woodway Dr, Houston, TX 77056
713/961-9292

Innova
20 Greenway Plaza, Houston, TX 77046
800/237-0617

Showplace Square
522 South 400 W, Salt Lake City, UT 84101
801/355-0519

Design Center Northwest
5701 Sixth Ave S, Seattle, WA 98108
206/767-6800

Northwest Home Furnishings Mart Inc
121 Boren Ave N, Seattle, WA 98109
206/343-8100

Architects

AIA Seattle
1911 First Ave, Seattle, WA 98101
206/488-4938
The nation's largest chapter with 1,800 members. Send for information on how to reach these architects.

American Institute of Architects
200 Lexington Ave #600, New York, NY 10016
212/683-0023
National headquarters.

❖ Innerspace Design
Shari Childs
133 E De la Guerra #180, Santa Barbara, CA
805/966-7786
Our firm uses living artists' work in various projects throughout the year:
3-dimensional 2-dimensional Posters
Prints
Source of artwork:
Emerging artists Established artists Consultant/Dealer
Gallery
Our clients are:
Stores Corporations Restaurants
Offices Hotel/Motel Private individuals
We keep artists' slides on file for possible future projects.
Particular style of artwork generally desired: Wide range
Particular medium of artwork generally desired: Wide range
Artists can contact us by: Send sample photos

❖ William Turnbull Associates Architects & Planners
Eric Haesloop/Architect
Margaret Simon/Interior Designer
Pier 1¹/2, The Embarcadero, San Francisco, CA 94111
415/986-3642 415/986-4778 Fax
Our firm uses living artists' work in various projects throughout the year:
Fine art originals 2- and 3-dimensional
Sculpture Glass work
Furnishing and finishes
Source of artwork:
Emerging artists Established artists Consultant
Dealer
Our clients are: Private individuals
Particular style of artwork generally desired: Depends on client; some sculptural, some paintings
Artists can contact us by: Call us to determine if current work involves artist participation.

chapter **3**

Galleries

If you're an artist looking for a gallery to carry your work, you need to think creatively and professionally. What is it that will set you and your artwork apart from all the other artists searching for a gallery? The answer needs to be, "I perform at the perk level" in order to out-do all the other artists.

The basic expectation approach doesn't carry much foresight and has a mediocre presentation, both with portfolio and personal appearance.

The perk level offers the gallery owner something unique—in quality, style and presentation of the work.

- *You've done your homework, and you know what to show a particular owner.*
- *You know what you do and do not want in a contract.*
- *You're confident (but not overly).*
- *You come from a professional basis of wanting to work in partnership with the gallery owner.*
- *After your initial phone call, you send a snazzy portfolio (not costly—but uniquely designed by you).*
- *You follow up with a call to the gallery owner/director to arrange a studio visit.*
- *If you are rejected you send a card of thanks and get on the gallery mailing list so you can attend future openings.*
- *At future openings you introduce yourself to the gallery owner, directors and other artists.*
- *You start networking.*
- *You add the gallery to your mailing list and invite them to your open studio.*

The following entries are arranged alphabetically by state, city within that state and then by gallery name.

❖ Art Trek

Ann Marie Stillion
113 W Phoenix Ave, Flagstaff, AZ 86001
520/774-9135 Telephone/Fax

We sell: Originals Limited Editions
Our gallery works with corporations collecting art.
We are seeking both new and established talent.
Year gallery was established: 1992
Gallery hours: Tues-Sat 1-6
Number of shows each year: 6-8
Commission gallery takes: 50%
Number of artists represented: 15
Gallery is insured.
Geographical limitations to artists we represent:
Flagstaff and Sedona
The gallery assumes some of the cost of:

Openings	Advertising	Installations
Promotion (brochures, etc.)		

Styles we carry:

Abstract	Alternative	Conceptual
Contemporary	Ethnic	Fantasy
Figurative	Impressionism	Landscape
Latin American	Modernism	Naive
Native American	Portraits	Realistic
Representational	Southwestern	Still life

Media we carry:

Acrylic	Bronze	Ceramic
Clay	Collage	Colored Pencil
Drawing	Fibre Arts	Glass
Installations	Mixed Media	Oil
Paper Sculpture	Pastel	Photography
Prints	Sculpture	Silkscreen
Tempra	Watercolor	Wood

Our target market:

Corporations	Architects	Private Collectors
Interior Designers	Offices	Tourists
Walk-ins		

Advice we can offer to artists interested in being represented by our gallery: Send slides and resumé, have fairly large body of work.
To contact us: Submit portfolio (brochure, statement, slides, etc.) for review/send slides/photos by mail for consideration.
Specific time of year we review work: Anytime
Type/style of artwork that has the best chance of being purchased by our clients in the next two years: Painting, sculpture, photography

❖ Rosequist Galleries Inc

Judith Williams
1615 E Fort Lowell Rd, Tucson, AZ 85719
520/327-5729

We sell: Originals Frames
Our gallery works with corporations collecting art.
We are seeking established talent mostly through referrals.
Year gallery was established: 1945
Gallery hours: Tues-Sat 10-5
Commission gallery takes: Varies
Number of artists represented: 50
Geographical limitations to artists we represent: None
The gallery assumes cost of:

Openings	Promotion (brochures, etc.)

Styles we carry:

Abstract	Aviation	Classic
Conceptual	Contemporary	Figurative
Floral	Historic	Impressionism
Landscape	Latin American	Native American
Representational	Southwestern	Still life
Traditional		

Media we carry:

Acrylic	Bronze	Collage
Mixed Media	Oil	Pastel
Sculpture	Watercolor	

Our target market:

Consultants	Private Collectors	Interior Decorators
Walk-ins		

To contact us: Arrange a personal interview to show portfolio/submit portfolio (brochure, statement, slides, etc.) for review/send slides/photos by mail for consideration.

Galleries

❖ **The Gallery**
Gene Brantley
121 W Ridge Ave, Harrison, AR 72601
501/741-6669

We sell: Originals Limited Editions
Posters Frames
Our gallery works with corporations collecting art.
 Corporate Consultant: Richard R Swearingen
We are seeking both new and established talent.
Year gallery was established: 1973
Gallery hours: Tues-Sat 9-5
Number of shows each year: 8
Commission gallery takes: 40%
Number of artists represented: 2
Gallery is insured.
The gallery assumes cost of:
Advertising Promotion (brochures, etc.)
Styles we carry:

Abstract	Contemporary	Figurative
Floral	Impressionism	Landscape
Modernism	Naive	Realistic
Representational	Still life	Surrealism
Traditional	Western	Wildlife

Media we carry:

Acrylic	Charcoal	Colored Pencil
Drawing	Mixed Media	Oil
Pastel	Pencil	Pen & Ink
Prints	Watercolor	

Our target market:

Consultants	Corporations	Restaurants
Architects	Private Collectors	Interior Decorators
Offices	Hotel/Motel	Tourists
Walk-ins		

Advice we can offer to artists interested in being represented by our gallery: Bear in mind the tastes and aversions of a traditional clientele.
To contact us: Arrange a personal interview to show portfolio/submit portfolio (brochure, statement, slides, etc.) for review.
Specific time of year we review work: Anytime
Type/style of artwork that has the best chance of being purchased by our clients in the next two years: Landscapes, florals and wildlife in oil, acrylics and watercolor

❖ **American Art Gallery**
James & Ann Gilbert
724 Central Ave, Hot Springs, AR 71901
501/624-0550

We sell: Originals Limited Editions
We are seeking both new and established talent.
Year gallery was established: 1993
Gallery hours: Tues-Sun 10-6
Number of shows each year: 12
Commission gallery takes: 40% originals/50% prints/ 35% on sculpture

Gallery is insured.
Geographical limitations to artists we represent: Local and regional artists
The gallery assumes cost of:

Openings	Advertising	Promotion

Styles we carry:

Floral	Historic	Landscape
Realistic	Romantic	Southwestern
Still life	Surrealism	Traditional
Wildlife		

Media we carry:

Acrylic	Airbrush	Bronze
Ceramic	Charcoal	Clay
Collage	Colored Pencil	Drawing
Glass	Marble	Oil
Pastel	Pencil	Pen & Ink
Photography	Pottery	Prints
Sculpture	Tempra	Watercolor

Our target market:

Museums	Medical Facilities	Private Collectors
Offices	Tourists	Walk-ins
Interior Decorators		

To contact us: Submit portfolio (brochure, statement, slides, etc.) for review.
Specific time of year we review work: Monthly
Type/style of artwork that has the best chance of being purchased by our clients in the next two years: Oil/ acrylic in realistic or impressionist, watercolor, wood sculpture

❖ **J Hudson Galleries**
Jay Hudson
512 N First St, Jacksonville, AR 72076
501/982-8407

We sell: Originals Limited Editions
Posters Frames Antiques
Our gallery works with corporations collecting art.
 Corporate Consultant: Michele Hudson
We are seeking both new and established talent.
Year gallery was established: 1980
Number of shows each year: Varies
Gallery is insured.
Geographical limitations to artists we represent: Arkansas/Arkansas-related art
The gallery assumes cost of:

Openings	Installations
Promotion (brochures, etc.)	

Styles we carry:

Abstract	Alternative	Animals
Aviation	Classic	Conceptual
Equestrian	Erotic	Ethnic
Figurative	Floral	Historic
Impressionism	Landscape	Naive
Nostalgia	Realistic	Religious
Representational	Romantic	Sci-Fi
Still life	Surrealism	Traditional
Tropical	Western	

Media we carry:

Acrylic	Bronze	Charcoal
Clay	Colored Pencil	Drawing
Fibre Arts	Glass	Mixed Media
Oil	Paper Sculpture	Pastel
Pencil	Pen & Ink	Photography
Pottery	Prints	Sculpture
Silkscreen	Watercolor	

Our target market:

Consultants	Corporations	Restaurants
Medical Facilities	Private Collectors	Interior Decorators
Offices	Schools	Hotel/Motel
Walk-ins		

To contact us: Query with resumé/send slides/photos by mail for consideration.

Specific time of year we review work: Anytime

Type/style of artwork that has the best chance of being purchased by our clients in the next two years: Wide range of buyers as we are in a military area

❖ Cantrell Gallery

Helen Scott
8206 Cantrell Rd, Little Rock, AR 72227
501/224-1335

We sell:

Originals	Limited Editions	Posters
Frames	Glass	

We are seeking both new and established talent.

Year gallery was established: 1970

Gallery hours: Mon-Sat 10-5:15

Number of shows each year: 8+

Commission gallery takes: Negotiable

Number of artists represented: 80+

Gallery is insured.

Styles we carry:

Abstract	Animals	Aviation
Contemporary	Figurative	Floral
Impressionism	Landscape	Marine
Minimal	Modernism	Naive
Native American	Oriental	POP
Portraits	Realistic	Representational
Still life	Surrealism	Western
Wildlife		

Media we carry:

Acrylic	Charcoal	Colored Pencil
Computer	Drawing	Glass
Mixed Media	Oil	Paper Sculpture
Pastel	Pencil	Pen & Ink
Photography	Prints	Sculpture
Silkscreen	Tempra	Watercolor

Our target market:

Corporations	Private Collectors	Interior Decorators
Offices	Tourists	Walk-ins

To contact us: Submit portfolio (brochure, statement, slides, etc.) for review.

Specific time of year we review work: Jan-Apr

Type/style of artwork that has the best chance of being purchased by our clients in the next two years: Well-executed art, artists with a great desire to make a statement and tell their story

❖ Wildflower Gallery

Frances K Harris
1 Pacific Valley Ctr, Big Sur, CA 93920
805/927-8655 805/927-5234 Fax

We sell:

Originals	Limited Editions	Posters

We are seeking established talent mostly through referrals.

Year gallery was established: 1989

Gallery hours: Mon-Sun 10-6

Commission gallery takes: 40%

Number of artists represented: 10

Styles we carry:

Animals	Impressionism	Landscape
Marine	Native American	New Age
Southwestern	Visionary	Wildlife

Media we carry:

Bronze	Ceramic	Collage
Colored Pencil	Glass	Oil
Pen & Ink	Photography	Pottery
Prints	Sculpture	

Our target market: Tourists Walk-ins

To contact us: Query with resumé.

Specific time of year we review work: Winter-Spring

Type/style of artwork that has the best chance of being purchased by our clients in the next two years: Small and under $500

❖ Rookie-To Gallery

Bob and Karen Altaras
14300 Hwy 128, PO Box 606, Boonville, CA 95415
707/895-2204

We sell: Originals

We are actively seeking both new and established talent.

Year gallery was established: 1986

Gallery hours: Daily 10-5:30

Number of shows each year: 4

Commission gallery takes: 40%

Number of artists represented: 200

Gallery is insured.

Geographical limitations to artists we represent: None

The gallery assumes cost of:

Openings	Advertising
Promotion (brochures, etc.)	

Styles we carry:

Abstract	Animals	Contemporary
Figurative	Wildlife	

Galleries

Media we carry:

Acrylic	Bronze	Ceramic
Clay	Collage	Glass
Mixed Media	Pastel	Pottery
Prints	Sculpture	

Our target market:

Private Collectors Interior Designers Tourists
Walk-ins

To contact us: Submit portfolio (brochure, statement, slides, etc.) for review.

Specific time of year we review work: Jan-Jun

❖ B&R Gallery

Dave Joseph/Owner Melissa Urcan/Marketing
17720 Sierra Hwy, Canyon City, CA 91351
805/298-2038 805/298-2292 Fax

We sell:

Originals	Limited Editions	Posters
Frames	Sculpture (bronze & wood)	
Indian Masks		

We are seeking both new and established talent.
Year gallery was established: 1975
Gallery hours: Mon-Fri 9-7, Sat-Sun 9:30-5
Number of shows each year: 3-6
Commission gallery takes: 40%
Gallery is insured.
Geographical limitations to artists we represent: None
The gallery assumes half the cost of:

Openings	Advertising	Installations
Promotion (brochures, etc.)		
Transportation of artwork		

Styles we carry:

Animals	Aviation	Classic
Equestrian	Fantasy	Historic
Impressionism	Landscape	Military
Native American	Nostalgia	Portraits
Realistic	Religious	Romantic
Sci-Fi	Southwestern	Traditional
Western	Wildlife	

Media we carry:

Acrylic	Bronze	Ceramic
Charcoal	Clay	Drawing
Glass	Marble	Mixed Media
Oil	Paper Sculpture	Pastel
Pencil	Pen & Ink	Prints
Sculpture	Watercolor	

We will consider other mediums as well, however.

Our target market:

Private Collectors Walk-ins

Advice we can offer to artists interested in being represented by our gallery: Send slides and photos accompanied by a price list/submit portfolio (brochure, statement, slides, etc.) for review.

Specific time of year we review work: Anytime

Type/style of artwork that has the best chance of being purchased by our clients in the next two years: Western, Native American, Wildlife

❖ The Joan Baker Gallery

Richard & Joan Baker
PO Box 8, 604 Main St, Half Moon Bay, CA 94019
415/726-3888 415/726-6674 Fax

We sell: Originals
Our gallery works with corporations collecting art.
 Corporate Consultant: Richard Baker
We are seeking both new and established talent.
Year gallery was established: 1992
Gallery hours: Daily 10-6
Number of shows each year: 3
Commission gallery takes: 50%
Number of artists represented: 15
Gallery is insured.
Geographical limitations to artists we represent:
Generally California
The gallery assumes cost of:

Openings	Advertising	Installations
Sometimes brochures, etc.		

Styles we carry:

Classic	Floral	Impressionism
Landscape	Nostalgia	Portraits
Realistic	Representational	Still life
Wildlife		

Media we carry:

Acrylic	Bronze	Collage
Colored Pencil	Oil	Pastel
Pencil	Sculpture	Tempra
Watercolor		

Our target market:

Private Collectors Tourists Walk-ins

To contact us: Submit portfolio (brochure, statement, slides, etc.) for review/query with resumé.

Specific time of year we review work: Anytime

Type/style of artwork that has the best chance of being purchased by our clients in the next two years: Regional, contemporary work in styles from impressionistic to realistic.

❖ Quint Gallery

Mark Quint
7447 Girard Ave, La Jolla, CA 92037
619/454-3409 619/454-3499 Fax

We sell: Originals
Our gallery works with corporations collecting art.
 Corporate Consultant: Michelle Roberto
We are seeking both new and established talent.
Year gallery was established: 1980
Gallery hours: Tues-Sat 11-5:30
Number of shows each year: 10
Commission gallery takes: 50%
Number of artists represented: 44
Gallery is insured.
Geographical limitations to artists we represent: None

The gallery assumes cost of:

Openings	Advertising	Installations
Promotion (brochures, etc.)		
Transportation of artwork		

Styles we carry:

Abstract	Alternative	Conceptual
Contemporary	Figurative	Landscape
Minimal	Modernism	Naive
POP	Representational	Still life

Media we carry:

Acrylic	Bronze	Charcoal
Collage	Colored Pencil	Drawing
Installations	Mixed Media	Oil
Pencil	Pen & Ink	Photography
Prints	Sculpture	Silkscreen
Tempra	Watercolor	Neon

Our target market:

Consultants	Museums	Corporations
Private Collectors		

Advice we can offer to artists interested in being represented by our gallery: Referrals from other artists.

To contact us: Query with resumé/send slides/photos by mail for consideration.

Specific time of year we review work: Anytime

Type/style of artwork that has the best chance of being purchased by our clients in the next two years: Abstract

❖ Leslie Sacks Fine Art

Leslie Sacks
11640 San Vicente Blvd, Los Angeles, CA 90049
310/820-9448 310/207-1757 Fax

We sell:

Originals	Limited Editions	
Books	Frames	

Our gallery works with corporations collecting art.

We are seeking established talent mostly through referrals.

Gallery hours: Tues-Sat 10-6

Gallery is insured.

Styles we carry:

Classic	Conceptual	Contemporary
Erotic	Ethnic	Figurative
Impressionism	Modernism	POP
Realistic	Traditional	

Media we carry:

Acrylic	Bronze	Ceramic
Charcoal	Collage	Drawing
Mixed Media	Oil	Pastel
Pencil	Pen & Ink	Photography
Pottery	Prints	Sculpture
Silkscreen	Watercolor	

Our target market:

Consultants	Museums	Corporations
Private Collectors	Interior Designers	Offices
Walk-ins		

To contact us: Send slides/photos and SASE by mail for consideration.

❖ Los Angeles Photography Center/Stage of the Arts Inc

William Reagh & Jorge Luis Rodriguez
412 Parkview St, Los Angeles, CA 90057
PO Box 26688, Los Angeles, CA 90026
213/382-81343 213/257-5756 Fax

Year gallery was established: 1960

Number of shows each year: 6

Gallery is insured.

Geographical limitations to artists we represent: None

Styles we carry: All

Media we carry: All

To contact us: Submit portfolio (brochure, statement, slides, etc.) for review.

❖ The Print Merchants

Sue Zaret
8687 Melrose Ave, Pacific Design Center, Los Angeles, CA 90069
310/659-9260 310/659-1690 Fax

We sell:

Originals	Limited Editions	
Posters	Frames	

Our gallery works with corporations collecting art.

 Corporate Consultant: Marilyn Eisenberg

We are actively seeking new talent.

Year gallery was established: 1980

Gallery hours: Mon-Fri 9-5

Commission gallery takes: 50%

Gallery is insured.

Styles we carry:

Abstract	Contemporary	Figurative
Floral	Impressionism	Marine
Representational	Romantic	Still life
Traditional		

Media we carry:

Monoprints	Prints	Silkscreen
Watercolor		

Our target market:

Consultants	Restaurants	Interior Decorators
Offices	Walk-ins	

Advice we can offer to artists interested in being represented by our gallery: Artwork, in general, should be designer-oriented, both price and subject matter. No provocative work.

To contact us: Arrange a personal interview to show portfolio/send slides/photos by mail for consideration.

Type/style of artwork that has the best chance of being purchased by our clients in the next two years: Monoprints

Galleries

❖ **Wild Blue**

Kristi Holmblad
7220 Melrose Ave, Los Angeles, CA 90046
213/939-8434

We sell: Originals
We are actively seeking new talent.
Year gallery was established: 1981
Gallery hours: Tues-Sat 11-6, Mon 12-5
Number of shows each year: 2
Commission gallery takes: 50%
Number of artists represented: 100
Gallery is insured.
The gallery assumes cost of:

Openings	Advertising	Installations

Styles we carry:

Contemporary	Functional	POP

Media we carry:

Ceramic	Clay	Glass
Jewelry	Metal Arts	Mixed Media
Photography	Pottery	Sculpture

Our target market:

Private Collectors	Interior Designers	Tourists
Walk-ins		

To contact us: Submit portfolio (brochure, statement, slides, etc.) for review/send slides/photos by mail for consideration.
Specific time of year we review work: Anytime
Type/style of artwork that has the best chance of being purchased by our clients in the next two years: Contemporary, functional work

❖ **Highlight Gallery**

Clyde Jones
PO Box 1515, 45052 Main St, Mendocino, CA 95460
707/937-3132

We sell: Originals High-end craft
Fine furniture (handmade)
We are seeking both new and established talent.
Year gallery was established: 1978
Gallery hours: Daily 10-5
Number of shows each year: 10
Commission gallery takes: 40%
Number of artists represented: 100+
Gallery is insured.
Geographical limitations to artists we represent:
American
The gallery assumes cost of:

Openings	Advertising	Installations
Promotion (brochures, etc.)		

Styles we carry:

Animals	Classic	Contemporary
Figurative	Floral	Impressionism
Landscape	Representational	Romantic
Traditional	Tropical	Visionary
Wildlife		

Media we carry:

Acrylic	Bronze	Ceramic
Clay	Collage	Fibre Arts
Glass	Marble	Mixed Media
Oil	Pastel	Photography
Pottery	Prints	Sculpture
Watercolor	Etchings	Woodturning
Furniture		

Our target market:

Private Collectors	Tourists	Walk-ins

Advice we can offer to artists interested in being represented by our gallery: Send good-quality photos/slides with SASE. Gallery is interested in collector-quality work only; no cute country craft or kitsch.
To contact us: Send slides/photos by mail for consideration.
Specific time of year we review work: Monday and Friday by appointment
Type/style of artwork that has the best chance of being purchased by our clients in the next two years: Work by talented, emerging artists which offers both artistic beauty and technical skill, at a good value. We have 3,600 sq ft of showroom in a prominent location at a popular resort.

❖ **Shasta Art Gallery & Frame Co**

Erik Poppke
416 W Mt Shasta Blvd, Mt Shasta, CA 96067
916/926-5499 916/926-1830 Fax

We sell: Originals Limited Editions
Posters Frames
Our gallery works with corporations collecting art.
We are seeking both new and established talent.
Year gallery was established: 1991
Gallery hours: Daily 10-5
Commission gallery takes: 40%
Gallery is insured.
Styles we carry:

African-American	Contemporary	Erotic
Fantasy	Landscape	Native American
New Age	Oriental	Religious
Romantic	Southwestern	Surrealism
Visionary	Western	Wildlife

Media we carry:

Acrylic	Airbrush	Bronze
Ceramic	Clay	Computer
Glass	Oil	Pastel
Photography	Pottery	Prints
Sculpture	Silkscreen	Watercolor

Our target market:

Private Collectors	Interior Designers	Tourists
Walk-ins		

To contact us: Arrange a personal interview to show portfolio/submit portfolio (brochure, statement, slides, etc.) for review/send slides/photos by mail for consideration.
Specific time of year we review work: Anytime

Galleries

❖ Galeria Don Pedro

Peter & Arcelia Lopez
434 S "A" St, Oxnard, CA 93030
805/486-5953 805/485-5060 Fax

We sell: Originals Limited Editions
Posters
We are seeking both new and established talent.
Year gallery was established: 1992
Gallery hours: Mon-Fri 10-5
Number of shows each year: 4
Commission gallery takes: 35%
Number of artists represented: 20
Geographical limitations to artists we represent: None
The gallery assumes cost of:
Advertising Installations
Promotion (brochures, etc.)
Styles we carry:

Abstract	Animals	Figurative
Floral	Historic	Impressionism
Landscape	Still life	Tropical

Media we carry:

Acrylic	Clay	Colored Pencil
Glass	Marble	Mixed Media
Oil	Pastel	Pen & Ink
Photography	Pottery	Watercolor

Our target market:

Corporations	Private Collectors	Interior Designers
Schools	Hotel/Motel	Tourists
Walk-ins		

To contact us: Arrange a personal interview to show portfolio/query with resumé/send slides/photos by mail for consideration.
Specific time of year we review work: Anytime
Type/style of artwork that has the best chance of being purchased by our clients in the next two years: Oil, watercolor, acrylic

❖ Rita Dean Gallery

Rita Dean/Owner James Healy/Director
548 5th Ave, San Diego, CA 92101
619/338-8153 619/338-0003 Fax

We sell: Originals Limited Editions
Posters
We are actively seeking both new and established talent.
Year gallery was established: 1988
Gallery hours: Tues-Wed 12-8; Thurs-Sat 12-11; Sun 12-6
Number of shows each year: 15
Commission gallery takes: 40-50%
Geographical limitations to artists we represent: None
The gallery assumes cost of:
Openings Installations
Styles we carry:

Alternative	Conceptual	Erotic
Naive	Anti-Religious	Surrealism
Prison art		

Media we carry:

Acrylic	Collage	Computer
Drawing	Installations	Mixed Media
Oil	Photography	

Our target market:

Museums	Private Collectors	Tourists
Walk-ins		

Advice we can offer to artists interested in being represented by our gallery: We like challenging, thought-provoking, hard-edged, quality art.
To contact us: Send slides/photos by mail for consideration.
Specific time of year we review work: Anytime
Type/style of artwork that has the best chance of being purchased by our clients in the next two years: All those mentioned above!

❖ Capson Artsvision

William Quan
1750 Union st Rear, San Francisco, CA 94123
415/292-6560 415/292-6565 Fax

We sell:
Originals Limited Editions Posters
Frames One-of-a-kind Furniture
Our gallery works with corporations collecting art.
We are seeking both new and established talent.
Year gallery was established: 1988
Gallery hours: Tues-Sat 11-5; Sun 1-4
Number of shows each year: 2
Number of artists represented: 100+
Gallery is insured.
Geographical limitations to artists we represent: U.S.
The gallery assumes cost of:
Openings Advertising
Promotion (brochures, etc.)
Styles we carry:

Contemporary	POP	Portraits

Mediums of artwork we carry:

Ceramic	Clay	Computer
Glass	Marble	Mixed Media
Paper Sculpture	Pottery	Prints
Sculpture		

Our target market:

Consultants	Museums	Corporations
Restaurants	Medical Facilities	Architects
Private Collectors	Interior Designers	Offices
Hotel/Motel	Tourists	Walk-ins

Advice we can offer to artists interested in being represented by our gallery: Only consignment will be considered
To contact us: Send slides/photos by mail for consideration.
Specific time of year we review work: Anytime
Type/style of artwork that has the best chance of being purchased by our clients in the next two years: Fine contemporary crafts

97

Galleries

❖ FIG Gallery

Peter Kosenko/Director
2022A Broadway, Santa Monica, CA 90404
310/829-0345 310-829-7425 Fax

We sell: Originals
Our gallery works with corporations collecting art.
We are seeking both new and established talent.
Year gallery was established: 1993
Gallery hours: Mon-Sat 11-6
Commission gallery takes: 25%
Number of artists represented: 23
Gallery is insured.
Geographical limitations to artists we represent:
Southern California
Styles we carry:

Abstract Contemporary Representational
Depends on what artists/owners select
Media we carry: Any and all
Our target market:

Consultants Museums Corporations
Private Collectors Walk-ins
Advice we can offer to artists interested in being represented by our gallery: Artist-owned and operated gallery/by membership for two-year periods.
To contact us: Submit portfolio (brochure, statement, slides, etc.) for review.
Specific time of year we review work: Fall 1996 and every two years

❖ Posner Fine Art

Judith and Wendy Posner
119 Montana Ave, Santa Monica, CA 90403
310/260-8858 310/260-8860 Fax

We sell: Originals Limited Editions
Posters Custom Framing Sculpture
Our gallery works with corporations collecting art.
 Corporate Consultant: Wendy Posner
We are seeking both new and established talent.
Gallery hours: Tues-Sat 10-6; Sun 12-5.
Number of shows each year: 8-10
Commission gallery takes: 50%
Number of artists represented: 50+
Gallery is insured.
Geographical limitations to artists we represent: None
The gallery assumes cost of:

Openings Advertising (part) Installations
Promotion (brochures, etc.) (part)
Transportation of artwork
Styles we carry:

Abstract	African-American	Alternative
Classic	Conceptual	Contemporary
Ethnic	Floral	Impressionism
Landscape	Latin American	Minimal
Modernism	Naive	Native American
Nostalgia	POP	Realistic
Representational	Southwestern	Sports
Still life	Traditional	Tropical
Western	Wildlife	

Media we carry:

Acrylic	Bronze	Charcoal
Collage	Colored Pencil	Drawing
Installations	Mixed Media	Oil
Paper Sculpture	Pastel	Pencil
Pen & Ink	Photography	Prints
Sculpture	Silkscreen	Watercolor

Our target market:

Consultants	Stores	Museums
Corporations	Medical Facilities	Architects
Private Collectors	Interior Designers	Offices
Schools	Hotel/Motel	Walk-ins

To contact us: Send slides/photos by mail for consideration with resumé and SASE.
Specific time of year we review work: End of each month
Type/style of artwork that has the best chance of being purchased by our clients in the next two years: We are a full-service gallery as well as poster publishers, so there are many different markets for the artists' work.

❖ John Nichols Gallery

John Nichols
PO Box 268, Santa Paula, CA 93061-0268
805/525-7804 805/933-2548 Fax

We sell: Originals Limited Editions
Frames
Our gallery works with corporations collecting art.
We are seeking established talent mostly through referrals.
Year gallery was established: 1984
Gallery hours: Mon-Sat 10-5
Number of shows each year: 3-4
Commission gallery takes: 50%
Number of artists represented: 15
Gallery is insured.
Geographical limitations to artists we represent: Global
The gallery pays 50% of:

Openings Advertising Installations
Promotion (brochures, etc.)
Transportation of artwork
Media we carry:

Oil Photography
Our target market:

Private Collectors Offices Walk-ins
Advice we can offer to artists interested in being represented by our gallery: Show professionalism and your commitment to a life in art.
To contact us: Query with resumé and SASE.
Specific time of year we review work: Anytime
Type/style of artwork that has the best chance of being purchased by our clients in the next two years: Art with universal themes, not urban decay and angst.

❖ **Parkhurst Enterprise**
Violet Parkhurst/Owner JC Barnudy/Director
130 Main St, Seal Beach, CA 90740
310/493-0996 Telephone/Fax
Second Gallery: On the Queen Mary, Queen Mary Wy,
Long Beach, CA
310/499-1758

We sell: Originals Limited Editions
Posters Frames
We are seeking both new and established talent.
Year gallery was established: 1959
Gallery hours: Mon-Fri 11-8
Number of shows each year: 3
Commission gallery takes: 50%
Number of artists represented: 15
The gallery assumes cost of:
Openings Advertising Installations
Styles we carry:
Animals Floral Marine
Military Nostalgia Representational
Still life Wildlife
Media we carry:
Acrylic Oil Prints
Our target market:
Private Collectors Walk-ins
To contact us: Arrange a personal interview to show
portfolio.
Specific time of year we review work: Anytime
**Type/style of artwork that has the best chance of being
purchased by our clients in the next two years:** Realism

❖ **Orlando Gallery**
Robert Gino/Don Grant
14553 Ventura Blvd, Sherman Oaks, CA 91403
818/789-6012

We sell: Originals
Our gallery works with corporations collecting art.
 Corporate Consultant: Don Grant
**We are actively seeking both new and established
talent.**
Year gallery was established: 1958
Gallery hours: Tues-Sat 10-4
Gallery is insured.
Geographical limitations to artists we represent:
California
The gallery assumes cost of: Installations
Styles we carry:

Abstract	African-American	Classic
Conceptual	Contemporary	Erotic
Ethnic	Fantasy	Figurative
Floral	Historic	Impressionism
Landscape	Modernism	New Age
Nostalgia	POP	Realistic
Religious	Representational	Romantic
Sci-Fi	Still life	Surrealism
Traditional	Visionary	

Media we carry:

Acrylic	Airbrush	Bronze
Ceramic	Charcoal	Clay
Collage	Colored Pencil	Computer
Drawing	Installations	Marble
Mixed Media	Oil	Paper Sculpture
Pastel	Pencil	Pen & Ink
Photography	Pottery	Sculpture
Tempra	Watercolor	

Our target market:

| Consultants | Museums | Corporations |
| Private Collectors | Tourists | Walk-ins |

**Advice we can offer to artists interested in being
represented by our gallery:** Make a good presentation.
To contact us: Submit portfolio (brochure, statement,
slides, etc.) for review/send slides/photos by mail for
consideration.

❖ **Susan Street Fine Art Gallery**
Susan Street/Owner Jennifer Faist/Director
444 S Cedros Ave #100, Solano Beach, CA 92075
619/793-4442 619/793-4491 Fax

We sell: Originals Limited Editions
Posters Frames Sculpture
We are seeking both new and established talent.
Year gallery was established: 1984
Gallery hours: Mon-Fri 9:30-5; Sat 12-4
Number of shows each year: 4-6
Commission gallery takes: 50%
Gallery is insured.
Geographical limitations to artists we represent: None
The gallery assumes cost of:
Openings Promotion (brochures, etc.)
Styles we carry:

Abstract	Contemporary	Floral
Impressionism	Landscape	Minimal
Modernism	Naive	Realistic
Representational	Still life	Traditional

Media we carry:

Acrylic	Bronze	Ceramic
Charcoal	Drawing	Glass
Marble	Mixed Media	Oil
Pastel	Photography	Sculpture
Watercolor		

Our target market:

Consultants	Corporations	Restaurants
Medical Facilities	Architects	Private Collectors
Interior Designers	Offices	Hotel/Motel
Walk-ins		

To contact us: Send slides/photos by mail for consideration, include price list, bio, statement and SASE.

Galleries

❖ Fine Eye Gallery

Gail Pimlott
PO Box 1494, 71 Main St, Sutter Creek, CA 95685
209/267-0571

We sell: Originals Limited Editions
We are seeking both new and established talent.
Gallery hours: Daily 10-5:30
Commission gallery takes: 40-50%
Number of artists represented: 3
Geographical limitations to artists we represent: Within 100-150-mile radius
The gallery assumes cost of:
Advertising Installations
Styles we carry:

Abstract	Conceptual	Contemporary
Impressionism	Modernism	Representational

❖ Cort Gallery

Gary & Catherine Cort
41881 Sierra Dr, Three Rivers, CA 93271
209/561-4036 209 561-4671 Fax

We sell: Originals Limited Editions
Posters
We are seeking local, established talent mostly through referrals.
Year gallery was established: 1987
Gallery hours: Thurs-Sun 12-5
Number of shows each year: 4-6
Commission gallery takes: 33%
Number of artists represented: Varies
Gallery is insured.
Geographical limitations to artists we represent: None
The gallery shares cost of:
Openings Advertising
Styles we carry:

Abstract	Alternative	Conceptual
Contemporary	Ethnic	Figurative
Floral	Impressionism	Landscape
Minimal	Modernism	Naive
Representational	Surrealism	Traditional
Visionary		

Media we carry: All
Our target market:

Tourists	Walk-ins	Private Collectors

To contact us: Call to arrange a personal interview to show portfolio.
Specific time of year we review work: Anytime

❖ Paragon Gallery

Francie Kelley/Owner Kelly Reemtsen/Director
607 W Knoll Dr, West Hollywood, CA 90069
310/659-0607 310/659-0895 Fax

We sell: Originals Posters
Frames
We are seeking both new and established talent.

Year gallery was established: 1987
Gallery hours: Mon-Fri 10-5:30
Number of shows each year: 2
Commission gallery takes: 50%
Number of artists represented: 30
Gallery is insured.
The gallery assumes cost of:
Openings Advertising Installations
Promotion (brochures, etc.)
Half of transportation costs of artwork
Styles we carry:

Abstract	Classic	Contemporary
Floral	Impressionism	Landscape
Representational	Romantic	Still life
Traditional	Tropical	

Media we carry:

Acrylic	Bronze	Charcoal
Collage	Colored Pencil	Drawing
Fibre Arts	Mixed Media	Oil
Pastel	Pencil	Pen & Ink
Photography	Prints	Sculpture
Silkscreen	Tempra	Watercolor

Our target market:

Consultants	Stores	Corporations
Restaurants	Medical Facilities	Architects
Private Collectors	Interior Designers	Offices
Hotel/Motel	Tourists	Walk-ins
Educational Facilities		

To contact us: Send slides/photos with resumé by mail for consideration.
Type/style of artwork that has the best chance of being purchased by our clients in the next two years: I need sophisticated, abstract work on paper.

❖ Generations...A Fine Art Gallery

Edward and Kathleen King
6526 Washington St, Yountville, CA 94599
707/944-1776 707/944-2015 Fax

We sell: Originals
We are seeking established talent mostly through referrals.
Year gallery was established: 1988
Gallery hours: Mon-Sun 10-8
Number of shows each year: 8
Commission gallery takes: Varies
Number of artists represented: 38
Gallery is insured.
Geographical limitations to artists we represent: None
The gallery assumes cost of:
Openings Advertising Installations
Promotion (brochures, etc.)
Styles we carry:

Classic	Figurative	Floral
Impressionism	Landscape	Realistic
Representational	Romantic	Still life
Traditional		

Media we carry: Oil
Our target market:
Museums Private Collectors
To contact us: Send slides/photos by mail for consideration.
Specific time of year we review work: Anytime
Type/style of artwork that has the best chance of being purchased by our clients in the next two years: Quality art with reputation.

❖ Ec-lec-tic Art, Contemporary Art Experiments
Mark Oeser
6754 Lowell Blvd, Denver, CO 80221
303/426-0147 303/428-2408 Fax

We sell: Originals
We are a cooperative gallery seeking established talent mostly through referrals.
Year gallery was established: 1979
Gallery hours: Varies
Number of shows each year: 12-16
Commission gallery takes: Donation
Number of artists represented: 10-30
Geographical limitations to artists we represent: Denver metro 5-county area
The gallery assumes cost of:
Openings Advertising Installations
Styles we carry: Our shows are eclectic; we consider all art, media style composite, experimental, found and recovered items and materials
Media we carry: All
Our target market:
Private Collectors Interior Designers Walk-ins
Advice we can offer to artists interested in being represented by our gallery: Get involved in the Alternative Art Alliance in the Denver area. Check out all galleries in the area, especially those of the underground.
Specific time of year we review work: Anytime
Type/style of artwork that has the best chance of being purchased by our clients in the next two years: Contemporary and traditional

❖ Gallery U'ltima
Karyn Gabaldon
1018 Main Ave, Durango, CO 81301
970/247-1812 970/247-0648 Fax

We sell: Originals Limited Editions
Our gallery works with corporations collecting art.
We are seeking both new and established talent.
Year gallery was established: 1980
Gallery hours: 10-6
Number of shows each year: 2
Commission gallery takes: 50%
Number of artists represented: 10
Gallery is insured.
Geographical limitations to artists we represent: None
The gallery assumes cost of:
Openings Advertising Installations
Promotion (brochures, etc.)

Styles we carry:
Floral	Landscape	Native American
Oriental	Realistic	Representational
Southwestern		

Media we carry:
Acrylic	Bronze	Ceramic
Clay	Marble	Mixed Media
Oil	Pastel	Pottery
Prints	Sculpture	Silkscreen
Watercolor		

Our target market:
Corporations	Private Collectors	Interior Decorators
Offices	Tourists	Walk-ins

Advice we can offer to artists interested in being represented by our gallery: Check to see if work fits with gallery genre and pricing.
To contact us: Submit portfolio (brochure, statement, slides, etc.) for review/send slides/photos by mail for consideration.
Specific time of year we review work: Anytime
Type/style of artwork that has the best chance of being purchased by our clients in the next two years: Landscapes

❖ Spirit in the Wind Gallery
Pam Eggemeyer
708 13th St, Golden, CO 80401
303/279-1192

We sell: Originals Limited Editions
Our gallery works with corporations collecting art.
We are seeking both new and established talent.
Year gallery was established: 1992
Gallery hours: Mon-Sat 10-6, Sun 12-5
Number of shows each year: 10-12
Commission gallery takes: 40%
Number of artists represented: 44
Gallery is insured.
Geographical limitations to artists we represent: None
The gallery assumes cost of:
Advertising Installations
Styles we carry:
Native American	Southwestern	Western

Media we carry:
Acrylic	Bronze	Charcoal
Clay	Colored Pencil	Mixed Media
Oil	Pen & Ink	Pottery
Prints	Sculpture	Watercolor

Our target market:
Corporations	Private Collectors	Interior Decorators
Hotel/Motel	Tourists	Walk-ins

To contact us: Submit portfolio (brochure, statement, slides, etc.) for review.
Specific time of year we review work: Anytime
Type/style of artwork that has the best chance of being purchased by our clients in the next two years: Western, Native American, Southwestern

Galleries

❖ Oak Creek Gallery
Sue Ann Carpenter
10998 Bonita Beach Rd, Bonita Springs, FL 33923
813/495-2799 Telephone/Fax

We sell:

Originals	Limited Editions	
Posters	Frames	Sculpture
Books	Notecards	

Decorative accessories
Dealer of Mill Pond Press and Greenwich Workshop prints.
Our gallery works with corporations collecting art.
We are seeking both new and established talent.
Year gallery was established: 1992
Gallery hours: Mon-Fri 10-5
Number of shows each year: 12-16
Commission gallery takes: 50%
Number of artists represented: 20
Gallery is insured.
Geographical limitations to artists we represent: None
The gallery assumes cost of:

Advertising	Installations

Styles we carry:

Animals	Ethnic	Floral
Impressionism	Landscape	Naive
Native American	Nostalgia	Realistic
Representational	Romantic	Southwestern
Sports	Traditional	Tropical
Western	Wildlife	Golf

Media we carry:

Acrylic	Ceramic	Charcoal
Clay	Collage	Colored Pencil
Mixed Media	Oil	Pastel
Pen & Ink	Pottery	Prints
Sculpture	Silkscreen	Watercolor

Our target market:

Private Collectors	Offices	Walk-ins
New Home Buyers		

Advice we can offer to artists interested in being represented by our gallery: I must see your work in person. I would like more Native American art as well as glass work and oil paintings.
To contact us: Arrange a personal interview to show portfolio.
Specific time of year we review work: Anytime
Type/style of artwork that has the best chance of being purchased by our clients in the next two years: Large, over-the-couch pieces.

❖ Gallery of the Eccentric
Claire Savitt
233 Aragon Ave, Coral Gables, FL 33134
305/446-5550

We sell: Originals
We are seeking both new and established talent.
Year gallery was established: 1990

Gallery hours: Tues-Sat 11-5
Number of shows each year: 12
Commission gallery takes: 50%
Number of artists represented: 40
Gallery is insured.
Geographical limitations to artists we represent: None
The gallery assumes cost of:

Openings	Advertising
Promotion (brochures, etc.)	

Styles we carry:

Alternative	Ethnic	Naive
Native American	Nostalgia	Visionary
Folk Art		

Media we carry:

Acrylic	Ceramic	Clay
Fibre Arts	Mixed Media	Oil
Paper Sculpture	Pottery	Sculpture

Our target market:

Private Collectors	Tourists	Walk-ins
Interior Decorators		

Advice we can offer to artists interested in being represented by our gallery: Set up specific appointment/ arrange a personal interview to show portfolio/send slides/photos by mail for consideration.
Specific time of year we review work: Anytime
Type/style of artwork that has the best chance of being purchased by our clients in the next two years: Folk art, outsider art

❖ Artcetera Fine Art Gallery
Gloria Waldman
640 E Atlantic Ave, Delray Beach, FL 33483
407/279-9939 407/279-9939 Fax (11-3)

We sell: Originals
Our gallery works with corporations collecting art.
We are seeking both new and established talent.
Year gallery was established: 1983
Gallery hours: Mon-Sat 10:30-5
Number of shows each year: 3-4
Commission gallery takes: 50%
Number of artists represented: 15-20
Gallery is insured.
Geographical limitations to artists we represent: International/no limitations
The gallery assumes cost of:

Openings	Advertising

Styles we carry:

Abstract	Classic	Contemporary
Fantasy	Figurative	Floral
Impressionism	Landscape	Latin American
Oriental	Realistic	Representational
Romantic	Still life	Traditional
Tropical		

Media we carry:

Acrylic	Bronze	Ceramic
Charcoal	Clay	Collage
Drawing	Glass	Installations
Marble	Mixed Media	Oil
Pen & Ink	Photography	Pottery
Sculpture	Watercolor	

Our target market:

Consultants	Corporations	Restaurants
Architects	Private Collectors	Walk-ins
Tourists	Interior Decorators	

Advice we can offer to artists interested in being represented by our gallery: Know something about what the gallery offers and then submit photos/slides, etc. with a SASE.

To contact us: Arrange a personal interview to show portfolio/submit portfolio (brochure, statement, slides, etc.) for review/query with resumé/send slides/photos by mail for consideration.

Specific time of year we review work: All year; summer for our winter season

Type/style of artwork that has the best chance of being purchased by our clients in the next two years: Original canvas packages, sculpture of all media, lifesize fine ceramics, glass; competitive pricing makes the difference between exhibiting and selling.

❖ Call of Africa's Native Visions Gallery

Ross Parker/Michael Giglio
807 E Las Olas Blvd, Ft Lauderdale, FL 33301
305/767-8737 305/767-4729 Fax

We sell: Originals Limited Editions
Our gallery works with corporations collecting art.
 Corporate Consultant: Ross Parker
We are actively seeking new talent.
Year gallery was established: 1987
Gallery hours: Mon-Thurs 10:30-10:00; Fri-Sat 10:30-11:00; Sun 12-10
Number of shows each year: 4
Commission gallery takes: 66%
Number of artists represented: 12
Gallery is insured.
Geographical limitations to artists we represent: None
The gallery assumes cost of:

Openings	Advertising	Installations
Promotion (brochures, etc.)		

Styles we carry:

Animals	Ethnic	Impressionism
Landscape	Marine	Realistic
Still life	Tropical	Wildlife

Media we carry:

Acrylic	Fibre Arts	Oil
Pastel	Pencil	Pen & Ink
Prints	Sculpture	Watercolor

Our target market:

Corporations	Private Collectors	Interior Decorators
Tourists	Walk-ins	

To contact us: Submit portfolio (brochure, statement, slides, etc.) for review.
Specific time of year we review work: Jun-Oct
Type/style of artwork that has the best chance of being purchased by our clients in the next two years: Realism, ultra realism

❖ Barbara Greene Gallery

Barbara Greene
1541 Brickell Ave #1503, Miami, FL 33129
305/858-7868

We sell: Originals
Our gallery works with corporations collecting art.
We are seeking both new and established talent.
Year gallery was established: 1983
Gallery hours: By appointment
Number of shows each year: 8
Geographical limitations to artists we represent: None
The gallery assumes cost of (with artists exclusively represented):

Openings	Advertising	Installations
Promotion (brochures, etc.)		
Transportation of artwork		

Styles we carry:

Abstract	African-American	Conceptual
Contemporary	Erotic	Latin American
Minimal		

Media we carry:

Acrylic	Airbrush	Bronze
Ceramic	Charcoal	Collage
Colored Pencil	Computer	Drawing
Installations	Marble	Marker
Mixed Media	Oil	Paper Sculpture
Pastel	Pencil	Pen & Ink
Photography	Prints	Sculpture
Silkscreen	Tempra	Watercolor

Our target market:

Private Collectors	Gallery Buyers

To contact us: Send slides/photos by mail for consideration.
Specific time of year we review work: Anytime
Type/style of artwork that has the best chance of being purchased by our clients in the next two years: Known and emerging Latin American artists

❖ Galeria 1-2-3

Alberto M Cohen
Vipsal #874, PO Box 52-5364, Miami FL 33152-5364
503/223-5540

We sell: Originals Posters
Our gallery works with corporations collecting art.
We are actively seeking new and established talent mostly through referrals.

Galleries

Year gallery was established: 1972
Gallery hours: Mon-Sat
Number of shows each year: 22
Commission gallery takes: 33-50%
Gallery is insured.
Geographical limitations to artists we represent: Latin America; will consider all artists with talent
Styles we carry:

Abstract	Contemporary	Latin American
Surrealism		

Media we carry:

Acrylic	Drawing	Mixed Media
Oil	Prints	Sculpture
Watercolor		

Our target market:

Corporations	Architects	Private Collectors

Advice we can offer to artists interested in being represented by our gallery: We will promote in Central America.
To contact us: Submit portfolio (brochure, statement, slides, etc.) for review/send slides/photos by mail for consideration.
Specific time of year we review work: Anytime
Type/style of artwork that has the best chance of being purchased by our clients in the next two years: Contemporary, Latin American, abstract, ecological motives

❖ Rado Gallery

Ava Rado-Harte
800 West Ave (inside South Bay Club), Miami Beach, FL 33139
305/538-2803 Telephone/Fax

We sell:

Originals	Limited Editions	
Posters	Frames	

Our gallery works with corporations collecting art. We are actively seeking both new and established talent, mostly through referrals.
Year gallery was established: 1991
Gallery hours: Mon-Sat 1-5
Commission gallery takes: 50%
Number of artists represented: 12
Gallery is insured: Each artist carries a floater.
Geographical limitations to artists we represent: None
The gallery assumes cost of:

Openings	Advertising	Installations
Promotion (brochures, etc.)		

Styles we carry:

Abstract	Conceptual	Contemporary
Figurative	New Age	POP
Surrealism		

Media we carry:

Acrylic	Airbrush	Ceramic
Collage	Installations	Oil
Pen & Ink	Prints	Sculpture
Silkscreen		

Our target market:

Consultants	Corporations	Private Collectors
Interior Decorators		

To contact us: Submit portfolio (brochure, statement, slides, etc.) for review.
Specific time of year we review work: Anytime

❖ The Art Shoppe/Betty Rowe Gallery

Ronald & Elizabeth Lippincott
405 St Johns Ave, Palatka, FL 32177
904/325-6262

We sell:

Originals	Limited Editions	
Posters	Frames	Art supplies

We are actively seeking both new and established talent.
Year gallery was established: 1987
Gallery hours: Mon-Fri 9-5:30
Gallery is insured.
Styles we carry:

Animals	Floral	Landscape
Marine	Native American	Oriental
Realistic	Religious	Southwestern
Still life	Traditional	Tropical
Western	Wildlife	

Media we carry:

Acrylic	Mixed Media	Oil
Watercolor		

❖ Hang-Up Gallery

Frank Troncale
45 S Palm Ave, Sarasota, FL 34236
813/953-5757

We sell:

Originals	Limited Editions	
Posters	Frames	

We are seeking both new and established talent.
Year gallery was established: 1971
Gallery hours: Mon-Sat 1-5
Number of shows each year: 6
Commission gallery takes: 50%
Number of artists represented: 25
Gallery is insured.
Geographical limitations to artists we represent: None
The gallery assumes cost of:

Openings ($^1/_2$)	Advertising	Installations
Promotion (brochures, etc.)		
Return transportation of artwork		

Styles we carry:

Abstract	Contemporary	Figurative
Impressionism	Landscape	

Media we carry:

Acrylic	Bronze	Ceramic
Collage	Mixed Media	Pencil
Pottery	Sculpture	Silkscreen

Our target market:

Corporations	Private Collectors	Interior Decorators
Tourists	Walk-ins	

To contact us: Send slides/photos by mail for consideration.
Specific time of year we review work: Anytime
Type/style of artwork that has the best chance of being purchased by our clients in the next two years: Who knows?

❖ Albertson-Peterson Gallery

Judy Albertson
329 Park Ave S, Winterpark, FL 32789
407/628-1258 407/647-6928 Fax

We sell:	Originals	Limited Editions
Posters		

Our gallery works with corporations collecting art.
 Corporate Consultant: Louise Peterson
We are seeking both new and established talent.
Year gallery was established: 1969
Gallery hours: Tues-Sat 10-5:30
Number of shows each year: 6
Commission gallery takes: Varies
Number of artists represented: Varies
Gallery is insured.
Geographical limitations to artists we represent: USA
The gallery assumes cost of:

Openings	Advertising	Installations
Promotion (brochures, etc.)		

Styles we carry:

Abstract	Contemporary	Figurative
Floral	Impressionism	Landscape
Minimal	Modernism	Naive
Representational	Still life	Surrealism
Tropical		

Media we carry: All
Our target market:

Consultants	Museums	Corporations
Restaurants	Medical Facilities	Architects
Private Collectors	Offices	Schools
Hotel/Motel	Tourists	Walk-ins

Advice we can offer to artists interested in being represented by our gallery: Please send a letter of introduction
To contact us: Submit portfolio (brochure, statement, slides, etc.) for review/query with resumé/send slides/photos by mail for consideration.

❖ Phoenix Galleries Inc

Marcia Brandes
5604 New Peachtree Rd, Atlanta, GA 30341
404/455-3626 404/455-3615 Fax

We sell:	Originals	Posters
Frames		

Our gallery sells wholesale to the home furnishings market.
We are seeking both new and established talent.
Year gallery was established: 1975

Number of shows each year: 4
Gallery is insured.
Styles we carry:

Abstract	African-American	Animals
Aviation	Classic	Conceptual
Contemporary	Equestrian	Ethnic
Figurative	Floral	Impressionism
Landscape	Latin American	Marine
Naive	Nostalgia	Oriental
Realistic	Representational	Southwestern
Sports	Still life	Traditional
Tropical	Western	

Media we carry:

Acrylic	Collage	Drawing
Mixed Media	Pastel	Photography
Prints	Watercolor	

Our target market:

Stores	Restaurants	Medical Facilities
Architects	Interior Designers	Offices
Hotel/Motel	Walk-ins	

Advice we can offer to artists interested in being represented by our gallery: Samples of prints (at no charge) accepted Feb, Mar, Aug, Sept. Photos or slides returned if SASE included.
To contact us: Submit portfolio (brochure, statement, slides, etc.) for review/send slides/photos by mail for consideration/samples of prints.
Specific time of year we review work: Feb/Mar, Aug/Sept
Type/style of artwork that has the best chance of being purchased by our clients in the next two years: All

❖ Tanzil Art Gallery

Tony Gottar
887 W Marietta St #J-101, Atlanta, GA 30318
404/872-4686 404/872-4687 Fax

We sell: Originals
We are seeking both new and established talent.
Year gallery was established: 1994
Gallery hours: Mon-Fri 12-6
Number of shows each year: 6-8
Commission gallery takes: 40%
Number of artists represented: 3
The gallery assumes cost of:

Openings	Advertising	Installations
Promotion (brochures, etc.)		

Styles we carry:

Abstract	Contemporary	Figurative
Modernism	POP	Surrealism
Visionary		

Media we carry:

Acrylic	Bronze	Drawing
Glass	Marble	Oil
Sculpture	Silkscreen	Watercolor

Galleries

Our target market:
Consultants Museums Corporations
Private Collectors Interior Decorators
To contact us: Submit portfolio (brochure, statement, slides, etc.) for review/send slides/photos by mail for consideration.
Type/style of artwork that has the best chance of being purchased by our clients in the next two years: Modern and contemporary in large sizes.

❖ Hale O Kula Goldsmith Gallery

Sam Rosen
PO Box 416, Old Holualoa Post Office Bldg, Holualoa, HI 96725
808/324-1688

We sell: Originals
We are seeking both new and established talent.
Year gallery was established: 1977
Gallery hours: Tues-Sat 10-5
Commission gallery takes: 40%
The gallery assumes cost of:
Openings Advertising Installations
Promotion (brochures, etc.)
Styles we carry: Small works
Mediums of artwork we carry:
Bronze Sculpture Jewelry
Multi-media
Our target market:
Private Collectors Tourists Walk-ins
Advice we can you offer to artists interested in being represented by our gallery: Works must be small, of high quality and unual ideas.
To contact us: Send slides/photos by mail for consideration with SASE.
Type/style of artwork that has the best chance of being purchased by our clients in the next two years: Works in metal or multi-media.

❖ Fine Art Galleries of Hawaii Ltd

Barbara Wagstaff and Lee Dye/Owners
PO Box 6510, 67-1185 Mamalahoa Hwy, Kamuela, HI 96743
808/885-7860 808/885-7861 Fax

We sell: Originals Limited Editions
Posters Frames
Hand-made custom furniture and crafts
Our gallery works with corporations collecting art.
 Corporate Consultant: Barbara Wagstaff
We are not seeking new talent at this time, but we are always interested in seeing new work.
Year gallery was established: 1989
Gallery hours: Mon-Sat 10-6
Number of shows each year: Varies
Number of artists represented: 75+
Gallery is insured.

Geographical limitations to artists we represent:
International to local
The gallery assumes cost of:
Openings Advertising (co-op) Installations
Styles we carry:
Abstract Animals Equestrian
Floral Impressionism Landscape
Native American Realistic Representational
Southwestern Still life Traditional
Tropical Western Wildlife
Media we carry:
Acrylic Airbrush Bronze
Ceramic Charcoal Clay
Collage Computer Drawing
Glass Mixed Media Oil
Paper Sculpture Pastel Pencil
Pen & Ink Photography Pottery
Prints Sculpture Silkscreen
Watercolor Tile
Our target market:
Tourists Walk-ins Local residents
Advice we can offer to artists interested in being represented by our gallery: Determine style and content needs, send photos first as well as price range, wait for gallery assessment and decision
Specific time of year we review work: Anytime
Type/style of artwork that has the best chance of being purchased by our clients in the next two years: Who knows? Basically tropical theme and Hawaiian cowboy and hi-golf courses.

❖ Art Centre at Mauna Lani

West Hawaii Cultural Society Julie Bancroft/Director
1 Mauna Lani Dr, PO Box 6303, Kohala Coast, HI 96743-6303
808/885-7779 808/885-0025 Fax

We sell: Originals Limited Editions
Our gallery works with corporations collecting art.
We are seeking both new and established talent.
Year gallery was established: 1983
Gallery hours: Daily 9:30-6
Number of shows each year: 4
Commission gallery takes: 50%
Number of artists represented: 25
Gallery is insured.
Geographical limitations to artists we represent: None
The gallery assumes cost of:
Advertising Installations
Styles we carry:
Abstract Classic Contemporary
Equestrian Floral Historic
Impressionism Landscape Oriental
Portraits Realistic Representational
Romantic Still life Traditional
Tropical

Galleries

Media we carry:

Acrylic	Bronze	Ceramic
Charcoal	Clay	Drawing
Fibre Arts	Glass	Marble
Mixed Media	Oil	Paper Sculpture
Pastel	Pen & Ink	Photography
Pottery	Prints	Sculpture
Tempra	Watercolor	Wood

Our target market:

Private Collectors Interior Designers Tourists
Walk-ins

To contact us: Submit portfolio (brochure, statement, slides, etc.) for review/send slides/photos by mail for consideration.

❖ Old Wailuku Gallery

Eric Westerlund
28 N Market St, Wailuku, Maui, HI 96793
708/244-4544 Telephone/Fax

We sell:	Originals	Limited Editions
Posters	Frames	Sculpture

Our gallery works with corporations collecting art.
We are seeking both new and established talent.
Gallery hours: Daily 10-6
Number of shows each year: 6
Commission gallery takes: 50%
Number of artists represented: 50
Gallery is insured.
Geographical limitations to artists we represent: Maui, Oahu, anywhere
The gallery assumes cost of:

Openings	Advertising	Installations
Promotion (brochures, etc.)		
Transportation of artwork		

Styles we carry:

Abstract	Classic	Conceptual
Fantasy	Figurative	Floral
Impressionism	Landscape	Marine
Oriental	Realistic	Representational
Still life	Traditional	Tropical
Wildlife		

Media we carry:

Acrylic	Bronze	Ceramic
Charcoal	Collage	Colored Pencil
Drawing	Glass	Marble
Mixed Media	Oil	Pastel
Pencil	Pen & Ink	Pottery
Prints	Sculpture	Silkscreen
Tempra	Watercolor	

Our target market:

Corporations	Restaurants	Medical Facilities
Interior Designers	Offices	Schools
Hotel/Motel	Tourists	Walk-ins

Advice we can offer to artists interested in being represented by our gallery: Have a professional portfolio and access to actual work.

To contact us: Send slides/photos by mail for consideration.
Specific time of year we review work: Anytime
Type/style of artwork that has the best chance of being purchased by our clients in the next two years: Watercolors, oils, pastels, prints

❖ Brown Galleries

G & G Brown
1022 Main St, Boise, ID 82702
208/342-6661 208/342-6677 Fax

Second Gallery: Randal Brown/Director
136 E Lake St, PO Box 1292, McCall, ID 83638
208/634-4404

We sell:	
Originals	Limited Editions

We are seeking both new and established talent.
Year gallery was established: 1967
Gallery hours: Mon-Fri 10-6; Sat 12-4
Number of shows each year: 12
Commission gallery takes: Varies
Number of artists represented: 40
Gallery is insured.
The gallery assumes cost of:

Openings	Advertising	Installations
Promotion (brochures, etc.)		

Styles we carry:

Abstract	Alternative	Animals
Aviation	Classic	Conceptual
Contemporary	Equestrian	Erotic
Fantasy	Figurative	Floral
Historic	Impressionism	Landscape
Marine	Military	Minimal
Modernism	Naive	Native American
New Age	Nostalgia	Oriental
POP	Portraits	Realistic
Representational	Romantic	Sci-Fi
Southwestern	Sports	Still life
Surrealism	Traditional	Tropical
Visionary	Western	Wildlife

Mediums of artwork we carry:

Acrylic	Airbrush	Bronze
Ceramic	Charcoal	Clay
Collage	Colored Pencil	Drawing
Fibre Arts	Glass	Marble
Mixed Media	Oil	Paper Sculpture
Pastel	Pencil	Pen & Ink
Pottery	Prints	Sculpture
Silkscreen	Tempra	Watercolor

Our target market:

Consultants	Museums	Corporations
Restaurants	Medical Facilities	Architects
Private Collectors	Interior Designers	Offices
Schools	Tourists	Walk-ins

Galleries

Advice we can you offer to artists interested in being represented by our gallery: Be friendly and professional, organization is a must!
To contact us: Submit portfolio (brochure, statement, slides, etc.) for review.
Specific time of year we review work: Weekly
Type/style of artwork that has the best chance of being purchased by our clients in the next two years: Large format impressionistic landscapes in oils or acrylics.

❖ **Stonington Gallery**
Nancy Taylor Stonington/Owner
Nicki Lee Foster/Director
PO Box 2237, 220 East Ave, Ketchum, ID 83340
208/726-4826 208/726-4550 Fax

We sell:

	Originals	Limited Editions
Posters	Jewelry	Fine crafts
Custom frames	Sculpture	

We are seeking established talent mostly through referrals.
Year gallery was established: 1978
Gallery hours: Mon-Sat 10-6; Sun 12-5
Number of shows each year: 8
Commission gallery takes: 50%
Number of artists represented: 20
Gallery is insured.
Geographical limitations to artists we represent: None
The gallery assumes cost of:
Openings Installations
Promotion (brochures, etc.) (50%)
Styles we carry:

Contemporary	Floral	Landscape
Naive	Realistic	Representational
Still life	Traditional	Wildlife

Media we carry:

Acrylic	Bronze	Ceramic
Drawing	Glass	Mixed Media
Oil	Paper Sculpture	Pen & Ink
Photography	Pottery	Prints
Sculpture	Silkscreen	Watercolor

Our target market:

Corporations	Private Collectors	Interior Decorators
Tourists	Walk-ins	

Advice we can offer to artists interested in being represented by our gallery: High quality slides/photos
To contact us: Query with resumé/send slides/photos by mail for consideration.

❖ **Pinson Fine Art**
Ellen Kinnebrew
PO Box 2840, Sun Valley, ID 83353
208/726-8461 208/726-0090 Fax

We sell: Originals
Our gallery works with corporations collecting art.
 Corporate Consultant: Jack Hewett

We are seeking both new and established talent.
Year gallery was established: 1992
Gallery hours: Daily 10-6
Number of shows each year: 8
Number of artists represented: 5-10
Gallery is insured.
Geographical limitations to artists we represent: None
Styles we carry:

Abstract	Contemporary	Floral
Surrealism		

Mediums of artwork we carry:

Acrylic	Bronze	Collage
Colored Pencil	Drawing	Mixed Media
Sculpture		

Our target market: Private Collectors
Advice we can you offer to artists interested in being represented by our gallery: High quality originall yconceived work
To contact us: Send slides/photos by mail for consideration.
Type/style of artwork that has the best chance of being purchased by our clients in the next two years: Paintings, sculpture

❖ **Beret International Ltd**
Ned Schwartz
1550 N Milwaukee Ave, Chicago, IL 60622
312/489-6518

We sell: Originals
Our gallery works with corporations collecting art.
We are actively seeking new talent.
Year gallery was established: 1989
Number of shows each year: 10
Number of artists represented: 25
Gallery is insured.
Geographical limitations to artists we represent: None
The gallery assumes cost of:
Openings Installations
Styles we carry:

Abstract	Alternative	Conceptual
Minimal		

Our target market: The art community
Advice we can offer to artists interested in being represented by our gallery: The art needs to be challenging, not decorative.
To contact us: Send slides/photos by mail for consideration.
Specific time of year we review work: Anytime

❖ **Dettaglio**
Koulé Addams/Owner Laurel Connel/Director
1573 N Milwaukee Ave #414, Chicago, IL 60622
312/943-4115 312/404-5633 Fax

We sell: Originals
Our gallery works with corporations collecting art.
 Corporate Consultant: Dana Ware

We are seeking both new and established talent.
Year gallery was established: 1990
Gallery hours: Tues-Sat 12-7; Sun 12-5
Number of shows each year: 4-6
Commission gallery takes: 50%
Number of artists represented: 8
Gallery is insured.
Geographical limitations to artists we represent: None
The gallery assumes cost of: Openings
Styles we carry:

Abstract	African-American	Contemporary
Erotic	Impressionism	Landscape
Latin American	Modernism	Native American
POP	Realistic	Religious
Still life	Surrealism	Traditional

Media we carry:

Acrylic	Charcoal	Collage
Mixed Media	Oil	Pastel
Pencil	Pen & Ink	Sculpture
Tempra	Watercolor	

Our target market:

Consultants	Museums	Corporations
Architects	Private Collectors	Interior Decorators
Walk-ins		

Advice we can offer to artists interested in being represented by our gallery: Be dedicated to your work.
To contact us: Arrange a personal interview to show portfolio/submit portfolio (brochure, statement, slides, etc.) for review/send slides/photos by mail for consideration.
Specific time of year we review work: August
Type/style of artwork that has the best chance of being purchased by our clients in the next two years: Contemporary, abstract

❖ Eva Cohon Gallery Ltd

Eva Cohon
301 W Superior St, Chicago, IL 60610
312/664-3669 312/664-8573 Fax

We sell: Originals
Our gallery works with corporations collecting art.
 Corporate Consultant: Dan Addington
We are seeking both new and established talent.
Gallery hours: Tues-Sat 10:30-5
Number of shows each year: 8
Commission gallery takes: 50%
Number of artists represented: 25
Gallery is insured.
Geographical limitations to artists we represent: None
The gallery assumes cost of:

Openings	Advertising	Installations
Promotion (brochures, etc.)		
Transportation of artwork		

Styles we carry:

Abstract	Contemporary	Figurative
Landscape	Modernism	Representational
Still life		

Media we carry:

Acrylic	Oil	Sculpture
Watercolor		

Our target market:

Consultants	Private Collectors	Interior Decorators
Offices	Walk-ins	

Advice we can offer to artists interested in being represented by our gallery: We have an open policy for contemporary painters and sculptors. Send a slide sheet, resumé, any supplementary materials (clippings, reviews, etc.) and SASE.
Specific time of year we review work: Anytime
Type/style of artwork that has the best chance of being purchased by our clients in the next two years: Medium-sized contemporary (abstract or figurative) original oil, acrylic, or mixed media paintings on canvas or panel.

❖ Greenview Art Gallery

Nicholas De Wolff
64-18 N Greenview, Chicago, IL 60626
312/508-0085 312/508-9400 Fax

We sell: Originals
We are seeking both new and established talent.
Year gallery was established: 1991
Gallery hours: Mon-Fri 1-5, depends on show
Number of shows each year: 5-15
Commission gallery takes: 30-50%
Number of artists represented: We have a non-exclusive agreement with artists.
Styles we carry: Quality is more important than style.
Media we carry: All
Our target market:

Restaurants	Private Collectors	Tourists
Walk-ins		

Advice we can offer to artists interested in being represented by our gallery: With talent and a well-put–together proposal, send slides/photo samples, but first give us a call.
Specific time of year we review work: November
Type/style of artwork that has the best chance of being purchased by our clients in the next two years: Financially accessible works.

❖ Gruen Galleries

Erwin Gruen/Renée Sax
226 W Superior St, Chicago, IL 60610
312/337-6262 312/337-7855 Fax

We sell: Originals Limited Editions
Our gallery works with corporations collecting art.
 Corporate Consultant: Bradley Lincoln
We are seeking both new and established talent.
Year gallery was established: 1971
Gallery hours: Mon-Sat 10-4:30
Number of shows each year: 8-10
Commission gallery takes: 50%
Number of artists represented: 20

Galleries

Geographical limitations to artists we represent: None
The gallery assumes cost of:

Openings	Advertising	Installations

Promotion (brochures, etc.)

Styles we carry:

Abstract	African Artifacts	Contemporary
Figurative	Floral	Impressionism
Landscape	Modernism	POP
Portraits	Realistic	Representational
Still life	Surrealism	Traditional

Media we carry:

Acrylic	Bronze	Ceramic
Charcoal	Collage	Drawing
Glass	Marble	Mixed Media
Oil	Pastel	Pencil
Photography	Prints	Sculpture
Watercolor		

Our target market:

Consultants	Corporations	Architects
Private Collectors	Offices	Tourists
Walk-ins	Interior Decorators	

To contact us: Submit portfolio (brochure, statement, slides, etc.) for review/send slides/photos by mail for consideration/include SASE with bio.
Specific time of year we review work: Anytime

❖ Liz Long Gallery

Dianna Long
1510 W Berwyn, Chicago, IL 60640
312/275-1319

We sell:

Originals	Limited Editions	Posters

Our gallery works with corporations collecting art.
We are actively seeking new talent.
Year gallery was established: 1988
Gallery hours: Thurs-Fri 5-9, Sat-Sun 1-5
Number of shows each year: 10
Commission gallery takes: 30%
Gallery is insured.
Geographical limitations to artists we exhibit: None
The gallery assumes cost of:

Openings	Advertising	Installations

Promotion (brochures, etc.)

Styles we carry:

Abstract	African-American	Alternative
Animals	Conceptual	Contemporary
Ethnic	Fantasy	Figurative
Floral	Historic	Impressionism
Landscape	Latin American	Marine
Minimal	Modernism	Naive
Native American	New Age	Oriental
POP	Portraits	Romantic
Southwestern	Sports	Still life
Surrealism	Tropical	Visionary
Wildlife		

Media we carry:

Acrylic	Airbrush	Charcoal
Clay	Collage	Colored Pencil
Computer art	Drawing	Fibre Arts
Glass	Mixed Media	Oil
Pastel	Pencil	Pen & Ink
Photography	Prints	Silkscreen
Tempra	Watercolor	

Our target market:

Corporations	Restaurants	Medical Facilities
Private Collectors	Interior Designers	Schools
Tourists	Walk-ins	

Advice we can offer to artists interested in being represented by our gallery: Send SASE, letter of introduction, slides/photographs
Specific time of year we review work: Ongoing
Type/style of artwork that has the best chance of being purchased by our clients in the next two years: Affordable, innovative, under 42", extremely creative and colorful

❖ Ohio Street Gallery

Debra Augustine & Jeff Levers/Owners
214 W Ohio, Chicago, IL 60610
312/988-9990 312/648-1057 Fax

We sell:	Originals	Limited Editions

We are actively seeking both new and established talent.
Year gallery was established: 1994
Gallery hours: Tues-Sat 10-5:30
Number of shows each year: 10
Commission gallery takes: 50%
The gallery assumes cost of:

Installations (negotiable)		Advertising
Promotion (brochures, etc.)		Openings
Transportation of artwork (negotiable)		

Styles we carry:

Abstract	Alternative	Conceptual
Contemporary	Fantasy	Minimal
New Age	Surrealism	Visionary

Media we carry:

Bronze	Computer	Mixed Media
Oil	Sculpture	

Our target market:

Corporations	Private Collectors	Interior Decorators
Tourists	Walk-ins	

To contact us: Submit portfolio (brochure, statement, slides, etc.) for review.
Specific time of year we review work: Anytime

❖ **Peter Miller Gallery Ltd**
Peter Miller & Natalie Domchenko/Directors
401 W Superior, Chicago, IL 60610
312/951-0252 312/951-2628 Fax

We sell: Originals
Our gallery works with corporations collecting art.
We are seeking both new and established talent.
Year gallery was established: 1979
Gallery hours: Tues-Sat 11-5:30
Number of shows each year: 9
Commission gallery takes: 50%
Number of artists represented: 15
Gallery is insured.
Geographical limitations to artists we represent: None
The gallery assumes cost of: Openings
Styles we carry:

Abstract	Conceptual	Contemporary
Figurative	Landscape	Realistic
Representational	Still life	

Media we carry:

Acrylic	Bronze	Clay
Collage	Installations	Mixed Media
Oil	Sculpture	

Our target market:

Consultants	Corporations	Private Collectors
Interior Designers	Commercial Offices	

Advice we can offer to artists interested in being represented by our gallery: Include SASE when mailing items for review.
To contact us: Send slides/photos by mail for consideration.

❖ **Richard Milliman Fine Art**
Richard Milliman
3309 Central, Evanston, IL 60201-150
708/328-3232 708/328-8802 Fax

We sell:

	Originals	Limited Editions
Posters	Frames	Sculpture
Books		

Our gallery works with corporations collecting art.
Corporate Consultant: Kathleen Duffy
We are seeking both new and established talent.
Year gallery was established: 1971
Gallery hours: By appointment
Number of shows each year: 12
Commission gallery takes: 50%
Number of artists represented: 25
Gallery is insured.
Geographical limitations to artists we represent: None
The gallery assumes cost (or sometimes shares) of:

Openings	Advertising	Installations
Promotion (brochures, etc.)		
Transportation of artwork		

Styles we carry:

Abstract	African-American	Alternative
Conceptual	Contemporary	Figurative
Floral	Landscape	Latin American
Minimal	Modernism	Oriental
Realistic	Representational	Still life

Media we carry:

Acrylic	Bronze	Ceramic
Collage	Colored Pencil	Computer
Drawing	Mixed Media	Oil
Paper Sculpture	Pastel	Pencil
Photography	Prints	Sculpture
Silkscreen	Tempra	Watercolor

Our target market:

Consultants	Museums	Corporations
Architects	Private Collectors	Interior Decorators

Advice we can offer to artists interested in being represented by our gallery: We offer "professional" representation and are only interested in artists who have made the commitment to achieve a professional level. Do your research.
To contact us: Query with resumé/send slides/photos by mail for consideration.
Specific time of year we review work: Anytime

❖ **Unique Accents**
Gary and Phyllis Fersten
3137 Dundee Rd, Northbrook, IL 60062
708/205-9400 708/205-9402 Fax

We sell: Originals Limited Editions
Our gallery works with corporations collecting art.
Corporate Consultant: Andrew Fersten
We are seeking established talent mostly through referrals.
Year gallery was established: 1989
Gallery hours: Mon-Fri 9-5
Number of shows each year: 2-3
Commission gallery takes: 50%
Number of artists represented: 150-200
Gallery is insured.
Geographical limitations to artists we represent: None
The gallery assumes cost of:

Openings	Advertising	Installations
Promotion (brochures, etc.)		

Styles we carry:

Abstract	Classic	Contemporary
Fantasy	Figurative	Impressionism
Realistic	Representational	Still life
Traditional		

Media we carry:

Acrylic	Bronze	Ceramic
Clay	Collage	Glass
Mixed Media	Oil	Paper Sculpture
Pottery	Sculpture	Silkscreen
Watercolor		

Galleries

Our target market:

Corporations Private Collectors Interior Decorators
Offices Walk-ins

To contact us: Arrange a personal interview to show portfolio/submit portfolio (brochure, statement, slides, etc.) for review/send slides/photos by mail for consideration.

Specific time of year we review work: Anytime

❖ Prestige Art Gallery

Louis Schutz Isa
3909 W Homaro St, Skokie, IL 60076
708/679-2555

We sell: Originals Limited Editions
Posters Frames

We are actively seeking new talent.
Year gallery was established: 1960
Gallery hours: Daily 10-5
Number of shows each year: 4
Commission gallery takes: Varies with each artist
Number of artists represented: 200
Gallery is insured.
Geographical limitations to artists we represent: None
The gallery assumes cost of:

Openings Advertising Installations

Styles we carry:

Abstract	Contemporary	Fantasy
Figurative	Floral	Impressionism
Landscape	New Age	Realistic
Romantic	Sci-Fi	Still life
Surrealism	Traditional	Visionary

Media we carry:

Acrylic	Airbrush	Bronze
Ceramic	Clay	Computer
Fibre Arts	Glass	Installations
Mixed Media	Oil	Paper Sculpture
Photography	Pottery	Prints
Sculpture	Silkscreen	

Our target market:

Private Collectors Interior Decorators

Advice we can offer to artists interested in being represented by our gallery: Be professional in your presentation.

To contact us: Send slides/photos by mail for consideration.

Type/style of artwork that has the best chance of being purchased by our clients in the next two years: Quality work

❖ Robert Galitz Fine Art

Robert Galitz
166 Hilltop Ct, Sleepy Hollow, IL 60118
708/426-8842 708/426-8846 Fax

We sell: Originals Limited Editions
Our gallery works with corporations collecting art.

We are actively seeking both new and established talent.
Year gallery was established: 1986
Gallery hours: By appointment
Number of artists represented: 100
Gallery is insured.
Geographical limitations to artists we represent: None
The gallery assumes cost of: Promotion (brochures, etc.)
Styles we carry:

Abstract	Contemporary	Floral
Impressionism	Landscape	Minimal
Modernism	Realistic	Representational
Still life	Traditional	

Media we carry:

Acrylic	Airbrush	Collage
Colored Pencil	Drawing	Fibre Arts
Marker	Mixed Media	Oil
Pastel	Pencil	Pen & Ink
Prints	Sculpture	Silkscreen
Tempra	Watercolor	

Our target market:

Consultants	Corporations	Medical Facilities
Architects	Private Collectors	Interior Decorators
Offices	Schools	Hotel/Motel

To contact us: Submit portfolio (brochure, statement, slides, etc.) for review/send slides/photos by mail for consideration.

Specific time of year we review work: Anytime

❖ Jubilee Gallery

Richard Lorenz
121 W Court Ave, Jeffersonville, IN 47130
812/282-9997

We sell: Originals Limited Editions
Posters

Our gallery works with corporations collecting art.
We are actively seeking new talent.
Year gallery was established: 1970
Gallery hours: Tues-Fri 10-5
Commission gallery takes: 40%
Number of artists represented: 8
Gallery is insured.
The gallery assumes cost of:

Installation Promotion, brochures, etc. (50%)

Styles we carry:

Animals	Equestrian	Erotic
Landscape	Marine	Naive
Native American	New Age	Southwestern
Still life	Traditional	Wildlife

Media we carry:

Acrylic	Bronze	Ceramic
Charcoal	Clay	Collage
Colored Pencil	Glass	Oil
Pastel	Pen & Ink	Photography
Pottery	Prints	Sculpture
Watercolor		

Our target market:
Corporations Private Collectors Tourists
Walk-ins
To contact us: Query with resumé.
Specific time of year we review work: Anytime

❖ Mississippi Fine Arts

David Losasso
2123 E 12th St, Davenport, IA 52803
319/324-7598 Telephone/Fax

We sell: Originals Limited Editions
Posters Frames
Our gallery works with corporations collecting art.
 Corporate Consultant: David Losasso
We are actively seeking new talent.
Year gallery was established: 1981
Gallery hours: Mon-Fri 9:30-5
Number of shows each year: 4
Commission gallery takes: 40%
Number of artists represented: 50
Gallery is insured.
Geographical limitations to artists we represent: None
The gallery assumes cost of:
Openings Installations
Transportation of artwork
Styles we carry:

Animals	Contemporary	Erotic
Figurative	Floral	Historic
Landscape	Modernism	Naive
Oriental	Realistic	Still life
Tropical		

Media we carry:

Bronze	Ceramic	Colored Pencil
Drawing	Glass	Mixed Media
Oil	Pastel	Pencil
Pottery	Prints	Sculpture
Silkscreen	Watercolor	

Our target market:

Corporations	Restaurants	Medical Facilities
Private Collectors	Interior Designers	Tourists
Walk-ins		

To contact us: Submit portfolio (brochure, statement, slides, etc.) for review/send slides/photos by mail for consideration.
Specific time of year we review work: Anytime
Type/style of artwork that has the best chance of being purchased by our clients in the next two years: Midwest landscape

❖ Lafayette Art Gallery

Lafayette Art Association/Ty Rona de Valcourt
700 Lee Ave, Lafayette, LA 70501
318/269-0363 Telephone/Fax

We sell: Originals Limited Editions
Posters
We are seeking both new and established talent.

Year gallery was established: 1959
Gallery hours: Tues-Fri 10-5
Number of shows each year: 14
Commission gallery takes: 25%
Number of artists represented: 250
Gallery is insured.
Geographical limitations to artists we represent: None
The gallery assumes cost of:
Openings Advertising Installations
Promotion (brochures, etc.)
Styles we carry:

Abstract	African-American	Animals
Classic	Conceptual	Contemporary
Ethnic	Fantasy	Figurative
Floral	Impressionism	Landscape
Latin American	Marine	Military
Minimal	Modernism	Naive
Native American	New Age	Nostalgia
Oriental	POP	Portraits
Realistic	Religious	Representational
Romantic	Sci-Fi	Southwestern
Sports	Still life	Surrealism
Traditional	Tropical	Visionary
Western	Wildlife	

Media we carry: All
Our target market:

Corporations	Restaurants	Medical Facilities
Private Collectors	Interior Designers	Offices
Schools	Hotel/Motel	Tourists
Walk-ins		

Advice we can offer to artists interested in being represented by our gallery: Request membership form and submit with slides and/or photographs.
To contact us: Arrange a personal interview to show portfolio/submit portfolio (brochure, statement, slides, etc.) for review/query with resumé/send slides/photos by mail for consideration.
Specific time of year we review work: Monthly
Type/style of artwork that has the best chance of being purchased by our clients in the next two years: Representational, impressionistic, abstract

❖ Earthworks Fine Art Gallery

Ray Fugatt/Owner Sharla Richardson/Director
1424 Ryan St, Lake Charles, LA 70601
318/439-1410 318/439-1441 Fax

We sell: Originals Limited Editions
Our gallery works with corporations collecting art.
 Corporate Consultant: Kemberly Davis
We are seeking established talent mostly through referrals.
Year gallery was established: 1990
Gallery hours: Mon-Fri 10-5; Sat 10-2
Number of shows each year: 3-6
Commission gallery takes: 40%
Number of artists represented: 25-30

Galleries

Gallery is insured.

Geographical limitations to artists we represent: None

The gallery assumes cost of:

Openings	Advertising	Installations

Styles we carry:

African-American	Contemporary	Figurative
Floral	Impressionism	Landscape
Marine	Native American	Nostalgia
Oriental	Realistic	Representational
Romantic	Southwestern	Sports
Still life	Wildlife	

Media we carry:

Acrylic	Bronze	Ceramic
Clay	Collage	Drawing
Glass	Marble	Mixed Media
Oil	Pen & Ink	Pottery
Sculpture	Silkscreen	Watercolor

Our target market:

Museums	Corporations	Restaurants
Medical Facilities	Private Collectors	Interior Decorators
Offices	Tourists	Walk-ins

To contact us: Submit portfolio (brochure, statement, slides, etc.) for review.

Specific time of year we review work: Anytime

Type/style of artwork that has the best chance of being purchased by our clients in the next two years: Oil, watercolor, acrylic, landscapes and still lifes.

❖ Hilderbrand Gallery

Clint Hilderbrand
4524 Magazine St, New Orleans, LA 70115
504/895-3312 504/899-9574 Fax

We sell: Originals

Our gallery works with corporations collecting art.
 Corporate Consultant: Holly Hilderbrand

We are seeking both new and established talent.

Year gallery was established: 1990

Gallery hours: Tues-Sat 10-5

Number of shows each year: 10

Number of artists represented: 38

Gallery is insured.

The gallery assumes cost of: Openings

Styles we carry:

Abstract	African-American	Alternative
Conceptual	Contemporary	Figurative
New Age	Realistic	Representational

Media we carry:

Acrylic	Bronze	Ceramic
Charcoal	Collage	Computer
Drawing	Fibre Arts	Glass
Installations	Mixed Media	Oil
Pastel	Pencil	Pen & Ink
Photography	Sculpture	Steel
Aluminum	Tempra	Watercolor

Our target market:

Consultants	Museums	Corporations
Medical Facilities	Architects	Private Collectors
Interior Designers	Offices	Hotel/Motel

To contact us: Submit portfolio (brochure, statement, slides, etc.) for review/send slides/photos by mail for consideration.

Specific time of year we review work: Anytime

Type/style of artwork that has the best chance of being purchased by our clients in the next two years: Nonobjective flatwork and industrial sculpture

❖ Westgate Gallery

Leilah Wendell
5219 Magazine St, New Orleans, LA 70115
504/899-3077

We sell:

	Originals	Limited Editions
Posters		

We also have a bookstore.

❖ The Finer Side Gallery

Tracy Causey-Jeffery
209B North Blvd, Salisbury, MD 21801
410/749-4081

We sell: Originals

Our gallery works with corporations collecting art.

We are seeking both new and established talent.

Year gallery was established: 1992

Gallery hours: Mon-Sat 10-5

Number of shows each year: 8

Commission gallery takes: 25%

Number of artists represented: 75

Gallery is insured.

The gallery assumes cost of:

Openings	Advertising
Promotion (brochures, etc.)	

Styles we carry:

Abstract	Alternative	Animals
Conceptual	Contemporary	Ethnic
Figurative	Impressionism	Minimal
Modernism	Oriental	POP
Romantic	Still life	Surrealism

Media we carry:

Acrylic	Airbrush	Bronze
Ceramic	Clay	Collage
Computer	Fibre Arts	Glass
Installations	Mixed Media	Oil
Paper Sculpture	Pastel	Pen & Ink
Photography	Pottery	Prints
Sculpture	Watercolor	

Our target market:

Corporations	Architects	Private Collectors
Interior Decorators	Offices	Tourists
Walk-ins		

To contact us: Submit portfolio (brochure, statement, slides, etc.) for review.

Specific time of year we review work: Anytime

❖ Arts & More

Richard Vega
31 Germania St, Boston, MA 02130
617/522-0889 617/524-6716 Fax

We sell: Originals Limited Editions
Posters
We are seeking both new and established talent.
Year gallery was established: 1990
Gallery hours: Mon-Sat 9-5
Number of shows each year: 7
Commission gallery takes: 50%
Number of artists represented: 17
Gallery is insured.
Geographical limitations to artists we represent: None
The gallery assumes cost of:
Openings Advertising Installations
Promotion (brochures, etc.)
Transportation of artwork
Styles we carry:
Contemporary Latin American
Media we carry:

Acrylic	Bronze	Charcoal
Collage	Colored Pencil	Drawing
Installations	Marble	Mixed Media
Oil	Paper Sculpture	Pastel
Pencil	Pen & Ink	Photography
Prints	Sculpture	Silkscreen
Tempra	Watercolor	

Our target market:

Consultants	Museums	Corporations
Restaurants	Medical Facilities	Architects
Private Collectors	Interior Designers	Offices
Hotel/Motel	Tourists	Walk-ins

Advice we can offer to artists interested in being represented by our gallery: Be professional in all aspects.
To contact us: Submit portfolio (brochure, statement, slides, etc.) for review.
Specific time of year we review work: Anytime
Type/style of artwork that has the best chance of being purchased by our clients in the next two years: Contemporary

❖ Aisling Gallery & Framing

John & Maureen Connolly
229 Lincoln St, Higham, MA 02043
617/749-0555 617/749-0177 Fax

We sell: Originals Limited Editions
Posters Frames Celtic Jewelry
Our gallery works with corporations collecting art.
We are actively seeking both new and established talent.
Gallery hours: Mon-Sat 10-6; Thurs 10-8; Sun 12-5
Commission gallery takes: 40%
Number of artists represented: 100
Gallery is insured.

The gallery assumes cost of:
Openings Installation
Styles we carry:
Ethnic Landscape Realistic
Still life Art of Ireland
Media we carry:
Acrylic Oil Pastel
Prints Sculpture Silkscreen
Watercolor
Our target market:
Private Collectors Interior Designers Walk-ins
Irish Americans
To contact us: Send slides/photos by mail for consideration.
Type/style of artwork that has the best chance of being purchased by our clients in the next two years: Oils, watercolors, prints, posters of Ireland's landscape and people—the more traditional, the better it sells—cottages, mountains, patchwork fields, older people playing fiddle, tin whistle.

❖ Cortland Jessup Gallery

Cortland Jessup
432 Commercial St, Box 616, Providencetown, MA 02657
508/487-4479

We are seeking established talent mostly through referrals. We do not respond to anyone who does not include an SASE for return of materials submitted.
Year gallery was established: 1990
The gallery assumes cost of:
Openings Advertising Installations
Styles we carry:
Abstract Conceptual Figurative
Landscape Native American Representational
Advice we can offer to artists interested in being represented by our gallery: Get to know the gallery and the kinds of work we show.
To contact us: Send slides/photos by mail for consideration with SASE for return.
Specific time of year we review work: Winter/Spring

❖ Thronja Art Gallery

Janice S Throne
260 Worthington St, Springfield, MA 01103
413/732-0260

We sell: Sculpture Pottery
Our gallery works with corporations collecting art.
 Corporate Consultant: Janice Throne/Janet Weiss
We are actively seeking new and established talent mostly through referrals.
Year gallery was established: 1966
Gallery hours: Tues-Sat 9:30-5
Number of shows each year: 4-6
Commission gallery takes: 50%

Galleries

Number of artists represented: 30-40
Gallery is insured but not for consigned works.
Geographical limitations to artists we represent: None
Styles we carry:

Abstract	African-American	Animals
Classic	Conceptual	Contemporary
Figurative	Floral	Impressionism
Landscape	Latin American	Minimal
Modernism	Naive	Native American
Nostalgia	Oriental	Realistic
Representational	Southwestern	Sports
Still life	Traditional	Western

Media we carry:

Acrylic	Airbrush	Bronze
Ceramic	Charcoal	Collage
Drawing	Fibre Arts	Glass
Mixed Media	Oil	Paper Sculpture
Pastel	Pencil	Pen & Ink
Photography	Pottery	Prints
Sculpture	Silkscreen	Tempra
Watercolor		

Our target market:

Consultants	Museums	Corporations
Restaurants	Medical Facilities	Architects
Private Collectors	Offices	Hotel/Motel
Walk-ins	Interior Decorators	

To contact us: Submit portfolio (brochure, statement, slides, etc.) for review/query with resumé/send slides/photos by mail for consideration/Include SASE
Specific time of year we review work: Anytime
Type/style of artwork that has the best chance of being purchased by our clients in the next two years: Realistic and impressionistic art in all media, $500-$2500 average retail cost.

❖ Saper Galleries

Roy C Saper
433 Albert Ave, E Lansing, MI 48823
517/351-0815

We sell: Originals Limited Editions
Frames
Our gallery works with corporations collecting art.
We are seeking both new and established talent.
Year gallery was established: 1986
Gallery hours: Mon-Fri 10-6; Thurs 10-9
Number of shows each year: 2 major shows
Commission gallery takes: Varies
Number of artists represented: 100
Gallery is insured.
Geographical limitations to artists we represent: None
The gallery assumes cost of:

Openings	Advertising	Installations

Styles we carry:

Abstract	African-American	Classic
Conceptual	Contemporary	Equestrian
Erotic	Ethnic	Fantasy
Figurative	Floral	Impressionism
Landscape	Latin American	Marine
Minimal	Modernism	Native American
New Age	Oriental	POP
Realistic	Representational	Romantic
Southwestern	Still life	Surrealism
Traditional	Visionary	Western

Media we carry:

Acrylic	Airbrush	Bronze
Collage	Colored Pencil	Drawing
Fibre Arts	Glass	Marble
Mixed Media	Oil	Paper Sculpture
Pastel	Pencil	Pen & Ink
Prints	Sculpture	Silkscreen
Tempra	Watercolor	

Our target market:

Consultants	Museums	Corporations
Restaurants	Medical Facilities	Architects
Private Collectors	Interior Designers	Offices
Schools	Hotel/Motel	Tourists
Walk-ins		

Advice we can offer to artists interested in being represented by our gallery: Must be of phenomenal quality; student-quality work is not considered.
To contact us: Send slides/photos by mail for consideration.
Specific time of year we review work: Anytime
Type/style of artwork that has the best chance of being purchased by our clients in the next two years: Any and all of outstanding quality.

❖ International Art Collections/IAC & Frameworld

Howard Plaggemars
221-223 N River Ave, Holland, MI 49424
616/396-6300 616/396-1099 Fax

We sell: Originals Limited Editions
Posters Frames Restorations
Appraisals
Our gallery works with corporations collecting art.
We are seeking established talent mostly through referrals.
Year gallery was established: 1984
Gallery hours: Mon-Sat 10-6
Number of shows each year: 4
Commission gallery takes: 50%
Number of artists represented: 20
Gallery is insured.
The gallery assumes cost of:

Openings	Advertising	Installations

Styles we carry:

Abstract	African-American	Animals
Classic	Contemporary	Figurative
Floral	Historic	Impressionism
Landscape	Marine	Modernism
Nostalgia	Oriental	Realistic
Representational	Romantic	Southwestern
Still life	Traditional	Wildlife

Media we carry:

Acrylic	Charcoal	Collage
Colored Pencil	Drawing	Installations
Oil	Paper Sculpture	Pastel
Pencil	Pen & Ink	Prints
Silkscreen	Tempra	Watercolor

Our target market:

Corporations	Restaurants	Architects
Private Collectors	Interior Designers	Commercial
Offices	Hotel/Motel	Tourists
Walk-ins		

Advice we can offer to artists interested in being represented by our gallery: Develop limited editions
To contact us: Send slides/photos by mail for consideration.
Specific time of year we review work: Spring
Type/style of artwork that has the best chance of being purchased by our clients in the next two years: Shoreline scenes

❖ CG Rein Galleries
Heather Anderson
3205 Galleria, Edina, MN 55435
612/927-4331 612/927-5276 Fax

We sell: Originals Limited Editions Posters Framing services
Our gallery works with corporations collecting art.
Year gallery was established: 1977
Gallery hours: Mon-Fri 10-9; Sat 10-6; Sun 12-5
Number of shows each year: 2-3
Commission gallery takes: Varies
Number of artists represented: Many
Gallery is insured.
Geographical limitations to artists we represent: None
The gallery assumes cost of:
Openings Advertising Installations Promotion (brochures, etc.)
Styles we carry:

Abstract	Contemporary	Equestrian
Figurative	Floral	Historic
Impressionism	Landscape	Minimal
Modernism	Oriental	Realistic
Representational	Romantic	Southwestern
Still life	Surrealism	Traditional
Western	Wildlife	

Media we carry:

Acrylic	Bronze	Collage
Colored Pencil	Drawing	Fibre Arts
Marble	Mixed Media	Oil
Pastel	Pencil	Pen & Ink
Prints	Sculpture	Tempra
Watercolor		

Our target market:

Corporations	Restaurants	Medical Facilities
Architects	Private Collectors	Interior Decorators
Offices	Hotel/Motel	Tourists
Walk-ins	Educational Facilities	

Advice we can offer to artists interested in being represented by our gallery: We try to rent or sell to corporations. We have over 30,000 pieces available.
To contact us: Send slides/photos by mail for consideration.
Specific time of year we review work: Anytime
Type/style of artwork that has the best chance of being purchased by our clients in the next two years: Contemporary, abstracts, figurative, sculpture, etc.

❖ Daley Gallery
Bill Daley
1016 Nicollet Mall, Minneapolis, MN 55403
612/333-4922

We sell: Originals
We are seeking both new and established talent mostly through referrals.
Year gallery was established: 1975
Number of shows each year: 2
Gallery is insured.
Styles we carry:

Abstract	Impressionism	Landscape
Naive	Realistic	Religious

Media we carry:

Acrylic	Airbrush	Colored Pencil
Pastel	Watercolor	

Our target market:
Private Collectors Tourists Walk-ins
Specific time of year we review work: Anytime

❖ Jean Stephen Galleries Inc
Steve and Jean Danio
914 Nicollet Mall, Minneapolis, MN 55402
612/338-4333 612/337-8435 Fax

We sell: Originals Limited Editions Frames
Our gallery works with corporations collecting art.
 Corporate Consultant: Steven Danio
We are seeking both new and established talent.
Year gallery was established: 1987
Gallery hours: Mon-Sat 10-6
Number of shows each year: 4
Commission gallery takes: 50%

Galleries

Number of artists represented: 12
Gallery is insured.
The gallery assumes cost of:

Openings	Advertising	Installations
Promotion (brochures, etc.)		

Styles we carry:

Abstract	Classic	Conceptual
Contemporary	Ethnic	Figurative
Impressionism	Latin American	Modernism
Naive	Oriental	Surrealism

Media we carry:

Acrylic	Airbrush	Bronze
Ceramic	Clay	Collage
Drawing	Glass	Marble
Mixed Media	Oil	Pastel
Pencil	Pen & Ink	Prints
Sculpture	Silkscreen	Tempra

Our target market:

Corporations	Private Collectors	Interior Decorators
Tourists	Walk-ins	

To contact us: Arrange a personal interview to show portfolio/submit portfolio (brochure, statement, slides, etc.) for review/query with resumé/send slides/photos by mail for consideration.

Specific time of year we review work: Anytime

❖ Grand Avenue Frame & Gallery

Brian J Valento
964 Grand Ave, St Paul, MN 55105
612/224-9716

We sell:

	Originals	Limited Editions
Craft	Frames	

We are seeking both new and established talent.
Year gallery was established: 1978
Gallery hours: Mon-Fri 10-6, Sat 10-4
Number of shows each year: 2-4
Commission gallery takes: 40%
Number of artists represented: 18
Gallery is insured.
Geographical limitations to artists we represent: None
The gallery assumes cost of:

Openings	Advertising	Return of artwork
Promotion (brochures, etc.)		

Styles we carry: Representational
Media we carry:

Ceramic	Clay	Etchings
Fibre Arts	Glass	Lithography
Photography	Pottery	Prints

Our target market:
Private Collectors Walk-ins
To contact us: Send slides/photos by mail for consideration.

Specific time of year we review work: Anytime

❖ The Source Fine Arts

Denyse Ryan Johnson
4137 Pennsylvania, Kansas City, MO 64111
816/931-8282 816/931-8283 Fax

We sell:

	Originals	Limited Editions
Posters	Frames	

Our gallery works with corporations collecting art.
We are seeking both new and established talent mostly through referrals.
Year gallery was established: 1985
Gallery hours: Mon-Fri 9-5, Sat 11-4
Commission gallery takes: 50%
Gallery is insured.
Geographical limitations to artists we represent:
Midwest and West Coast
The gallery assumes cost of:

Openings	Advertising	Installations
Partial promotion (brochures, etc.)		
Transportation of artwork from gallery		

Styles we carry:

Abstract	Conceptual	Contemporary
Impressionism	Landscape	Minimal
Realistic	Representational	Still life

Media we carry:

Acrylic	Bronze	Ceramic
Fibre Arts	Glass	Mixed Media
Oil	Paper Sculpture	Pastel
Prints	Sculpture	Silkscreen
Watercolor		

Our target market:

Corporations	Medical Facilities	Architects
Private Collectors	Interior Designers	Offices
Tourists		

Advice we can offer to artists interested in being represented by our gallery: Artists should have a professional exhibition and sales record.
To contact us: Submit portfolio (brochure, statement, slides, etc.) for review/send slides/photos by mail for consideration.
Type/style of artwork that has the best chance of being purchased by our clients in the next two years: Nonobjective or abstract paintings, impressionistic landscape paintings, ceramic and glass art

❖ Gomes Gallery Inc

Larry Gomes
7513 Forsyth Blvd, St Louis, MO 63105
314/725-1808 314/725-2870 Fax

We sell:

	Originals	Limited Editions
Frames		

Our gallery works with corporations collecting art.
We are seeking both new and established talent.
Year gallery was established: 1985
Gallery hours: Mon-Thurs 10-6, Fri-Sat 10-8, Sun 11-4
Number of shows each year: 5

Commission gallery takes: 50%
Number of artists represented: 70
Gallery is insured.
Geographical limitations to artists we represent: None
The gallery assumes cost of:

Openings Advertising Installations
Promotion (brochures, etc.)

Styles we carry:

Native American Still life Southwestern
Western Wildlife

Media we carry:

Acrylic Airbrush Bronze
Ceramic Clay Colored Pencil
Drawing Glass Marble
Mixed Media Oil Paper Sculpture
Pastel Pottery Prints
Sculpture Silkscreen Tempra
Watercolor

Our target market:

Consultants Corporations Restaurants
Architects Private Collectors Interior Decorators
Offices Tourists Walk-ins

Advice we can offer to artists interested in being represented by our gallery: Send photos/slides, include medium, size and suggested retail
To contact us: Submit portfolio (brochure, statement, slides, etc.) for review/send slides/photos by mail for consideration.
Specific time of year we review work: Jan-Nov
Type/style of artwork that has the best chance of being purchased by our clients in the next two years: Western and Southwestern

❖ Harriette's Gallery

Harriette Stewart
510 1st Ave N #115, Great Falls, MT 59405
406/761-0881 Fax

We sell: Originals Limited Editions
Old masters
We are seeking both new and established talent.
Year gallery was established: 1970
Gallery hours: Mon-Fri 1:30-4:30
Number of shows each year: 1
Commission gallery takes: 33%
Number of artists represented: 20
Gallery is insured: Artist must insure if consigned.
The gallery assumes cost of: Advertising
Styles we carry:

Animals Floral Landscape
Western Wildlife

Media we carry:

Acrylic Bronze Charcoal
Mixed Media Oil Paper Sculpture
Pastel Pen & Ink Photography
Pottery Sculpture Watercolor

Our target market:

Stores Private Collectors Tourists
Walk-ins

To contact us: Send slides/photos by mail for consideration.
Specific time of year we review work: September
Type/style of artwork that has the best chance of being purchased by our clients in the next two years: Wildlife

❖ Sutton West Gallery

Geoffrey Sutton
121 W Broadway, Missoula, MT 59802
406/721-5460

We sell: Originals
We are seeking both new and established talent.
Year gallery was established: 1983
Gallery hours: Mon-Sat
Number of shows each year: 15
Commission gallery takes: 40%
Number of artists represented: 75
Gallery is insured.
The gallery assumes cost of:

Openings Advertising Installations
Promotion (brochures, etc.)
One-way transportation of artwork

Styles we carry:

Abstract Conceptual Contemporary
Figurative Floral Impressionism
Landscape POP Realistic
Representational Still life Traditional

Media we carry:

Acrylic Bronze Ceramic
Collage Colored Pencil Computer Art
Drawing Fibre Arts Glass
Installations Marker Mixed Media
Oil Pastel Pencil
Pen & Ink Pottery Sculpture
Silkscreen Watercolor

Our target market:

Private Collectors Offices Tourists
Walk-ins

To contact us: Submit portfolio (brochure, statement, slides, etc.) for review.
Specific time of year we review work: August

❖ Richardson Gallery of Fine Art

Mark Richardson/Owner George Bamburg/Director
3670 S Virginia St, Reno, NV 89502
702/828-0888 702/828-4329 Fax

We sell: Originals Limited Editions
Posters Frames
Our gallery works with corporations collecting art.
 Corporate Consultant: Cathy Riley

Galleries

We are seeking both new and established talent.
Year gallery was established: 1993
Gallery hours: Daily 10:30-6:30
Number of shows each year: 5
Commission gallery takes: 55%
Number of artists represented: 325
Gallery is insured.
Geographical limitations to artists we represent:
International
The gallery assumes cost of:

Openings	Advertising	Installations
Promotion (brochures, etc.)		

Styles we carry:

Classic	Contemporary	Equestrian
Figurative	Floral	Impressionism
Landscape	Latin American	Naive
Oriental	Portraits	Realistic
Representational	Romantic	Still life
Surrealism	Tropical	Visionary
Western	Wildlife	Women

Mediums of artwork we carry:

Acrylic	Airbrush	Bronze
Ceramic	Computer	Glass
Marble	Mixed Media	Oil
Pastel	Photography	Prints
Sculpture	Silkscreen	Tempra
Watercolor		

Our target market:

Corporations	Private Collectors	Interior Designers
Tourists	Walk-ins	

To contact us: Send slides/photos by mail for consideration.
Type/style of artwork that has the best chance of being purchased by our clients in the next two years: Unique, stylized, creative paintings, retailing between $1,000 and 5,000.

❖ McGowan Fine Art Inc

Mary McGowan/Owner Terri Towle/Director
10 Hills Ave, Concord, NH 03301
603/225-2515 603/225-7791 Fax

We sell: Originals Frames
Our gallery works with corporations collecting art.
 Corporate Consultant: Mary McGowan
We are seeking established and new talent mostly through referrals.
Year gallery was established: 1980
Gallery hours: Mon-Fri 9-5, Sat 10-2
Number of shows each year: 10
Number of artists represented: 30
Gallery is insured.
Geographical limitations to artists we represent: Prefer New England region
Styles we carry:

Abstract	Animals	Contemporary
Landscape	Naive	Representational
New England		

Media we carry:

Acrylic	Bronze	Charcoal
Collage	Drawing	Fibre Arts
Installations	Marble	Mixed Media
Oil	Pastel	Pen & Ink
Photography	Prints	Sculpture
Tempra	Watercolor	

Our target market:

Corporations	Medical Facilities	Private Collectors
Offices	Schools	Walk-ins

To contact us: Send slides/photos by mail for consideration.
Specific time of year we review work: Monthly
Type/style of artwork that has the best chance of being purchased by our clients in the next two years: Work in a unique voice—abstract, figurative or landscape from established or emerging artists.

❖ Askton Gallery

W A Stretch
PO Box 814, Kims Ct, Keene, NH 03431
603/357-3317

We sell: Limited Editions Posters
Frames
Our gallery works with corporations collecting art.
 Corporate Consultant: Evan John
We are seeking both new and established talent.
Year gallery was established: 1984
Gallery hours: Mon-Fri 9-5:30; Sat 9-3:30
Gallery is insured.
Styles we carry:

Aviation	Floral	Landscape
Military	Nostalgia	Realistic
Southwestern	Still life	Traditional
Wildlife		

Media we carry: Prints
Our target market:

Consultants	Corporations	Medical Facilities
Architects	Commercial Offices	

Advice we can offer to artists interested in being represented by our gallery: Provide affordable, traditional limited edition prints.
To contact us: Send slides/photos by mail for consideration.
Specific time of year we review work: Anytime

❖ Perfection Framing

Valerie Little
213 Rockingham Rd, Londonderry, NH 03053
603/434-7939 Telephone/Fax

We sell: Originals Limited Editions
Posters Frames
Our gallery works with corporations collecting art.
We are actively seeking both new and established talent.

Year gallery was established: 1986
Gallery hours: Tues-Sat 10-6
Number of shows each year: 4-5
Commission gallery takes: 25%
Number of artists represented: 100
Gallery is insured.
Geographical limitations to artists we represent: New England for originals
The gallery assumes cost of:

Openings	Advertising	Installations
Promotion (brochures, etc.)		

Styles we carry:

Animals	Aviation	Contemporary
Floral	Impressionism	Landscape
Nostalgia	Realistic	Romantic
Still life	Traditional	Western
Wildlife		

Media we carry:

Charcoal	Fibre Arts	Glass
Pastel	Pen & Ink	Photography
Prints	Watercolor	

Our target market:

Consultants	Corporations	Restaurants
Medical Facilities	Architects	Private Collectors
Interior Designers	Offices	Tourists
Walk-ins		

To contact us: Send slides/photos by mail for consideration.
Specific time of year we review work: All year, but mainly Jan/Feb

❖ Everhart Gallery
Nancy Everhart-Mordacai
117 S Maple Ave, Basking Ridge, NJ 07920
908/221-9007

We sell:

	Originals	Limited Editions
Posters	Frames	Notecards

Our gallery works with corporations collecting art.
We are seeking both new and established talent mostly through referrals.
Year gallery was established: 1978
Number of shows each year: 7
Gallery is insured.
Geographical limitations to artists we represent: Somerset County artists with national reputations
The gallery assumes cost of:

Openings	Installations
Promotion (brochures, etc.)	

Styles we carry:

Abstract	Animals	Aviation
Contemporary	Equestrian	Floral
Historic	Impressionism	Minimal
Native American	Oriental	Portraits
Representational	Romantic	Still life
Traditional	Wildlife	

Media we carry:

Acrylic	Bronze	Ceramic
Clay	Collage	Colored Pencil
Drawing	Fibre Arts	Glass
Marble	Mixed Media	Oil
Paper Sculpture	Pastel	Pencil
Pen & Ink	Photography	Sculpture
Silkscreen	Tempra	Watercolor

Our target market:

Consultants	Stores	Museums
Corporations	Restaurants	Medical Facilities
Architects	Private Collectors	Interior Decorators
Offices	Schools	Hotel/Motel
Tourists	Walk-ins	

Advice we can offer to artists interested in being represented by our gallery: Call or come into gallery
To contact us: Arrange a personal interview to show portfolio/send slides/photos by mail for consideration.
Specific time of year we review work: Spring & Fall
Type/style of artwork that has the best chance of being purchased by our clients in the next two years: Realistic, conservative watercolors, pastels, oil

❖ Scherer Gallery
Marty Scherer/Tess Scherer
93 School Road W, Marlboro, NJ 07746
908/536-9465 908/536-8475 Fax

We sell:
Originals Hand-pulled Limited Editions
Our gallery works with corporations collecting art.
We are seeking established talent mostly through referrals.
Year gallery was established: 1968
Gallery hours: Wed-Sun 10-5
Number of shows each year: 5
Commission gallery takes: 50%
Number of artists represented: 30
Gallery is insured.
Geographical limitations to artists we represent: None
Styles we carry:

Abstract	Latin American	Minimal
Modernism	Surrealism	

Media we carry:

Drawings	Etchings	Lithographs
Sculpture	Silkscreen	Watercolor

Our target market: Private collectors
To contact us: Query with resumé

❖ Adobe East Gallery
Phyllis Schwartz
445 Springfield Ave, Summit, NJ 07901
908/273-8282 908/277-1483 Fax

We sell: Originals Limited Editions
Our gallery works with corporations collecting art.
Corporate Consultant: Ian Schwartz

We are seeking both new and established talent.
Year gallery was established: 1977
Gallery hours: Tues-Sat 9:30-5:30
Number of shows each year: 5-6
Commission gallery takes: 50%
Number of artists represented 20+
Gallery is insured.
Geographical limitations to artists we represent: 50-mile radius
The gallery assumes cost of:

Openings	Advertising	Installations

Styles we carry:

Native American	Portraits	Realistic
Southwestern	Western	

Media we carry:

Acrylic	Airbrush	Bronze
Ceramic	Charcoal	Clay
Collage	Colored Pencil	Drawing
Fibre Arts	Glass	Marble
Mixed Media	Oil	Pastel
Pencil	Pen & Ink	Pottery
Sculpture	Silkscreen	Tempra
Watercolor		

Our target market:

Architects	Private Collectors Walk-ins

To contact us: Submit portfolio (brochure, statement, slides, etc.) for review/send slides/photos by mail for consideration.
Specific time of year we review work: Anytime
Type/style of artwork that has the best chance of being purchased by our clients in the next two years: Oil paintings of the southwest

❖ Age of the Oil
LPVR
1045A Stuyvesant Ave, Union, NJ 07083
908/687-1244

We sell:

Limited Editions	Posters	Frames

Year gallery was established: 1975
Gallery hours: Tues-Sat 11-5

❖ Adobe Patio Gallery
Henry and Carolyn Bunch
Box 697, 1885 Boutz Rd, Mesilla, NM
505/524-7091

We sell: Originals
Artist's prints (not mechanical reproductions)
Our gallery works with corporations collecting art.
 Corporate Consultant: Sheila Duffy
We are seeking established talent mostly through referrals.
Year gallery was established: 1985
Gallery hours: Tues-Sun 11-5
Number of shows each year: 2-3
Commission gallery takes: 35%

Number of artists represented: 25-30
Geographical limitations to artists we represent: None
The gallery assumes cost of:

Openings	Installations
Promotion (brochures, etc.)	

Styles we carry:

Classic	Ethnic	Figurative
Floral	Impressionism	Landscape
Latin American	Portraits	Realistic
Representational	Southwestern	Still life
Traditional		

Mediums of artwork we carry:

Acrylic	Bronze	Ceramic
Clay	Collage	Glass
Marble	Mixed Media	Oil
Pastel	Pen & Ink	Pottery
Prints	Sculpture	Silkscreen
Watercolor		

Our target market:

Corporations	Medical Facilities	Private Collectors
Interior Designers	Offices	Tourists
Walk-ins		

Advice we can you offer to artists interested in being represented by our gallery: Take time to see the work represented in a gallery and determine if yours would fit
To contact us: Arrange a personal interview to show portfolio/submit portfolio (brochure, statement, slides, etc.) for review.
Specific time of year we review work: Anytime
Type/style of artwork that has the best chance of being purchased by our clients in the next two years: Southwestern in theme, priced between $300-1,000.

❖ Eden Gallery
Michelle Rogers/Owner Doug Rogers/Director
1 Mariano Rd, Santa Fe, NM 87505
505/474-3319

We sell: Originals Limited Editions
We are seeking both new and established talent.
Year gallery was established: 1993
Gallery hours: Mon-Sat 10-8; Sun 11-6
Commission gallery takes: 50%
Number of artists represented: 50
Gallery is insured.
Geographical limitations to artists we represent: Prefer Santa Fe area or New Mexico artists, but will consider others
Styles we carry:

Alternative	Animals	Classic
Conceptual	Erotic	Ethnic
Fantasy	Figurative	Impressionism
Native American	Representational	Romantic
Southwestern	Surrealism	Traditional
Visionary	Western	Wildlife

Media we carry:

Bronze	Charcoal	Clay
Drawing	Glass	Marble
Pen & Ink	Pottery	Prints
Sculpture		

Our target market:

Private Collectors Interior Designers Tourists
Walk-ins

Advice we can offer to artists interested in being represented by our gallery: We sell mostly 3-dimensional art; 2-dimensional art isn't big in this location

To contact us: Submit portfolio (brochure, statement, slides, etc.) for review/send slides/photos by mail for consideration.

Specific time of year we review work: Anytime

Type/style of artwork that has the best chance of being purchased by our clients in the next two years: Metal sculpture (small) and bronzes, carved gems/stones, jewelry

❖ Kirkland-Wade Fine Arts of the West

Skip Kirkland/Joe Wade
102 E Water St, Santa Fe, NM 87501
505/982-1640 505/988-2725 Fax

We sell: Originals
Our gallery works with corporations collecting art.
We are seeking established talent mostly through referrals.
Year gallery was established: 1971
Gallery hours: Mon-Sat 10-6; Sun 10-4
Number of shows each year: 6
Commission gallery takes: Varies
Number of artists represented: 18
Gallery is insured.
The gallery shares cost of: Openings
Styles we carry:

Figurative	Landscape	Representational
Traditional	Western	Wildlife

Media we carry:

Acrylic	Bronze	Oil
Pen & Ink	Sculpture	Watercolor

Our target market:

Museums	Corporations	Private Collectors
Interior Designers	Tourists	Walk-ins

To contact us: Send slides/photos by mail for consideration.

Specific time of year we review work: Anytime

Type/style of artwork that has the best chance of being purchased by our clients in the next two years: Western/realistic

❖ Great Liberty Craft and Trading Co

Walter R Keller
31 S Main St, Liberty, NY 12754
914/292-3460

We sell: Originals Limited Editions
Handmade crafts
We are seeking both new and established talent.
Year gallery was established: 1976
Gallery hours: Mon-Sun 10-5:30
Number of shows each year: Ongoing
Commission gallery takes: 40%
Number of artists represented: 50-100
Gallery is insured.
Geographical limitations to artists we represent: Within the Western Hemisphere
Styles we carry: Art Deco
Media we carry:

Ceramic	Glass	Mixed Media
Pottery		

Our target market: Tourists Walk-ins
To contact us: Send slides/photos by mail for consideration.

Type/style of artwork that has the best chance of being purchased by our clients in the next two years: Art deco

❖ S Zucker Gallery Ltd

Sandra Zucker
17 Brookline Wy, New City, NY 10956
914/634-4414

We sell: Originals Limited Editions
Posters Frames Sculpture
Our gallery works with corporations collecting art.
We are seeking established talent mostly through referrals.
Year gallery was established: 1984
Gallery hours: By appointment
Number of shows each year: 2
Commission gallery takes: 50%
Number of artists represented: 30
Geographical limitations to artists we represent: None
The gallery assumes cost of:

Openings	Advertising	Installations
Promotion (brochures, etc.)		

Styles we carry:

Abstract	African-American	Animals
Aviation	Classic	Conceptual
Contemporary	Equestrian	Ethnic
Fantasy	Figurative	Floral
Historic	Impressionism	Landscape
Latin American	Marine	Military
Minimal	Modernism	Naive
Native American	New Age	Nostalgia
Oriental	POP	Portraits
Realistic	Representational	Romantic
Sci-Fi	Southwestern	Sports
Still life	Surrealism	Traditional
Tropical	Visionary	Western
Wildlife		

Galleries

Media we carry: All
Our target market:

Consultants	Stores	Museums
Corporations	Restaurants	Medical Facilities
Architects	Private Collectors	Interior Decorators
Offices	Hotel/Motel	

To contact us: Send slides/photos by mail for consideration.
Specific time of year we review work: Anytime

❖ Elaine Wechsler Gallery
Elaine Wechsler
245 W 104 St #5B, New York, NY 10025
212/222-3619

We sell: Originals
We are seeking both new and established talent.
Year gallery was established: 1985
Gallery hours: By appointment
Number of shows each year: Varies
Commission gallery takes: 50%
Number of artists represented: 10
Gallery is insured.
Geographical limitations to artists we represent: None
Styles we carry:

Abstract	Figurative	Historic
Landscape	Latin American	Representational
Traditional	Visionary	

❖ Jadite Galleries
Roland Sainz
413-415 W 50th St, New York, NY 10019
212/315-2740 Telephone/Fax

We sell: Originals Limited Editions
Our gallery works with corporations collecting art.
We are seeking both new and established talent.
Year gallery was established: 1985
Gallery hours: Mon-Sat 11-6
Number of shows each year: 30 (two galleries)
Commission gallery takes: 40%
Number of artists represented: 25
Gallery is insured.
Geographical limitations to artists we represent:
International
The gallery assumes 50% of the cost of:

Openings	Advertising	Installations
Promotion (brochures, etc.)		

Styles we carry:

Abstract	Conceptual	Contemporary
Figurative	Floral	Impressionism
Landscape	Latin American	Oriental
Realistic	Religious	Representational

Media we carry:

Acrylic	Bronze	Charcoal
Clay	Collage	Colored Pencil
Computer	Drawing	Marble
Mixed Media	Oil	Pastel
Pencil	Pen & Ink	Photography
Prints	Sculpture	Tempra
Watercolor		

Our target market:

Consultants	Corporations	Architects
Private Collectors	Interior Decorators	

To contact us: Arrange a personal interview to show portfolio/submit portfolio (brochure, statement, slides, etc.) for review/query with resumé/send slides/photos by mail for consideration.
Specific time of year we review work: One day per month
Type/style of artwork that has the best chance of being purchased by our clients in the next two years: Good work

❖ The Landon Gallery at Lincoln Center
Annette Landon
1926 Broadway, New York, NY 10023
212/721-1716 212/721-2313 Fax

We sell: Originals Limited Editions
Our gallery works with corporations collecting art.
 Corporate Consultant: Annette or Christophe Landon
We are seeking both new and established talent mostly through referrals.
Year gallery was established: 1993
Gallery hours: Mon-Fri 10-7; Sat 12-6
Number of shows each year: 4
Commission gallery takes: 50%
Number of artists represented: 8
Gallery is insured.
Geographical limitations to artists we represent: Since transportation costs are up to artist
The gallery assumes cost of:

Openings	Advertising
Promotion (brochures, etc.)	

Styles we carry:

Abstract	African-American	Contemporary
Erotic	Figurative	Oriental
Surrealism		

Media we carry: All
Our target market:

Corporations	Restaurants	Private Collectors
Interior Designers	Offices	

To contact us: Submit portfolio (brochure, statement, slides, etc.) for review/send slides/photos by mail for consideration.
Type/style of artwork that has the best chance of being purchased by our clients in the next two years: Very hard to predict

❖ Miller Gallery

R Kenneth Miller
560 Broadway, New York, NY 10012
212/226-0702 212/334-9391 Fax

We sell: Originals
Our gallery works with corporations collecting art.
 Corporate Consultant: Elinore Miller
We are seeking both new and established talent.
Year gallery was established: 1986
Gallery hours: Tues-Sat 11-6
Number of shows each year: 10
Commission gallery takes: 50%
Number of artists represented: 50
Gallery is insured.
Geographical limitations to artists we represent: None
The gallery assumes cost of:

Openings	Advertising	Installations

Promotion (brochures, etc.)
Styles we carry:

Abstract	Conceptual	Contemporary
Figurative		

Media we carry:

Glass	Mixed Media	Sculpture
Metal	Jewelry (one-of-a-kind)	

Our target market:

Consultants	Museums	Corporations
Restaurants	Architects	Private Collectors
Offices	Tourists	Walk-ins
Interior Decorators		

Advice we can offer to artists interested in being represented by our gallery: Come in and see the gallery (or send someone in) before submitting query or portfolio. Make sure this is the right place for your work.
To contact us: Query with resumé.
Specific time of year we review work: Ongoing
Type/style of artwork that has the best chance of being purchased by our clients in the next two years: Sculpture in glass and mixed media, both abstract and figurative

❖ O'Leary Associates Fine Art

Brian O'Leary
342 E 65th St #5RW, New York, NY 10021-6796
212/628-5322

We sell:	Originals	Limited Editions
Antiques	Paintings	Prints

Our gallery works with corporations collecting art.
We are seeking both new and established talent.
Year gallery was established: 1982
Gallery hours: Daily 11-6
Number of shows each year: Ongoing
Commission gallery takes: 50%
Number of artists represented: 12
Gallery is insured.

Styles we carry:

Abstract	Conceptual	Contemporary
Figurative	Religious	Representational

Media we carry:

Acrylic	Bronze	Collage
Drawing	Installations	Mixed Media
Pastel	Pencil	Sculpture
Silkscreen		

Our target market:

Consultants	Museums	Corporations
Private Collectors	Offices	Interior Decorators

To contact us: Phone
Specific time of year we review work: Spring & Fall
Type/style of artwork that has the best chance of being purchased by our clients in the next two years: Classical realism, abstract painting and numbered works on paper

❖ Savacou Gallery

Loris Crawford
240 E 13th St, New York, NY 10003
212/473-6904 212/529-2923 Fax

We sell:	Originals	Limited Editions
Posters	Frames	

Styles we carry: African-American

❖ The Exposures Gallery

Nick Zungoli
PO Box 5, Kings Hwy, Sugar Loaf, NY 10981
914/469-9382

We sell:	Originals	Limited Editions
Posters		

Our gallery works with corporations collecting art.
 Corporate Consultant: Jan Fusco Block
We are seeking both new and established talent.
Year gallery was established: 1979
Gallery hours: Weds-Sun 11-5
Number of shows each year: 4
Commission gallery takes: 25%
Number of artists represented: 4
Gallery is insured.
The gallery assumes cost of:

Openings	Advertising	Installations

Promotion (brochures, etc.)
Media we carry: Photography
Our target market:

Consultants	Private Collectors	Interior Decorators
Tourists	Walk-ins	

To contact us: Submit portfolio (brochure, statement, slides, etc.) for review.
Specific time of year we review work: Anytime

Galleries

❖ Jerald Melberg Gallery

Jerald Melberg
3900 Colony Rd, Charlotte, NC 28211
704/365-3000 704/365-3016 Fax

We sell: Originals
Our gallery works with corporations collecting art.
We are seeking both new and established talent.
Year gallery was established: 1983
Gallery hours: Mon-Sat 10-6
Number of shows each year: 8-10
Commission gallery takes: 50%
Number of artists represented: 25
Gallery is insured.
Geographical limitations to artists we represent: None
The gallery assumes cost of:

Advertising (some)	Installations
Promotion (brochures, etc.) (split)	Openings
Transportation of artwork (split)	

Styles we carry:

Abstract	Classic	Contemporary
Floral	Impressionism	Landscape
Realistic	Representational	Still life
Traditional		

Media we carry:

Acrylic	Collage	Mixed Media
Oil	Pastel	Sculpture
Watercolor		

Our target market:

Museums	Private Collectors

To contact us: Send slides/photos by mail for consideration.
Specific time of year we review work: Anytime
Type/style of artwork that has the best chance of being purchased by our clients in the next two years: Representational

❖ Clark Art

Owen Walker
300 Glenwood Ave, Raleigh, NC 27603
919/832-8319 919/833-2535 Fax

We sell:	Originals	Limited Editions

Our gallery works with corporations collecting art.
We are seeking both new and established talent.
Year gallery was established: 1923
Number of shows each year: 4
Number of artists represented: 50
Gallery is insured.
Geographical limitations to artists we represent: None
Styles we carry:

Equestrian	Floral	Historic
Impressionism	Landscape	Latin American
Marine	Oriental	Realistic
Representational	Romantic	Still life
Traditional		

Media we carry:

Acrylic	Oil	Pastel
Prints	Watercolor	

Our target market:
Private Collectors Walk-ins
Advice we can offer to artists interested in being represented by our gallery: Offer good work.
To contact us: Send slides/photos by mail for consideration.
Type/style of artwork that has the best chance of being purchased by our clients in the next two years: Impressionism

❖ Village Smith Galleries Inc

Gary Smith/Steve Hickman
119-A Reynolda Village, Winston-Salem, NC 27103
910/724-3134 910/723-9050 Fax

We sell:	Originals	Limited Editions
Posters	Frames	Fine crafts

Our gallery works with corporations collecting art.
We are seeking both new and established talent.
Year gallery was established: 1977
Gallery hours: Tues-Sat 10-5
Number of shows each year: 3-5
Commission gallery takes: 50%
Number of artists represented: Varies; 50-60%
Gallery is insured. Artists will insure their work also.
Geographical limitations to artists we represent: None
The gallery assumes cost of:

Openings	Advertising	Installations

Styles we carry:

Abstract	Classic	Contemporary
Figurative	Floral	Historic
Impressionism	Landscape	Realistic
Religious	Representational	Sports
Still life	Traditional	Tropical
Wildlife		

Media we carry:

Acrylic	Bronze	Ceramic
Clay	Collage	Drawing
Glass	Mixed Media	Oil
Pottery	Prints	Sculpture
Silkscreen	Watercolor	

Our target market:

Consultants	Medical Facilities	Private Collectors
Offices	Tourists	Walk-ins
Interior Decorators		

Advice we can offer to artists interested in being represented by our gallery: We are highly selective—must have exceptional work!
To contact us: Arrange a personal interview to show portfolio/submit portfolio (brochure, statement, slides, etc.) for review.
Specific time of year we review work: Jan-Aug
Type/style of artwork that has the best chance of being purchased by our clients in the next two years: Sophisticated, quality works

❖ The Gold Medal Gallery
Pam McMillan
2151 Murray Hill Rd, Cleveland, OH 44106
216/721-4114 Telephone/Fax

We sell: Originals Limited Editions
We are seeking both new and established local talent.
Year gallery was established: 1990
Gallery hours: Wed-Sun 12-6; Fri-Sat 12-8
Number of shows each year: 6-8
Commission gallery takes: 30%
Number of artists represented: 30+
Gallery is insured. Individual artists also carry coverage on work over $500.
Geographical limitations to artists we represent: Local (NE Ohio)
The gallery assumes cost of:
Openings Advertising Installations
Promotion (brochures, etc.)
Styles we carry:

Alternative	Classic	Conceptual
Contemporary	Equestrian	Ethnic
Fantasy	Figurative	Impressionism
Landscape	Modernism	Native American
New Age	Nostalgia	Oriental
Representational	Romantic	Southwestern
Still life	Surrealism	Traditional
Western	Wildlife	Decorative
Functional	Wearable	

Media we carry:

Acrylic	Bronze	Ceramic
Charcoal	Clay	Collage
Colored Pencil	Fibre Arts	Glass
Marble	Marker	Pastel
Pencil	Pen & Ink	Photography
Pottery	Prints	Sculpture
Silkscreen	Watercolor	

Our target market:
Private Collectors Tourists Walk-ins
Interior Decorators
Advice we can offer to artists interested in being represented by our gallery: Price it to sell, love what you are doing, have unique business cards.
To contact us: Arrange a personal interview to show portfolio/submit portfolio (brochure, statement, slides, etc.) for review. I like to see the artist and his/her work and for the artist to see the gallery.
Specific time of year we review work: Apr/May before June 1 Artwalk; Aug/Sep before the holidays
Type/style of artwork that has the best chance of being purchased by our clients in the next two years: Clients looking for quality for their dollar; unique one-of-a-kind—both functional and wearable—classics. Minimal art.

❖ Design Studio Gallery
Loren Naji
2905 Mayfield Rd, Cleveland Heights, OH
216/321-6644

We sell: Originals
Our gallery works with corporations collecting art.
We are actively seeking both new and established talent mostly through referrals.
Gallery hours: Tues-Sat 12-5
Number of shows each year: 5-7
Commission gallery takes: 40%
Geographical limitations to artists we represent: None
The gallery assumes cost of:
Openings Advertising Installations
Styles we carry:

Abstract	Alternative	Conceptual
Contemporary	Ethnic	Figurative
Impressionism	Landscape	Minimal
Portraits	Still life	Traditional

Media we carry:

Ceramic	Charcoal	Clay
Drawing	Mixed Media	Oil
Pencil	Pottery	Sculpture
Watercolor		

Our target market:
Stores Private Collectors Interior Decorators
Tourists Walk-ins
Advice we can offer to artists interested in being represented by our gallery: Quality; no shoddy, thrown together work
To contact us: Arrange a personal interview to show portfolio.
Specific time of year we review work: Anytime
Type/style of artwork that has the best chance of being purchased by our clients in the next two years: Ceramics and affordable paintings

❖ Gallery at Jung Haus
Jung Association of Central Ohio/J Claire Hogan
29 E Russell St, Columbus, OH 43215
614/621-8217

We sell: Originals Limited Editions
We are seeking both new and established talent, primarily from Ohio.
Year gallery was established: 1990
Gallery hours: Mon, Wed, Thurs 11-2; Sat 10-12
Number of shows each year: 6
Commission gallery takes: 10%
Gallery is insured.
Geographical limitations to artists we represent: Primarily Ohio
The gallery assumes cost of:
Openings Advertising Installations
Styles we carry: Interested in work that reveals the individual artist's path of individuation, particularly based on dreams, inner messages, etc.

Galleries

Media we carry:

Acrylic	Charcoal	Clay
Collage	Colored Pencil	Drawing
Fibre Arts	Mixed Media	Oil
Pastel	Pencil	Pen & Ink
Photography	Prints	Sculpture
Silkscreen	Watercolor	

Our target market:

Private Collectors Walk-ins

To contact us: Send slides/photos by mail for consideration.

Specific time of year we review work: Anytime

❖ Wile Kovach Gallery

Mary Wile Kovach
1417B Grandview Ave, Columbus, OH 43212
614/488-3323 Fax

We sell: Originals
We are seeking both new and established talent.
Year gallery was established: 1991
Gallery hours: Tues-Sat 10-6
Number of shows each year: 12
Commission gallery takes: 40%
Number of artists represented: 60
Gallery is insured.
Geographical limitations to artists we represent: None
The gallery assumes cost of: Openings
Styles we carry:

African-American	Animals	Classic
Equestrian	Ethnic	Figurative
Floral	Historic	Impressionism
Landscape	Latin American	Naive
Oriental	Portraits	Realistic
Representational	Romantic	Still life
Surrealism	Traditional	Wildlife

Media we carry:

Acrylic	Bronze	Ceramic
Charcoal	Clay	Collage
Colored Pencil	Drawing	Fibre Arts
Glass	Marble	Mixed Media
Oil	Pastel	Pencil
Pen & Ink	Pottery	Sculpture
Tempra	Watercolor	

Our target market:

Private Collectors	Tourists	Walk-ins
Interior Decorators		

Advice we can offer to artists interested in being represented by our gallery: Original representational works only
To contact us: Send slides/photos by mail for consideration.
Specific time of year we review work: Anytime
Type/style of artwork that has the best chance of being purchased by our clients in the next two years: Original representational

❖ Alder Gallery

160 E Broadway, Eugene, OR 97401
503/342-6411

We sell: Originals Limited Editions
Posters Frames
We are seeking both new and established talent.
Year gallery was established: 1985
Number of artists represented: 35
Geographical limitations to artists we represent: West
Styles we carry:

Abstract	Classic	Contemporary
Figurative	Impressionism	Landscape
Modernism	Realistic	Representational
Surrealism	Traditional	Western

Media we carry:

Acrylic	Airbrush	Bronze
Ceramic	Charcoal	Collage
Colored Pencil	Drawing	Fibre Arts
Glass	Installations	Marble
Mixed Media	Oil	Paper Sculpture
Pastel	Pencil	Pen & Ink
Photography	Sculpture	Silkscreen
Tempra	Watercolor	

Our target market:

Corporations	Medical Facilities	Private Collectors
Interior Designers	Offices	

Advice we can offer to artists interested in being represented by our gallery: Make an appointment first.
To contact us: Arrange a personal interview to show portfolio/send slides/photos by mail for consideration.

❖ Southwest Journey Ltd

Lo Candle
196 E 5th Ave, Eugene, OR 97401
503/484-6804

We sell: Originals Limited Editions
Posters
We are actively seeking new and established Native American talent.
Year gallery was established: 1988
Gallery hours: Daily 10-6
Number of shows each year: 6
Commission gallery takes: 50%
Number of artists represented: Many
Gallery is insured.
Geographical limitations to artists we represent: Native American from the Southwest or Northwest Coast and Alaska
The gallery assumes cost of: Advertising
Styles we carry:

Landscape	Native American	Southwestern

Media we carry:

Acrylic	Ceramic	Collage
Drawing	Fibre Arts	Glass
Mixed Media	Pencil	Photography
Pottery	Prints	Sculpture
Silkscreen	Watercolor	

Our target market:
Private Collectors Interior Designers Tourists
Walk-ins
To contact us: Call and arrange a personal appointment
to show portfolio.
Specific time of year we review work: Anytime

❖ As If By Magic

Dave & Kathy Jackson
1428 SE 36th Ave, Portland, OR 97214
503/235-6985

We sell:	Originals	Limited Editions
Posters	Frames	

Our gallery works with corporations collecting art.
We are seeking both new and established talent.
Year gallery was established: 1985
Gallery hours: Mon-Fri 10-5:30, Sat 10-4, Sun 12-4
Gallery is insured.
Styles we carry:

African-American	Animals	Classic
Contemporary	Equestrian	Ethnic
Figurative	Floral	Historic
Impressionism	Landscape	Marine
Naive	Native American	Nostalgia
Oriental	Portraits	Realistic
Representational	Romantic	Southwestern
Still life	Traditional	Western
Wildlife		

Media we carry:

Mixed Media	Pen & Ink	Prints
Silkscreen	Watercolor	

Our target market:

Corporations	Private Collectors	Tourists
Walk-ins		

To contact us: Query with resumé.
Specific time of year we review work: Anytime except
during Christmas.

❖ Gango Gallery

Tom Muzzio/Owner Martha Lee/Director
205 SW 1st Ave, Portland, OR 97204
Second Gallery: Nikki Director/Director
8748 SW Hall Blvd, Portland, OR 97223
503/222-3850 503/228-0749 Fax

We sell:	Originals	Limited Editions
Posters	Frames	Sculpture

Our gallery works with corporations collecting art.
 Corporate Consultant: Any sales staff person
**We are actively seeking both new and established
talent.**
Year gallery was established: 1979
Gallery hours: Mon-Sun 10-5:30
Number of shows each year: 12 times per year at each
gallery
Commission gallery takes: 50%

Number of artists represented: 70
Gallery is insured.
Geographical limitations to artists we represent:
National
The gallery assumes cost of:

Openings	Advertising	Installations
Promotion (brochures, etc.)		
Return transportation of artwork		

Styles we carry:

Abstract	Conceptual	Contemporary
Figurative	Floral	Impressionism
Landscape	Modernism	Still life
Traditional		

Media we carry:

Acrylic	Ceramic	Charcoal
Clay	Colored Pencil	Drawing
Glass	Mixed Media	Oil
Paper Sculpture	Pastel	Pen & Ink
Photography	Pottery	Prints
Sculpture	Tempra	Watercolor
Metal		

Our target market:

Consultants	Corporations	Restaurants
Medical Facilities	Architects	Interior Decorators
Offices	Hotel/Motel	Tourists
Walk-ins	Educational Facilities	

**Advice we can offer to artists interested in being
represented by our gallery:** Send quality transparencies/
slides.
To contact us: Send slides/photos by mail for consider-
ation.
Specific time of year we review work: Once every
month.
**Type/style of artwork that has the best chance of being
purchased by our clients in the next two years:**
Abstract—to fit corporate settings

❖ Photographic Image Gallery

Guy Swanson
240 SW 1st, Portland, OR 97204

We sell:	Originals	Limited Editions
Posters	Frames	

Our gallery works with corporations collecting art.
We are seeking both new and established talent.
Year gallery was established: 1984
Gallery hours: Mon-Sat 10-5:30
Number of shows each year: 12
Commission gallery takes: 50%
Number of artists represented: 25
Gallery is insured.
The gallery assumes cost of:

Openings	Advertising	Installations

Styles we carry:

Erotic	Figurative	Landscape
Traditional		

Media we carry: Photography

Galleries

Our target market:

Consultants	Corporations	Restaurants
Medical Facilities	Private Collectors	Interior Decorators
Offices	Tourists	Walk-ins

To contact us: Submit portfolio (brochure, statement, slides, etc.) for review/query with resumé.

Specific time of year we review work: Anytime

❖ Cat's Paw Gallery
John/Louise Herbster
31 Race St, Jim Thorpe, PA 18229
717/325-4041

We sell:	Originals	Limited Editions

Sculpture

We are seeking both new and established talent.
Year gallery was established: 1985
Gallery hours: April-Dec: Wed-Sun 11-5; Jan-Mar by chance
Number of shows each year: 2-3
Commission gallery takes: 40%
Number of artists represented: 100
Gallery is insured.
Geographical limitations to artists we represent: USA
The gallery shares the cost of:

Openings	Advertising	Installations

Promotion (brochures, etc.)
Transportation of artwork

Styles we carry: Domestic feline images in all styles
Media we carry:

Acrylic	Bronze	Ceramic
Clay	Colored Pencil	Drawing
Fibre Arts	Glass	Mixed Media
Oil	Pastel	Pencil
Pottery	Prints	Sculpture
Silkscreen	Tempra	Watercolor

Our target market:

Private Collectors	Tourists	Walk-ins
Interior Decorators		

Advice we can offer to artists interested in being represented by our gallery: We are not interested in cute, commercial, mass market kitties.
To contact us: Arrange a personal interview to show portfolio/submit portfolio (brochure, statement, slides, etc.) for review/query with resumé/ Send slides/photos by mail for consideration.
Specific time of year we review work: Sep-Dec for Apr-Dec season

❖ Artworks
Liz Reilly
121 E State St, Box 1186, Kennett Square, PA 19348
610/444-6544 Telephone/Fax

We sell:	Originals	Custom Frames

We are seeking both new and established talent.
Year gallery was established: 1986

Gallery hours: Tues-Sat 11-5; eve by appointment
Number of shows each year: 5+
Commission gallery takes: 50%
Number of artists represented: 200
Gallery is partially insured.
Geographical limitations to artists we represent: 12 miles
The gallery assumes cost of:

Openings	Advertising	Installations

Styles we carry:

Abstract	Animals	Contemporary
Equestrian	Floral	Historic
Impressionism	Landscape	Modernism
Naive	Portraits	Realistic
Representational	Sports	Still life
Traditional	Wildlife	

Media we carry:

Acrylic	Bronze	Ceramic
Charcoal	Clay	Collage
Drawing	Fibre Arts	Glass
Mixed Media	Oil	Paper Sculpture
Pastel	Pencil	Pen & Ink
Photography	Pottery	Prints
Sculpture	Silkscreen	Tempra
Watercolor		

Our target market:

Private Collectors	Tourists	Walk-ins

To contact us: Arrange a personal interview to show portfolio/submit portfolio (brochure, statement, slides, etc.) for review/send slides/photos by mail for consideration.
Specific time of year we review work: Fall/Winter
Type/style of artwork that has the best chance of being purchased by our clients in the next two years: Horses, hunt scenes, landscapes with stone barns, bridges, traditional, light contemporary

❖ Hewlett Gallery
Carnegie Mellon University/Petra Fallaux
College of Fine Arts #111, 5000 Forbes Ave, Pittsburgh, PA 15213
412/268-3877 412/268-2829 Fax

We sell: Originals
We are seeking both new and established talent.
Year gallery was established: 1912
Gallery hours: Mon-Fri 11:30-5; Sat 1-4
Number of shows each year: 8-12
Commission gallery takes: 40%
Gallery is insured.
Geographical limitations to artists we represent: None
The gallery assumes cost of:

Openings	Advertising	Installations

Promotion (brochures, etc.)

Styles we carry:

Abstract	Conceptual	Contemporary
Figurative		

Media we carry:

Acrylic	Collage	Computer
Drawing	Installations	Mixed Media
Oil	Photography	Sculpture

Our target market: Educational Facilities

To contact us: Submit portfolio (brochure, statement, slides, etc.) for review.

Specific time of year we review work: Dec

Type/style of artwork that has the best chance of being purchased by our clients in the next two years: New media

❖ Gallery on Spring Street

Rod Bedow/Joe Barnhart/Lisa Fye
108 W Spring St, Titusville, PA 16360
814/827-4357

We sell:

Originals	Limited Editions
Posters	Custom frames

Our gallery works with corporations collecting art.

Corporate Consultant: Lisa Fye

We are actively seeking new talent.

Year gallery was established: 1993

Gallery hours: Tues-Thurs 12-5; Friday 12-8; Sat 10-2

Number of shows each year: 3

Commission gallery takes: 33%

Number of artists represented: 65

Gallery is insured.

Geographical limitations to artists we represent: Mostly Pennsylvania and surrounding states

The gallery assumes cost of:

Openings	Advertising	Installations
Promotion (brochures, etc.)		
Transportation of artwork		

Styles we carry:

Animals	Classic	Contemporary
Fantasy	Floral	Historic
Landscape	Marine	Naive
New Age	Portraits	Realistic
Southwestern	Still life	Surrealism
Traditional	Western	Wildlife

Media we carry:

Acrylic	Airbrush	Bronze
Ceramic	Drawing	Mixed Media
Oil	Pencil	Pen & Ink
Photography	Pottery	Prints
Sculpture	Silkscreen	Watercolor
Jewelry		

Our target market:

Corporations	Private Collectors	Tourists
Walk-ins		

Advice we can offer to artists interested in being represented by our gallery: We like to keep work for sixty days, then change it if it hasn't sold. The art market is new to our area—tourism and private collectors are customers.

To contact us: Send photos by mail for consideration.

Specific time of year we review work: Anytime

Type/style of artwork that has the best chance of being purchased by our clients in the next two years: Rural scenes in a small format; watercolor, pen and ink, and acrylic

❖ The Goin Gallery

David Goin
PO Box 32446, Charleston, SC 29417-2446
803/722-4895

We sell:

	Originals	Frames

Our gallery works with corporations collecting art.

Year gallery was established: 1963

Gallery hours: Mon-Sat 10-5

Number of shows each year: 6

Commission gallery takes: 40%

Number of artists represented: 15

Gallery is insured.

Geographical limitations to artists we represent: Southeastern U.S.

The gallery assumes cost of:

Advertising	Promotion (brochures, etc.)

Styles we carry:

Abstract	African-American	Contemporary
Figurative	Floral	Impressionism
Landscape	Minimal	Modernism
Naive	Realistic	Representational
Still life		

Media we carry:

Acrylic	Bronze	Charcoal
Collage	Colored Pencil	Drawing
Mixed Media	Oil	Pastel
Pencil	Sculpture	Tempra
Watercolor		

Our target market:

Consultants	Corporations	Medical Facilities
Architects	Private Collectors	Interior Designers
Offices	Tourists	Walk-ins

To contact us: Send slides/photos by mail for consideration.

Specific time of year we review work: Anytime

Type/style of artwork that has the best chance of being purchased by our clients in the next two years: Need more nonobjective

Galleries

❖ Sewee Bay Gallery

J A Huggins
211 Meeting St, Charleston, SC 29401
803/723-1757 803/723-4729 Fax

We sell: Originals Limited Editions Posters Frames
Our gallery works with corporations collecting art.
 Corporate Consultant: Cathy Geddis
Year gallery was established: 1983
Gallery hours: Mon-Sat 10-6
Number of shows each year: 4
Commission gallery takes: 40%
Number of artists represented: 200
Gallery is insured.
Geographical limitations to artists we represent: None
The gallery assumes cost of:

Openings	Advertising	Installations

Promotion (brochures, etc.)
Styles we carry:

Animals	Equestrian	Floral
Landscape	Marine	Southwestern
Western	Wildlife	

Media we carry:

Acrylic	Bronze	Charcoal
Colored Pencil	Mixed Media	Oil
Pastel	Pencil	Pen & Ink
Prints	Sculpture	Watercolor

Our target market:

Corporations	Private Collectors	Interior Decorators
Offices	Tourists	Walk-ins

To contact us: Submit portfolio (brochure, statement, slides, etc.) for review/send slides/photos by mail for consideration.

❖ The Outlook Gallery

Vaughan Greene
3815 St Elmo Ave, Chattanooga, TN
615/821-5212

We sell: Originals
Our gallery works with corporations collecting art.
We are seeking both new and established talent.
Year gallery was established: 1990
Gallery hours: Tues-Sat 10:30-5:30
Number of shows each year: 2
Commission gallery takes: 40%
Number of artists represented: 80
Gallery is insured.
Geographical limitations to artists we represent: None
The gallery assumes cost of:

Openings	Advertising

Styles we carry:

Abstract	Contemporary	Landscape
Naive	Representational	

Media we carry:

Bronze	Clay	Drawing
Pastel	Pen & Ink	Photography
Pottery	Sculpture	Furniture

Our target market:

Corporations	Interior Designers	Offices
Hotel/Motel	Tourists	Walk-ins
Local gift market		

To contact us: Arrange a personal interview to show portfolio/send slides/photos by mail for consideration.
Specific time of year we review work: Anytime except December.

❖ Madison Ave Art Gallery

Pat Norris/Lynda Tate
6655 Poplar Ave #106, Germantown, TN 38138
901/759-9402

We sell: Originals Limited Editions Sculpture Frames Jewelry Hand-painted Furniture
Our gallery works with corporations collecting art.
 Corporate Consultant: Lynda Tate
We are seeking both new and established talent.
Year gallery was established: 1991
Gallery hours: Mon-Wed 10-5; Thurs 11-11; Fri-Sat 11-6
Number of shows each year: 4
Commission gallery takes: 40%
Number of artists represented: 100+
Gallery is insured.
Geographical limitations to artists we represent: None
The gallery assumes cost of:

Openings	Advertising	Installations

Promotion (brochures, etc.)
Styles we carry:

Abstract	Animals	Classic
Conceptual	Contemporary	Equestrian
Fantasy	Figurative	Floral
Historic	Impressionism	Landscape
Marine	Military	Modernism
Oriental	Portraits	Realistic
Representational	Romantic	Southwestern
Sports	Still life	Traditional
Western	Wildlife	

Media we carry:

Acrylic	Bronze	Ceramic
Clay	Collage	Colored Pencil
Drawing	Fibre Arts	Glass
Marble	Mixed Media	Oil
Pastel	Pencil	Pen & Ink
Photography	Pottery	Prints
Sculpture	Silkscreen	Watercolor

Our target market:

Consultants	Corporations	Restaurants
Private Collectors	Interior Designers	Offices
Tourists	Walk-ins	

Advice we can offer to artists interested in being represented by our gallery: Send only your best work.
To contact us: Submit portfolio (brochure, statement, slides, etc.) for review/send slides/photos by mail for consideration.
Specific time of year we review work: Once each month.
Type/style of artwork that has the best chance of being purchased by our clients in the next two years: Abstracts, impressionism, romantic, landscapes in oils and watercolors

❖ Michelle D Long Gallery
Michelle D Long
509¹/₂ W Bethel Rd, Coppell, TX 75019
214/393-9095

We sell:	Originals	Posters
Frames		

Our gallery works with corporations collecting art.
We are seeking both new and established talent.
Year gallery was established: 1995
Gallery hours: Tues-Fri 10-6; Sun 10-5
Number of shows each year: 4
Commission gallery takes: 50%
Number of artists represented: 22
Gallery is insured.
Geographical limitations to artists we represent: None
The gallery assumes cost of:

Advertising	Installations

Styles we carry:

Abstract	Conceptual	Contemporary
Figurative	Landscape	Minimal
Naive	POP	Portraits
Realistic	Representational	Sports
Still life	Surrealism	Visionary

Media we carry:

Acrylic	Airbrush	Ceramic
Charcoal	Clay	Collage
Colored Pencil	Drawing	Mixed Media
Oil	Pastel	Pencil
Pen & Ink	Photography	Pottery
Prints	Sculpture	Watercolor

Our target market:

Corporations	Restaurants	Medical Facilities
Private Collectors	Interior Designers	Offices
Walk-ins		

To contact us: Send slides/photos, resumé, price list, statement by mail for consideration.
Specific time of year we review work: Anytime
Type/style of artwork that has the best chance of being purchased by our clients in the next two years: Ceramics

❖ Adkins Hoover Gallery
Anni Adkins, Joe Hoover
1315 Skiles St, Dallas, TX 75204
214/826-7405

We sell:	Originals	Limited Editions

Our gallery works with corporations collecting art.
 Corporate Consultant: Joe Hoover
We are seeking both new and established talent.
Year gallery was established: 1995
Geographical limitations to artists we represent: National
The gallery assumes cost of:

Openings	Advertising	Installations

Styles we carry:

Abstract	African-American	Alternative
Classic	Conceptual	Contemporary
Erotic	Ethnic	Fantasy
Figurative	Floral	Impressionism
Landscape	Latin American	Modernism
Naive	Native American	New Age
Nostalgia	POP	Portraits
Realistic	Representational	Romantic
Southwestern	Sports	Still life
Surrealism	Traditional	Tropical
Visionary	Western	Photo-Realism

Media we carry:

Acrylic	Bronze	Ceramic
Charcoal	Clay	Collage
Colored Pencil	Computer	Drawing
Fibre Arts	Glass	Installations
Marble	Mixed Media	Oil
Paper Sculpture	Pastel	Pencil
Pen & Ink	Photography	Pottery
Original prints	Sculpture	Silkscreen
Watercolor		

Our target market:

Consultants	Museums	Corporations
Restaurants	Medical Facilities	Architects
Private Collectors	Interior Designers	Offices
Hotel/Motel	Tourists	Walk-ins

Advice we can offer to artists interested in being represented by our gallery: Prepare a professional presentation including an SASE if you would like your material returned (include something for the gallery to keep on file; slides/photos/color photocopy)
To contact us: Submit portfolio (brochure, statement, slides, etc.) for review.
Specific time of year we review work: Anytime
Type/style of artwork that has the best chance of being purchased by our clients in the next two years: Professionally executed and presented fine art in all styles and media for private and corporate collections.

Galleries

❖ Hummingbird Originals Art Gallery Inc

Carole Alford/Owner Mary Ann White/Director
4319 Camp Bowie Blvd, Fort Worth, TX 76107
817/732-1549

We sell:
Originals Limited Editions
Posters Fine Crafts
Our gallery works with corporations collecting art.
 Corporate Consultant: Carole Alford
We are seeking both new and established talent.
Year gallery was established: 1983
Gallery hours: Mon-Fri 10-5; Sat 10-6
Number of shows each year: 2-4
Commission gallery takes: 50%, usually
Number of artists represented: 100
Gallery is insured.
Geographical limitations to artists we represent: USA
The gallery assumes cost of:
Openings Advertising Installations
Promotion (brochures, etc.)
Transportation of artwork
Styles we carry:

Abstract	African-American	Animals
Classic	Contemporary	Equestrian
Figurative	Floral	Impressionism
Landscape	Marine	Oriental
Portraits	Realistic	Religious
Representational	Romantic	Southwestern
Still life	Surrealism	Traditional
Tropical	Western	Wildlife

Media we carry:

Acrylic	Bronze	Ceramic
Charcoal	Clay	Collage
Colored Pencil	Computer	Drawing
Fibre Arts	Glass	Installations
Marble	Mixed Media	Oil
Paper Sculpture	Pastel	Pencil
Pottery	Prints	Sculpture
Tempra	Watercolor	

Our target market:

Consultants	Corporations	Restaurants
Medical Facilities	Architects	Private Collectors
Interior Designers	Offices	Schools
Hotel/Motel	Tourists	Walk-ins

Advice we can offer to artists interested in being represented by our gallery: Call first, send slides or portfolio, examples of work.
To contact us: Arrange a personal interview to show portfolio/submit portfolio (brochure, statement, slides, etc.) for review/query with resumé/send slides/photos by mail for consideration.
Specific time of year we review work: Jan-Aug
Type/style of artwork that has the best chance of being purchased by our clients in the next two years: Painting: landscape, abstract, decorative, contemporary, traditional, ceramics, bronze sculpture, glass, wood, wearable art

❖ Hanson Galleries

Donna Milstein/Owner Larry Williams/Director
Town & Country Mall, 800 W Sam Houston Pkwy N
#E118, Houston, TX 77024
713/984-1242 713/984-1680 Fax

We sell: American fine crafts and art cards
We are seeking both new and established talent.
Year gallery was established: 1977
Gallery hours: Mon-Sat 10-9; Sun 12-6
Number of shows each year: 6
Commission gallery takes: 50%
Number of artists represented: 500
Gallery is insured.
Geographical limitations to artists we represent: None
The gallery assumes cost of:
Advertising Installations
Styles we carry:

Abstract	Alternative	Animals
Contemporary	Ethnic	Fantasy
Floral	Impressionism	Marine
New Age	Oriental	Romantic
Sports	Wildlife	

Media we carry:

Bronze	Ceramic	Clay
Fibre Arts	Glass	Mixed Media
Pottery	Sculpture	Wood/exotic

Our target market:
Tourists Walk-ins Our own following
Advice we can offer to artists interested in being represented by our gallery: Do not drop in.
To contact us: Send slides/photos by mail for consideration.
Specific time of year we review work: Jan-Oct
Type/style of artwork that has the best chance of being purchased by our clients in the next two years: Artcards

❖ Art Inc

Joan & Robert Grothes/Owner Cathie Clark/Director
9401 San Pedro, San Antonio, TX 78216
800/225-0278 210/340-1091 210/340-4761 Fax

We sell:
Originals Limited Editions
Posters Frames
Our gallery works with corporations collecting art.
 Corporate Consultant: Robert Grothes
We are seeking established talent mostly through referrals.
Year gallery was established: 1975
Gallery hours: Mon-Sat 10-6
Number of shows each year: 4
Commission gallery takes: 40%
Number of artists represented: 20
Gallery is insured.
The gallery assumes cost of:
Openings Advertising (part) Installations
Promotion (brochures, etc.) (part)
Transportation of artwork

Styles we carry:

Abstract	African-American	Animals
Contemporary	Fantasy	Figurative
Floral	Impressionism	Landscape
Minimal	Portraits	Realistic
Representational	Southwestern	Still life
Surrealism	Western	Wildlife

Media we carry:

Acrylic	Bronze	Ceramic
Clay	Collage	Drawing
Fibre Arts	Glass	Marble
Mixed Media	Oil	Pastel
Pencil	Photography	Pottery
Prints	Sculpture	Silkscreen
Tempra	Watercolor	

Our target market:

Consultants	Museums	Corporations
Restaurants	Medical Facilities	Architects
Private Collectors	Interior Designers	Schools
Hotel/Motel	Tourists	Walk-ins

Advice we can offer to artists interested in being represented by our gallery: Be professional, be prepared; have professionally prepared material (i.e. photos)
To contact us: Send slides/photos by mail for consideration with SASE.
Specific time of year we review work: July-Aug
Type/style of artwork that has the best chance of being purchased by our clients in the next two years: Abstract to transitional to realist to romantic

❖ Prince Royal Gallery Inc
JR & MW Byers
204 S Royal St, Alexandria, VA 22314
703/548-5151

We sell: Originals Limited Editions Frames
Our gallery works with corporations collecting art.
 Corporate Consultant: JR Byers
We are seeking both new and established talent.
Year gallery was established: 1977
Gallery hours: Tues-Sun 11-5; Fri 11-7
Number of shows each year: 6
Commission gallery takes: 40%
Number of artists represented: 52
Gallery is insured.
Geographical limitations to artists we represent: None
The gallery assumes cost of:

Openings (50%)	Advertising	Installations
Promotion (brochures, etc.)		
Transportation of artwork (50%)		

Styles we carry:

Contemporary	Floral	Impressionism
Landscape	Nostalgia	Oriental
Portraits	Representational	Still life
Traditional		

Media we carry:

Acrylic	Bronze	Clay
Marble	Mixed Media	Oil
Pastel	Sculpture	Silkscreen
Watercolor	Prints (only if we show original work)	

Our target market:

Corporations	Private Collectors	Interior Decorators
Walk-ins		

Advice we can offer to artists interested in being represented by our gallery: Send 5-10 slides/photos of work with dimensions and prices. We'll respond within a week.
Specific time of year we review work: Anytime
Type/style of artwork that has the best chance of being purchased by our clients in the next two years: Representational, especially impressionist

❖ JuBe Art & Frame
AJ McEinheran & B Svendson/Owners
June McElherun/Director
213 First Ave S, Kent, WA 98032
206/859-1416 206/852-8442 Fax

We sell: Originals Limited Editions Posters Frames
Our gallery works with corporations collecting art.
 Corporate Consultant: June McElherun
We are seeking established talent mostly through referrals.
Year gallery was established: 1981
Gallery hours: Mon-Fri 9:30-5:30; Sat 10-5
Commission gallery takes: 50%
Number of artists represented: 15
Gallery is insured.
Styles we carry:

Abstract	Classic	Contemporary
Ethnic	Figurative	Floral
Impressionism	Landscape	Modernism
Oriental	Representational	Traditional

Media we carry:

Acrylic	Charcoal	Collage
Drawing	Glass	Mixed Media
Oil	Pastel	Prints
Sculpture	Silkscreen	Tempra
Watercolor		

Our target market:

Consultants	Museums	Corporations
Private Collectors	Interior Designers	Walk-ins

Advice we can offer to artists interested in being represented by our gallery: Well established biography including education, awards, achievements, permanent collections, shows
To contact us: Query with resumé.
Specific time of year we review work: Anytime

Galleries

❖ **Benham Studio Gallery**
Marita Holdawa/Lisa Sharamitaro
1216 First Ave, Seattle, WA 98001
206/622-2980 206/682-6594 Fax

We sell: Originals
We are seeking both new and established talent.
Year gallery was established: 1987
Gallery hours: Mon-Fri 9-5; Sat 11-3
Number of shows each year: 12
Commission gallery takes: 40%
Number of artists represented: 15
Gallery is insured.
Styles we carry:

Abstract	African-American	Alternative
Classic	Conceptual	Contemporary
Erotic	Ethnic	Figurative
Historic	Impressionism	Landscape
Latin American	Modernism	Native American
Nostalgia	Portraits	Realistic
Representational	Romantic	Southwestern
Surrealism	Traditional	Visionary
Western		

Media we carry: Photography
Our target market:

Consultants	Private Collectors	Tourists
Walk-ins		

To contact us: Arrange a personal interview to show portfolio (in August).
Specific time of year we review work: August

❖ **Marchand Fine Art**
Gary Porter & Leslie Fjouflas
1300 Dexter Ave N #1312, Seattle, WA 98109
206/283-1469 Telephone/Fax

We sell: Originals Limited Editions
Our gallery works with corporations collecting art.
 Corporate Consultant: Gary Porter
We are seeking both new and established talent mostly through referrals.
Year gallery was established: 1987
Gallery hours: By appointment
Number of shows each year: 2-3
Commission gallery takes: 50%
Number of artists represented: 20
Gallery is insured.
Geographical limitations to artists we represent: None
The gallery assumes cost of:

Openings	Installations

Styles we carry:

Abstract	Conceptual	Contemporary
Impressionism	Modernism	Still life

Media we carry:

Acrylic	Bronze	Computer
Drawing	Glass	Mixed Media
Oil	Pastel	Photography
Prints	Sculpture	Silkscreen
Watercolor		

Our target market:

Consultants	Corporations	Medical Facilities
Architects	Private Collectors	Interior Decorators
Offices	Hotel/Motel	

To contact us: Send slides/photos by mail for consideration.
Specific time of year we review work: Anytime
Type/style of artwork that has the best chance of being purchased by our clients in the next two years: Contemporary

❖ **Summer Song Gallery**
Jim P Malecki
600 19th Ave G, Seattle, WA 98112-4009
907/443-2566 907/443-3762 Fax

We sell: Originals Limited Editions
Posters Frames
Photographic and graphic services
Our gallery works with corporations collecting art.
We are seeking both new and established talent.
Year gallery was established: 1994
Gallery hours: Tues-Fri 10-7
Number of shows each year: 12
Commission gallery takes: 40%
Number of artists represented: 60+
Gallery is insured.
The gallery assumes cost of:

Openings	Advertising	Installations
Promotion (brochures, etc.) (50%)		
Transportation of artwork from gallery		

Styles we carry:

Abstract	Alternative	Classic
Conceptual	Contemporary	Erotic
Ethnic	Fantasy	Figurative
Historic	Impressionism	Landscape
Marine	Modernism	Native American
New Age	POP	Portraits
Realistic	Romantic	Sci-Fi
Southwestern	Still life	Surrealism
Traditional	Tropical	Visionary
Wildlife		

Media we carry:

Acrylic	Airbrush	Ceramic
Charcoal	Clay	Collage
Colored Pencil	Computer	Drawing
Fibre Arts	Glass	Installations
Marble	Mixed Media	Oil
Paper Sculpture	Pastel	Pencil
Pen & Ink	Photography	Pottery
Prints	Sculpture	Tempra
Watercolor		

Our target market:

| Consultants | Corporations | Private Collectors |
| Interior Designers | Tourists | Walk-ins |

To contact us: Submit portfolio (brochure, statement, slides, etc.) and SASE for review.

Specific time of year we review work: Anytime

Type/style of artwork that has the best chance of being purchased by our clients in the next two years: All mediums sell

❖ Walsdorf Gallery

Don Walsdorf
PO Box 245, Spokane, WA 99210-0245
509/838-5847

We sell: Originals

Our gallery works with corporations collecting art.

 Corporate Consultant: Don & Gert Walsdorf

Year gallery was established: 1987

Gallery hours: Mon-Fri 8-5

Number of shows each year: 1 major/2 small

Commission gallery takes: 40%

Number of artists represented: 12

Gallery is insured.

Geographical limitations to artists we represent: US & European

The gallery assumes cost of:

| Openings | Advertising | Installations |

Styles we carry:

Animals	Classic	Equestrian
Figurative	Floral	Historic
Impressionism	Landscape	Marine
Native American	Nostalgia	Oriental
Portraits	Realistic	Representational
Romantic	Sports	Still life
Traditional	Western	Wildlife

Media we carry:

Acrylic	Bronze	Charcoal
Fibre Arts	Glass	Marble
Mixed Media	Oil	Paper Sculpture
Pastel	Pencil	Pen & Ink
Photography	Pottery	Sculpture
Watercolor		

Our target market:

Consultants	Stores	Corporations
Architects	Private Collectors	Interior Decorators
Offices	Tourists	Walk-ins

Advice we can offer to artists interested in being represented by our gallery: Must be full-time professional, able to perform on commissions. Must have a good body of work. We search for good artists who wish to participate in art shows.

To contact us: We usually seek out artists we wish to represent.

Specific time of year we review work: Constantly

Type/style of artwork that has the best chance of being purchased by our clients in the next two years: We produce the Spokane Western Art Show (for 25 years), Art Exposition at Bend (2 years), and are working on an International Sculpture Event and an Exposition in Florida.

❖ Tomorrow's Treasures

Debra Peden
801 Washington St, Vancouver, WA 98660
360/695-2130

We sell: Originals Limited Editions Frames

We are seeking both new and established talent.

Year gallery was established: 1988

Gallery hours: Mon-Fri 10-5:30; Sat 11-4

Number of shows each year: 2-6

Commission gallery takes: 35%

Number of artists represented: 6-8

Gallery is insured.

The gallery assumes cost of: Openings

Styles we carry:

Abstract	Animals	Fantasy
Floral	Landscape	Marine
Naive	Native American	Portraits
Southwestern	Sports	Still life
Western	Wildlife	

Media we carry:

| Bronze | Oil | Paper Sculpture |
| Watercolor | | |

Our target market:

| Private Collectors | Walk-ins | Interior Decorators |

To contact us: Query with resumé.

❖ The Fannie Garver Gallery

Jack Garver
7432 Mineral Point Rd, Madison, WI 53717
608/833-8000

We sell: Originals Limited Editions

Our gallery works with corporations collecting art.

We are seeking both new and established talent.

Year gallery was established: 1972

Gallery hours: Every day

Number of shows each year: 18

Commission gallery takes: Varies

Number of artists represented: 100

Geographical limitations to artists we represent: 75 miles

Styles we carry:

Abstract	Conceptual	Contemporary
Figurative	Floral	Impressionism
Modernism	Still life	Surrealism

Galleries

Media we carry:

Acrylic	Ceramic	Charcoal
Clay	Collage	Colored Pencil
Drawing	Glass	Installations
Oil	Pastel	Pen & Ink
Pottery	Prints	Sculpture
Silkscreen	Tempra	Watercolor

Our target market:

Corporations	Medical Facilities	Architects
Private Collectors	Interior Designers	Tourists
Walk-ins		

To contact us: Submit portfolio (brochure, statement, slides, etc.) for review/send slides/photos by mail for consideration.

Specific time of year we review work: Anytime

Type/style of artwork that has the best chance of being purchased by our clients in the next two years: Unique, quality work

❖ Art Elements Gallery

Deborah Fierke
10050 N Pt Washington Rd, Mequon, WI 53092
414/241-7040 414/963-2126 Fax

We sell: Originals Limited Editions

Our gallery works with corporations collecting art.

We are seeking both new and established talent.

Year gallery was established: 1990

Gallery hours: Mon, Wed, Fri 11-6; Thurs 11-8

Number of shows each year: 6

Commission gallery takes: 45%

Number of artists represented: 200+

Gallery is insured.

Geographical limitations to artists we represent: None

The gallery assumes cost of:

Openings	Advertising	Installations
Promotion (brochures, etc.)		

Styles we carry:

Abstract	Alternative	Classic
Conceptual	Contemporary	Fantasy
Figurative	Floral	Impressionism
Landscape	Marine	Minimal
Modernism	POP	Portraits
Realistic	Representational	Still life
Surrealism	Traditional	Visionary

Media we carry:

Acrylic	Bronze	Ceramic
Charcoal	Clay	Collage
Colored Pencil	Drawing	Fibre Arts
Glass	Marble	Marker
Mixed Media	Oil	Paper Sculpture
Pastel	Pencil	Pen & Ink
Pottery	Sculpture	Silkscreen
Tempra	Watercolor	Glass Sculpture
Outdoor sculpture		

Our target market:

Consultants	Corporations	Architects
Private Collectors	Interior Decorators	

Advice we can offer to artists interested in being represented by our gallery: High quality works

To contact us: Submit portfolio (brochure, statement, slides, etc.) for review/send slides/photos by mail for consideration.

Specific time of year we review work: Anytime

❖ The Hang Up Gallery of Fine Art

William and Karen Casper/Owners
Kathleen Kavaney Zuleger/Director
204 W Wisconsin Ave, Neenah, WI 54956
414/722-0481 414/722-9144 Fax

We sell:

Originals	Limited Editions	
Posters	Frames	Jewelry
Pottery	Plates	Handmade Cards

Our gallery works with corporations collecting art.

 Corporate Consultant: Karen Casper

We are seeking both new and established talent.

Year gallery was established: 1968

Gallery hours: Mon, Tues, Wed, Fri 9-5:30; Thurs 9-8; Sat 9-5

Number of shows each year: 12

Commission gallery takes: 35%

Number of artists represented: 200

Gallery is insured.

Geographical limitations to artists we represent: None

The gallery assumes cost of:

Openings	Installations
Promotion (brochures, etc.) (some)	

Styles we carry:

Abstract	Animals	Classic
Contemporary	Fantasy	Figurative
Floral	Impressionism	Landscape
Minimal	Naive	Nostalgia
Portraits	Realistic	Romantic
Southwestern	Still life	Traditional
Wildlife		

Media we carry: Almost all

Our target market:

Consultants	Stores	Corporations
Restaurants	Medical Facilities	Architects
Private Collectors	Interior Designers	Offices
Schools	Hotel/Motel	Tourists
Walk-ins	Secondary market	

Advice we can offer to artists interested in being represented by our gallery: Make appointment.

To contact us: Submit portfolio (brochure, statement, slides, etc.) for review/send slides/photos by mail for consideration.

Specific time of year we review work: Anytime

Type/style of artwork that has the best chance of being purchased by our clients in the next two years: Traditional or impressionistic watercolors/oils of landscapes, florals

❖ Dornan's Gifts

Tricia Dornan
PO Box 39, #10 Moose St, Moose, WY 83012
307/733-2415 307/733-3544 Fax

We sell: Originals Limited Editions
Posters Cards Gifts
We are seeking new talent.
Year gallery was established: 1985
Gallery hours: Summer 10-6
Number of shows each year: 3
Commission gallery takes: 20%
Number of artists represented: 30
Gallery is insured.
The gallery assumes cost of:
Openings Advertising Installations
Styles we carry:
Abstract Animals Equestrian
Floral Landscape Western
Wildlife
Media we carry:
Bronze Ceramic Fibre Arts
Marble Pastel Pencil
Pen & Ink Photography Sculpture
Silkscreen Watercolor
Our target market: Tourists
Advice we can offer to artists interested in being represented by our gallery: Only artists from the state of Wyoming
To contact us: Query with resumé.
Specific time of year we review work: Jan-May
Type/style of artwork that has the best chance of being purchased by our clients in the next two years: Miniatures, landscapes

University Galleries

Many artists overlook the possibility of exhibition at college and university galleries. Often there are listings of university galleries open to new exhibitors noted in the back sections of artist newspapers. Artists (both emerging and established) often have well-received shows at these galleries, with prices ranging into the five- and six-digit numbers (per painting!). Don't overlook the universities in your communitiy! Since there is a quick turn-over in college staffing, it is good to note when you are sending something to "Forward to Art Gallery." If you call, remember that extensions often change also, so you might be transferred to a new extension.

Following is only a smattering of university galleries across the nation. ArtNetwork (916/432-7630) has a complete list of 2100 on pressure-sensitive labels available for rent for $140.

U of Alabama
Glenn Dasher
Huntsville, Al 35899
205/895-6114

Northern Arizona U
Joel S Eide Gallery
Box 6020, Flagstaff, AZ 86011-6031
602/523-4612

University of Arizona
Rotunda Gallery/Andy Polk
Art Bldg R101D, Tucson, AZ 85720
602/621-1251

San Diego State U
The Artist's Gallery
720 Heber Ave, Calexico, CA 92231
619/357-5500

De Anza College
Euphrat Gallery
21250 Stevens Creek Blvd Cupertino, CA 95014
408/996-4945

Idyllwild School of the Arts/ISOMATA
William Lowman
PO Box 38, 52500 Temecula Rd, Idyllwild, CA 92549
909/659-2171

Art Institute of Southern California
Ettinger Gallery/Jonathan Burke
2222 Laguna Canyon Rd, Laguna Beach, CA 92651
714/497-3309

Loyola Marymount U
Laband Gallery
7101 W 80th St, Los Angeles, CA 90045
310/338-2880

UCLA
Wright Art Gallery
405 Hilgard Ave, Los Angeles, CA 90089
213/825-3281

USC
Fischer Arts Gallery
Watt Hall 104, University Park, Los Angeles, CA 90007
213/740-2781

Saddleback College
Patricia Levin/Director
28000 Marguerite Pkwy, Mission Viejo, CA 92692
714/582-4924

Cerritos College
Gail Jacobs/Director
11110 E Alondra Blvd, Norwalk, CA 90650
213/860-2451

California College of Arts and Crafts
CCAC Design Gallery
5212 Broadway, Oakland, CA 94618
415/653-8118

Laney College
Ana Montana/Director
900 Fallon, Oakland, CA 94607

Mills College
Fine Arts Gallery/Suzanne Dunaway
5000 MacArthur Blvd, Oakland, CA 94613
415/430-2117

Sonoma State University
University Art Gallery
1801 E Cotati Ave, Rohnert Park, CA 94928
707/664-2151

San Francisco Art Institute
Walter McBean Gallery/Jeanie Weisenbach
800 Chestnut St, San Francisco, CA 94133
415/771-7020

LA Harbor College
1111 Figueroa Pl, Wilmington, CA 90744
310/522-8474

U of Colorado
Fine Arts Gallery/Michael Crane
Campus Box 318, Boulder, CO 80309
303/492-6504

Rocky Mountain College of Art & Design
Philip J Steele Gallery
1441 Ogden St, Denver, CO 80218
303/832-1557

University of New Haven
UNH Arts Gallery
300 Orange St, West Haven, CT 06516
203/932-7308

George Washington U
Dimock Gallery
7300 21st St NW, Washington, DC 20052
202/994-6085

U of Delaware
Fine Arts Gallery/Belena Chapp
Recitation Ave #105, Newark, DE 19716
302/451-1209

Stetson U
Sampson Arts Gallery/Gary Bokling
Sampson Hall, De Land, FL 32720
Southeastern artists.

Miami-Dade Community College
Frances Wolfson Art Gallery
11300 NE 2nd Ave, Miami, FL 33130
305/899-3426

Valencia Community College
East Campus Galleries/Nancy Jay
PO Box 3028, Orlando, FL 32802
407/299-1300

Broward CC
The Art Gallery/Kyra Belan
7200 Hollywood Blvd, Pembroke Pines, FL 33024
305/963-8895

Savannah College of Art
Exhibit A Gallery
PO Box 3146, Savannah, GA 31402-3146
912/356-2208

U of Hawaii
Fine Arts Gallery/Tom Klobe
2444 Dole St, Honolulu, HI 96822
808/956-8111

North Idaho College
Union Art Gallery/Allie Vogt
1000 W Garden Ave, Coeur d'Alene, ID 83814
208/769-3427

U of Idaho
Prichard Art Gallery
414/16 S Main, Moscow, ID 83843
208/885-6111

Illinois Wesleyan U
Merwin & Wakeley Gallery
PO Box 2900, Bloomington, IL 61702
309/556-3077

North Park College
Carlson Tower Gallery/Jan Wesseis
3225 W Foster, Chicago, IL 60625
312/583-2700 ext 296

Richard J Daley College
Olive Tree Gallery
7500 S Pulaski, Chicago, IL 60652
312/735-3000

Saint Xavier College
Fine Arts Gallery/Cathie Ruggie
3700 W 103rd St, Chicago, IL 60655
312/298-3081

School of the Arts Institute of Chicago
Betty Rymer Gallery
Columbus Dr & Jackson Blvd, Chicago, IL 60603
312/443-3703

Univ of Illinois at Chicago
Gallery 400/Karen Indeck
400 S Peoria, Chicago, IL 60607
312/996-3351

Northern Illinois University
Gallery 200
Dekalb, IL 60115
815/753-1473

Elgin Community College
Janet Ecklebarger
1700 Spartan Dr, Elgin, IL 60123
708/697-1000 ext 7405

College of Dupage
Arts Center Gallery
22nd & Lambert Rd, Glen Ellyn, IL 60137
312/858-2800 ext 2321

Long Grove School
Dianne Hilligross
360 Historical Ln, Long Grove, IL 60047
708/634-4244

Western Illinois U
Macomb, IL 61455
309/298-2400

University Galleries

Concordia College
Elizabeth Ferguson Gallery
7400 Augusta St, River Forest, IL 60305
708/771-8300 ext 372

Augustana College
Centennial Hall Gallery
3520 7th Ave, Rock Island, IL 61201
309/794-7231

Rockford College
Clark Arts Center Gallery
5050 State, Rockford, IL 61108
815/226-4034

Sangamon State U
Gallery I
Shepherd Rd, Springfield, IL 62708
217/786-6790

Indiana U NW
Gallery Northwest/Gordon Ligocki
Gary, IN 46408
219/980-6891

Herron School of Art
Herron Gallery/William Voos
1701 N Pennsylvania St, Indianapolis, IN 46202
317/920-2420

U of S Indiana
New Harmony Gallery/Connie Weinzapfel
506 Main St, New Harmony, IN 47631
812/682-3156

St Mary's College
Moreau Gallery/K Johnson Bowles
Notre Dame, IN 46556
219/284-4587

Purdue University
Watson's Crick Gallery/Linda Achgill
1352 CA1 Bldg, Dept of Art, West Lafayette, IN 47907
317/494-3056

Grace College
Arthur Davis
200 Seminary Dr, Winona Lake, IN 46590
219/372-5268

Iowa State U
Brunnier Gallery
158 College of Design Bldg, Ames, IA 50011
515/294-6724

Fort Hays State U
Fine Arts Gallery/Joann Harwick
600 Park St, Hays, KS 67601-4099
913/625-3066

University of Kansas
Fine Arts Gallery/Andrea Norris
300 Art & Design, Lawrence, KS 66044
913/864-3991

Wichita State U
Clayton Staples Gallery
PO Box 67, Wichita, KS 67208
316/689-3555

Berea College
Doris Ulmann Galleries
CPO 2342, Berea, KY 40404
606/986-9341 ext 292

New Orleans Academy of Fine Arts
Academy Gallery
5256 Magazine St, New Orleans, LA 70115
504/899-8111
Mostly regional artists.

Portland School of Art
Baxter Gallery
97 Spring St, Portland, ME 04101
207/775-3052

Baltimore School for the Arts
Alcazar Gallery/Stephen Kent
712 Cathedral St, Baltimore, MD 21201
410/396-1185

Maryland Institute of Art
Decker & Meyerhoff Gallery
1300 Mt Royal Ave, Baltimore, MD 21217
410/669-9200

U of MA
Helaine Posner
125A Herter Hall, Amherst, MA 01003
413/545-1902

Massachusetts College of Art
North Hall Gallery/George Morgan
621 Huntington Ave, Boston, MA 02115
617/232-1555

School of the Museum of Fine Arts
Barbara & Steven Grossman Gallery
230 The Fenway, Boston, MA 02115
617/267-1218

U of MI
Slusser Gallery
2000 Bonisteel Blvd, Ann Arbor, MI 48109
313/764-0397

Minneapolis College of Art
MCAD Gallery/Brian Bott
2501 Stevens Ave S, Minneapolis, MN 55404
612/874-3700

Culver-Stockton College
Mabee Gallery/Catherine Royer
Canton, MO 63435
314/288-5221 ext 367

Kansas City Art Institute
Charlotte Crosby Kemper Gallery
4415 Warwick Blvd, Kansas City, MO 64111
816/561-4856

U of Missouri
210 Gallery
8001 Natural Bridge Rd, St Louis, MO 63121
314/535-5975

Eastern Montana College
Northcutt Steele Gallery/Tracy Linder
1500 N 30th St, Billings, MT 59101-0298
406/657-2980

U of Nebraska at Omaha
Fine Arts Gallery/Nancy Kelly
60th & Dodge, Omaha, NE 68132
402/554-2420

Truckee Meadows CC
Red Mountain Gallery/Erik Lauritzen
7000 Dandini Blvd, Reno, NV 89512

Saint Paul's School
Center Arts Gallery/Karen Smith
325 Pleasant St, Concord, NH 03301
603/225-3341

School of Art
561 Piermont Rd, Demarest, NJ 07627
201/767-7160

Burlington CC
Leslie Kaufman
Pemberton, NJ 08068
609/894-9311 ext 212

U of NM
Johnson Gallery/Joseph Traught
1909 Las Lomas NE, Albuquerque, NM 87131
505/277-2446

SUNY at Binghamton
University Arts Gallery/Lynn Gamwell
Binghamton, NY 13901
607/777-2171

92nd Street School of the Arts
Robert Gilson
1395 Lexington Ave, New York, NY 10128
212/415-5563

Columbia University
Miriam and Ira P Wallach Art Gallery
617 Dodge Hall, New York, NY 10027
212/280-2829

Marymount Manhattan College
Gallery/Karen Harris
221 E 71st St, New York, NY 10021
212/517-0400

U of NC
Owen Gallery
University Heights, Asheville, NC 28804
704/251-6559

U of NC
Carolina U Gallery/Sylvia Thyssen
101 Hanes Art Center, Chapel Hill, NC 27599-3405
919/962-2015

U of NC
Lowe Art Gallery
137 Rowe Bldg, Charlotte, NC 28223
704/547-2473

North Carolina Central U
Norman Pendergraft/Director
PO Box 19555, Durham, NC 27707
919/560-6211

U of NC
Weatherspoon Gallery
1000 Spring Garden St, Greensboro, NC 27412
919/379-5243

North Carolina State U
Charlotte Brown/Director
PO Box 7306, Raleigh, NC 27695-7306
919/515-3503

Wake Forest U
Scales Fine Arts Gallery
PO Box 7232, Winston-Salem, NC 27109-7232
919/761-5201

University Galleries

Dickson State U
Mind's Eye Gallery
Dickinson, ND 58601-4896
701/227-2331

U of Akron
Emily H Davis Gallery
150 E Exchange, Akron, OH 44325
216/375-7100

Baldwin-Wallace College
Fawick Gallery
95 E Bagley Rd, Berea, OH 44017
216/826-2900

Art Academy of Cincinnati
Cal Kowal
1125 St Gregory St, Cincinnati, OH 45202
513/562-8777

Cleveland Institute of Art
Reinherger Galleries/Bruce Checofsky
11141 East Blvd, Cleveland, OH 44106
216/421-4322

Kent State U
Fine Arts Gallery/Fred Smith
201 Art Building, Kent, OH 44240
216/672-2192

Ohio State U
Pearl Conard Gallery
1680 University Dr, Mansfield, OH 44906
419/755-4255

U of Toledo
Deborah Orloff
620 Grove Pl, Toledo, OH 43620

Oklahoma State U
Gardiner Art Gallery
4th & Mission, Okmulgee, OK 74447
918/756-6211

Oregon School of Arts & Crafts
Hoffman Gallery
8245 SW Barnes Rd, Portland, OR 97225
503/297-5544

Pacific Northwest College of Art
Wentz Gallery
1219 SW Park Ave, Portland, OR 97205-2486
503/226-0462

Portland State U
Littman Gallery
1872 SW Broadway/Box 751, Portland, OR 97201

Reed College
Douglas F Cooley Arts Gallery/Susan Fillin-Yeh
3203 SE Woodstock Blvd, Portland, OR 97202-8199
503/771-1112 ext 251 or 270

Hoyt Institute of Fine Arts
124 E Leasure Ave, New Castle, PA 16105
412/652-2882

Moore College of Art
Goldie Paley Gallery
1938 Race St, Philadelphia, PA 19103
215/568-4515

Art Institute of Pittsburg
Glen Barclay Arts Gallery
526 Penn Ave, Pittsburgh, PA 15222
412/263-6600

Carnegie-Mellon U
Torkes St Art Gallery
5000 Forbes Ave, Pittsburgh, PA 15213
412/268-2000

U of RI
Main Gallery
F207 Fine Arts Ctr, Kingston, RI 02881
401/792-2164

Brown University
David Winton Bell Gallery
PO Box 1861, Providence, RI 02912
401/863-2423

Rhode Island School of Design
Sol Koffler Gallery
2 College St, Providence, RI 02902
401/454-6402

Coker College
Cecelia Coker Bell Gallery
East College Ave, Hartsville, SC 29550
803/332-1391

Converse College
Milliken Gallery
580 E Main St, PO Box 29, Spartanburg, SC 29301
803/569-9180

South Dakota State U
Ritz Gallery
102 Solberg Hall, PO Box 2223, Brookings, SD 57007
605/688-4121

Augustana College
Eide-Dairymaple Gallery
PO Box 727, Sioux Falls, SD 57197
605/336-5516

Austin Peay State U
Margaret Fort Trahem Gallery/Kell Black
PO Box 4677, Clarksville, TN 37044
615/648-4076

Memphis State U
University Gallery
Jones Hall 201, Memphis, TN 38152
901/454-2101

Vanderbilt U
Sarratt Gallery/Joel Logiudice
PO Box 1801, Nashville, TN 37235
615/322-2831

U of Texas
Arthur M Huntington Arts Gallery
Box 19089, Arlington, TX 76019
817/273-2891

Bosque Conservatory of Fine Arts
PO Box 373, 701 W 9th, Clifton, TX 76634

Rice University
Sewall Art Gallery
PO Box 1892, Houston, TX 77005
713/527-4815

San Jacinto College
Dixon Bennett
13735 Beamer Rd, Houston, TX 77089
713/922-3418

Coppini Academy of Fine Arts
Hugh Hoeffler
115 Melrose Pl, San Antonio, TX 78212
512/684-6385

Austin College
Ida Green Gallery
PO Box 1177, Sherman, TX 75090
214/892-9101

Johnson State College
Dibden Gallery/Julian Scott Memorial Gallery
Johnson, VT 05656
802/635-2356

Vermont College
TW Wood Art Gallery
College Arts Center, Montpelier, VT 05602
802/229-0522 ext 279

James Madison University
Sawhill Gallery
Harrisonburg, VA 22807
703/568-6147

Washington & Lee University
du Pont Gallery
Lexington, VA 24450
703/463-8710

Norfolk State U
Rod Taylor
2401 Corprew Ave, Norfolk, VA 23504
804/683-8844

Western Washington U
Western Gallery
High St, Bellingham, WA 98225
206/676-3660

Central Washington U
Sarah Spurgeon Arts Gallery
Ellensburg, WA 98926
509/963-2665

Cornish College of the Arts
Robert Funk
710 E Roy St, Seattle, WA 98102
206/323-1400

University of WA
Cunningham Gallery
DM 10/Art Dept, Seattle, WA 98195
206/543-0970

U of WI
Foster Gallery
Park & Garfield Ave, Eau Claire, WI 54701-5008
715/836-5415

U of WI
Lawton Gallery
2420 Nicolet Dr, Green Bay, WI 54302-7001
414/465-2348

U of Wisconsin
Memorial Union Galleries
800 Langton St, Madison, WI 53706

Nicolet College
Bowery Gallery
Rhinelander, WI 54501
Annual national competition.

University of Wyoming
Charles Guerin
PO Box 3138, Laramie, WY 82071
307/766-5160

chapter **4**

Shows

Suppliers

A Steele
Rt 1, Box 180, Stockholm, WI 54769
800/693-3353
Battery-operated cash register.

Anywhere Chair
Rt 1 Box 290, Flowing Rock, NC 28605
800/662-0920
Oak and canvas, 41" high.

Armstrong Products
PO Box 979, Guthrie, OK 73044
405/282-7584
Panels used in making booths for art fairs.

Colorado Artist Tour/CAT
PO Box 1634, Boulder, CO 80306
303/499-0199
Find out about all the shows in Colorado for only $5 (in 1996 it will cost $5.50!). You get a packet with entry forms from all the fairs in Colorado.

DKT Designs
PO Box 3741, Huntsville, AL 35810
Sells plans for "The Fransfolder," a folding display stand ($4.75).

E-Z Up Canopies
800/4-EASYUP

Flourish Co
5763 Wheeler Rd, Fayetteville, AR 72703
501/444-8400
Canopies.

Gibson Displays
Rt 6, Box 369, Statesville, NC 28677
704/873-8121
Mini-bins and easels made of wood.

Graphic Display Systems
1243 Lafayette St, Lebanon, PA 17042
800/848-3020
Displays.

Hawaiian Sun Inc
Box 5447, Louisville, KY 40205
Canopies.

Houtz & Barwick
PO Box 435, Elizabeth City, NC 27907
800/775-0337 919/335-4191
Stools, folding racks in canvas and lightweight aluminum.

John Mee Canopies
PO Box 11220, Birmingham, AL 35202
800/475-0288
Displays, canopies, and exhibition supplies.

Nelson Envelopes
Box 536, Southold, NY 19971
Clear polyethylene envelopes to protect your artwork in transit or in storage; 50 sizes.

New Venture Products Inc
7441 114th Ave N #605, Largo, FL 34643
813/545-4899
Displays and canopies.

Newton's Mobile Canvas
400 South Rd, Ft Myers, FL 33907
800/678-8677
Displays, canopies and exhibition supplies.

Picture Frame Products Inc
34 Hamilton, Arlington, MA 02174
800/221-0530
Sells an inexpensive model ($135) shrink-wrapper. Also has a brochure, "Shrink Packaging Art."

Showoff
800/771-SHOW
Indoor/outdoor displays.

Skycap
37 W 19th St, New York, NY 10011
800/243-9227
Fast delivery on low-priced canopies.

United MFRS Supplies Inc
80 Gordon Dr, Syosset, NY 11791
516/496-4430
Shrink-wrap supplies.

Art Shows

Directories

Also see listings under "Regional Directories" in ArtNetwork Yellow Pages.

ACF News
PO Box 371, Glenshaw, PA 15116
412/487-7715
800 art and craft listings each issue. $15 per year.

ArtFair SourceBook
1234 S Dixie Hwy #111, Coral Gables, FL 33146
800/358-2045
Tracks the nation's 250 fine arts shows (as well as fine craft events). $95, yearly renewals $50.

Arts and Crafts Show Guide
208D E High St, Jefferson City, MO 65101
(formerly ACN Showtime, Art and Craft News, Art and Craft Network). $18 per year. Covers central states.

Cape May County Dept of Culture & Heritage
4 Moore Rd, Cape May, NJ 08210
Request a calendar of events (free). It will include grants and fellowships in the area.

Craft Digest
Box 155, New Britain, CT 06050

Craft Show Bulletin
Box 1914, Westfield, MA 01086

Craft Show Directory
Box 424, Devault, PA 19432
$6.36 yearly subscription.

Craft Show Guide
Northwest Bergen Craft Guild
Mary Dolan
953 Maple Ave, Ridgefield, NJ 07657
Fall or winter guide to more than 100 craft shows in New Jersey. Free with SASE.

Craft Show List
Robert James Publishing
PO Box 3322, Easton, PA 18043
215/252-3150

Crafts Fair Guide
Box 5508, Mill Valley, CA 94942
$42.50 for four quarterly issues. Reviews of 1,000 fairs occurring throughout the west.

Directory of Craft Fairs in Arkansas
Cooperative Extension Service, U of AR
Box 391, Little Rock, AR 72203

Directory of Promoters
Robert James Publishing
PO Box 3322, Easton, PA 18043-3322
215/252-3150
National promoters, $5.

Directory of South Dakota Arts Festivals
South Dakota Arts Council
108 W 11th St, Sioux Falls, SD 57102-0788
605/339-6646

Exhibition Review Magazine
4620 SW Beaverton Hillsdale Hwy #B1, Portland, OR 97221
800/235-3324
$24.95.

Exhibits, Fairs, Festivals and Performances
Tennessee Arts Commission
320 6th Ave N #100, Nashville, TN 37243
615/741-1701
Free.

Fairs and Festivals in the Northeast and Fairs and Festivals in the Southeast
Arts Extension Service/Division of Continuing Ed
604 Goodell, Box 33260, University of MA, Amherst, MA 01003-3260
413/545-2360
$12.50 + shipping. Also prints an "Arts Festival Work Kit."

Festival Network
3711 S Elm-Eugene St, Greensboro, NC 27406
910/275-7782

Florida Festivals
Pinellas County Arts Council
400 Pierce Blvd, Clearwater, FL 34616
813/464-3327
Listings of 500 shows, $12.

Hands-on Guide
Christel Luther
255 Cranston Crest, Escondido, CA 92025-7037
619/747-8206

Illinois Art Fair Directory
Illinois Arts Council
100 W Randolph #10-500, Chicago, IL 60601
800/237-6994 312/814-6750
Lists hundreds of shows in Illinois. Free.

Iowa Tourism
Economic Development
200 E Grand, Des Moines, IA 50309
800/345-IOWA 515/242-4705

Michigan Council for the Arts
State Plaza Bldg, 1200 6th St, Detroit, MI 48226-2461
313/256-3731
Send SASE in #10 envelope with 78¢ postage.

Minnesota Explorer
Minnesota Travel Information Center
100 Metro Sq, 121 7th Pl E, St Paul, MN 55101
800/657-3700 612/296-5029

National Calendar of Indoor/Outdoor Art Fairs
Washington Festival Directory and Resource Guide,
Puget Sound Festival Association, 500 Wall St, 319A,
Seattle, WA 98121
206/448-9340

Neighbors & Friends
PO Box 294402, Lewisville, TX 75029-4402
800/779-1073 214/539-1073

Ohio Arts and Crafts Guild 1992 Jury Report
Box 3080, Lexington, OH 44904
419/884-9622

Ohio Arts Festivals and Competitions Directory
Festival Directory/Ohio Arts Council
727 E Main St, Columbus, OH 43205
614/466-2613
Free with 78¢ in postage stamps.

Oklahoma Arts Fairs & Festivals
State Arts Council of Oklahoma
PO Box 52001-2001, Oklahoma City, OK 73152-2001
405/521-2931
Free.

Rhodes Guide
Larry Harris
Box 142, La Veta, CO 81055-0142
719/742-3146
$45 for 180 medium- to high-end rated show listings. Larry Harris is also a consultant with much knowledge about shows across the country ($40 per hour). Mailing labels are available for $22.

Ronay Guide
A Step Ahead Ltd
1950 Pangborn Rd, Decatur, GA 30033
404/939-2452
Covers over 2,300 arts and crafts shows, fairs, festivals, competitions and art exhibitions held in the six southeastern states of Georgia, Florida, Alabama, Tennessee, and the Carolinas. $7.95.

Show Circuit Planner
13860 Wellington Tr #250, Wellington, FL 33414
407/790-7245

South Dakota Arts Fairs
South Dakota Arts Council
230 S Phillips Ave #204, Sioux Falls, SD 57102-0720
605/339-6646
Send 55¢ postage.

Sunshine Artists
1700 Sunset Dr, Longwood, FL 32750
305/323-5927
Monthly magazine, highly recommended to read to study the fine art and craft market. Has an annual edition that lists the top 100 fine art shows.

Wisconsin Art and Craft Fairs Directory
Wisconsin Arts Board
131 Wilson St #301, Madison, WI 53703-3233

Wisconsin Arts and Crafts Fairs
Wisconsin Arts Board, 101 E Wilson St 1Fl, Madison,
WI 53703
608/266-0190

Art Shows

National Trade Shows

For further show listings, specific or general, look in your local library, as well as in the following three directories and magazines:

· **Trade Shows & Professional Exhibition Directory**

· **The Exhibition Review**
A magazine that lists trade shows, including art shows.

· **Trade Show Exhibiting by Diana Weintraub**
McGraw/Liberty Hall Press
800/262-4729

American Institute of Architects Annual Expo
1735 New York Ave NW, Washington DC 20006
202/626-7407 202/626-7518

American Stationery Fair
AMC Trade
240 Peachtree St NW #2200, Atlanta, GA 30303
404/220-2218

Atlanta International Gift & Accessories Market
Atlanta Gift Mart
240 Peachtree St NW #2200, Atlanta, GA 30303-1327
404/220-3000
January.

California Gift Shows
AMC Trade Shows
885 S Figueroa St #600, Los Angeles, CA 90017
213/747-3488
February in San Francisco, July in Los Angeles.

Chicago Gifts & Accessories Market
Merchandise Mart
200 World Trade Ctr #470, Chicago, IL 60654
312/527-4141
Jan-Feb.

Dallas Super Market at the World Trade Center
2100 Stemmons Freewy, Dallas, TX 75207
214/665-6100
January.

Florida Gift Show
404/220-3000
May.

Furniture and Accessory Shows
Karel Exposition Management/KEM
PO Box 19-1217, Miami Beach, FL 33119
305/534-7469

Home and Apartment Show
MSF Production Inc/Ann Thurston
1120 Avenue of the Americas 4Fl, New York, NY 10036
212/626-6705
At Jacob Javitts Center in November.

Imprinted T-Shirt & Actionwear Show
WFC Inc
3000 Hadley Rd, South Plainfield, NJ 07080
908/769-1160

International Home Furnishings Market
High Point, NC
910/889-0203
Apr-May.

Licensed Product World Expo
PEMCO
191 S Gary Ave, Carol Stream, IL 60188-2092
800/323-5155 708/260-9700

Licensing
Expocon Management Associates
7 Cambridge Dr, PO Box 1019, Trumbull, CT 06611
203/374-1411
June. Sponsored by Licensing Industry Merchandisers Association at 212/244-1944.

National Art Materials Trade Association/NAMTA
178 Lakeview Ave, Clifton, NJ 07011
201/546-6400
Has 2-3 trade shows per year exhibiting the latest in art materials and supplies, along with various lectures and seminars for artists. Annual Pasadena show in October.

National Stationery Show
George Little Management
2 Park Ave #1100, New York, NY 10016-5748
800/272-7469 212/686-6070
Held annually in New York in mid-May.

Premium Incentive Show
Trent & Co
594 Broadway #302, New York, NY 10012
212/966-0024
May.

Seybold
PO Box 5856, Santa Monica, CA 94402-0856
800/488-2883
Computer and art-related.

Siggraph
401 N Michigan Ave, Chicago, IL 60611
312/644-6610
Computer art, held in July.

National Art Shows

ArtExpo
Advanced Star Communications
7500 Old Oak Blvd, Cleveland, OH 44130
800/827-7170 216/826-2858
Las Vegas (October) and ArtExpo NY (March). Both have costly booths for artists. Worthwhile to check out the show to see what's happening in the art scene. Upscale art.

ArtFair/Seattle
270 S Hanford St #208, Seattle, WA 98134
206/624-7363
Similar to ArtExpo, held in February.

ArtLA
November in Los Angeles. Upscale art.

Art Americas
Miami Beach Convention Center
407/220-2690
March.

Art Boston
518/861-5062
October.

Art Chicago
Thomas Blackman Associates
230 W Huron St, Chicago, IL 60610
312/587-3300
Held in May, upscale art.

Art Miami
11640 San Vicente Blvd #108, Los Angeles, CA 90049
310/820-0498
January. This group also sponsors shows in Hong Kong, Chicago, San Francisco and Los Angeles.

Art New York International
Piers 90 & 92, New York City
407/220-2690
Apr-May.

Arts in the Parks
Grand Teton National Park
Jackson Lake Lodge, Jackson Hole, WY
800/553-2787
September.

Arts of Pacific Asia
Civic Auditorium, Santa Monica, CA
310/455-2886
March.

Atlanta Art Expo
1700 Jeurgens Ct, Norcross, GA 30093
404/279-9899
April.

Hawaii Art Expo
Neal Blaisdell Center, Honolulu, HI
808/239-4027
March.

LA Modernism Show
Civic Auditorium, Santa Monica, CA
310/455-2886
May.

Northern Plain Tribal Arts
Sioux Falls, SD
800/658-4797

Philadelphia Art Show
Peg Archdeacon
Adams Mark Hotel Exhibition Center, Philadelphia, PA
610/565-5277
November.

Rock Art Expo
Herbst Pavilion, Ft Mason Center, San Francisco, CA
800/ROC-EXPO
September.

SOFA Miami
312/654-0870
March.

USArtists
Philadelphia Academy of Arts/Ms Medveckis
118 N Broad St, Philadelphia, PA 19102
215/972-7600 ex 3273
December.

West Coast Art & Frame Show
Vancouver, BC Canada
604/266-3163
March.

Art Shows

International Art Fairs

Most of the following fairs occur annually in different major cities throughout the world. ArtNews and Art in America often carry advertising from these shows that will keep you current on the exact dates.

ARCO
Madrid, Spain
February.

ArtAsia
David Lester
11640 San Vicente Blvd #108, Los Angeles, CA 90049
November.

Artcologne
KolnMesse
Postfach 21 07 60, D-50532 Cologne, Germany
November.

Artfiera
Maurizio Mazzotti
Pza Constituzione 6, 40128 Bologna, Italy
January.

ArtFrankfurt
Thomas Becki
Ludwig-Erhard-Anlage 1, D-6000 Frankfurt, Germany
212/974-8853
April.

Art Hamburg
Jugliusstrasse 13, Postfach 30 24 80, W-2000 Hamburg 36, Germany
December.

Art in Pordenone
France.

Australian Contemporary Art Fair
21 Macarthur Pl, PO Box 5004, Carlton 3053 Australia
October.

Basel Fine Art Fair
Sue Bond
011/44-71-381-1324

China Art Expo
Canton, China
601/826-2579

Decouvertes
62 rue de Mironmesnil, 75008 Paris, France
February.

Documenta IX
Jan Hoet
Friedrichsplatz, 3500 Kassel, Germany
June.

ELAAC
Marise Labrecque
1435 rue de Bieury, Bureau 806, Montreal, PQ Canada H3A 2H7
November.

Europe Art Salon
29 rue de Bourg Ch-1002 Lausanne, Switzerland

European Fine Art Fair
Sue Bond
PO Box 1035, 5200 BA's-Hertogenbosch, Netherlands
011/44-71-381-1324
March.

Expo Guadalajara
Feria de Arte Contemporaneo
Circunvalacion Providencia, 1210-ACP 44610 Jalisco, Guadalajara Mexico
February.

Feria Iberoamericana de Arte/FIA
Calle Londres esq, NY Centro, DMC Las Mercedes Caracas 1060, Venezuela

FIAC
Jessie Westenholz
62 rue de Mironmesnil, 75008 Paris, France
October.

Foire D'art Actuel de Bruxelles
Albert Baronian
rue Vilain XIII 14, 1050 Bruxelles, Belgium
April.

Frankfurt International Herbstmesse Fair
404/984-8016

International Autumn Fair
Adam Ash
National Exhibition Center, Birmingham, England
201/659-0134

International Contemporary Art Fair
11 Manchester Sq, London W1M 5AB UK
April.

Jonction Cannes
21 rue St Philippe, 06000 Nice, Cannes, France
June.

Kotka Finland
Kotka Cultural Office, Keskuskatu 33, SF-48100 Kotka
Finland
Jun-Aug.

Lineart
Jan Pieter Ballegeer
Intl Congrescentrum, B-9000 Gent, Belgium
Nov-Dec.

London Contemporary Art Fair
Business Design Centre, Upper St, Islington Green,
London N1 0QH
071/359-3535
January.

Messe Frankfurt
Edward Kurcin
480 University Ave #1410, Toronto, Ontario Canada
M5G 1V2
416/596-7607

New Trends
Hong Kong
March.

NICAF
Tokyo Tower Bowling Ctr, 1Fl, 4-4-13 Shibakoen,
Minato-ku, Tokyo 105 Japan
March in Yokohama.

pARTy
Phillippe Levy
Messeplatz, PO Box CH-4021, Basel, Switerland
June.

SAGA
Parc des Expositions de Paris, Porte de Versailles, Paris,
France
011/33-1-49-532700
March.

Sal International des Beaux Arts
Espace Eiffel-Branly, Paris, France
011/33-1-49-532700

Stockholm Art Fair
Leif Stahle
Sollentunamassan AB, Box 174, S-191, Sollentuna
Sweden
011/46-8-789-2400
March.

Tokyo International Art Show
379 W Broadway, New York, NY 10012
212/941-6010
Held in January with 1200 exhibitors.

Venice Biennale
Next one is the summer of 1997.

Westdeutsche Kunstmesse
Heinhallen Messeplatz 1, Cologne Germany
49-221-8210
April.

Art Shows

Western Art Shows

Cowboy Artists of America Show and Sale
Phoenix Art Museum
602/258-5263
October.

Festival of Western Arts
Box 146, San Dimas, CA 91773
909/599-5374
April.

Kalispell Western Art Show & Auction
Walsdorf Gallery
516 W First Ave, Spokane, WA 99204
509/838-5847
September.

Prix de West Invitational Exhibition
National Cowboy Hall of Fame
Oklahoma City
405/478-2250
Jun-Sep.

Southwestern Indian Art Exhibition
Johnson and Associates/Marilynn Kelly
445 W Erie St #100, Chicago, IL 60610
312/988-7237
April.

Western Art Exhibit & Auction
Trails West Art Association
5001 NE Thurston Way #203, Vancouver, WA 98662
206/256-6963
October.

Western Art Roundup
Custer County Art Center
PO Box 1284, Miles City, MT 59301
Exhibit, seminars, held in Apr-Jun.

Western Rendezvous of Art
Helena Arts Council/Dick Duffy
PO Box 1231, Helena, MT 59624
406/442-8683
Museum show held in August.

Wildlife & Western Art Show
SCWAA/Larry Waggoner
PO Box 33757, Granada Hills, CA 91394
714/284-9399
October.

Wildlife & Western Art Show
Hyatt Regency, Minneapolis, MN
218/825-7469
April.

Print Shows

Art Buyers Caravan
Decor Magazine
330 N 4th St, St Louis, MO 63102
314/421-5445
Held 4-6 times a year. Call for specific dates and locations. Around $675 for a booth.
Dallas/April Cincinnati/May
Long Beach/June San Diego/August
Atlanta/September Philadelphia/October

Atlanta Fine Print Fair
Atlanta College of Art
1280 Peachtree St NE, Atlanta, GA 30309
404/898-1157
April.

Frame-O-rama
Paul Karel
314/421-5445

Galeria
Paul Karel
314/421-5445

Print Club of Albany
Charles Semowich
PO Box 6578 Ft Orange Station, Albany, NY 12206
518/449-4756 518/432-9514

Prints/Chicago
Allerton Hotel, Chicago
312/243-6481

Professional Picture Framers Association/PPFA
4305 Sarellan Rd, Richmond, VA 23231
800/832-7732 804/226-0430
Various places throughout the year.

St Louis Print Market
Washington University Gallery of St Louis
Cecile Lowenhaupt
314/361-3737 314/441-7771
Virginia Benson
314/772-3644

Washington International Print Fair
Rosslyn Westpark Hotel, Arlington, VA
202/638-6008
April.

Works on Paper
Park Ave Armory at 67th St, New York City
212/777-5218

Wildlife Shows

Listed alphabetically.

American Museum of Wildlife Art
Ultima Art and Media/Jan Van Hoesen
8005 Pinon Pl, Bozeman, MT 59715
Show and workshops.

Baltimore Wildlife & Nautical Art Expo
November.

Birds in Art
Leigh Yawkey Woodson Art Museum, Wausau, WI

Buckhorn Wildlife Art Festival
Box 280, Buckhorn, Ontario Canada K0L 1J0
705/657-1918
August.

Bucks County Wildlife Art Exhibition
Audubon Society/Sally DeStefano
6324 Upper York Rd, New Hope, PA 18938
212/297-5880
December.

Cape Charles Wildlife Show
PO Box 87, Cape Charles, VA 23310
804/331-2304
September.

Currituck Wildlife Festival
Currituck Wildlife Guild
PO Box 91, Shawboro, NC 27973
September.

The Exposition
Wildlife America Foundation
4535 S Berkeley Lake Rd, Norcross, GA 30071
404/441-7777
October.

Idaho Wildlife Art Show
Idaho Sportsmen's Coalition
PO Box 2091, Boise, ID 83701
208/344-1433
November.

Kansas City National Wildlife Art Show
PO Box 7728, Shawnee Mission, KS 66207
913/588-NWAS
February.

Michigan Wildlife Art Festival
West Michigan Wildlife Habitat Foundation
6425 S Pennsylvania #9, Lansing, MI 48911
517/882-3630
In March and October..

Minnesota Wildlife Expo
Collectors Society
2400 Hwy 7 #200, Excelsior, MN 55331
612/474-3873
April.

Minnesota Wildlife Heritage Art Show
5701 Normandale Rd #325, Minneapolis, MN 55424
612/925-1923
July.

Nature's Kingdom Wildlife Expo
Michigan Artist Assoc
PO Box 142, Linden, MI 48451
313/735-5129
September.

Nautical & Wildlife Art Festival
Donald's Duck Gallery
11455 Gold Coast Mall, Ocean City, MD 21842
301/524-9177
January.

New England Wildlife Art Expo
795 Hoop Pole Rd, Guilford, CT 06437
203/457-1571
October.

North Carolina Wildlife and Sportsmen's Show
PO Drawer C, New Bern, NC 28563
919/637-3111
October.

North Carolina Wildlife Art Exhibit
PO Box 10626, Raleigh, NC 27605-0626
919/833-1923
December.

Northeastern Wildlife Art Exposition
Bootlegger Productions/Michael Geer
PO Box 3624 Stn C, Hamilton, Toronto, Ontario
Canada L8H 7M9
416/664-2004
April, includes lectures and seminars.

Art Shows

Wildlife Shows (cont.)

Oklahoma Wildlife Festival
Nature Works
320 S Boston #1222, Tulsa, OK 74103
918/585-1117
Feb-Mar.

Pacific Rim Wildlife Art Show
Robert Farrelly
PO Box 11225, Tacoma, WA 98411
206/383-3523 206/759-7895 206/596-6728
September, largest on West Coast.

Piedmont Wildlife Expo
5471 Central Ave, Charlotte, NC 28212
704/568-1262
October.

Southeastern Wildlife Exposition
James Huggins
211 Meeting St, Charleston, SC 29401
803/723-1757 803/723-1748
Largest exposition of wildlife art in the country, usually in February.

Southern Maryland Wildlife Festival
Gallery Jamel
630 Old Line Center, Rte 5 S, Waldorf, MD 20602
301/870-6570
September.

Southern Wildlife Festival
Calhoun Community College
PO Box 1684, Decatur, AL 35602
November.

Vermont Institute of Natural Science Wildlife Art Show
PO Box 86, Woodstock, VT 05091
802/457-2779
September.

Virginia Wildlife Arts Show
Belvoir Outdoor Recreation
Bldg 773, Ft Belvoir, VA 22060
703/805-2964
August.

Ward Art Exhibition & Sale
Ward Foundation
PO Box 3416, Salisbury, MD 21802
800/742-4988
October.

Waterfowl Festival
PO Box 4997, Annapolis, MD 21403-6997
April.

Waterfowl Festival
PO Box 929, Easton, MD 21601
301/822-4567
November.

Watertown Wildlife and Western Art Show
Box 10, Watertown, SD 57201
605/886-6901
September.

Western Pennsylvania Wildlife Art Expo
Slippery Rock U, Slippery Rock, PA
412/738-2027
May.

Wild Wings Annual Fall Festival
Barb Arndt
PO Box 451, S Hwy 61, Lake City, MN 55041
612/345-5355
September.

Wildlife and Sporting Art/The Masters Show
Loyalhanna Watershed Association
PO Box 561, Ligonier, PA 15658
412/238-7560
September.

Wildlife Art and Photography Show
Hidden Oak Nature Center/Thomas Frullo
4020 Hummer Rd, Annandale, VA 22030
703/941-1065
March.

Wildlife Art in America
Donald Luce
10 Church St SE, Minneapolis, MN 55455

Wildlife Art Show
Southern Illinois Hunting and Fishing Commission
PO Box 1088, Marion, IL 62959
800/433-7399
September .

World Wildlife Exposition
PO Box 461, Gatlinburg, TN 37738
800/253-9453
June.

Fine Art Shows

We are unable to review each show personally; however, we talk to many artists who attend various shows and try to deduce which ones seem to bring the best in sales. As we visit these shows we review them in our newsletter, ArtSource Quarterly. Listed alphabetically by state. Ones with an asterisk () before their name are ones the editor has attended and recommends.*

Festival in the Park
Parks and Recreation Department
1010 Forrest Ave, Montgomery, AL 36106
205/241-2300
Considered the best in Alabama; October.

***Scottsdale Celebration of Fine Art**
Thomas Morrow
8602 E Cortez St, Scottsdale, AZ 85260
602/443-2647
Jan-Mar in Scottsdale, AZ; Jul-Aug in Del Mar, California. Held under a tent, styled like a galleria of artists, a great venue to sell fine art.

***Affaire in the Gardens**
Beverly Hills Arts & Parks
8400 Gregory Way, Beverly Hills, CA 90211
310/550-4628
May and October. 75,000 attendance. #1 in California (by editor's standards!). All fine art. Repeat exhibition will guarantee repeat customers.

Hollywood Bowl Father's Day Fair
Hollywood Arts Council/Pasquel Bettio
PO Box 931056, Hollywood, CA 90093
213/462-2355
June.

***La Jolla Festival of the Arts**
4130 La Jolla Village Dr #10717, La Jolla, CA 92122
619/456-1268
June. One of the best in California. All media and styles, outstanding work, varying price ranges to $2000+.

***Art-A-Fair**
Festival Grounds
777 Laguna Canyon Rd, Laguna Beach, CA 92651
714/494-4514
Jul-Aug.

***Laguna Festival of the Arts**
650 Laguna Canyon Rd, PO Box 1659, Laguna Beach, CA 92651
800/487-3378 714/494-1145
Jul-Aug

Artists Market
Long Beach Museum of Art
2300 E Ocean Blvd, Long Beach, CA 90803
310/435-7350
June.

Monterey Bay Fine Art Festival
Timothy Callahan
PO Box 51784, Pacific Grove, CA 93950
408/375-5019
July.

Art & Wine Festival
Rancho Bernardo CC/Roy Houtz
11650 Iberia Pl #M, San Diego, CA 92128
619/487-1767
October.

Tapestry in Talent
Carol Schreiber
118 N 4th St #C, San Jose, CA 95112
408/293-9727
September; 400,000 attendance.

American Cetacean Society Art Show
ACS National Headquarters
PO Box 2639, San Pedro, CA 90731
November.

Santa Barbara Art Walk
SBMNH League
2559 Puesta del Sol, Santa Barbara, CA 93105
October.

Peppertree Ranch
Irma Eubanks
3617 Roblar Ave, Santa Ynez, CA 93460
805/688-6205
Invitational show featuring top, contemporary artists from all over the country in May and November.

Sausalito Arts Festival
Diane Sasson
PO Box 566, Sausalito, CA 94966
415/332-0505
Held over Labor Day weekend for three days with 60,000 people in attendance. #1 show in Northern California, with some of the richest buyers in the Bay area as patrons. Original work only, no prints.

Salute to the Arts
Sonoma Plaza, CA
July.

Art Shows

Fine Art Shows (cont.)

Cherry Creek Arts Festival
Bill Charney
201 Fillmore St #200, Denver, CO 80206-5003
303/355-2787
July. Original work only, no prints.

Sculpture in the Park
Priscilla Williams
PO Box 7006, Loveland, CO 80537-7006
303/663-2940 303/669-7390 Fax
August. 15,000 attendees.

Fairfield Festival of the Arts
1597 Post Rd, Fairfield, CT 06430
June.

On the Green
Glastonbury Art Guild
PO Box 304, Glastonbury, CT 06033
203/659-1196
September.

Boca Raton Museum of Art
801 W Palmetto Rd, Boca Raton, FL 33486
407/392-2500
February.

***Coconut Grove Arts Festival**
2960 McFarlane Rd #204, Coconut Grove FL 33133
305/447-0401
February. Considered one of the top in the country for fine artists, and indeed it deserves its reputation. The predicted crowd of 750,000 was believable. Artwork ranged from $50-$9,000+. All media and styles were included—with glass artists reigning as spectacular.

Affairs of the Art
Karel Hillemann
PO Box 292224, Davie, FL 33329
305/791-2754
February and September.

Museum of Art Festival
Las Olas Art Festival/Museum of Art
PO Box 2211, Ft Lauderdale, FL 33303
305/525-3838
March.

Hollywood Festival of the Arts
PO Box 737, Hollywood, FL 33022
305/920-7809
February.

Islamorada Rain Barrel Arts Festival
Carol Cutshall
86700 Overseas Hwy, Islamorada, FL 33036
305/852-3084
March. 20,000 attendees.

Miami Beach Festival of the Arts
PO Bin O, Miami Beach, FL 33119
305/673-7722
February.

Riviera Art Fair International
420 Lincoln Rd #393-394, Miami Beach, FL 33139
305/672-2322

Mt Dora Arts Festival
Center for the Arts
PO Box 231, Mt Dora, FL 32757
904/383-0880
February. 200,000 attendees. Original fine art only.

Azalea Festival Art Show
Lori Malhoit
PO Box 722, Palatka, FL 32177
904/325-8750
March. 20,000 attendees.

Contemporary American Paintings
Society of the Four Arts
Four Arts Plaza, Palm Beach, FL 33480
407/655-7226
November.

Gulfcoast Arts Festival
Arts Council of NW Florida
PO Box 731, Pensacola, FL 32594
904/432-9906
November.

Lowe Museum Beaux Arts Festival
PO Box 431216, S Miami, FL 33143-1216
January.

Winterpark Sidewalk Art Festival
Chuck Robbins
PO Box 597, Winter Park, FL 32790
407/623-3292
March. 300,000 attendees.

Arts in the Heart of Augusta
Greater Augusta Arts Council
PO Box 1776, Augusta, GA 30903
404/826-4702
September.

Art in the Park
Clinton Art Association/Carol Glahn
Box 132, Clinton, IA 52733
319/259-8308
May. 20,000 attendees.

Beaux Arts Fair
Davenport Museum of Art
1737 W 12th St, Davenport, IA
319/326-7804
September.

Riveressance Festival of Fine Art
PO Box 2183, Davenport, IA 52809-2183
319/386-8006
20,000 attendees.

57th St Art Fair
Susan Goldhamer
5201 S Cornell #9C, Chicago, IL 60615
312/324-5848
June. 100,000 attendees.

Gold Coast Art Fair
222 W Ontario St, Chicago, IL 60610-3695
312/787-2677
August. 830,000 attendees.

Wells St Arts Festival
Old Town Chamber of Commerce
1543 N Wells, Chicago, IL 60610-1307
312/951-6106
June. 50,000 attendees.

Midwest Salute to the Masters
Susan Burgess
10035 Bunkum Rd, Fairview Hts, IL 62208
800/782-9587 618/397-7743
Must have won primary prize previously in order to apply. Held in September.

***Port Clinton Art Festival**
Amy Amdor
PO Box 1338, Highland Park, IL 60035
305/653-6525
August. 100,000 attendees.

Naperville Women's Art Fair
Alice Dieter
229 W Spring Ave, Naperville, IL 60540
708/355-1443
July.

Three Rivers Festival
2301 Fairfield Ave #107, Ft Wayne, IN 46807
219/745-5556
July. 160,000 attendees.

Chatauqua of the Arts
Dixie McDonough
1119 W Main, Madison, IN 47250
812/265-5080
September. 100,000 attendees.

Kansas City Festival
Johnson County Park & Recreation
6501 Antioch Rd, Shawnee Mission, KS 66202
913/831-3355
June.

New Orleans Fine Arts Festival
New Orleans Art Association
1149 Melody Dr, Metairie, LA 70002
504/486-4637
March.

Pirates Alley Open Show
Betty LeBlanc
5104 Tartan Dr, New Orleans, LA 70003
April. Fine art only.

Art in the Park
331 Salem St, Andover, MA 01810
September.

West Springfield Arts Festival
Recreation Department
26 Central St, W Springfield, MA 01089
413/781-7550
August.

***Ann Arbor Arts Fair**
Michigan Guild of Artists/Shary Brown
118 N 4th Ave, Ann Arbor, MI 48104-1402
313/662-ARTS

***Ann Arbor Street Art Fair**
Susan Froelich
Box 1352, Ann Arbor, MI 48106
313/995-4681
July. 400,000 expected.

Orchid Show
Detroit Garden Center/Moross House
1460 E Jefferson Ave, Detroit, MI 48207
313/259-6363
February.

Art Shows

Fine Art Shows (cont.)

Art in the Park
751 Hendrie Blvd, Royal Oak, MI 48067
313/543-3050
September. 50,000 expected.

White Lake Maritime Festival
White Lake Rotary Club
425 Gibbs St, Whitehall, MI 49461
616/893-4585
August.

Two River Arts Expo
Corky Hubbell
4055 SW 30th St, Des Moines, MN 50321
November.

Marine Art Fair
Doris Strand
1313 Broadway, Marin on St Croix, MN 55047
612/433-2078
August.

An Art Affair
White Company
940 W Port Plaza #264, St Louis, MO 63146
314/878-0400
June.

Laumeier Contemporary Art Fair
Pamela Grant
12580 Rott Rd, St Louis, MO 63127
314/821-1209 314/726-6888
May. Only originals (sculpture too). 20,000 attendees.

Missouri Botanical Garden Show Art Fair
2211 S 39th St, St Louis, MO 63110
314/772-1766
October. 11,000 attendees.

Arts in the Park
Hockaday Center for the Arts
Box 83, Kalispell, MT 59903
406/755-5268
July.

Art in the Park
Sophie Budner/Pascack Art Association
205 Elizabeth St, Oradell, NJ 07649
June.

Magnifico
Albuquerque, NM
800/733-9918 505/842-9918
May.

Art Santa Fe
La Posada Hotel/East Palace, Santa Fe, NM
212/505-3405
Mid-July.

Fine Art Fiesta
Sweeney Convention Ctr
201 W Marcy St, Santa Fe, NM 87501
505/988-7322
November.

Taos Spring Arts Celebration
Taos Chamber of Commerce, Taos, NM
800/732-TAOS 505/758-3873
Apr-May.

Artists on the Lane
South Bay Art Association
PO Box 244, Bellport, NY 11713
No crafts.

Art on the Common
Judy Osburn
20 John St, Goshen, NY 10924
Located at Woodbury Common, the Northeast's largest upscale shopping district 40 miles from New York City.

Fine Art Outdoor Show
Suburban Art League
37 Fox Pl, Hicksville NY 11801
October. Original fine art. Held in conjunction with flower show.

Village Green
Huntington Township Art League
PO Box 351, Huntington, NY 11743
516/368-0018
June. No reproductions.

Central Park South Annex
PO Box 7010, New York, NY 10116-4627

Springfest Charlotte
129 W Trade St #420, Charlotte, NC 28205-2175
704/332-0126
May. 250,000 attendees, $20,000 in purchase awards.

Annual Art Fest
Judi Allen/Minot Art Association
Box 325, Minot, ND 58702
701/838-0678
March.

SummerFair
PO Box 8287, Cincinnati, OH 45208
513/531-0050
June. 60,000 attendees.

Cain Park Arts Festival
H Feinberg
40 Severance Cir, Cleveland Heights, OH 44118
216/381-9274
July. 60,000 attendees, $500,000 in sales, in its 15th year.

Art in the Park
Riverbend Art Council
1301 E Siebenthaler Ave, Dayton, OH 45414
513/278-0655
May. 30,000 attendees.

Boston Mills Artfest
Don Getz
PO Box 175 Peninsula, OH 44264-0175
216/467-2242
June. 200,000 attendees, $1,200,000 in sales, upscale.

Festival in the Park
Lachenmeyer Arts Center
PO Box 586, Cushing, OK 74023
918/225-7525
October.

Salem Art Fair
600 Mission St SE, Salem, OR 97302
503/581-2228
July.

Children's Hospital of Phil Benefit
Classic Productions
927C Mt Eyre Rd, Newtown, PA 18940
215/493-0706
June.

Three Rivers Arts Festival
Harriet Mendlowitz
207 Sweetbriar St, Pittsburgh, PA 15211
412/481-7040
June. 600,000 attendees, $1 million in sales.

Newport Outdoor Art Festival
PO Box 3034 Broadway St, Newport, RI 02840
401/683-4009
June.

Riverplace Festival
409 E North St, Box 10, Greenville, SC 29601
Oldest festival in SC held in Apr-May.

Memphis Arts Festival/Arts in the Park
Martha Maxwell
4646 Poplar Ave #535, Memphis, TN 38117-4435
901/761-1278 (also fax)
October. Has "Wholesale Days," 30,000 attendees.

***Fiesta**
9909 Oak Hollow Dr, Austin, TX 78758
512/388-2303
May.

Artfest
Debra Barry-Benton
8300 Douglas #800, Dallas, TX 75225
214/361-2011
May. 80,000 attendees, largest festival in SW, only the best work.

Arts in the Park
RS Lovelace III
1112 Sunset Ave, Richmond, VA 23221
804/353-8198
May. 100,000 attendees, high-end sells well.

***Pacific Northwest Arts Fair**
Bellevue Art Museum
301 Bellevue Sq, Bellevue, WA 98004
206/454-4900
July.

Rhododendron State Outdoor Art Festival
Robert Harden
429 Highland Ave, S Charleston, WV 25303
304/744-4323
June. Original work only.

Arti Gras/Art Street
NE Wisconsin Arts Council
PO Box 704, Green Bay, WI 54305-0704
414/435-2787
February and August.

***Toronto Outdoor Art Exhibition**
Tracy Capes
35 McCaul St, Toronto, Ontario, Canada M5T 1V7
416/408-2754
July. Variety of quality, fine art work, as well as glass and other crafts.

chapter **5**

Museums

Listed alphabetically by state.

❖ **Yupiit Piciryarait Museum**
Mary Stachelrodt
PO Box 219, Bethel, AK 99559
907/543-3521 907/543-3596 Fax

Year museum was established: 1994
Days/hours open: Tues-Sat 10-6
Our museum is planning to show contemporary art:
Periodically during special exhibits
We are planning a show of contemporary artists within the next 2 years.
Requirements for artists who seek to sell/donate artwork: Submit portfolio for review.
Particular style of artwork we are adding to our collection: Alaskan and/or Northern Artic
Particular medium of artwork we are adding to our collection:

Acrylic Drawing Oil
Pen & Ink Sculpture

❖ **Carrie McLain Museum**
Janet Williams
PO Box 53, Nome, AK 99762
907/443-2566 907/443-3762 Fax

Year museum was established: 1960
Days/hours open: Tues-Sat 10-5
Our museum shows contemporary art: Periodically, during special exhibits
We are planning a show of contemporary artists within the next 2 years.
Requirements for artists who seek to sell/donate artwork: Send slides by mail for consideration.

❖ **Phippen Museum of Western Art**
Sue Willoughby
4701 Highway 89 N, Prescott, AZ 86301
602/778-1385

Annual Spring show, open to all artists including sculptors/work must feature western subjects.

❖ **Long Beach Museum of Art**
2300 E Ocean Blvd, Long Beach, CA 90803
310/439-2119 310/439-3587 Fax

Year museum was established: 1950
Days/hours open: Wed-Sun 10-5; Fri 10-8
Our museum shows contemporary art: Periodically
We are planning a show of contemporary artists within the next 2 years.
We are accepting donations of work.

Requirements for artists who seek to sell/donate artwork: Send slides by mail for consideration.
Particular style of artwork we are adding to our collection: All
Particular medium of artwork we are adding to our collection: All, as well as video and media arts

❖ **Southwest Museum**
Jeannette O'Malley
PO Box 41558, 234 Museum Dr, Los Angeles, CA 90041-0558
213/221-2164 213/224-8223 Fax

Year museum was established: 1907
Days/hours open: Tues-Sun 11-5
Our museum shows contemporary art: Periodically
We are planning a show of contemporary Native American artists in May 1996.
We are not accepting new works for review at this time.
We have a bookstore selling posters, cards, books, prints, etc.
 Name of Buyer: Jan Posson
We have an art library.
 Name of librarian: Kim Walters
 Open to the public: Wed-Sat 11-5

❖ **Palm Springs Desert Museum**
PSDM Artists Council
PO Box 2288, Palm Springs, CA 92263
619/325-7186

❖ **San Bernardino County Museum**
2024 Orange Tree Ln, Redlands, CA 92374

❖ **Matruango Museum**
Mary Lundstrom
100 E Las Flores Ave, Ridgecrest, CA 93555
619/735-6900

❖ **Crocker Museum**
216 O St, Sacramento, CA 95814
916/264-5423

Bi-annual Crocker-Kingsley Exhibition—juried from emerging artist's entries.

❖ **San Diego Museum of Art**
Mary Stofflet
PO Box 2107, Balboa Park, San Diego, CA 92112

Reviews slides on a continuous basis.

Museums

❖ Cartoon Art Museum
814 Mission St, San Francisco, CA
415/CAR-TOON

❖ California Museum of Art
Luther Burbank Center for the Arts, 50 Mark West
Springs Rd, Santa Rosa, CA 95403
707/527-0297

Year museum was established: 1982
Days/hours open: Wed-Sun 11-4
Our museum shows contemporary art: All the time
We are accepting donations of work.
Requirements for artists who seek to sell/donate
artwork: Send slides by mail for consideration. Artists
must live in California.
Particular style of artwork we are adding to our
collection: All
Particular medium of artwork we are adding to our
collection: All permanent media

❖ Museum of Neon Art/MONA
Mary Carter
Westwalk #154, 1000 Universal Center Dr,
Universal City, CA 91608
818/761-6662 213/620-8904 Fax

Days/hours open: Daily 11-11

❖ Mattatuck Museum
144 W Main St, Waterbury, CT 06702
203/753-0381

Annual show for emerging artists.

❖ Peace Museum
350 W Ontario 4Fl, Chicago, IL 60610
312/440-1860

Various exhibits regarding peace.

❖ Fort Wayne Museum of Art
311 E Main St, Fort Wayne, IN 46802
219/422-6467

Regional biennial.

❖ Waterloo Museum of Art
Cammie Scully
225 Commercial St, Waterloo, IA 50701
319/291-4491 319/291-4270 Fax

Our museum shows contemporary art.
We sponsor classes and seminars in the visual arts.
We have a slide registry.
We have a newsletter, Kae Lind editor.
We have an art library.

❖ Edwin A Ulrich Museum of Art
Dana Self
Wichita State U, Wichita, KS 67260
316/689-3664 316/689-3898 Fax

Year museum was established: 1974
Days/hours open: Mon-Fri 8-5
Our museum shows contemporary art: All the time
We are planning a show of contemporary artists within
the next 2 years.
We are purchasing new works.
Particular style of artwork we are adding to our
collection:

Abstract	Alternative	Conceptual
Contemporary	Latin American	Modernism

Particular medium of artwork we are adding to our
collection:

Bronze	Clay	Fibre Arts
Installations	Oil	

❖ Museum of Fine Art
49 Chestnut St, Springfield, MA 01103
413/732-6092

Year museum was established: 1979
We have a rental gallery connected with the museum
which shows and rents contemporary artists' works.
The rental gallery is seeking both new and established
artists' work from New England only.
Commission: 50%
To contact the rental gallery: Send slides, resumé, SASE/
arrange for a personal interview.
Particular style of artwork we are adding to our
collection:

Abstract	Conceptual	Contemporary
Figurative	Impressionism	Modernism
Realistic	Representational	Traditional

Particular medium of artwork we are adding to our
collection:

Acrylic	Oil	Sculpture

Extremely original and well-done work

❖ James Ford Bell Museum of Natural History
Byron Webster
10 Church St, Minneapolis, MN 55455
612/624-7083 612/626-7044 Fax

Year museum was established: 1872
Days/hours open: Tues-Fri 9-5; Sat 10-5; Sun 12-5
Our museum shows contemporary art: Periodically
We are accepting donations of work.
Requirements for artists who seek to sell/donate artwork: Send slides by mail for consideration.
Particular style of artwork we are adding to our collection: Wildlife
Particular medium of artwork we are adding to our collection:

Acrylic	Airbrush	Bronze
Colored Pencil	Drawing	Marble
Oil	Pastel	Pen & Ink
Prints	Sculpture	Silkscreen
Watercolor		

We have a bookstore selling posters, cards, books, prints, etc.
 Name of Buyer: Chris Schoffler

❖ The Dog Museum
Barbara Jedda
1721 S Mason, St Louis, MO 63131
314/821-3647 314/821-7381 Fax

Year museum was established: 1984
Days/hours open: Tues-Sat 9-5; Sun 12-5
Our museum shows contemporary art: All the time
We are planning a show of contemporary artists within the next 2 years.
We are accepting donations of work on a select basis.
Requirements for artists who seek to sell/donate artwork: Arrange a personal interview to show portfolio.
Particular style of artwork we are adding to our collection:

Contemporary	Figurative	Folk Art
Realistic	Representational	Traditional

All work must be of canine subject.
Particular medium of artwork we are adding to our collection:

Acrylic	Bronze	Ceramic
Charcoal	Clay	Colored Pencil
Drawing	Glass	Mixed Media
Oil	Pastel	Pen & Ink
Photography	Prints	Sculpture
Silkscreen	Watercolor	

We have a bookstore selling posters, cards, books, prints, etc.
 Name of Buyer: Sandra Williams

❖ Roswell Museum
100 W 11th St, Roswell, NM 88201

Have six-month residencies.

❖ Museum of the City of New York
Dr Jan Ramirez
1220 Fifth Ave, New York, NY 10029
212/534-1672 ext 247 212/534-5974 Fax

Year museum was established: 1923
Days/hours open: Weds-Sat 10-5; Sun 1-5; Tues groups only
Our museum shows contemporary art: Periodically
We are accepting donations of work.
We are purchasing new works occasionally.
Requirements for artists who seek to sell/donate artwork: Arrange a personal interview to show portfolio/submit portfolio for review/send slides by mail for consideration.
Particular style of artwork we are adding to our collection:

Impressionism	Marine	Portraits
Representational	City Views (NYC only)	

Particular medium of artwork we are adding to our collection: Will consider any medium
We have a bookstore selling posters, cards, books, prints, etc.
 Name of Buyer: Ann Goldsmith

❖ Yeshiva University Museum
Reba Wulkan
2520 Amsterdam Ave, New York, NY 10033
212/960-5390 212/960-5406 Fax

Days/hours open: Tues-Thurs 10:30-5; Sun 12-6
Our museum shows contemporary art: Periodically
We are planning a show of contemporary artists within the next 2 years.
Requirements for artists who seek to sell/donate artwork: Arrange a personal interview to show portfolio/submit portfolio for review/send slides by mail for consideration.
Particular style of artwork we are adding to our collection:

Judaica	Abstract	Conceptual
Contemporary	Figurative	Folk Art
Landscape	Minimal	Modernism
POP	Portraits	Realistic
Religious	Surrealism	Traditional

Museums

Particular medium of artwork we are adding to our collection:

Acrylic	Bronze	Ceramic
Clay	Collage	Drawing
Fibre Arts	Glass	Mixed Media
Oil	Paper Sculpture	Pastel
Pen & Ink	Photography	Prints

We have a bookstore selling posters, cards, books, prints, etc.
 Name of Buyer: Randi Glickberg

❖ Asheville Art Museum
Frank Thomson
PO Box 1717, 2 S Pack Sq, Asheville, NC 28802
704/253-3227 704/251-5652 Fax

Year museum was established: 1948
Days/hours open: Tues-Sat 10-5
Our museum shows contemporary art: All the time
We are planning a show of contemporary artists within the next 2 years.
We are accepting donations of work.
Requirements for artists who seek to sell/donate artwork: Send slides by mail for consideration.
Particular style of artwork we are adding to our collection:

Abstract	Alternative	Conceptual
Contemporary	Figurative	Folk Art
Impressionism	Landscape	Minimal
Modernism	Naive	POP
Portraits	Realistic	Religious
Representational	Surrealism	Traditional
Visionary		

Particular medium of artwork we are adding to our collection: All
We have two galleries used for temporary exhibitions. For artists interested in being considered for an exhibition, the deadline is September 30. You need to send 20 slides in a good quality slide page, a separate slide list, resumé/statement/reviews, along with a SASE. Send in 9x12" manila envelope, unfolded, not in a notebook, portfolio case, etc. No original work. The museum is not responsible for loss, damage or delay of materials being returned.

❖ Fayetteville Museum of Art
PO Box 35134, Fayetteville, NC 28303
910/485-5121

Annual competition for North Carolina artists.

❖ Taft Museum
David Torbet Johnson
316 Pike St, Cincinnati, OH 45202
513/241-0343 513/241-7762 Fax

Year museum was established: 1932
Days/hours open: Mon-Sat 10-5; Sun 1-5
Our museum shows contemporary art: Periodically
We organize a contemporary show every year and sponsor a juried competition for a minority artist-in-residence every four years.
We have a bookstore selling posters, cards, books, prints, etc. that are related to our collections, special exhibitions or educational mission.
 Name of Buyer: Treva Lambing
We have an art library.
 Open to the public: By appointment

❖ No Man Land Museum
Kenneth Turner
PO Box 278, 207 W Sewell St, Goodwell, OK 73939
405/349-2670 405/349-2302 Fax

Our museum shows contemporary art.
We sponsor competitive exhibitions.

❖ Fred Jones Jr Museum of Art
Thomas R Toperzer
University of Oklahoma, Norman, OK 73079
405/325-3272 405/325-7696 Fax

Year museum was established: 1971
Days/hours open: Mon-Fri 10-4:30
Our museum shows contemporary art: All the time
We are planning a show of contemporary artists within the next 2 years.
We are accepting donations of work.
We are purchasing new works.
We are not accepting new works for review at this time.
We have a bookstore selling posters, cards, books, prints, etc.
 Name of Buyer: Mary Jane Rutherford
We have an art library.
 Name of librarian: Gail Anderson

❖ Oklahoma City Art Museum
Alyson B Stanfield
3113 Pershing Blvd, Oklahoma City, OK 73107
405/946-4477 405/946-7671 Fax

Year museum was established: 1989
Days/hours open: Tues-Sat 10-5; Sun 1-5
Our museum shows contemporary art: Periodically
We are planning a show of contemporary artists within the next 2 years.
We are accepting donations of work.

We are purchasing new works.
Requirements for artists who seek to sell/donate artwork: Send slides by mail for consideration.
Particular style of artwork we are adding to our collection:

Abstract	Conceptual	Contemporary
Fantasy	Figurative	Impressionism
Landscape	Latin American	Marine
Minimal	Modernism	POP
Portraits	Realistic	Representational
Surrealism	Traditional	Western

Particular medium of artwork we are adding to our collection:

Acrylic	Bronze	Ceramic
Charcoal	Clay	Collage
Colored Pencil	Computer Art	Drawing
Fibre Arts	Glass	Marble
Mixed Media	Oil	Paper Sculpture
Pastel	Pen & Ink	Photography
Prints	Sculpture	Silkscreen
Watercolor		

We have a rental gallery connected with the museum which shows and rents contemporary artists' works.
Director: Deborah Williams
Address of rental gallery: 20 W Main, Oklahoma City, OK 73102
The rental gallery is seeking both new and established artists' work.
To contact the rental gallery: Send slides by mail for consideration.
We have a bookstore selling posters, cards, books, prints, etc.
We have an art library.

❖ Philbrook Museum of Art
Marcia Manhart
PO Box 52510, 2727 S Rockford Rd, Tulsa, OK 74152
918/749-7941 918/743-4230 Fax

Our museum shows Native American art.
We have a bookstore selling posters, cards, books, prints, etc.
Name of Buyer: Denise Montgomery
We sponsor classes and seminars in the visual arts.
We have a slide registry.
We have an art library.

❖ Grants Pass Museum of Art
Hatje Joswick
PO Box 966, Grants Pass, OR 97526
503/479-3290

❖ Olin Fine Arts Gallery
Paul Edwards
Olin Fine Arts Center, Washington & Jefferson College, Washington, PA 15301
412/223-6110 Fax

Year museum was established: 1982
Days/hours open: Daily 12-7
Our museum shows contemporary art: All the time
We are planning a show of contemporary artists within the next 2 years.

❖ Contemporary Arts Museum
Lynn Herbert
5216 Montrose Blvd, Houston, TX 77006-6598
713/526-0773

Has a continually updated slide registry for all Texas artists.

❖ Bellevue Art Museum
301 Bellevue Square, Bellevue, WA 98004
206/454-3322

Annual outdoor show—Pacific Northwest Annual.

❖ Center on Contemporary Art
PO Box 277, Seattle, WA 98111
206/682-4568

Annual competition for Washington artists.

❖ Charles and Emma Frye Museum
PO Box 3005, Seattle, WA 98114

Annual show—Puget Sound Area Exhibition.

❖ Sunrise Museum
Kelli Burns/Richard Ambrose
746 Myrtle Rd, Charleston, WV 25314
304/344-8035 304/344-8038 Fax

Year museum was established: 1968
Days/hours open: Wed-Sat 11-5
Our museum shows contemporary art: All the time
We are planning a show of contemporary artists within the next 2 years. If interested in showing, send slides, vitae and artist's statement.
We are accepting donations of work.
Requirements for artists who seek to sell/donate artwork: Send slides by mail for consideration.
Particular style of artwork we are adding to our collection: All except aboriginal and erotic
Particular medium of artwork we are adding to our collection: All

Museums

We have a bookstore selling posters, cards, books, prints, etc.
Name of Buyer: Fish Ofeisch, Cyndy Carr
We have an art library.
Name of librarian: Kelli Burns

❖ Huntington Museum of Art
Mary Anne Pennington
2033 McCoy Rd, Huntington, WV 25701
304/529-2701 304/529-7447 Fax

Our museum shows contemporary art.
We sponsor competitive exhibitions.
We sponsor residencies.
We sponsor classes and seminars in the visual arts.
We have a bookstore selling posters, cards, books, prints, etc.
Name of Buyer: Tamara Miller
We have an art library.

❖ Nicolaysen Art Museum and Discovery Center
Karen R Mobley
400 E Collins Dr, Casper, WY 82601
307/235-5247 307/235-0923 Fax

Year museum was established: 1967
Days/hours open: Tues-Sat 10-5; Thurs 10-8
Our museum shows contemporary art: Periodically
We are planning a biennial juried show of Wyoming Artists' Works in 1996.
We are accepting donations of work; they must be reviewed by the acquisitions committee.
We are not purchasing new works at this time.
Requirements for artists who seek to sell/donate artwork: Send slides by mail for consideration.
Particular style of artwork we are adding to our collection:

Abstract	Alternative	Conceptual
Contemporary	Fantasy	Figurative
Folk Art	Landscape	Latin American
Minimal	Modernism	Naive
Portraits	Realistic	Representational
Southwestern	Surrealism	Traditional
Wildlife	Western	

Particular medium of artwork we are adding to our collection: All
We have a bookstore selling posters, cards, books, prints, etc.

❖ Buffalo Bill Historical Center
Dr Sarah E Boehme
PO Box 1000, Cody, WY 82414
307/587-4771 307/587-5714 Fax

Year museum was established: 1917
Days/hours open: Varies
Our museum shows contemporary art: All the time; we have a small, permanent collection.
Requirements for artists who seek to sell/donate artwork: Send slides by mail for consideration.
Particular style of artwork we are adding to our collection: Western
We have a bookstore selling posters, cards, books, prints, etc.
Name of Buyer: Jean Xrampert
We have an art library.
Name of librarian: Christina Stopka
Open to the public: Mon-Fri 8-5 and by appt.

chapter **6**

Publishers

The first pages of this section cover self-publishing. ArtNetwork Yellow Pages also has many listings to help you with self-publishing, especially pages 79-88.

Calendars

Calendar Marketing Association
 Maria Tuthill
 621 E Park Ave, Libertyville, IL 60048
 800/828-8225 708/816-8660

Greeting Cards

Many artists these days are starting out their greeting card business by making hand-made greeting cards; some sell through local stores, some through distributors and some at local art fairs.

ArtPress
 8125 Uehling Ln, Dayton, OH 45414
 800/833-2961
100 greeting cards for $25. A great deal if you are just starting out and want to do some market testing.

Clear Solutions
 PO Box 2460, W Brattleboro, VT 05303
 603/256-6644
Manufacturer of racks for cards.

CW Zumbiel Co
 2339 Harris Ave, Cincinnati, OH 45212
 513/531-3600
Boxes for packaging cards.

Greeting Card Creative Network/GCCN
 1200 G St NW #760, Washington, DC 20005
 202/393-1778
Provides access to a network of industry professionals, including publishers, licensing agents. Acts as a clearing house for information on design and market trends, legal and financial concerns. Publishes the Directory of Greeting Card Sales Representatives, Greeting Card Industry Directory as well as a bi-monthly newsletter Card News.

Impact Images
 Benny Wilkins
 4961 Windplay Dr, El Dorado Hills, CA 95762
 916/933-4700
Plastic protective envelopes to insert hand-made cards into for selling purposes.

Mason Box Co
 521 Mt Hope St, PO Box 129, N Attleboro, MA 02761
 800/255-2708
Boxes for packaging cards.

Masta Designs Inc
 95 Cedar Ln, Englewood, NJ 07631
 201/871-0850

Millrock Displays
 PO Box 974, Sanford, ME 04073
 207/324-0041
Innovative space-efficient displays.

Nelson Envelopes
 Box 536, Southold, NY 19971
Clear polyethylene envelopes to protect your artwork in transit or storage in 50 sizes.

Steven Stewart & Associates Inc
 David Rhoads, New Products
 1000 FM 1960 West #107, Houston, TX 77090
 713/893-7718
Distributes cards to grocery stores, drug stores, variety stores, bookstores and non-traditional retail outlets.

Licensing

Licensing Industry Merchandisers' Association/LIMA
 350 Fifth Ave #6210, New York, NY 10118-0110
 212/244-1944
Produces an annual show in New York in June, as well as a licensing resource directory and newsletter.

Paper Companies

Robert Paper Co Inc
 404 Park Ave S, New York, NY 10016
 212/696-2640
Unusual papers for cards.

Schoeller Technical Papers Inc
 Box 250, Pulaski, NY 13142
 315/298-5133
High-quality paper for cards.

Simpson Paper Company
 9393 W 100th #500, Overland Park, KS 66210
 913/451-6746

Print Display Units

Gibson Displays
 122 White Dogwood Ln, Statesville, NC 28677
 704/873-8121

Metro Associates
 PO Box 7685, Rutherford, NJ 07073
 800/343-4423

Presentation Systems
 951 Hensley, Richmond, CA 94801
 510/236-8882

Southgate USA
 359 Wales Ave, Bronx, NY 10454
 800/347-2008 718/665-4600

Art Publishers

Print Distributors

ArtNetwork has a more complete mailing list of print distributors—120 names for $30ppd which come on pressure-sensitive mailing labels.

Artists' Marketing Service
Jim Chidester
160 Dresser Ave, Prince Frederick, MD 20678
301/855-1007

Aah Yess!
Janet Herman
827 SW 152nd St, Burien, WA 98166
800/358-8419 206/243-4272

Print Information

See previous section in this book (Shows) for information on wholesale distribution.

Art Business News
Susan Carroll
777 Summer St, Stamford, CT 06901
203/656-3402
Will publish a free review of new limited editions of 100 or under, as well as posters. Send four-color transparencies or slides.

Art Print Index
1233 Quarry Ln #125, Pleasanton, CA 94566
800/346-5924 510/846-0655
Resource directory that helps you answer questions about the availability, size and price of any print (from artist's name or title). $49.95.

Artists in Print
665 Third St #519, San Francisco, CA 94107
415/243-8244
Offers a course as well as assists with marketing information.

Decor
330 N Fourth St, St Louis, MO 63102
314/421-5445
Send B&W photo to "Showcase" for exhibiting new prints for free. They have a reader card number attached to your image, so readers can easily circle a number on a Reader Service Card, and you receive their name and address to send them detailed information.

Informart
1727 E Second St, Casper, WY 82601
307/237-1659
Introduce your first limited edition print free in "First Print" section. It must be a first print, signed and numbered limited edition; release date must be within two months of publication date of magazine, must have B&W photo and artist biography.

National Rep Directory
Spoor & Associates
5921 Midiron Cir, Huntington Beach, CA 92649
Lists thousands of rep groups, along wih contact persons, for such markets as gift decorative accessories, paper products and gourmet food. $97.50.

The Print World Directory
800/788-9101
1,200 pages listing print publishers, printers and printer workshops.

Printers

Color Magic Corporation
381 Brook Ave, Passaic, NJ 07055
800/832-3107 201/471-8029

Island Printing Inc
Curt Baskin
23 W 438 Greenbriar Dr, Naperville, IL 60540
800/647-2966 708/416-3742 Fax
They hold a patent on a static-cling greeting card. The front of the card can be peeled off and applied to any smooth surface, such as glass. They also do bumper stickers that can be put on windows and peel off easily.

Watt/Peterson Inc
15020 27th Ave N, Plymouth, MN 55447-4816
303/979-8607

Specialty Printers

Call or send for a brochure from each of the following specialty printers.

A Stroke of Art Inc
302 Victory Ln #9, Sunland Park, NM 88063
800/530-8680 505/589-3000
Canvas transfers.

August Art Co
Jodi Stoute
5524 Buckingham Dr, Huntington Beach, CA 92649
714/373-8305
Hand-finished canvas transfer.

Canvas Portrait Picture Co
6086 Comey Ave, Los Angeles, CA 90034
800/214-7424
Photo reproductions on canvas.

CRA Productions Lab
Tim Siahatgar
12 Hammond Dr #201, Irvine, CA 92718
800/4-REPLIGRPH 714/581-7090
Transfers to canvas.

Electric Paintbrush
Brenda Faire
7 Oakhurst Rd, Hopkinton, MA 01748
508/435-7726
Computer to fine art paper.

EverColor Corp
David Kraus
5145 Golden Foothill Pkwy #140, El Dorado HIlls, CA 95762
800/533-5050
Photographic prints from digital images.

Fox Graphics
4 Mechanica St, Merrimac, MA 01860
508/346-8859
Master atelier for limited editions. One of the largest mono-type presses in the country.

Icon Imaging Inc
Tom Georges
30-30 Northern Blvd, New York, NY 11101
718/937-3004
Various mugs, etc.

LDC Graphics
4702 NW 165th St, Miami, FL 33015
800/553-0085
Prints onto canvas.

Masterpiece Artist Canvas Inc
1415 Bancroft Ave, San Francisco, CA 94124
415/822-8707
Transfer any image onto artist canvas.

Micropix
900 Walt Whitman Rd, Huntington Station, NY 11746
516/271-5119
Hand-pulled prints.

Old Grange Graphics
1590 Reed Rd Bldg B #101, W Trenton, NJ 08628
800/282-7776 609/737-6797
Transfers to canvas.

Photos on Canvas
4430¹/₂ 48th St, San Diego, CA
619/582-6858
Print/photo to canvas.

Picture This
Patty O'Banion
124 Lomas Santa Fe Dr #204, Solano Beach, CA 92075
619/755-0333
Computer to canvas in large sizes.

Supergraphics
Brian Labadi
408/541-9400
400 dpi on vinyl applied to board.

Sweet Dreams Factory
Daniel Balbi
6810 Front St, Key West, FL 33040
305/293-9905
Produces fine quality tile and magnet plaques.

Tonbe Group
Gerard Belsito
10130 Mula Rd, Stafford, TX 77477
713/564-2787
Waterless presses to special coated papers.

Service Bureaus for Iris Prints

If you are not familiar with the term 'Iris Print,' see ArtSource Quarterly Spring 1995.

Cannonball Graphics
408/943-9511

Clearlight Imaging
408/625-9585

Color Space
212/366-6600

Cone Editions Press
802/439-5751

DigiColor
206/284-2198

Digital Image Plus
312/464-0416

Harvest Productions
714/961-1212

Image Transform
515/288-0000

Impact Presentations
212/741-0247

Nash Editions
310/545-4352

Paris Photo Lab Imaging
310/204-0500

Today's Graphics
215/634-6200

Tulip Graphics
510/843-8171

Art Publishers

Interviews

Evergreen Press

Evergreen Press has been in business over 25 years. They publish greeting cards. They also distribute greeting cards from a manufacturer in England (mostly pop-ups and cut-outs). Their main style of card is fine art by living artists and the Victorian era. Mr Nielson notes they don't publish 'cutesy cards' (though they are very popular and sell well). He also says that ecology and nature-oriented visuals are the most popular, printed on recycled papers. Evergreen Press publishes a variety of cost levels—75¢ to $3. He suggests that artists do not print their own cards, because most artists forget the second step—the marketing. Evergreen Press works with 50-60 artists a year who submit their slides. They do not take commission work but use pieces created directly by the artists on their own initiative. No black and white. For spec sheet and guidelines, send SASE to 3380 Vincent Rd, Pleasant Hill, CA 94523 510/993-9700.

Amber Lotus

Amber Lotus has been in business for over 25 years, publishing cards, calendars, posters, prints and a variety of books. The most common size greeting card they publish is 5x7", presently on recycled paper. The most popular style of artwork for them is ethnic art—African-American, Australian aborigine, Native American, etc.—primitive, colorful and beautiful. Amber Lotus pays their artists in a variety of ways—from royalties (usually 5-7$\frac{1}{2}$%, but it can go as high as 10% depending on the situation) to 'right fees,' a trade for additional cards, or whatever other creative ideas the artist wants to work with. Mr Emerson likes to receive samples of all types of work and remains open to unusual styles that he has not seen to date.

He references annual directories (such as the *Encyclopedia of Living Artists*) each year looking for new and unusual work. He says lots of times their choices come from scientists. For instance, their most popular cards now are fractals that an engineer designed on his computer. Contact Amber Lotus at 1241 21st St, Oakland, CA 94607 510/639-3931.

Carli Oliver Company Inc

David Ayling, part-owner of Carli Oliver Company Inc, lives and works in a beachfront home in Hawaii. He reps his wife's work: originals, note cards and prints. When he started this business he had no background in it.

David's niche is the tourist trade in Hawaii via retail outlets, interior designers, consultants and private sales. When he first started repping his wife, he scanned the Yellow Pages for interior designers. One of these designers got his wife a job at a hotel. She was advanced money to print and ended up with extra prints to sell elsewhere. She soon expanded into note cards (with 'Made in Hawaii' noted on them) and other unusual printed matter, quite sellable to the tourist trade in Hawaii.

David's recommendations if the artist is acting as the publisher are:

• Get 4x5" transparencies of all the work as soon as it is completed. He has gotten stuck without a transparency, and it's hard to track down the work.

• If necessary, pay double for an excellent transparency. It's worth it. You must have a quality product.

• Work closely with the printer.

• Before the press is set up, find out what pieces of paper will be blank and try to print small business cards, gift enclosure cards, etc. Don't waste any white space when printing.

• Make sure the customer can reach you easily. He puts the company name and address on the back of each printed card.

• Inside each box of notecards he encloses a card that says, "send for a free brochure."

• If you are in business, you'll need a computer.

When dealing with art publishers, there are several things to keep in mind to make your contact a congenial one:
• Always send a SASE with your review package, and make sure it has enough postage.
• You can send slides or photos. If you send slides, put them in an 8¹/2x11" slide sleeve, even if you only send 5 slides (they're easier not to lose).
• Write a brief cover letter; enclose a vitae or resumé.
• Know about the publisher before you approach them.
• Give them a great idea on how to use your particular artwork.
• Don't give up if someone doesn't return your call. Publishers are busy people with many deadlines. They are always keeping their eyes open for that special style of art that will be the big seller.
What do publishers want to see when you send them your portfolio? Read up on this topic in Art Marketing Handbook for the Fine Artist. Simplified, they want to see:
• a series of similar style photos/slides
• a brief resumé
• a SASE
These entries are listed alphabetically by state.

❖ Creative Age
Finley Eversole/Nicole Rose
2824 Rhodes Cir, Birmingham, AL 35205
205/933-5003 205/933-9966 Fax

Year company was established: 1991
We are seeking both emerging and established artists.
We publish:

T-Shirts	Open edition prints

Age-group we cater to: All ages
Target market:

Interior Designers	General Public	The Trade
Showroom	Framers	

Type of art we publish: Serious
Style of artwork we publish:

Animals	Classic	Ethnic
Impressionism	Landscape	Marine
New Age	Traditional	Visionary
Western		

Medium of artwork we publish:

Acrylic	Oil	Watercolor

Advice we offer to an artist interested in being published or distributed by us: We are looking for exceptional talent, artists with solid art training, good use of color, marketable subject matter.
Review policy: Send slides by mail for consideration.
Specific time of the year we review work: Anytime

❖ Sun Country Clip-Art Publishers
Bruce Fischer
4117 N Longview Ave, Phoenix AZ 85014
602/285-9596 602/279-0263 Fax

Year company was established: 1990
We are actively seeking new artists.
We publish: Clip-art books
Age-group we cater to: All ages
Target market:

Newspaper	Magazines	Printers
Craftpeople	Commercial/Graphic Artists	

Type of art we publish:

Humorous	Serious	Action
Cartoon	Realistic	Stylized
Silhouettes		

Style of artwork we publish:

Classic	Equestrian	Graphic
Historic	Landscape	Southwestern
Traditional	Western	Wildlife

Medium of artwork we publish: Pen & ink line drawings
We are a distributor as well as a publisher.
We are interested in distributing clip-art books published by others.
Advice we offer to an artist interested in being published or distributed by us: Send SASE for artists' guidelines
Specific time of the year we review work: All year

❖ Rocky Mountain Editions
Pam Montgomery
PO Box 2231, Prescott, AZ 86302
800/829-4278

Year company was established: 1991
We are seeking both emerging and established artists.
We publish: Limited editions
Age-group we cater to: Adult
Target market:

General Public	The Trade

Type of art we publish: Serious
Style of artwork we publish:

Animals	Western	Wildlife

Medium of artwork we publish:

Oil	Watercolor

Review policy: Submit portfolio for review/send SASE for submission guidelines.

Art Publishers

❖ WLE Publishing Inc

Tanna Wyatt
6401 N Montrose, Tucson, AZ 85741-3126
602/742-3929 602/742-6353 Fax

Year company was established: 1994
We are seeking both emerging and established artists.
We publish: Limited editions
Age-group we cater to:

Adult	All ages

Target market:

General Public	The Trade

Style of artwork we publish:

Animals	Florals	Seascapes
Realistic	Southwestern	Wildlife

Medium of artwork we publish:

Oil	Pastel

Review policy: Send slides by mail for consideration.
Specific time of the year we review work: Quarterly

❖ Sourcehouse

Jerry S Kaye
6433 Topanga Cyn Blvd #102, Canoga Park, CA 91303
818/347-2894

Year company was established: 1976
We are seeking both emerging and established artists.
We publish:

Greeting cards	Posters	Limited Editions
Open editions	Serigraphs	Calendars

Age-group we cater to: All ages
Target market:

Poster Stores	Museums	Interior Designers
General Public	The Trade	Showrooms

Type of art we publish:

Humorous	Serious	English
Victorian	Country	

Style of artwork we publish:

Abstract	African-American	Animals
Classic	Equestrian	Erotic
Ethnic	Fantasy	Graphic
Historic	Impressionism	Landscape
Marine	Naive	New Age
Nostalgia	Realistic	Representational
Southwestern	Surrealism	Traditional
Visionary	Western	

Medium of artwork we publish: All except Computer Art
We are a distributor as well as a publisher.
We are not interested in distributing works published by others.
We distribute:

Lithographs	Limited editions	Greeting cards
Postcards		

Review policy: Send SASE for submission guidelines.
Specific time of the year we review work: All the time

❖ Smith-Cosby Gallery

Sonya Smith
PO Box 7401, Carmel, CA 93921-7401
408/626-6563

Year company was established: 1978
We are seeking established artists mostly through referrals.
We publish:

Limited editions	Serigraphs

Age-group we cater to:

Young adult	Adult

Target market:

Interior Designers	General Public	The Trade

Type of art we publish: Serious
Style of artwork we publish:

Impressionism	Landscape	Marine
Representational		

Medium of artwork we publish:

Acrylic	Oil

We are a distributor as well as a publisher.
We are interested in distributing works published by others.
We distribute: Limited editions
Review policy: Submit portfolio for review with SASE.
Specific time of the year we review work: Anytime

❖ Vibrant Fine Art

Phyliss Stevens
3444 Hillcrest Dr, Los Angeles, CA 90016
213/766-0818 213/737-4025 Fax

Year company was established: 1990
We are seeking both emerging and established artists.
We publish:

Limited editions	Open editions	Serigraphs

Age-group we cater to: Adult
Target market:

Interior Designers	The Trade

Style of artwork we publish:

African-American	Ethnic	Figurative
Graphic		

Medium of artwork we publish:

Acrylic	Collage	Mixed Media
Silkscreen	Watercolor	

We are a distributor as well as a publisher.
We are interested in distributing works published by others.
We distribute:

Lithographs	Limited editions

Advice we offer to an artist interested in being published or distributed by us: Be sure that presentation of slide and/or portfolio is a good quality with sharp photos accompanied by artist resumé.
Review policy: Send slides by mail for consideration/ send SASE for submission guidelines.
Specific time of the year we review work: Anytime

❖ Art a la Carte

Gabor Dalmand
25 Harveston, Mission Viejo, CA 92692
714/455-0957

Year company was established: 1993
We are actively seeking both emerging and established artists.
We publish:

Limited editions	Open editions	Serigraphs

Age-group we cater to: Adult
Target market: The Trade
Type of art we publish:

Humorous	Serious	New Age

Style of artwork we publish:

Abstract	Classic	Graphic
Impressionism	Landscape	Naive
Nostalgia	Realistic	Sport
Traditional		

Medium of artwork we publish:

Mixed Media	Oil	Pastel
Sculpture	Silkscreen	Watercolor

We are a distributor as well as a publisher.
We are interested in distributing works published by others.
We distribute:

Lithographs	Limited editions

Advice we offer to an artist interested in being published or distributed by us: We distribute for small publishing houses or self-published artists. We sell wholesale to fine art galleries, interior designers, corporate art consultants and national retail chains.
Review policy: Send photos by mail for consideration.
Specific time of the year we review work: Year-round

❖ Wild Side

Frank or Jim
1543 Truman, San Fernando, CA 91340
818/421-3130 818/365-6667 Fax

Year company was established: 1979
We are actively seeking new artists and established artists mostly through referrals.
We publish: T-shirts
Age-group we cater to: All ages
Target market: Worldwide
Type of art we publish: All
Style of artwork we publish:

Animals	Fantasy	Graphic
Impressionism	Nostalgia	Religious
Southwestern	Western	Wildlife

Medium of artwork we publish: Most
Review policy: Submit portfolio for review/send slides by mail for consideration.
Specific time of the year we review work: Anytime

❖ Coast Publishing

Gary Koeppel
418 Elder Ave, Sand City, CA 93955
408/625 -4145 408/625-3575 Fax

Year company was established: 1958
We are seeking both emerging and established artists.
We publish:

Greeting Cards	Posters	Limited Editions
Open Editions	Serigraphs	Books

Age-group we cater to: Adult
Target market:

Poster Stores	General Public	The Trade

Type of art we publish:

Serious	Other

Style of artwork we publish:

Animals	Impressionism	Landscape
Marine	Realistic	Representational
Wildlife		

Medium of artwork we publish:

Acrylic	Drawing	Mixed Media
Oil	Sculpture	Silkscreen
Watercolor		

Review policy: Send slides by mail for consideration with SASE for return.
Specific time of the year we review work: All year

❖ Porterfield's

Lance Klass
5020 Yaple Ave, Santa Barbara, CA 93111

Year company was established: 1994
We are seeking both emerging and established artists.
We publish:

Limited editions	Collectors' plates

Age-group we cater to: Adult
Target market: Direct response sales only
Type of art we publish:

Serious	Children	Cottages
Puppies	Kittens	

Style of artwork we publish:

Animals	Figurative	Realistic
Representational	Wildlife	

Medium of artwork we publish:

Acrylic	Colored Pencil	Oil
Watercolor		

We are a distributor as well as a publisher.
We are interested in distributing works published by others.
We distribute: Limited editions Plates
Advice we offer to an artist interested in being published or distributed by us: Send slides or photos; SASE is helpful. All submissions will be returned.
Specific time of the year we review work: All year

Art Publishers

❖ **Lawrence Publishing**
Gretchen Peck
531 Fourth St, Santa Rosa, CA 95401
707/578-9202 707/578-9209 Fax

We are seeking both emerging and established artists.
We publish: Serigraphs
Age-group we cater to: Adult
Target market: General Public The Trade
Type of art we publish: Serious
Style of artwork we publish:
Ethnic Impressionism Latin American
Medium of artwork we publish:
Acrylic Drawing Mixed Media
Pastel
We are a distributor as well as a publisher.
We are interested in distributing works published by others.
We distribute:
Lithographs Limited editions
Review policy: Send slides by mail for consideration.

❖ **Leanin' Tree Inc**
Ed Trumble/Sara Sheldon
PO Box 9500, Boulder, CO 80301
303/530-1442 303/530-7283

Year company was established: 1949
We are seeking both emerging and established artists.
We publish: Greeting cards
Age-group we cater to: Adult
Style of artwork we publish:
Contemporary Cowboy Historic
Landscape Native American Realistic
Representational Southwestern Traditional
Western Wildlife
Medium of artwork we publish:
Acrylic Oil Pastel
Watercolor
Review policy: Send SASE for submission guidelines. Do not send slides, transparencies or original art; only photos, brochures or xeroxes accepted.
Specific time of the year we review work: Anytime
We also have a corporate art collection with over 750 pieces which is bought privately and never solicited through slides or brochures.

❖ **Drinker/Durrance Graphics**
Susan G Drinker
PO Box 6396, 1079 Sinclair Rd, Snowmass Village, CO 81615
303/923-5353 303/923-5092 Fax

Year company was established: 1993
We are seeking both emerging and established artists.
We publish:
Greeting Cards Posters Open Editions

Age-group we cater to: Adult
Target market:
Poster Stores Museums Interior Designers
General Public The Trade Commercial Spaces
Type of art we publish: Serious
Style of artwork we publish:
Landscape Wildlife
Medium of artwork we publish: Photography
We are a distributor as well as a publisher.
We are interested in distributing works published by others.
Review policy: Send slides by mail for consideration.
Specific time of the year we review work: Anytime

❖ **National Art Publishing Corp**
Lissa Robinson
11000-33 Metro Parkwy, Ft Myers, FL 33912
813/939-7518 813/936-2788 Fax

Year company was established: 1978
We publish:
Posters Limited editions Open editions
Age-group we cater to: Adult
Target market:
Interior Designers General Public The Trade
Commercial Spaces
Type of art we publish: Serious
Style of artwork we publish:
Animals Equestrian Impressionism
Latin American Realistic Traditional
Visionary Western Wildlife
Medium of artwork we publish:
Acrylic Mixed Media Oil
Pastel Watercolor
We are a distributor as well as a publisher.
We are not interested in distributing works published by other publishers.
We distribute:
Lithographs Limited editions Duck stamp prints
Review policy: Send slides by mail for consideration.
Specific time of the year we review work: Anytime

❖ **Watercolours Marine Art Publishing**
Jennifer McComb
2808 Kinloch Dr, Orlando, FL 32817
407/657-9561 407/678-2369 Fax

Year company was established: 1994
We are actively seeking both emerging and established artists.
We publish:
Greeting cards Posters Limited editions
Open editions Calendars
Age-group we cater to: All ages
Target market:
Poster Stores General Public The Trade
Marina Shops Tackle Shops Dive Shops

Type of art we publish:

| Humorous | Serious | Ocean-related |

Style of artwork we publish: Marine
Medium of artwork we publish:

Acrylic	Airbrush	Charcoal
Collage	Colored Pencil	Computer Art
Drawing	Marker	Mixed Media
Oil	Pastel	Pen & Ink
Photography	Watercolor	

We are a distributor as well as a publisher.
We are interested in distributing works published by others.
We distribute:

| Limited editions | Greeting cards |

Advice we offer to an artist interested in being published or distributed by us: We are primarily looking for saltwater fishing and/or underwater reef scenes.
Review policy: Send slides by mail for consideration.
Specific time of the year we review work: All the time, but the end of the year for calendars (two years ahead)

❖ Prime Products/All Sales
Dee Abraham
5772 N Ocean Shore Blvd, Palm Coast, FL 32137
800/741-7747 800/741-7747 Fax

Year company was established: 1972
We are actively seeking new artists.
We publish: Limited editions Open editions
Age-group we cater to: Adult
Target market: The Trade
Type of art we publish: Serious
Style of artwork we publish:

| Sport | Wildlife |

We are a distributor as well as a publisher.
We are interested in distributing works published by others.
We distribute: Lithographs Limited editions
Advice we offer to an artist interested in being published or distributed by us: At this time we are seeking Audubon-style birds, black Labs and Nascar auto racing pieces.
Review policy: Send slides by mail for consideration.

❖ Termini Art Network
Carolyn Termini
PO Box 14066, Atlanta, GA 30324
404/320-0970 404/320-9197

Year company was established: 1991
We are actively seeking new artists.
We publish: Limited editions
Age-group we cater to: Adult
Target market: General Public
Type of art we publish: Serious
Style of artwork we publish:

| Animals | Landscape | Oriental |

We are a distributor as well as a publisher.
We are interested in distributing works published by others.
We distribute: Lithographs Limited editions
Review policy: Submit portfolio for review.

❖ Dynamic Graphics Inc
Steve Justice
6000 N Forest Park Dr, Peoria, IL 61614
309/688-8800 ext 204 309/688-8515 Fax

Year company was established: 1964
We are seeking both emerging and established artists.
We publish: Clip-art
Age-group we cater to: All ages
Type of art we publish: Humorous and realistic design styles
Style of artwork we publish: All
Medium of artwork we publish:

Acrylic	Airbrush	Colored Pencil
Computer Art	Mixed Media	Oil
Pen & Ink		

Advice we offer to an artist interested in being published or distributed by us: As a clip-art company (syndicator), we commission illustrations from free-lancers. We are primarily interested in black & white line work, electronic illustrations, etc. suitable for advertising purposes, brochures, posters and most other print applications.
Review policy: Submit portfolio for review. Call for submission guidelines.
Specific time of the year we review work: Year-round

❖ Prestige Art Galleries Inc
Louis Schutz Isa
3909 W Howard St, Skokie, IL 60076
708/679-2555

Year company was established: 1960
We are seeking both emerging and established artists.
We publish: Posters Limited editions
Age-group we cater to: Adult
Target market: Interior Designers General Public
Type of art we publish: New Age
Style of artwork we publish:

Abstract	Classic	Fantasy
Impressionism	Realistic	Representational
Sci-Fi	Surrealism	Visionary

Medium of artwork we publish:

| Acrylic | Airbrush | Mixed Media |
| Oil | Sculpture | |

We are a distributor as well as a publisher.
We are interested in distributing works published by others.
We distribute:

| Lithographs | Limited editions | Greeting cards |

Art Publishers

Advice we offer to an artist interested in being published or distributed by us: Be professional with presentations. Enclose a SASE if you expect your photos back. Include prices, sizes, medium on each photo/slide.
Review policy: Submit portfolio for review with SASE.

❖ Acme Graphics Inc
Stan Richardson
201 3rd Ave SW, Box 1348, Cedar Rapids, IA 52406
319/364-0233 319/363-6437 Fax

Year company was established: 1913
We are seeking both emerging and established artists.
We publish:
Greeting cards Merchandise for funeral directors
Age-group we cater to: Adult
Target market: Funeral Homes
Type of art we publish: Serious
Style of artwork we publish:
Abstract Landscape Realistic
Religious
Medium of artwork we publish:
Acrylic Drawing Pen & Ink
Photography Watercolor
Review policy: Submit portfolio for review/send slides by mail for consideration/send SASE for submission guidelines.
Specific time of the year we review work: Anytime

❖ Inspirational & Scripture
Lisa Edwards
PO Box 5550, Cedar Rapids, IA 52406-5550
319/366-8286 319/366-2573 Fax

Year company was established: 1994
We are actively seeking new artists.
We publish: Posters
Age-group we cater to:
Children Teenager Young adult
Adult All ages
Target market: Christian-related markets
Type of art we publish: Christian
Style of artwork we publish: Contemporary religious
Medium of artwork we publish: All
We are a distributor as well as a publisher.
We are not interested in distributing works published by others.
Review policy: Send SASE for submission guidelines.
Specific time of the year we review work: 4-5 times a year

❖ Wildlife Trading Co
Brad Donahue
Box 496, Monroe, IA 50170-0496
515/259-2327

We are seeking both emerging and established artists.
We publish: Limited editions

Age-group we cater to: All ages
Target market: General Public
Type of art we publish: Serious
Style of artwork we publish:
Animals Equestrian Western
Wildlife
Medium of artwork we publish:
Charcoal Collage Mixed Media
Oil Watercolor
We are a distributor as well as a publisher.
We are interested in distributing works published by others.
We distribute: Limited editions
Review policy: Send slides by mail for consideration.

❖ Sportsman's Galleria
John Latham
432 Bayou Blue Rd, Houma, LA 70364
504/868-5733 Telephone/Fax

Year company was established: 1986
We are actively seeking new artists.
We publish: Limited editions
Age-group we cater to: Adult
Target market:
The Trade Galleries that handle sporting art
Type of art we publish: Sporting, hunting, fishing
Style of artwork we publish:
Animals Landscape Marine
Realistic Wildlife
Medium of artwork we publish:
Charcoal Oil Watercolor
We are a distributor as well as a publisher.
We are interested in distributing works published by others.
We distribute: Lithographs Limited editions
Advice we offer to an artist interested in being published or distributed by us: Be patient.
Review policy: Send slides by mail for consideration.
Specific time of the year we review work: Summer

❖ Afterschool Publishing Co
Herman Kelly
PO Box 14157, Detroit, MI 48214
313/571-0363

Year company was established: 1977
We are actively seeking new artists/seeking both emerging and established artists/seeking established artists mostly through referrals.
We publish:
Posters Books Records
Tapes CD's Sheet music
Age-group we cater to: All ages
Target market:
Poster Stores Museums General Public
Schools The Trade Showroom
Commercial Spaces

Type of art we publish:

Humorous	Serious	New Age
Rap	POP	Country
Jazz		

Style of artwork we publish:

African-American	Classic	Ethnic
Fantasy	Historic	Latin American
New Age	POP	Realistic
Sci-Fi	Sport	Traditional
Visionary		

Medium of artwork we publish:

Computer Art	Drawing	Mixed Media
Pen & Ink	Photography	

We are a distributor as well as a publisher.
We are interested in distributing works published by others.
We distribute:

Lithographs	Limited editions	Greeting cards
Postcards		

Advice we offer to an artist interested in being published or distributed by us: Be able to make a long-term deal for commission work that relates to titles and poetry, words, objects.
Review policy: Arrange a personal interview to show portfolio/submit portfolio for review/send slides by mail for consideration/send SASE for submission guidelines.
Specific time of the year we review work: Anytime

❖ Far Corners Importers Ltd

Sandra Cook
740 Livernois St, Ferndale, MI 48220-2307
810/541-2889

Year company was established: 1981
We are seeking card lines which fit our customers.
We distribute: Greeting cards
Age-group we cater to: All ages
Target market: Museum Retail Stores
Type of art we publish: Multi-cultural/typical or derived from designs or traditions of various cultures
Style of artwork we publish: Ethnic
We are a distributor.
We are interested in distributing works published by others.
We distribute: Blank greeting cards
Advice we offer to an artist interested in being published or distributed by us: Send one or two sample cards; include envelope if non-standard and contact information.
Specific time of the year we review work: Anytime

❖ Design Design Inc

Tom Vitus
PO Box 2266, 820 Monroe NW, Grand Rapids, MI 49503
616/774-2448 616/774-4020 Fax

Year company was established: 1987

We are actively seeking new artists.
We publish: Greeting cards
Age-group we cater to: All ages
Target market:

Museums	The Trade	Showrooms

Type of art we publish:

Humorous	Serious

Style of artwork we publish:

Abstract	Animals	Classic
Ethnic	Fantasy	Figurative
Graphic	Historic	Impressionism
New Age	POP	Portraits
Representational	Traditional	

Medium of artwork we publish:

Acrylic	Charcoal	Collage
Colored Pencil	Drawing	Marker
Mixed Media	Oil	Pastel
Pen & Ink	Photography	Silkscreen
Watercolor		

We are a distributor as well as a publisher.
We are not interested in distributing works published by others.
We distribute: Greeting cards
Review policy: Send SASE for submission guidelines.
Specific time of the year we review work: Anytime

❖ Nancy Lund

555 SW 78th St, Edina, MN 55439
612/942-7754 612/942-6307 Fax

Year company was established: 1986
We are seeking both emerging and established artists.
We publish:

Greeting cards	Calendars	Books

Age-group we cater to:

Adult	All ages

Target market: Various
Style of artwork we publish:

Classic	Fantasy	Floral
Landscape	Traditional	

Medium of artwork we publish:

Colored Pencil	Computer Art	Oil
Pen & Ink	Watercolor	

Review policy: Send SASE for submission guidelines.
Specific time of the year we review work: Anytime

❖ Courage Cards

Fran Bloomfield
3915 Golden Valley Rd, Golden Valley, MN 55442
612/520-0585 612/520-0299 Fax

We are actively seeking established artists mostly through referrals.
We publish: Greeting cards
Age-group we cater to:

Adult	All ages

Target market: General Public Retail
Type of art we publish: Serious

Style of artwork we publish:

Classic	Graphic	Impressionism
Landscape	Naive	Nostalgia
Realistic	Religious	Traditional
Wildlife		

Medium of artwork we publish:

Acrylic	Colored pencil	Mixed Media
Oil	Pastel	Silkscreen
Watercolor		

We are a distributor as well as a publisher.
We are not interested in distributing works published by others.
We distribute: Greeting cards Postcards
Advice we offer to an artist interested in being published or distributed by us: Only submit works we are interested in; we receive a lot of art that is very definitely out of our criteria.
Review policy: Send SASE for submission guidelines.
Specific time of the year we review work: Jan/Feb

❖ Printery House
Rev Norbert Schappler
PO Box 12, Conception, MO 64433
816/944-2331 816/944-2582 Fax

Year company was established: 1950
We are actively seeking both emerging and established artists.
We publish:

Greeting cards	Calendars	Stationery

Age-group we cater to: Adult
Target market:

General Public	Bookstores	The Trade

Type of art we publish: Serious
Style of artwork we publish:

Religious	Stylistic	Contemporary
Calligraphy		

Medium of artwork we publish:

Acrylic	Computer Art	Watercolor

Advice we offer to an artist interested in being published or distributed by us: Knowledge and skills to provide camera-ready artwork are necessary. Calligraphic skills are desired but not always essential.
Review policy: Submit portfolio for review/send SASE for submission guidelines.
Specific time of the year we review work: All year

❖ Comstock Cards Inc
Patricia Wolf
600 S Rock Blvd #15, Reno, NV 89502-4115
702/856-9400 702/856-9406 Fax

Year company was established: 1991
We are seeking both emerging and established artists.
We publish: Greeting cards
Age-group we cater to: Adult
Target market: General Public

Type of art we publish: Humorous
Style of artwork we publish: Erotic
Medium of artwork we publish:

Colored Pencil	Computer Art	Drawing
Oil	Photography	Watercolor

We are a distributor as well as a publisher.
We are not interested in distributing works published by others.
We distribute: Greeting cards Postcards
Review policy: Send SASE for submission guidelines.
Specific time of the year we review work: All year

❖ Smart Art Inc
Barb Hauck-Mah
PO Box 661, Chatham, NJ 07928
201/635-1690 201/635-2011 Fax

Year company was established: 1992
We are seeking both emerging and established artists.
We publish: Greeting cards
Age-group we cater to:

Children	Adult

Target market:

Card Stores	Gift Stores	Bookstores
Photo Shops	Hospitals	

Type of art we publish:

Humorous	Serious

Style of artwork we publish:

Animals	Borders	Cartoons
Florals	Nature	Representational
Whimsical		

Medium of artwork we publish:

Pen & Ink	Watercolor

We are a distributor as well as a publisher.
We are not interested in distributing works published by others.
We distribute: Greeting cards
Advice we offer to an artist interested in being published or distributed by us: We work with free-lance artists who are children's book illustrators or cartoonists. Art is pen & ink/watercolor only. Artists need to submit complete card concepts (art and inside copy). Looking for both a witty, sophisticated, humoristic style and a traditional, romantic style.
Review policy: Send SASE for submission guidelines.
Specific time of the year we review work: Anytime

❖ Winston Roland Ltd
Greg Peppler
85 River Rock Dr #201, Buffalo, NY 14207
519/659-6601 519/659-2923 Fax

Year company was established: 1988
We are seeking both emerging and established artists.
We publish:

Posters	Limited editions	Open editions
Collector plates		

Age-group we cater to: All ages
Target market:

Museums	Interior Designers	General Public

Many others; depends on subject matter
Type of art we publish:

Humorous	Serious	New Age

Style of artwork we publish:

Animals	Aviation	Classic
Fantasy	Graphic	Historic
Landscape	New Age	Nostalgia
Realistic	Southwestern	Sport
Traditional	Visionary	Western
Wildlife		

Medium of artwork we publish:

Acrylic	Airbrush	Charcoal
Collage	Colored Pencil	Computer Art
Drawing	Marker	Mixed Media
Oil	Pastel	Pen & Ink
Photography	Sculpture	Silkscreen
Watercolor		

We are a distributor as well as a publisher.
We are interested in distributing works published by others.
We distribute:

Lithographs	Limited editions	Greeting cards

Review policy: Send profile, bio and slides by mail for consideration.
Specific time of the year we review work: Anytime except Nov-Dec

❖ **Idealdecor USA**
Gerald Greenberg
3180 Expressway Dr S, Central Islip, NY 11722
516/234-7777 516/234-7798

Year company was established: 1979
We are seeking both emerging and established artists.
We publish: Posters
Age-group we cater to: All ages
Target market:

Poster Stores	Schools	General Public
The Trade	Showroom	Commercial
Spaces		

Type of art we publish:

Serious	New Age

Style of artwork we publish:

Abstract	African-American	Animals
Classic	Erotic	Ethnic
Fantasy	Graphic	Historic
Impressionism	Landscape	Marine
New Age	Nostalgia	Realistic
Religious	Sci-Fi	Southwestern
Sport	Surrealism	Traditional
Western	Wildlife	

Medium of artwork we publish:

Acrylic	Drawing	Mixed Media
Oil	Photography	Watercolor

We are a distributor as well as a publisher.
We are not interested in distributing works published by others.
Review policy: Send slides by mail for consideration.
Specific time of the year we review work: Anytime

❖ **Gallery 25**
Charles Becker
25 Jericho Tnpk, Mineola, NY 11501
516/294-6060 516/294-6707 Fax

Year company was established: 1975
We are actively seeking both emerging and established artists.
We publish:

Posters	Limited editions	Open editions

Age-group we cater to: All ages
Target market:

Interior Designers	General Public	The Trade

Type of art we publish: Serious
Style of artwork we publish:

Abstract	Fantasy	Figurative
Impressionism	Landscape	Portraits
Realistic	Sport	Traditional

Medium of artwork we publish:

Airbrush	Collage	Drawing
Mixed Media	Pen & Ink	Silkscreen

We are a distributor as well as a publisher.
We are interested in distributing works published by others.
We distribute:

Lithographs	Limited editions

Review policy: Submit portfolio for review/send slides by mail for consideration.
Specific time of the year we review work: Anytime

❖ **Fotofolio**
Ron Schick/Joanne Seador
536 Broadway, New York, NY
212/226-0923 212/226-0072 Fax

Year company was established: 1976
We are seeking both emerging and established artists.
We publish:

Greeting cards	Posters	Calendars
T-shirts		

Age-group we cater to: All ages
Target market:

Poster Stores	Museums	General Public

Type of art we publish:

Humorous	Serious	Fine art

Style of artwork we publish:

African-American	Animals	Classic
Figurative	Graphic	Historic
POP	Portraits	Realistic
Representational	Surrealism	Traditional

Art Publishers

Medium of artwork we publish:
Mixed Media Oil Photography
Silkscreen
We are a distributor as well as a publisher.
We are interested in distributing works published by others.
We distribute:
Greeting cards Postcards
Advice we offer to an artist interested in being published or distributed by us: Limit submission of slides to 40; no oversize portfolios; submit by mail and include SASE.
Specific time of the year we review work: Anytime

❖ **John Szoke Graphics Inc**
John Szoke
164 Mercer St, New York, NY 10012
212/219-8300 212/966-3064 Fax

Year company was established: 1970
We are actively seeking new artists.
We publish: Limited editions
Age-group we cater to: Adult
Target market:
Interior Designers General Public The Trade
Type of art we publish:
Humorous Serious
Style of artwork we publish:
Fantasy Figurative Impressionism
Landscape Realistic Sport
Surrealism
We are a distributor as well as a publisher.
We are not interested in distributing works published by others.
We distribute: Limited editions
Review policy: Send SASE for submission guidelines.

❖ **Opus One Publishing**
James Munro
790 Riverside Dr #2E, New York, NY 10032
212/862-4095 212/862-3767

Year company was established: 1991
We are actively seeking both emerging and established artists.
We publish:
Greeting cards Posters Open editions
Calendars
Age-group we cater to:
Children Teenager Young adult
Adult All ages
Target market:
Poster Stores Interior Designers Showrooms
The Trade Commercial Spaces
Type of art we publish:
Humorous Serious
High-end decorative art

Style of artwork we publish:
Abstract Animals Classic
Fantasy Figurative Graphic
Impressionism Landscape Marine
Nostalgia POP Realistic
Representational Surrealism Traditional
Wildlife
Medium of artwork we publish:
Acrylic Airbrush Collage
Computer Art Drawing Mixed Media
Oil Pastel Photography
Watercolor
Review policy: Send slides by mail for consideration.
Specific time of the year we review work: Quarterly

❖ **SE Feinman Fine Arts Ltd**
Stephen Feinman
448 Broome St, New York, NY 10013
212/431-6820 212/431-6495 Fax

Year company was established: 1992; 30 years an owner of a gallery
We are actively seeking both emerging and established artists.
We publish: Limited editions Serigraphs
Age-group we cater to: All ages
Target market:
Interior Designers General Public The Trade
Showrooms Commercial Spaces
Type of art we publish: Serious
Style of artwork we publish:
Abstract Classic Erotic
Figurative Graphic Impressionism
Landscape Latin American Naive
Realistic Representational Surrealism
Traditional
Medium of artwork we publish:
Silkscreen Mezzotints
We are a distributor as well as a publisher.
We are not interested in distributing works published by others.
We distribute: Lithographs Limited editions
Review policy: Arrange a personal interview to show portfolio/submit portfolio for review/send photos by mail with SASE for consideration.
Specific time of the year we review work: Anytime

❖ **Artaffects**
Richard Habeeb
PO Box 98, Staten Island, NY 10307
718/948-6767

Year company was established: 1975
We are actively seeking new artists.
We publish: Limited editions
Age-group we cater to: Adult
Target market: General Public Collectors
Type of art we publish: Serious

Style of artwork we publish:

African-American	Animals	Aviation
Equestrian	Ethnic	Fantasy
Figurative	Historic	Landscape
Latin American	Marine	Naive
Portraits	Realistic	Religious
Representational	Southwestern	Traditional
Wildlife		

Medium of artwork we publish:

Acrylic	Airbrush	Colored Pencil
Mixed Media	Oil	Pastel
Pen & Ink	Sculpture	Watercolor

We are a distributor as well as a publisher.
We are not interested in distributing works published by others.
We distribute: Limited editions
Review policy: Submit portfolio for review/send slides by mail for consideration.

❖ Syracuse Cultural Works

Dik Cool/Linda Malik
Box 6367, Syracuse, NY 13217
315/474-1132

Year company was established: 1982
We are actively seeking new artists.
We publish:

Greeting cards	Posters	Calendars

Age-group we cater to: All ages
Target market:

Poster Stores	General Public	Schools
The Trade		

Type of art we publish: Social issues
Style of artwork we publish:

Abstract	African-American	Ethnic
Graphic	Historic	Latin American
Portraits	Realistic	Representational
Multi-cultural		

Medium of artwork we publish: All
We are a distributor as well as a publisher.
We are interested in distributing works published by others.
We distribute:

Lithographs	Greeting cards	Postcards

Advice we offer to an artist interested in being published or distributed by us: Look through our catalog (send $1 for it).
Review policy: Send SASE for submission guidelines.
Specific time of the year we review work: Anytime

❖ Webster Fine Art

John Stephenson
1185 Tall Tree Rd, Clemmons, NC 27012
910/712-0900 910/712-0974 Fax

Year company was established: 1987
We are actively seeking new artists.
We publish: Limited editions Open editions
Age-group we cater to: All ages
Target market: The Trade
Type of art we publish:

Humorous	Serious

Style of artwork we publish:

Animals	Classic	Equestrian
Figurative	Historic	Impressionism
Landscape	Marine	Naive
Nostalgia	Traditional	Wildlife

Medium of artwork we publish:

Airbrush	Oil	Pastel
Silkscreen	Watercolor	

We are a distributor as well as a publisher.
We are interested in distributing works published by others.
We distribute: Lithographs
Advice we offer to an artist interested in being published or distributed by us: We publish runs of 1500-2500. The artist has to image the work submitted to appeal to that many residencies. The work has to be of a commercially appealing nature. Must send SASE for slides/photos to be returned.
Review policy: Send slides by mail for consideration/send SASE for submission guidelines.
Specific time of the year we review work: All year

❖ Lola Ltd/LT'EE

Lola Jackson
118 Egret St SW, Charlotte, NC 28470
910/754-8002

Art Distributor
Year company was established: 1968
We are actively seeking new artists.
We sell: Limited editions Etchings
Age-group we cater to: Adult
Target market:

Poster Stores	Museums	Interior Designers
General Public	Frame Shops	The Trade
Showrooms		

Art Publishers

Style of artwork we sell:

Aviation	Classic	Ethnic
Figurative	Historic	Impressionism
Landscape	Marine	Nostalgia
Realistic	Representational	Traditional

Medium of artwork we sell:

Acrylic	Airbrush	Charcoal
Collage	Colored Pencil	Drawing
Etchings	Mixed Media	Oil
Pastel	Pen & Ink	Silkscreen
Watercolor		

We are a distributor as well as a publisher.
We are interested in distributing works published by others.
We distribute:

Lithographs	Limited editions	Greeting cards

Review policy: Send photos or reproduction prints by mail for consideration/send SASE for submission guidelines.

❖ Crumb Elbow Publishing

Michael Jones
Box 294, Rhododendron, OR 97049
503/622-4798 503/622-4994

Year company was established: 1982
We are actively seeking both emerging and established artists.
We publish:

Greeting cards	Posters	Limited editions
Calendars	Magazines	Books

Age-group we cater to: All ages
Type of art we publish:

Humorous	Serious	New Age
Historical		

Style of artwork we publish:

Abstract	Animals	Equestrian
Ethnic	Fantasy	Graphic
Impressionism	Landscape	Marine
New Age	Nostalgia	POP
Realistic	Representational	Sci-Fi
Southwestern	Surrealism	Traditional
Visionary	Western	Wildlife

We are a distributor as well as a publisher.
We are not interested in distributing works published by others.
We distribute:

Lithographs	Limited editions	Greeting cards
Postcards		

Advice we offer to an artist interested in being published or distributed by us: Don't be afraid to try something new. Although you may be interested in a particular subject, your talent will also be revealed in a subject matter that you may not particularly think would be a good topic to illustrate—so don't give up a good job offer.

Review policy: Submit portfolio for review/send slides by mail for consideration/send SASE for submission guidelines.
Specific time of the year we review work: All year

❖ Reflection Publishing Press

Anthony Salibagh
63 Pershing Blvd, White Hall, PA 18052-6709
610/264-0566

Year company was established: 1988
We are actively seeking both emerging and established artists, mostly through referrals.
We publish:

Greeting cards	Posters	Limited editions
Open editions	Serigraphs	Calendars

Age-group we cater to:

Adult	All ages	

Target market: Poster Stores | The Trade

Type of art we publish:

Humorous	Serious	New Age

Style of artwork we publish:

Animals	Ethnic	Landscape
Portraits	Realistic	Religious
Traditional	Wildlife	

Medium of artwork we publish:

Computer Art	Oil	Photography
Silkscreen	Watercolor	

We distribute: Greeting cards
Review policy: Send slides by mail for consideration.
Specific time of the year we review work: Open

❖ Penny Laine Papers

Penny Nye
2008 Partridge Run Ln, Knoxville, TN 37919
615/588-3413

Year company was established: 1984
We publish: Announcements | Invitations
Age-group we cater to: Adult
Target market: General Public
Type of art we publish:

Whimsical	Juvenile	Feminine
Clever		

Style of artwork we publish:

Fantasy	Graphic	Impressionism
Naive	Southwestern	

Medium of artwork we publish:

Airbrush	Colored Pencil	Gouache
Marker	Pastel	Watercolor

We are a distributor as well as a publisher.
We are not interested in distributing works published by others.
We distribute:

Postcards	Invitations	Announcements

Review policy: Submit portfolio for review/send slides by mail for consideration.
Specific time of the year we review work: Anytime

❖ Ideals Publications Inc

Lisa Thompson
565 Marriott Dr #800, Nashville, TN 37214
615/231-6752

Year company was established: 1944
We are seeking both emerging and established artists.
We publish:

Calendars	Magazines	Books

Age-group we cater to: Adult
Target market: General Public
Type of art we publish:

Humorous	Serious

Style of artwork we publish:

African-American	Latin American	Nostalgia
Religious		

Medium of artwork we publish:

Acrylic	Colored Pencil	Oil
Pastel	Watercolor	

Review policy: Send SASE for submission guidelines.

❖ Arts Limited Inc

Diana Anderson
PO Box 41, Bulverde, TX 78163
210/438-2614 210/438-3196 Fax

We are seeking both emerging and established artists.
We publish: Limited editions Open editions
Age-group we cater to: All ages
Target market:

Interior Designers	General Public	The Trade
Showrooms	Commercial Spaces	

Type of art we publish:

Humorous	Serious	New Age

Style of artwork we publish:

Animals	Aviation	Classic
Fantasy	Impressionism	Landscape
Latin American	Marine	Nostalgia
Realistic	Southwestern	Traditional
Western	Wildlife	

Medium of artwork we publish:

Acrylic	Airbrush	Collage
Colored Pencil	Mixed Media	Oil
Pastel	Pen & Ink	Watercolor

We are a distributor as well as a publisher.
We are not interested in distributing works published by others.
We distribute: Limited editions Open editions
Review policy: Submit portfolio for review.

❖ Portfolio Graphics

Kent Barton
4060 S 500 W, Salt Lake City, UT 84123
801/266-4844 801/263-1076 Fax

Year company was established: 1987
We are seeking established artists mostly through referrals.
We publish:

Greeting cards	Posters	Limited editions

Age-group we cater to:

Children	Adult

Target market: The Trade
Type of art we publish: Serious
Style of artwork we publish:

Impressionism	Landscape

Medium of artwork we publish:

Acrylic	Oil	Watercolor

Advice we offer to an artist interested in being published or distributed by us: Become well established as an artist before seeking publication. If you can't sell it as an original, it won't sell as a print.
Review policy: Send slides by mail for consideration.
Specific time of the year we review work: January and July

❖ Wild Apple Graphics Ltd

Laurie Chester
HCR 68 Box 131 Rt 106, Woodstock, VT 05091
802/457-3003 802/457-3214

Year company was established: 1990
We are actively seeking new artists.
We publish:

Posters	Limited editions	Open editions

Age-group we cater to: All ages
Target market:

Poster Stores	Museums	The Trade
Showrooms		

Type of art we publish: All
Style of artwork we publish:

Animals	Classic	Fantasy
Landscape	Western	Wildlife

Medium of artwork we publish: All
We are a distributor as well as a publisher.
Review policy: Submit portfolio for review/send slides by mail for consideration.
Specific time of the year we review work: Anytime

Art Publishers

❖ Visuality Inc
Michael Steele
10780 Falk Rd, Bainbridge Island, WA 98110
206/842-5497 206/842-5497

Year company was established: 1992
We are actively seeking emerging artists.
We publish:

Greeting cards	Posters	Limited editions
Open editions	Calendars	

Target market:

Poster Stores	Interior Designers	General Public
Commercial Spaces		

Type of art we publish:

Humorous	Serious

Style of artwork we publish:

Animals	Ethnic	Graphic
Impressionism	Naive	Southwestern
Western		

Medium of artwork we publish: Photography

❖ Poster Graphics Inc
Deborah Dreher
PO Box 2280, Bremerton, WA 98310
206/479-8961 206/479-8964 Fax

Year company was established: 1992
We are actively seeking both emerging and established artists.
We publish:

Greeting cards	Posters	Limited editions
Open editions	Calendars	

Age-group we cater to: All ages
Target market:

Poster Stores	Museums	Interior Designers
General Public	Schools	The Trade
Showrooms	Commercial Spaces	

Type of art we publish:

Humorous	Serious

Style of artwork we publish:

Animals	Equestrian	Ethnic
Figurative	Graphic	Impressionism
Landscape	Marine	Naive
Nostalgia	Realistic	Southwestern
Traditional	Western	Wildlife

Medium of artwork we publish:

Acrylic	Airbrush	Computer Art
Drawing	Mixed Media	Oil
Pastel	Photography	Watercolor

We are a distributor as well as a publisher.
We are not interested in distributing works published by others.
We distribute:

Lithographs	Limited editions	Greeting cards
Postcards		

Advice we offer to an artist interested in being published or distributed by us: We market both originals and reproduction prints. We help you find your place in today's art industry.
Review policy: Submit portfolio for review/send slides by mail for consideration.
Specific time of the year we review work: Anytime

❖ Winn Devon Art Group
Buster Morris
6015 Sixth Ave S, Seattle, WA 98108
206/763-9544 206/763-1389 Fax

Year company was established: 1977
We are actively seeking new artists.
We publish:

Greeting cards	Posters	Limited editions
Serigraphs		

Age-group we cater to: Adult
Target market:

Poster Stores	Museums	Interior Designers
The Trade	Commercial Spaces	

Type of art we publish:

Humorous	Serious

Style of artwork we publish:

Abstract	Classic	Figurative
Impressionism	Landscape	Marine
Realistic	Representational	Sport
Surrealism	Traditional	

Medium of artwork we publish:

Acrylic	Charcoal	Collage
Colored Pencil	Computer Art	Drawing
Marker	Mixed Media	Oil
Pastel	Photography	Silkscreen
Watercolor		

We are a distributor as well as a publisher.
We are not interested in distributing works published by others.
We distribute: Limited editions Posters
Advice we offer to an artist interested in being published or distributed by us: Send artwork in the form of a slide, photo or transparency to Buster Morris with a SASE.

❖ Nordmann-America Publishing
TA Hanson
PO Box 561, Eau Claire, WI 54702-0561
715/832-6118 715/832-8116 Fax

Year company was established: 1990
We are actively seeking both emerging and established artists.
We publish:

Posters	Limited editions	Open editions
Books		

Age-group we cater to: All ages
Target market:

Poster Stores	General Public	The Trade

Type of art we publish:
Humorous Serious
Style of artwork we publish:

Animals	Erotic	Historic
Landscape	Nostalgia	Realistic
Traditional	Wildlife	

Medium of artwork we publish:

Acrylic	Mixed Media	Oil
Pen & Ink	Watercolor	

We are a distributor as well as a publisher.
We are not interested in distributing works published by others.
We distribute: Lithographs Limited editions
Review policy: Send slides by mail for consideration/send SASE for submission guidelines.
Specific time of the year we review work: Anytime

❖ Images of America Publishing Co
Board of Directors
PO Box 1/3610 S Park Dr, Jackson Hole, WY 83001
307/739-9444 307/739-1199 Fax

Year company was established: 1991
We are seeking new artists through Arts for the Parks contest.
We publish: Posters Limited editions
Age-group we cater to: All ages
Target market:

Poster Stores	Interior Designers	General Public

Style of artwork we publish:

Animals	Aviation	Historic
Landscape	Nostalgia	Southwestern
Wildlife		

Medium of artwork we publish:

Acrylic	Colored Pencil	Oil
Pastel	Watercolor	

Advice we offer to an artist interested in being published or distributed by us: Enter the Arts for the Parks contest/deadline is June 1 of each year.

❖ Paperpotamus Paper Products Inc
George Jackson
Box 310, Delta, British Columbia, Canada V4K 3Y3
604/270-4580

Year company was established: 1988
We are actively seeking both emerging and established artists.
We publish: Greeting cards
Age-group we cater to: All ages
Target market: General Public
Type of art we publish:
Humorous Serious

Style of artwork we publish:

Animals	Aviation	Fantasy
Impressionism	Marine	Nostalgia
Realistic	Wildlife	Cartoon

Medium of artwork we publish:

Acrylic	Mixed Media	Photography
Watercolor		

We are a distributor as well as a publisher.
We are interested in distributing works published by others.
We distribute: Greeting cards
Review policy: Send SASE for submission guidelines; do not send slides.
Specific time of the year we review work: Anytime

❖ Canadian Art Prints
J H Krieger
160-6551 Westminster Hwy, Richmond, BC, Canada
V7C 4V4
604/276-4551

Year company was established: 1965
We are actively seeking both emerging and established artists.
We publish:

Greeting cards	Posters	Limited editions
Open editions	Serigraphs	

Age-group we cater to: All ages
Target market:

Poster Stores	Museums	Interior Designers
The Trade	Showrooms	Galleries
Wholesale Framers		

Type of art we publish: Serious
Style of artwork we publish:

Aviation	Figurative	Impressionism
Landscape	Marine	Naive
Realistic	Sport	Traditional
Western	Wildlife	

Medium of artwork we publish:

Acrylic	Airbrush	Collage
Mixed Media	Oil	Silkscreen
Watercolor		

We are a distributor as well as a publisher.
We are not interested in distributing works published by others.
We distribute: Serigraphs
Review policy: Send slides/photos by mail for consideration.
Specific time of the year we review work: All year

Book Publishers

❖ **Valley of the Sun Publishing**
Jason McKean
Box 38, Malibu, CA 90265

We use free lance fine artists for: Book covers
We are actively seeking new artists.
Age-group we cater to: Young adult Adult
Advice we offer to an artist interested in working with us: We look for eye-catching color, spiritual/surreal imagery, realistic style.
Review policy: Send slides by mail for consideration/send SASE for submission guidelines.
Specific time of the year we review work: Anytime

❖ **Pacific Press Publishing Association**
Merwin Stewart
1350 N Kings Rd, Nampa, ID 83687
208/465-2592 208/465-2531 Fax

We use free lance fine artists for:
Book covers Interior illustration Interior layout
We are seeking established artists.
Age-group we cater to:

Children	Teenager	Young adult
Adult	All ages	

Target market:

General Public	Religious Organizations
Schools	Commercial Spaces

Advice we offer to an artist interested in working with us: Send high-quality, full-color samples of your art (tear sheets, photographs, color photocopies) which may be kept on file for future assignment. Do not send materials you wish to have returned. Illustration projects are based on the editorial needs of the magazines and books published. Pre-existing art is rarely used, since editorial art must directly illustrate the text.
Review policy: Send SASE for submission guidelines.
Specific time of the year we review work: Continuously

❖ **Crossway Books**
Good News Publishers/Arthur Guye
1300 Crescent St, Wheaton, IL 60187
708/682-4300

Year company was established: 1939
We are seeking both emerging and established artists.
Age-group we cater to: All ages

Target market:	Religious	General Public

Styles used:

Classic	Fantasy	Historic
Nostalgia	Realistic	Religious
Representational	Sci-Fi	Traditional
Western	Maps	Digital
Calligraphy/Hand Lettering		

Advice we offer to an artist interested in working with us: We are looking for Christian artists who are committed to spreading the Gospel of Jesus Christ through quality literature. Since we are a nonprofit organization, we may not be able to afford an artist's 'going rate.' Quality and the ability to meet deadlines are critical.
Review policy: Send slides/tear sheets/color copies by mail for consideration.
Specific time of the year we review work: Constantly

❖ **Stemmer House Publishers Inc**
Barbara Holdridge
2627 Caves Rd, Owings Mills, MD 21117
410/363-3690 410/363-8459 Fax

We use free lance fine artists for:
Book covers Interior illustration
We are actively seeking new artists. We keep artists on file in case of need.
Age-group we cater to:
Children Adult
Advice we offer to an artist interested in working with us: We are not interested in cartoon style.
Review policy: Send printed pieces that do not have to be returned.
Specific time of the year we review work: Anytime

❖ **Kitchen Sink Press**
320 Riverside Dr, Northampton, MA 01060
413/586-9525 413/586-7040 Fax

We use free lance fine artists for:
Book covers Interior illustration Interior layout
Age-group we cater to:

Children	Teenager	Young adult
Adult	All ages	

Advice we offer to an artist interested in working with us: Original, innovative comic book work
Review policy: Send SASE for submission guidelines.
Specific time of the year we review work: Anytime

❖ **Charlesbridge Publishing**
Elena Dworkin Wright
85 Main St, Watertown, MA
617/926-0329 617/926-5720 Fax

We use free lance fine artists for:
Book covers Interior illustration
We are actively seeking new artists.
Age-group we cater to: Children
Review policy: Submit portfolio for review/send slides by mail for consideration.

❖ Instructional Fair/TS Denison

Annette Hollister Papp
PO Box 1650, Grand Rapids, MI 49501

We are an educational publishing company of supplemental teacher/teaching resource materials.
We use free lance fine artists for:
Book covers Interior illustration
We are actively seeking new artists.
Age-group we cater to:
Children Teenager
Advice we offer to an artist interested in working with us: Always seeking good, clean, black line of children and samples of color work.
Review policy: Send slides by mail for consideration.
Specific time of the year we review work: Spring/Summer

❖ Augsburg Fortress Publishers

Ellen Maly
426 S 5th St, PO Box 1209, Minneapolis, MN 55440
612/330-3408 612/330-3455 Fax

We use free lance fine artists for:
Book covers Interior illustration Interior layout
We are actively seeking new artists.
Age-group we cater to: All ages
Advice we offer to an artist interested in working with us: Religious market; know our products!
Review policy: Send slides (no originals) by mail for consideration.
Specific time of the year we review work: Anytime

❖ John Muir Publications

Kathryn Lloyd
PO Box 613, Santa Fe, NM 87504
505/982-4078 505/988-1680 Fax

We use free lance fine artists for: Book covers
We are actively seeking new artists.
Age-group we cater to:
Children Adult
Review policy: Arrange a personal interview to show portfolio/send slides by mail for consideration.
Specific time of the year we review work: Anytime

❖ Art Direction Book Co

Don Barron
10 E 39th St 6Fl, New York, NY 10016
212/889-6500

We use free lance fine artists for: Book covers
We are actively seeking new artists.
Age-group we cater to: Adult
Review policy: Send SASE for submission guidelines.
Specific time of the year we review work: Anytime

❖ Galison Books

36 W 44 St, New York, NY 10036
212/354-8840 212/391-4037 Fax

We publish stationery and sidelines.
We are actively seeking new artists.
Age-group we cater to: All ages
Review policy: Send non-original art/tear sheets/duplicates/slides with SASE.
Specific time of the year we review work: Anytime

❖ Crumb Elbow Publishing

Michael Jones
PO Box 294, Rhododendron, OR 97049
503/622-4798

We use free lance fine artists for:
Book covers Interior illustration Interior layout
We are actively seeking new artists.
Age-group we cater to:
Children Teenager Young adult
Adult All ages
Advice we offer to an artist interested in working with us: Send us enough samples to allow us to become familiar with your style. We specialize in black and white, particularly pen and ink.
Review policy: Submit portfolio for review/send slides by mail for consideration/send SASE for submission guidelines.
Specific time of the year we review work: Anytime

❖ Mennonite Publishing House/Herald Press

Jim Butti
616 Walnut Ave, Scottdale, PA 15683
412/887-8500 ext 244 412/887-3111 Fax

We use free lance fine artists for:
Book covers Interior illustration
We are actively seeking new artists.
Age-group we cater to: All ages
Advice we offer to an artist interested in working with us: Choices based on the handling of people and faces; we publish church materials as well as books.
Review policy: Send slides by mail for consideration/send SASE for submission guidelines.
Specific time of the year we review work: Anytime

Book Publishers

❖ Incentive Publications

Marta Johnson Drayton
3835 Cleghorn Ave, Nashville, TN 37215
615/385-2934 615/385-2967 Fax

We use free lance fine artists for:
Book covers Interior illustration
We are not seeking artists at this time but are willing to consider for future work.
Age-group we cater to: Teachers of early learning through middle grades
Advice we offer to an artist interested in working with us: Spontaneous and warm, whimsical, not cartoony
Review policy: Send SASE for submission guidelines.
Specific time of the year we review work: Anytime

❖ Northworld Press Inc

Russell Kuepper
7520 Hwy 51 S, Minocqua, WI 54548
715/356-7644 715/356-6066 Fax

We publish records as well as books.
We use free lance fine artists for:
Book covers Interior illustration Interior layout
We are actively seeking new artists.
Age-group we cater to:
Children Young adult Adult
Review policy: Send slides by mail for consideration/send SASE for submission guidelines.
Specific time of the year we review work: Anytime

❖ Banff Centre Press

Mary Anne Moser
Box 1020-50, 107 Tunnel Mountain Dr, Banff, Alberta
Canada T0L 0C0
403/762-6288 403/762-6238 Fax

We publish: Books Limited editions
We are seeking established artists mostly through referrals.
Age-group we cater to: Adult
Target marget: Schools The Trade
Type of art:
African-American Erotic Ethnic
Latin American Contemporary Serious
Mediums of art:
Collage Computer Mixed Media
Photography Sculpture Silkscreen

Look through these listings for companies that produce album/CD covers which your artwork would be appropriate for. ArtNetwork's mailing list of 1400 recording companies on pressure sensitive labels is available for $95. Other places you can research:
 · *Song Writer's Market* edited by Brian Rushing
 · *Songwriter's & Musician's Guide to Nashville* by Sherry Bond

❖ Timberline Music

Michael Gulezian
PO Box 40493, Tucson, AZ 85717
520/624-5812 Telephone/Fax

We use free-lance fine artists for: Album covers
We are seeking established artists mostly through referrals.
Age-group we cater to: All ages
Style of music we publish:
Jazz New Age
Advice we offer to an artist interested in working with us: Never send originals! Send a sampling of your best work. We do not return materials.

❖ Imagine a Better World Inc

Lon Van Eaton
326 W Oak Hills Dr, Castle Rock, CO 80104-9239
303/799-0070 303/799-0078 Fax

We use free-lance fine artists for:
Album covers Film Video
Age-group we cater to:
Children Teenager Young adult
Adult All ages
Style of music we publish:
Rock Jazz New Age
Pop Classical Country western
Children Christian AAA
Review policy: Submit portfolio for review.

❖ Smithsonian Folkways Recordings

Brenda Dunlap/Matt Walters
955 L'Enfant Plz #2600, MRC 714, Washington, DC 20560
202/287-3251 202/287-3699 Fax

We use free-lance fine artists for:
Album covers Brochures Catalogues
We are actively seeking new artists.
Age-group we cater to:
Children Teenager Young adult
Adult All ages
Style of music we publish:
Jazz Classical Folk
Blues Bluegrass Children's
Review policy: Submit portfolio for review.
Specific time of the year we review work: Anytime

❖ The Rainbow Collection LTD/Gemini Music Group/Happy Man Records

Dick O'Bitts
4501 Spring Creek Dr #73, Bonita Springs, FL 33923
941/947-6978

We use free-lance fine artists for:
Album covers Brochures Other
We are actively seeking new artists.
Age-group we cater to:
Teenager Young adult Adult
All ages
Style of music we publish:
Rock Pop Country Western
Review policy: Submit portfolio for review/Send SASE for submission guidelines.
Specific time of the year we review work: Anytime

❖ Blair Vizzion Music

Willie Hunter
1315 Simpson Rd NW #5, Atlanta, GA 30314
404/642-2645

We use free-lance fine artists for:
Album covers Brochures
We are actively seeking new artists.
Age-group we cater to:
Teenager Young adult Adult
Style of music we publish:
Rhythm & Blues Rap Dance
Review policy: Send SASE for submission guidelines.
Specific time of the year we review work: Anytime

❖ BCN/Beacon Records

PO Box 3129, Peabody, MA 01961
508/762-8400 508/762-8467 Fax

We use free lance fine artists for:
Album covers Brochures
We are actively seeking new and established artists mostly through referrals.
Age-group we cater to: Adult
Style of music we publish:
New Age Celtic Folk
Country Western
Review policy: Submit portfolio for review.
Specific time of the year we review work: Anytime

❖ JHO Music

Jonne Hammil
11 Marshall Terr, Wayland, MA 01778
508/358-5213 Telephone/Fax

We use free-lance fine artists for:
Album covers Brochures Songbooks
Teachers materials
We are actively seeking new artists and through referrals.

Recording Companies

Age-group we cater to:
Children Adult
Style of music we publish:
Children's music Teachers materials
Review policy: Submit portfolio for review.

❖ Betty Jane/Josie Jane Music Pub Co/ CER Records

Claude Reed
7400 N Adams Rd, N Adams, MI 49262
517/287-4421

We use free-lance fine artists for:
Album covers Brochures Tray cards
We are seeking established artists mostly through referrals.
Age-group we cater to: All ages
Style of music we publish:
Gospel Country western
Review policy: Submit portfolio for review/Send SASE for submission guidelines.
Specific time of the year we review work: Anytime

❖ Ace Records

John Vincent
PO Box 5782, 103 Fairmont Ln, Pearl, MS 39208
601/939-6868 601/932-3038 Fax

We use free-lance fine artists for:
Album covers Brochures
We are seeking established artists mostly through referrals.
Age-group we cater to:
Young adult Adult
Style of music we publish:
Rhythm & Blues Gospel
Review policy: Submit portfolio for review.
Specific time of the year we review work: Anytime

❖ Essay Recording

Richard Kapp
145 Palisade St, Dobbs Ferry, NY 10522
914/693-5595 914/693-7040 Fax

We use free lance fine artists for:
Album covers Brochures
We are seeking established artists mostly through referrals.
Age-group we cater to: Adult
Style of music we publish: Classical
Specific time of the year we review work: Anytime

❖ High Harmony Records

Benjie Pastore
194 Katonah Ave, Katonah, NY 10536
914/245-0815 914/245-0816 Fax

We use free lance fine artists for: Album covers

We are seeking established artists mostly through referrals.
Age-group we cater to:
Young adult Adult
Style of music we publish:
Jazz New Age Pop
Classical
Review policy: Submit portfolio for review.

❖ SOS Productions Inc/Chiaroscuro Records

Hank O'Neal/New York
Andrew Sordoni/Pennsylvania
830 Broadway, New York, NY 10003
212/473-0479 212/475-1567 Fax

We use free lance fine artists for:
Album covers Brochures Posters
We are actively seeking new and established artists mostly through referrals.
Age-group we cater to:
Young adult Adult
Style of music we publish: Jazz
Review policy: Submit portfolio for review.
Specific time of the year we review work: Anytime

❖ Earth Flight Productions

Pam Montgomery
PO Box 2231, Prescott, AZ 86302
800/829-4278 800/829-4278 Fax

We use free lance fine artists for:
Album covers Brochures
We are seeking established artists mostly through referrals.
Age-group we cater to: Adult
Style of music we publish: Jazz
Review policy: Send SASE for submission guidelines.
Specific time of the year we review work: Anytime

❖ Dreambox Media Inc

Jim Miller
Box 8132, Philadelphia, PA 19101
610/328-1619

We use free lance fine artists for:
Album covers Brochures
We are seeking established artists mostly through referrals.
Age-group we cater to: Adult
Style of music we publish: Jazz
Review policy: Send SASE for submission guidelines.
Specific time of the year we review work: Anytime

❖ Gizmo Records/Amethyst Group Ltd/Plug Production

Mr Gibb/Mr Mitchell/Mr Mack
273 Chippewa Dr, Cola, SC 29210-6508
803/750-5391

We are actively seeking new artists.

Age-group we cater to: All ages
Style of music we publish:

Rock	Jazz	New Age
Pop	Classical	Country western

Review policy: Submit portfolio for review.

❖ Asylum Records

Michelle Myers
1906 Acklen Ave, Nashville, TN 37212
615/292-7990 615/298-4385 Fax

We use free lance fine artists for:
Album covers Brochures
Advertising, promotion pieces, POP's
We are actively seeking new artists.
Age-group we cater to: All ages
Style of music we publish: Country
Review policy: Submit portfolio for review.
Specific time of the year we review work: Anytime

❖ Arista Records Inc

Maude Gilman
7 Music Cir N, Nashville, TN 37203
615/780-9142 615/780-9193 Fax

We use free lance fine artists for: Album covers
We are actively seeking new artists, mostly photographers.
Age-group we cater to:
Teenager Young adult Adult
Style of music we publish: Country
Review policy: Submit portfolio or samples for review.
Specific time of the year we review work: Anytime

❖ Emerald Records

Cliff Ayers
159 VIllage Green Dr, Nashville, TN 37217
615/361-7902 615/361-7600 Fax

Age-group we cater to:
Young adultAdult All ages
Style of music we publish:
Pop Country western
Review policy: Submit portfolio for review.
Specific time of the year we review work: Anytime

❖ Stardust/Wizard/Doss Records

Buster Doss
341 Billy Goat Hill Rd, Winchester, TN 37398
615/649-2577 615/649-2732 Fax

We use free-lance fine artists for:
Album covers Brochures
We are actively seeking new artists.
Age-group we cater to:

Children	Teenager	Young adult
Adult	All ages	

Style of music we publish:
Rock Country western
Review policy: Submit portfolio for review.
Specific time of the year we review work: Anytime

❖ Panoramic Sound

Jerry Elliott
PO Box 58182, Houston, TX 77258
713/488-7411

We use free lance fine artists for:
Album covers Book illustrations
We are actively seeking new artists.
Age-group we cater to:
Children Adult
Style of music we publish: New Age
Review policy: Submit portfolio by mail or call (evenings only).
Specific time of the year we review work: Anytime

❖ Dejadisc

Steve Wilkison
537 Lindsey St, San Marcos, TX 78666
512/392-6610 512/754-6886 Fax

We use free-lance fine artists for:
Album covers Brochures Other
We are actively seeking new artists.
Age-group we cater to:
Young adult Adult
Style of music we publish:

Rock	Pop	Folk
Country western		

Review policy: Submit portfolio for review.
Specific time of the year we review work: Anytime

❖ Alcazar Productions

Jennifer Harwood
PO Box 429, S Main St, Waterbury, VT 05676
802/244-7845 802/244-6128 Fax

We use free-lance fine artists for: Album covers
Age-group we cater to: All ages
Review policy: Submit portfolio for review.
Specific time of the year we review work: Anytime

❖ Rebel Records

Gary Reid
PO Box 3057, Roanoke, VA 24015
514/343-5355 540/343-3240 Fax

We use free lance fine artists for: Album covers
We are seeking established artists mostly through referrals.
Age-group we cater to: All ages
Style of music we publish:
Country Western Bluegrass
Review policy: Submit portfolio for review.
Specific time of the year we review work: Anytime

chapter **7**

Photo
Markets

Associations

Alaska Photographic Center
Hal Gage
PO Box 243514, Anchorage, AK 99524-3514

American Society of Photographers
Box 52900, Tulsa, OK 74152

American Society of Magazine Photographers/ASMP
14 Washington Rd #502, Princeton Junction, NJ 08550
609/799-8300
Publishes "ASMP Professional Business Practices in Photography" ($13.50 ppd) as well as other books and publications.

Aperture Foundation
20 E 23rd St, New York, NY 10010

Associated Photographers of Winston-Salem
PO Box 24096, Reynolda Station, Winston-Salem, NC 27114

Association of International Photography Art Dealers
1609 Connecticut Ave NW, Washington, DC 20009
202/986-0105
Publishes a directory of photography galleries throughout the U.S.

Blue Photographic Center
1231 NW Hoyt St, Portland, OR 97209
503/225-0210

Center for Photography at Woodstock
Colleen Kenyon
59 Tinker Way, Woodstock, NY 12498
914/679-9957
Gallery space; gives fellowships to photographers, sponsors classes and seminars, has a slide registry, art library and publishes 'Photography Quarterly.'

Colorado Photographic Arts Center
Skip Kohloff
PO Box 12616, Denver, CO 80212-0616
303/278-3693

East Texas State U Photographic Society
Stan Godwin
Box D, ET Station, Commerce, TX 75428

En Foco
32 E Kingsbridge Rd, Bronx, NY 10468
718/584-7718

Eye Gallery
Lynette Molnar
1151 Mission St, San Francisco, CA 94103
415/431-6911

Friends of Photography
Ron Egherman
250 4th St, San Francisco, CA 94103
415/495-7000

Houston Center for Photography
1441 W Alabama, Houston, TX 77006
713/529-4755

International Center of Photography Midtown
1133 Ave of the Americas, New York, NY 10036
212/768-4682

Light Factory
PO Box 32815, Charlotte, NC 28232
704/333-9755

Light Work
316 Waverly Ave, Syracuse, NY 13244
315/443-1300

Los Angeles Photography Center
412 S Park View St, Los Angeles, CA

Photo Market Association
3000 Picture Pl, Jackson, MI 49201
517/788-8100
Has an annual trade show in February (Las Vegas 1996).

Photographic Resource Center
John Jacob
602 Commonwealth Ave, Boston, MA 02215
617/353-0700
Membership organization providing a range of programs to support and encourage photographers; gallery space, slide registry, art library, classes and seminars and newsletters 'PRC' and 'Views.'

Professional Photographers of North Carolina
PO Box 52179, Raleigh, NC 27612-0179

Raleigh Photographic Arts Association
Marshall Clayton
113 Dundee Ct, Cary, NC 27511

Randolph Photography Club
Robert Cox
1809 Portage Pkwy, Asheboro, NC 27203

Society of Photographic Art Reps/SPAR
60 E 42nd St #1166, New York, NY 10165
212/779-7464

Soho Photo
David Chalk
15 White St, New York, NY 10013
212/226-8571

Photo Markets

Texas Photographic Society
D Clarke Evans
102 Arcadia Pl #702, San Antonio, TX 78209
210/824-4123
Sponsors competitive exhibitions, gives grants to members and publishes a newsletter 'Contact Sheet.'

Toledo Friends of Photography
PO Box 8408, Toledo, OH 43623

University Photographers Association of America
Dan Raoloski
607 Cohades, NMU, Marquette, MI 49855
906/227-2720

Visual Studies Workshop
Nathan Lyons
31 Prince St, Rochester, NY 14607
716/442-8676

Auctions

Major photography auctions are held twice annually (April and October).

Butterfield & Butterfield
220 San Bruno Ave, San Francisco, CA 94103
415/861-7500
7601 Sunset Blvd, Los Angeles, CA 90046
213/850-7500

Christie's
502 Park Ave, New York, NY 10022
212/606-0490

Sothby's
1334 York Ave, New York, NY 10021
212/606-7240
308 N Rodeo Dr, Beverly Hills, CA 90210
310/274-0340

Books

You can probably find many of the books listed below at your nearest library or university. Ask your librarian for an inter-library loan if need be. To locate publishers noted with an asterisk (), look in the section following under 'Book Sellers.'*

Artists' Handbook for Photographing Their Own Artwork by John White
Crown Trade Paperbacks

ASMP Stock Photography Handbook
14 Washington Rd #502, Princeton Junction, NJ 08550
609/799-8300
$32.95 ppd.

Best Sellers: One Hundred Ways to Moneymaking Stock Photos by James Ong
Images Press*

Big Bucks Selling Your Photography by Cliff Hollenbeck

Business and Legal Forms for Photographers by Tad Crawford
Allworth Press*

The Care of Photographs by Siegfried Rempel
Lyons and Burford*

Focalguide to Selling Your Photographs by Ed Busiak

Free Stock Photography Directory
Infosource Business Publications
212/727-3856
Lists over 250 government and corporate sources of free photos.

Freelance Photographer's Handbook by T J Marino and Donald Sheff

Freelance Photography: Advice from the Pros by Curtis Casewit

Gold Book of Photography Prices
Photography Research Institute
310/328-9272
$43.95 ppd.

Guide to Photo Workshops and Schools
800/247-6553

Hazards for Photographers
Artists Foundation
860 Harrison Ave #309, Boston, MA 03127
617/859-3810
Free brochure available.

Health Hazards for Photographers by Siegfried and Wolfgang Rempel
Lyons & Burford*

How to Begin and Operate a Successful Commercial Photography Business by Bill Montaigne

How to Sell Your Photographs and Illustrations by Elliott and Barbara Gordon
Allworth Press*

How To Shoot Stock Photos that Sell by Michal Heron
$16.95.

How to Start A Professional Photography Business by Ted Schwarz
Contemporary Books*

How to Start & Run a Successful Photography Business by Gerry Kopelow
Images Press*

How to Start, Finance, and Manage a Profitable Photography Business by John Stockwell and Bert Holtje

How You Can Make $25,000 a Year with Your Camera: No Matter Where You Live by Larry Cribb
Writer's Digest*

Making a Living in Photography
Jay Daniel Associates
PO Box 1232, San Rafael, CA 94915
415/459-1495

Nature and Wildlife Photography: A Practical Guide to How to Shoot and Sell by Susan McCarteny
Allworth Press*

Overexposure: Health Hazards in Photography by Susan Shaw and Monona Rossol
American Council on the Arts*
$18.95.

Permanence and Care of Color Photographs by Henry Wilhelm

Photo Gallery Workshop Handbook by Jeff Cason
Images Press*

Photo Marketing Handbook by Jeff Cason
Images Press*

Photograph Collectors' Resource Directory edited by Peter Hastings Falk
Consultants Press*
Over 1,700 listings of worldwide galleries, dealers and exhibitions and places where photographic prints are sold, $24.95.

Photographer's Business and Legal Handbook by Leonard Duboff
Images Press*

Photographer's Complete Guide to Exhibition & Sales Spaces
The Consultants Press*
$24.95.

Photographer's Guide to Marketing and Self-Promotion by Maria Piscopo
Allworth Press*

Photographer's Market: Where to Sell Your Photographs by Robert D Lutz
Writer's Digest*
Includes 2,500 listings annually. Can be found in or ordered from most book stores.

Photographer's Organizer by Michal Heron
Allworth Press*

Photographer's Publishing Handbook by Harold Davis
Images Press*

Photography and the Law by Christopher DuVernet
Self-Counsel Press
206/676-4530

Photography and the Law by George Chernoff and Hersel Sarbin
Images Press*

Photography for the Art Market by Kathryn Marx
A great reference book written by an experienced photographer marketing her work.

Photography: What's the Law, How the Photographer and the User of Photographs Can Protect Themselves by Roger Cavallo and Stuart Kahan

Picture Researcher's Handbook by Hilary Evans

Professional Business Practices in Photography
American Society of Magazine Photographers/ASMP
609/799-8300

Professional Photographer's Guide to Shooting & Selling Nature & Wildlife Photos by Jim Zuckerman
Writer's Digest*

Professional Photographer's Survival Guide by Charles E Rotkins
Writer's Digest*

Profitable Model Photography by Art Ketchum
Images Press*

Sell and Re-Sell Your Photos by Ron Engl
715/248-3800

Selling Photographs: Rates and Rights by Lou Jacobs
Images Press*

Selling Your Photography: The Complete Marketing, Business and Legal Guide by Tad Crawford and Arie Kopelman
Allworth Press*

Photo Markets

Starting and Succeeding in Your Own Photography Business by Jeanne C Thwaites

Stock Photo and Assignment Source Book
RR Bowker
800/521-8110
$29.95.

Stock Photo Deskbook
Consultants Press *
$29.95.

Stock Photography: How to Shoot It, How to Sell It by Ellis Herwig
Images Press*

Successful Fine Art Photography: How to Market Your Art Photography by Harold Davis

User's Guide to Photographic Film by Dan O'Neill

Where and How to Sell Your Photographs by Arvel Ahlers
Images Press*

Winning Photo Contests by Jeanne Stallman
Images Press*

Working Photographer: The Complete Manual for the Money Making Professional by Marija and Todd Bryant

You Can Sell Your Photos by Henry Scanlon
Harper & Row

Booksellers

Allworth Press
10 E 23rd St #400, New York, NY 10010
212/777-8395

American Council for the Arts
1 E 53rd St #400, New York, NY 10022
800/321-4510 212/223-2787

A Photographer's Place
133 Mercer St, New York, NY 10012
212/431-9358

Consultants Press
163 Amsterdam, New York, NY 10023
212/838-8640

Contemporary Books
180 N Stetson Ave, Chicago, IL 60601
312/540-4500

Images Press
Peter Gould
89 5th Ave #903, New York, NY 10003
212/675-3707

Lyons and Burford
31 W 21st St, New York, NY 10010
212/620-9580

Photo-Eye Books
376 Garcie St, Santa Fe, NM 87501
505/988-4955

Writer's Digest
800/289-0963

Consultants

Maria Piscopo
20388 Calwert Dr, Costa Mesa, CA 92626-3520
714/556-8133
Marketing and management seminars for photographers and other creative people. Call for exact dates and cities.

Photography Library Management
Sandra Kinsler
2674 E Main St #C-240, Ventura, CA 93003-2899
805/641-2400

Exhibits & Fairs

Del Mar Fair
2260 Jimmy Durante Blvd, Del Mar, CA 92014-2216
619/755-1161
A special exhibition for photography. Write for prospectus.

Fotofest
20 Greenway Plz #368, Houston, TX 77046
713/840-9711
March 1996.

Les Recontres Intl de la Photographic
10, Rond-Point de Arenes, B P 96, 13362 Arles Cedex
France

Natural World Photographic Competition
Carnegie Museum of Natural History
4400 Forbes Ave, Pittsburgh, PA 15213
412/622-3283

Photo Competition USA
Alan Marshall
2200 Ben Franklin Pkwy #1505-S, Philadelphia, PA 19130
For listings of photo competitions.

Photography Show
Association of International Photography Art Dealers/ AIPAD
1609 Connecticut Ave NW, Washington, DC 20009
202/986-0105
Held in New York in March in coordination with ArtExpo.

Galleries
(See pages 204-206)

Grants

Aaron Siskind Foundation
73 Warren St, New York, NY 10007
Photographer's fellowship of up to $5,000.

Documentary Photography Grants by Bill Owens
Working Press, Box 687, Livermore, CA 94550

Ferguson Award
Friends of Photography
250 Fourth St #103, San Francisco, CA 94103
415/495-7000

Grants in Photography - How to Get Them by Lida Moser
212/675-3707

International Fund for Documentary Photography
Mother Jones/Sharon Huntley
731 Market St #600, San Francisco, CA 94103
415/357-1777
Annual documentary photo contest. Write for info.

Polaroid Foundation
201/265-6900

Ruttenberg Foundation Award
Friends of Photography
250 Fourth St #103, San Francisco, CA 94103
415/495-7000
Annual $2,000 purchase award to a photographer who has demonstrated excellence in and commitment to the medium and who concentrates his efforts on portrait photography. Two-stage jury procedure.

W Eugene Smith Grant in Humanistic Photography
International Center of Photography
1130 Fifth Ave, New York, NY 10128
212/860-1777
A jury award of $20,000 and a second of $5,000 are given annually to a photographer who aspires to perpetuate the spirit of Smith's work.

Magazines & Newsletters

Write on your letterhead for a "complimentary copy and rate card."

Afterimage
31 Prince St, Rochester, NY 14607
716/442-8676

American Photo
1633 Broadway, 43Fl, New York NY 10019
212/719-6000

Aperture
20 E 23rd St, New York, NY 10010
212/505-5555

APIDEA Newsletter
21822 Sherman Way #101, Canoga Park, CA 91303

Camera Canada
255 Dolly Varden Blvd #43, Scarborough, Ontario, M1H 2K8 Canada

Darkroom Photography
PO Box 5500, Agoura, CA 91301

Darkroom Techniques
PO Box 48312, 7800 Merrimac Ave, Niles, IL 60648

Kodak Studio Light
343 State St, Rochester, NY 14650

Nature Photographer
PO Box 2037, W Palm Beach, FL
407/586-7332

Nueva Luz
Miriam Romais
32 E Kingsbridge Rd, Bronx, NY 10468
212/584-7718
A photographic journal.

Photo District News
1515 Broadway Bldg 15, New York, NY 10036-5701

Photo Marketing
3000 Picture Pl, Jackson, MI 49201

Photo Metro
17 Tehama St, San Francisco, CA 94105

Photo Opportunity
PO Box 838, Montclair, NJ 07042

Photo Review
PO Box 698, Langhorne, PA 19047

Photo Weekly
1515 Broadway, New York, NY 10036

Photographer's Forum
614 Santa Barbara St, Santa Barbara, CA 93101-1609

Photo Markets

Photographer's Place
133 Mercer, New York, NY 10012-3819

Photographically Speaking
1071 Wisconsin Ave NW, Washington, DC

Photography Center
PO Box 1100, Carmel, CA 93921

Photography in New York
Bill Mindlin
64 W 89th St, New York, NY 10024
212/787-0401

Photoletter
PhotoSource International/Rohn Engh
Pine Lake Farm, Osceola, WI 54020
715/248-3800
Excellent reference source for photographers in business; highly recommended.

Professional Photographer
57 Forsyth St NW #1600, Atlanta, GA 30303-2206
404/522-8600

PSA Journal
3000 United Founders Blvd, #103, Oklahoma City, OK 73112

Rangefinder
PO Box 1703, 1312 Lincoln Rd, Santa Monica, CA 90406

Re: View
250 4th St, San Francisco, CA 94103

SF Camerawork
70 12th St, San Francisco, CA 94103

Shutterbug
PO Box F, Titusville, FL 32781

SMP Photo Market Newsletter
1500 Cardinal Dr, Little Falls, NJ 07424

Mailing Lists

ArtNetwork
PO Box 1268, Penn Valley, CA 95946
916/432-7630
The following mailing lists for photographers are available on a one-time rental basis and come in zip code order on pressure sensitive labels, easy to peel off with the hand:
245 Stock Photo Companies $25
220 Corporations Collecting Photography $45
250 Galleries Selling Photography $45

Museums

International Center for Photography
1130 Fifth Ave, New York, NY 10028
212/860-1777

International Museum of Photography
Eastman House
900 East Avenue, Rochester, NY 14607
716/271-3361

Publishers

Avanti
800 Penebscot Bldg, Detroit, MI 48231
313/961-0022
Major player in the production of photographic greeting and note cards.

Palm Press
Gus Kayafas
23 Bradford St, PO Box 338, Concord, MA 01742
508/371-1727

Services & Suppliers

Books for Business Professionals
Business Catalog/US Government Printing Office
Office of Marketing/Stop SM RM 3123, Washington DC 20401
202/521-1800
Free catalog of business books.

Crown Products
2160 Superior Ave, Cleveland, OH 44114
216/781-0900
Presentation products, photomounts, albums, mailers.

EP Levine
23 Drydock Ave, Boston, MA 02210
617/951-1499
New and used professional photographic hardware, sales and repairs.

Exposures
800/222-4947
Mail order catalog of photography goods.

Hunt's Photo & Video
100 Main St, Melrose, MA 02176
617/662-8822
Equipment and supplies.

Lens and Repro Equipment Corp
34 W 17th St 5Fl, New York, NY 10011
212/675-1900
Complete line of used and new quality cameras and accessories.

Photo Markets

Light Impressions
PO Box 940, Rochester, NY 14603-0940
800/828-6216
Visual resource catalog featuring over 300 titles, videos, slide sets and storage materials. Call for free brochure.

Porter's Camera Store
PO Box 628, Cedar Falls, IA 50613
800/553-2001

Twentieth Century Plastics
PO Box 30022, Los Angeles, CA 90016
800/767-0777
Slide sheets, archival safety, superior durability.

Sourcebook

Black Book Marketing Group
212/539-9800

Workshops

Catskill Center for Photography
59 Tinker St, Woodstock, NY 12498
914/679-9957

Maine Photographic Workshops
2 Central St, Rockport, ME 04856
207/236-8581
Over 100 courses offered from basic to advanced.

Galleries Carrying Photography

Here is a smattering of galleries across the nation that carry photography. ArtNetwork (916/432-7630) has a list available of over 250 galleries across the nation on pressure-sensitive labels for $45.

Center For Creative Photography
U of Arizona
843 E University Blvd, Tucson, AZ 85719-5046
602/621-7968

Refractions Space
600 San Pablo Ave #105, Albany, CA 94706
415/527-8664

Alpha Photo Gallery
2999 College Ave, Berkeley, CA 94705

Photography West Gallery
Carol Williams
PO Box 4829, Carmel, CA 93921-4829
408/625-1587

Laguna Beach Gallery of Photography
Tylk Pennock
24843 del Prado #534, Dana Point, CA 92629-2834

International Gallery of Photographic Art
1114 N Highway 101 #5, Encinitas, CA 92024-1421
619/459-0349

Fiddles & Cameras Photo Gallery
303 N Main St, Fort Bragg, CA 95437

Contemporary Photography
5631 La Jolla Blvd, La Jolla, CA 92037

Black Gallery
Roland Charles
107 Santa Barbara Plz, Los Angeles, CA 90008-2508
213/294-9024

City of LA Photography Centers
Glenna Boltuch
412 S Parkview St, Los Angeles, CA 90057
213/482-3566

LA Center for Photographic Studies
Howard Spector
814 S Spring St, Los Angeles, CA 90014

Photo Impact Gallery
931 N Citrus Ave, Los Angeles, CA 90038-2401
213/461-0141

Photographers Gallery
Amy Saret
732 Emerson St, Palo Alto, CA 94301
415/328-0662

Lightwork Gallery
712 57th St, Sacramento, CA 95819
916/451-9678

Photographers Gallery of Sacramento
Doug Alberts
905 23rd St, Sacramento, CA 95816
916/646-4257

Eye Gallery
Lynette Molnar
1151 Mission St, San Francisco, CA 94103-1514
415/431-6911

Friends of Photography
250 11th St, San Francisco, CA 94103

SF Camerawork
Marnie Gillett
70 12th St, San Francisco, CA 94103

SF Photoscape
1412 Alabama St, San Francisco, CA 94110

G Ray Hawkins Gallery
G Ray Hawkins
910 Colorado Ave, Santa Monica, CA 90401-2717
310/394-5558

Hill Gallery of Photography
312 S Mill St, Aspen, CO 81611-1977
303/925-1836

Vintage Fine Art Photography
2525 Arapahoe Ave, Boulder, CO 80302-6720
303/444-4042

2/C: A Community of Photographers
3659 Navajo, Denver, CO 80218
303/744-7488

Camera Obscura Gallery
Hal Gould
1309 Bannock St, Denver, CO 80204
303/623-4059

Colorado Photographic Arts Center
Glenn Cuerden
1730 Gaylord St, Denver, CO 80206-1209

Photo Mirage
Sara Frances
1801 S Pearl St, Denver, CO 80210
303/744-1807

Connecticut Photographics
Catherine Vanaria
128 E Liberty St, Danbury, CT 06810

Spectrum Gallery
Anna Proctor
1132 29th St NW, Washington, DC 20007-3827
202/333-0954

Photogroup
130 Madeira Ave, Miami, FL 33134
305/444-0198

Eye of The Beholder
Holland Cooley
320 Tamiami Trl S, Nokomis, FL 34275
813/923-4696

Photographic Investments Gallery
Ed Symmes
PO Box 8191, Atlanta, GA 30306-0191

Printworks Ltd
Sidney Block
311 W Superior St #105, Chicago, IL 60610-3537
312/664-9407

Photospace
Northern Ill University/E Michael Flanagan
Swen Parson Bldg, Dekalb, IL 60115

Ron Herman Photography Gallery
U of Notre Dame, Notre Dame, IN 46556

A Gallery of Fine Photography
Joshua Mann Pailet
5423 Magazine St, New Orleans, LA 70115-3149

Photo Gallery at Portland School of Art
John Eide
619 Congress St, Portland, ME 04101

Maine Photographic Workshops
John Doncaster
2 Central St, Rockport, ME 04856-5936
207/236-8581

Photographic Resource Center
Anita Douthat
602 Commonwealth Ave, Boston, MA 02215-2400
614/353-0700

Polaroid Corporation Gallery
Linda Benedict-Jones
770 Main St, Cambridge, MA 02139

Jeb Gallery
Ronald Caplain
295 Albany St, Fall River, MA 02720

Arthur Griffin Center for Photographic Art
67 Shore Rd, Winchester, MA 01890
617/729-1158

Minneapolis Photographer's Gallery
Eric Enge
2117 Lyndale Ave S, Minneapolis, MN 55405-3207
612/374-9755

Contemporary Photography
PO Box 32284, Kansas City, MO 64171

Photographers' Gallery Inc
Julie Montgomery
2539 N 49th St, Omaha, NE 68104
402/551-5731

DVS/Photography
William Davis
PO Box 1642, Taos, NM 87571-1642

Focal Point Gallery
Ron Terner
321 City Island Ave, Bronx, NY 10464
212/885-1403

Rick Wester Photographic
465 Broadway, Hastings-on-Hudson, NY 10706-2332

Benrubi Fine Art Photographs
150 E 74th St, New York, NY 10021
212/517-3766

Burden Gallery at Aperture
20 E 23rd St, New York, NY 10010
212/475-8790

Camera Club of New York
853 Broadway, 2nd Floor, New York, NY 10003

K & L Custom Photographic
Jim Vazoulas
222 E 44th St, New York, NY 10017

Kimmel/Cohn Photography Arts
Roberta Kimmel Cohn
1 W 64th St, New York, NY 10023

Leica
679 Broadway 5Fl, New York, NY 10012

Lumina
Yancey Richardson
251 W 19th St, New York, NY 10011
212/807-0233

Galleries Carrying Photography

Midtown Photography Gallery
Michael Spano
344 E 14th St, New York, NY 10003
212/967-7200

Neikrug Photographica Ltd
Marjorie Neikrug
224 E 68th St, New York, NY 10021
212/288-7741

Photocollect
740 W End Ave, New York, NY 10025
212/222-7381

Photographics Unlimited Gallery
17 W 17 St, New York, NY 10010
12/980-5454

Soho Photo Gallery
15 White St, New York, NY 10013
212/226-8571

Staley-Wise
560 Broadway, New York, NY 10012

Warsaw Photographic Inc
110 Leroy St, New York, NY 10014

Light Impressions Spectrum Gallery
Lance Speer
439 Monroe Ave, Rochester, NY 14607
716/271-8960

Visual Studies Workshop Galleries
Nathan Lyons
30 Prince St, Rochester, NY 14607

Sea Cliff Photograph Co
Diann Mistretta
310 Sea Cliff Ave, Sea Cliff, NY 11579
516/671-6070

Iris Photographics
Ralph Burns
15 W Walnut St, Asheville, NC 28801

Contemporary Arts Center
Sarah Rogers-Lafferty
115 E 5th St, Cincinnati, OH 45202

Photo Zone
164 W Broadway, Eugene, OR 97401
503/485-2278

Camerawork Gallery
2255 NW Northrup St, Portland, OR 97210-2952
503/228-6509

Pacific Arts Photography Gallery
526 SW Yamhill, Portland, OR 97204
503/274-0598

Photographic Image Gallery
Guy Swansen
208 SW 1st Ave, Portland, OR 97204
503/224-3543
1-1810

Photo Forum
Eric Mendelson
5884 Ellsworth Ave, Pittsburgh, PA 15232-1738
412/661-5800

Southern Light Gallery
Robert Hirsch
PO Box 447, Amarillo, TX 79178-0001
806/371-5000

Fotofest Gallery
20 E Greenway Plz #368, Houston, TX 77046-2002

Woodstock Gallery
Charles Fenton
Gallery Place, Rte 4 E, Woodstock, VT 05091
802/457-1900

Hudson Photographic Gallery
321 Pacific Ave, Bremerton, WA 98310
206/373-5300

Photographic Center Northwest
Brian Allen
2617 5th Ave, Seattle, WA 98121-1517
206/441-7030

Silences
Christina Howe
111 S Lander St #301, Seattle, WA 98134-1843
206/343-9468

Silver Image Gallery
Dan Fear
123 S Jackson St #1, Seattle, WA 98104
206/623-8116

Sunprint Gallery
Rena Gelman
638 State St, Madison, WI 53703-1023

Silver Paper
217 N Broadway, Milwaukee, WI 53202
414/271-8644

This is only a small list of the hundreds of stock photo agencies throughout the nation. ArtNetwork has a mailing list you can rent that comes on pressure-sensitive labels (for $25) with 245 company names.

There are several directories available with such companies also. Ask your librarian or:

• **Blue Book 96-97**
AG Editions Inc
41 Union Sq W #523, New York, NY 10003
800/727-9593
Reference directory for photobuyers of geograhic, travel and destination stock photos. Photographers with minimum 10 publications credit may apply.

• **Picture Agency Council of America/PAGA**
PO Box 308, Northfield, MN 55057
Over 100 pages of information for $10.

• **Stock Photo Desbook, Fifth Edition**
Photographic Arts Center
163 Amsterdam Ave, New York, NY 10023
212/838-8640
$44.95 ppd.

Aerolist Photographers Inc
12830 Interurban Ave S, Seattle, WA 98168

Art Resource
65 Bleecker St, 9Fl, New York, NY 10012

Artstreet
25 E Delaware, Chicago, IL60611

Cape Scapes
542 Higgins Crowell Rd , West Yarmouth, MA 02673

Digital Stock Inc
400 S Sierra Ave #100, Solana Beach, CA 92075

Dynamic Graphics
6000 N Forrest Park Dr, Peoria, IL 61614

Earth Images
Box 10352, Bainbridge Island, WA 98110

Elite Photography
PO Box 2789, Toledo, OH 43606

Florida Image File
526-11 Ave NE, St. Petersburg, FL 33701

Folio Inc
3417$^{1}/_{2}$ M St NW, Washington, DC 20007

Fotos International
4230 Ben Ave, Studio City, CA 91604

Hot Shots Stock Shots Inc
34 Lesmill Rd, Toronto, Ontario Canada M3B 2V
416/441-3281

Image Bank Northwest
101 Yesler Way, #206, Seattle, WA 98104

Images Unlimited
13510 Floyd Rd, Dallas, TX 75243

Impact Visuals Photo & Graphics
28 W 27th St #901, New York, NY 10001

International Color Stock
555 NE 34th St #701, Miami, FL 33137

Light Sources Stock
23 Drydock Ave, Boston, MA 02210

Masterfile
415 Yonge St, Toronto, Ontario, Canada M5B2E7

Mon Tresor
Tim Potter
1257 Haslett Rd, Haslett, MI 48840-8953

National Stock Network
8960 SW 114 St, Miami, FL 33176

Office of Printing & Photo Services
Smithsonian Institute, Washington, DC 20060

Pacific Stock
PO Box 90517, Honolulu, HI 96835

Scenic Photo Imagery
9208 32nd Ave N, Minneapolis, MN 55427

Star File Photo Agency
1501 Broadway, NY, NY 10036

Stock Market
360 Park Ave S 16Fl, New York, NY 10010

Superstock Inc
11 W 19th St, New York, NY 10011

Tony Stone Worldwide Stock
6100 Wilshire Blvd #1250, Los Angeles, CA 90048

Uniphoto Picture Agency
1071 Wisconsin Ave NW #B, Washington, DC 20007

Wide World Photos Inc
50 Rockefeller Plaza, New York, NY 10020

Craft Markets

Associations

Look for a craft organization in your own area to join and network with other craftspeople.

American Concern for Artistry and Craftsmanship
PO Box 650, Montclair, NJ 07042
201/746-0091
Produces art shows at Lincoln Center in New York.

American Craft Association
21 S Eltings Corner Rd, Highland, NY 12528
800/724-0859

American Crafts Council
72 Spring St, New York, NY 10012
A non-profit organization with museum.

American Quilt Study Group
660 Mission St #400, San Francisco, CA 94105-4007
415/495-0163

Blue Ridge Hearthside Crafts
Route 1 Box 738, Bonner Elk, NC 28604
704/963-5252 704/295-9454
A craft cooperative with two retail shops. They serve members in a nine-state region (NC, SC, GA, TN KY, VA, WV, MD, AL). They sponsor four craft shows (June, July, August and October). You must live and work in the nine-state region to become a member, and only members can exhibit.

Brookfield Craft Center Inc
PO Box 122, Brookfield, CT 06804
203/775-4526
Educational center that offers many classes.

Cartgeret County Arts & Crafts
Meg Forward
414 Ann St, Beaufort, NC 28516

Connecticut Guild of Craftsmen
PO Box 155, New Britain, CT 06050-0155

Craft Alliance
6640 Delmar Blvd, Saint Louis, MO 63130
314/725-1177

Craftman's Advisory Board
Kit Cornell
69 High St, Exeter, ME 03833

Craftman's Guild of Mississippi
Martha Garrott
PO Box 15454, Jackson, MS 39210

Crafts Center
1001 Connecticut Ave NW #925, Washington, DC 20036
202/728-9603
International service and networking resource on business start-up, publications, etc.

Desert Mountain Crafts
PO Box 23276, Albuquerque, NM 87192-3276

Duke Craft Center
Krista Cipriano
Box KM Duke Station, Durham, NC 27706

Johnston County Arts and Crafts Association
Saundra Freeman
4020 Buffalo Rd, Clayton NC 27520

Kentucky Art and Craft Gallery
609 W Main St, Louisville, KY 40202
502/589-0102

League of New Hampshire Craftsmen
205 N Main St, Concord, NH 03301
603/224-3375

Maine Crafts Association
Box 228, Deer Isle, ME 04627
207/348-9943

Minnesota Crafts Council
528 Hennepin Ave #308, Minneapolis, MN 55403
612/333-7789

Mississippi Crafts Center
PO Box 69, Ridgeland, MS 39158
601/856-7546

Piedmont Craftsmen
1204-A Reynolda Rd, Winston-Salem, NC 27104-1122

Qualla Arts and Crafts Gallery
Betty Dupree
PO Box 310, Cherokee, NC 28719

Society for Connecticut Crafts
PO Box 615, Hartford, CT 06142-0615

Society of Arts and Crafts
175 Newbury St, Boston, MA 02116
617/266-1810

Southern Highland Handicraft Guild
PO Box 9545, Asheville, NC 28815
704/298-7928

Craft Market

Southwest Craft Center
300 Augusta St, San Antonio, TX 78205
512/224-1848

Southwestern Craft and Hobby Association/SWCHA
PO Box 1987, McKinney, TX 75070-1987
214/562-0757
Offers grants and scholarships.

Surface Design Minnesota
Marit Lee Kucera
30 St Albans St S, St Paul, MN 55105
612/222-2483

Vermont Craft Council
PO Box 928, Montpelier, VT 05601
802/223-3380

Vermont State Craft Center
Mill St, Middlebury, VT 05753
802/388-3177

Wake Weavers Guild
Box 7320, Raleigh, NC 27695

Watershed Center for the Ceramic Arts
RR 1 Box 845, Edgecomb, ME 04556
207/882-6075
Offers residencies.

Weaver Education Center
Daniel Seaman
300 S Spring St, Greensboro, NC 27406

Weaving Edge
3107 Franklin Rd SW, Roanoke, VA 24104
703/982-0970

Western Maine Weavers
13 Trim St, Camden, ME 04843-1625

Winston-Salem Fiber Guild
600 N Trade St, Winston-Salem, NC 27101

Books

If a publisher's name has an arterisk () following its listing, their phone number is listed in the next section under 'Book Sellers.' Also see pages 148-149 for fair directories.*

Business Bibliography
Ontario Craft Councils*
$5.08

Business Forms and Contracts (In Plain English) for Craftspeople by Leonard D DuBoff/Michael Scott
Crafts Report
PO Box 1992, Wilmington, DE 19899-1992
800/777-7098 302/656-2209
144 pages, $15. More than 20 ready-to-use forms and agreements, i.e. consignment, trademarks, copyrights, collections and employee contracts.

Contemporary Crafts Market Place
RR Bowker Co
1180 Ave of the Americas, New York, NY 10036
800/521-8110

Craft Buyers Directory
Craftmarket Listing/Francisco Enterprise
572 143rd St, Caledonia, MI 49316
616/877-4185
Mailing lists of 3,000 retail shops, $100ppd.

Craft Specialist
USDA, Craft Specialist, Washington, DC 20250
Free brochure on craft career.

Craft Supply Sourcebook by Margaret Boyd
Betterway Books
800/289-0963

Craft Workers' Market; Where to Sell Your Crafts by Lynne Lapin
Writers Digest Books
800/289-0963

Crafting as a Business by Wendy Rosen
Rosen Group
3000 Chestnut Ave #350, Baltimore, MD 21211
800/CRAFT-93 410/889-2933
$22.95 ppd.

Craftperson's Guide to Good Business
Ontario Crafts Council*
$12.84

Craftperson's Resource Guide to the Lower Mainland
Crafts Association of British Columbia/CABC
1286 Cartwright St, Granville Island, BC, Canada
V6H 3R8
604/687-6511

Creative Crafter's Directory
Front Room Publishers*

Creative Outlets Directory
The Country Press
PO Box 5024, Durango, CO 81301
$7.95 ppd. Updated listings of shops and shows buying and consigning handcrafts as well as wholesale sources for craft supplies.

Directory of Textile Collections in the US and Canada
HGA Inc
120 Mountain Ave #B101, Bloomfield, CT 06002-1634
$5 plus $3 postage.

Directory of Wholesale Reps for Craft Professionals
Sharon Olson
13451 Essex Ct, Eden Prairie, MN 55347
612/937-5275
$15.95.

Great Craft Show
FairCraft Publishing
PO Box 5508, Mill Valley, CA 94942
$15 ppd. Planning the event, shaping the show, advertising, food and drink, follow up.

Guide to Art & Craft Workshops
ShawGuides Inc
Travel programs and retreats throughout the world.

How to Make Money with Crafts by Lita Clark

The Law (In Plain English) for Craftspeople by Leonard D DuBoff and Michael Scott
800/777-7098
$8. Written for art dealers, it contains answers to legal questions about liability, contracts, insurance, collections, consignment.

Maine Craft Guide
PO Box 287, West Bath, ME 04530
A guide to craft fairs and craft-related businesses in Maine; $9.50ppd.

New Fiberworks Sourcebook
Fiberworks Publications/Bobbi McRae
PO Box 49770, Austin, TX 78765-9770
512/343-6112
$18.95ppd.

Personal Risk Assessment for Craftspeople and Artists
Ontario Craft Councils*
$2.14.

Photographing Your Craftwork by Steve Meltzer
800/777-7098

Start and Run a Profitable Craft Business by William Hynes
Self-Counsel Press
1704 N State St, Bellingham, WA 98225
800/663-3007 206/676-4530
$15.45 ppd.

Starting Your Own Craft Business
Ontario Craft Councils*
$5.08.

Surface Designer's Art
Lark Distributors
800/284-3388

Trials of Jurying: A Guide for Organizers and Jurors
Ontario Craft Councils*

Ventilation: A Practical Guide
Ontario Craft Councils*
$17.07.

Book Sellers

American Council for the Arts/ACA
1285 Ave of the Americas 3Fl, New York, NY 10019
800/321-4510 212/232-2787

American Craft Council
72 Spring St, New York, NY 10012
212/274-0630

Art Books and Exhibition Catalogs
U of Washington Press
Box 50096, Seattle, WA 98145-5096

Dos Tejedoras
Fiber Arts Publications
Box 14238, St Paul, MN 55114
612/646-7445
Fiber art books.

Front Room Publishers
PO Box 1541, Clifton, NJ 07015-1541
201/773-4215

Interweave Press
201 E 4th St, Loveland, CO 80537
Catalog of books and magazines.

Ontario Crafts Council
35 McCaul St, Toronto, Ontario, Canada M5T 1V7
416/969-7430

Catalogs

Americraft
PO Box 814, Wendell, MA 01379
800/866-2723
Rep to catalog companies for craftsmen.

Artisans
9337-B Katy Freewy #333, Houston, TX 77024
800/566-2787

Coldwater Creek
1123 Lake St, Sandpoint, ID 83864
208/263-2266

Craft Market

Expedition Crafts
1605 George Dieter #636, El Paso, TX 79936
Source for international crafts.

Kansas and Missouri Craft Registers
PO Box 820, Wichita, KS 67201-0820
800/967-2665
Show listings.

NW Crafts Catalog
Market Publishing Co/Adelle Allen
4567 Liberty Rd S, #170, Salem, OR
97302-5000
Crafts persons from OR, WA, ID & MT can buy space for national exposure for their product lines. Categories include decorative crafts, personal accessories, fiber & apparel, toys, furniture, paper & cards.

Shopping for Crafts in the USA
American Craft Enterprises
PO Box 10, New Paltz, NY 12561
$5.

Spirit Echoes Gallery
701 Brazos #120, Austin, TX 78701
512/320-1492
Has a newsletter catalog of craftwork.

U.S. Dept of Agriculture National Resource Catalog
Mary Anne Lambert
Box 96576, Washington, DC 20090-6576

Fairs & Fair Guides

(See "Show Section" on pages 157-161)

Funding & Loans

Archie Bray Foundation
Carol Roorbach
2915 Country Club Ave, Helena, MT 59601
406/443-3502

Craftsman Emergency Relief Fund/CERF
245 Main St, Northampton, MA 01060
413/586-5898
Offers low-interest loans and outright grants to those working in the crafts field suffering from career-threatening ailments.

Ruth Chenven Foundation
7 Park Ave #103, New York, NY 1001

Insurance

Bollinger
830 Morris Turnpike #5000, Short Hills, NJ 07078-5000
800/526-1379

Craftsman Protection Plan
PO Box 2510, Rockville, MD 20852-0510

Magazines

You need to keep current on what's happening in your marketplace. Write to the following publications on your letterhead for a 'complimentary issue and rate card.' Usually they will send you one issue free!

American Craft
72 Spring St, New York, NY 10012
212/274-0630

Artichoke
1270 Robson St #607, Vancouver, BC, V6E 3Z6 Canada

Arts & Crafts News
Wayne Smith
PO Box 159, Bogalusa, IN 70429

Ceramics Monthly
Spence Davis
PO Box 12788, Columbus, OH 43212
614/488-8236

Contact
Alberta Potters' Assocation
Box 5303, Station A, Calgary, Alberta, Canada T2M 1X6
Full-color ceramic magazine.

Country Press Newsletter
Box 5024, Durango, CO 81301
Contains listing of boutiques and shops buying handcrafts.

Craft Crier
PO Box 2313, Lehigh Valley, PA 18001
Covers Pennsylvania and NJ.

Craft Factor
Saskatchewan Craft Council
Box 7408, Saskatoon, Saskatchewan, S7K 4J3 Canada

Craft Marketing News
Front Room Publishers
PO Box 1541, Clifton, NJ 07015
$12.95 for six issues. Also available is the "Directory of Craft Malls & Rent-A-Space Shops" for $14.45ppd.

Craft Show Calendar
Rose Brein Finkel, Editor
PO Box 424, Devault, PA 19432
215/647-5484 215/640-2332 Fax
Covers mostly the Pennsylvania area.

Craft Show List
Robert James Publishing/Jesse Sostorecz
PO Box 3322, Easton, PA 18043
610/252-3150

Craft Market

Crafters' Qwest
836-B Southampton Rd #240, Benicia, CA 94510
707/557-2795

Crafts Magazine
PO Box 2137, Naperville, IL 60566

Crafts Report
PO Box 1992, Wilmington, DE 19899-1992
800/777-7098 302/656-2209
Highly recommended for the business side of crafts.

Crafts Unlimited
HCR 80 Box 308, Cuba, MO 65453

Crafty News
PO Box 149, Shartlesville, PA 19554

Fiberarts
50 College St, Asheville, NC 28801
704/253-0468

Hands-On Guide
255 Cranston Crest, Escondido, CA 92025-7037
619/747-8206
$25 per year.

Ontario Craft
35 McCaul St, Toronto, Ontario, M5T 1V7 Canada
416/969-7430

Profitable Craft Merchandising
PO Box 1796, Peoria, IL 61656
$35 per year for 13 issues. Has new and valuable ideas for crafts.

ShowGuide
ACN Publications
PO Box 104628, Jefferson City, MO 65110-4628

Shuttle, Spindle & Dyepot
120 Mountain Ave #B101, Bloomfield, CT 06002-1634

Mailing Lists

Whispers of Nature Photography
14618 Tyler Foote Rd, Nevada City, CA 95959
916/292-3727
Country store and nautical lists. Also publish "How to Get New Retail Shops in Your Craft by Mail & Phone." This four-page guide includes how to identify your market, how to design a successful mailing package, finding a mailing list and how to use the phone.

Manufacturers Rep

Ed Finkel Associates
11 Salem Way, Malvern, PA 19355
215/644-1734

Retail Contacts

Craftlink
35410 Anderson Ave, Abbottsford, Canada V3G 1N4
604/920-8424
Has directories for British Columbia of wholesale gift stores and gift shows and 500 wholesale suppliers. Craftlink also hosts monthly networking nights in Fort Langley with various types of seminars on marketing. A 75-page booklet is available on starting a home-based craft business in Canada. Quarterly newsletter is $35 for two years.

Crafts People
424 Spillway Rd, W Hurley, NY 12491
914/331-3859

RobinWood
755 Beacon St, Newton Centre, MA 02159
617/630-8233

Software

Silver Lining
1320 Standford St #170, Modesto, CA 95350
800/828-4143
Designed for craftspeople. IBM Compatible. $99.95 for full package.

Supply Sources

Write or call for copies of these sources of various supplies.

Consolidated Plastics Co
8181 Darrow Rd, Twinsburg, OH 44087
800/362-1000
Packaging, wrapping and shipping supplies.

Craft Supply Magazine
Box 420, Manapalan, NJ 07726
800/969-7176

Craft Supplies of New York
Workman Publishing
231 E 51st St, New York, NY 10022

Crafts Board
3617 McFarland Blvd N, Northport, AL 35476
205/333-8045
On-line database of craft events, suppliers, newsletter and more.

Crow
Box 14, Somerset, MA 02726
508/676-3838
Materials for fiber artists.

Directory of Suppliers
PO Box 3322, Easton, PA 18043-3322
215/252-3150

Pull Cart
31 W 21 St 7Fl, New York, NY 10010
212/727-7089
A place where you can use the ceramic facilities.

Index

ArtNetwork

The source for all your art marketing needs

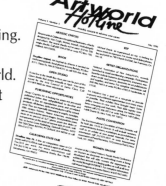

ArtSource Quarterly
New ideas and contacts to further your marketing.
ArtWorld Hotline
Monthly listings of openings in the fine art world.
Art Marketing Handbook for the Fine Artist
How to market your artwork.
ArtNetwork Yellow Pages
2000 listings of resources for artists.
Seminars
Held throughout the country
Encyclopedia of Living Artists
The 10th anniversary edition will be coming out in 1997.
To participate send a SASE for a prospectus.
Cover contest
Be a winner of our bi-annual cover contest for the *Encyclopedia of Living Artists.*
Consultations
Constance Smith, owner of ArtNetwork, conducts private phone or mail consultations.
$30 for 30 minutes/$50 per hour

Forthcoming books in 1996:
Vacationing on the Right Side of the Brain
Business Forms for Fine Artists
Business Plans for Fine Artists
Making It Legal

Free Brochure
To order any of the above items with
a credit card, call 916/432-7630.
For a free brochure on all the above materials, send a 6x9" or
larger SASE with 55¢ postage to:

ArtNetwork
PO Box 1268
18757 Wildflower Dr,
Penn Valley, CA 95946

MAILING LISTS

ArtNetwork compiles lists of artworld professionals to sell our own products. We will also rent these clean and thoroughly composed lists to you! For a complete price break down and order form, send us a SASE indicating you want a copy of our mailing list order form. Mail to ArtNetwork, PO Box 1268, 18757 Wildflower Dr, Penn Valley, CA 95946. Some examples of our lists are as follows:

```
48,000 artists . . . . . . . . . $90 per 1000
3200 reps, consultants, dealers . . . $195
1000 art councils . . . . . . . . . . . . . . $65
2900 art publishers. . . . . . . . . . . . $185
250 art publications . . . . . . . . . . . . $45
2120 art school art departments . . $140
6500 galleries . . . . . . . . . $65 per 1000
2600 frame and poster galleries . . $175
750 foreign galleries. . . . . . . . . . . . $55
2800 art organizations . . . . . . . . . $182
870 museum store buyers . . . . . . . . $65
1400 record companies. . . . . . . . . . $90
430 book publishers. . . . . . . . . . . . $45
265 photo galleries. . . . . . . . . . . . . $45
1100 greeting card publishers . . . . . $70
```

FREE DIRECTORY LISTINGS!

Help us with the next edition of *Art Marketing Sourcebook*. Did we miss a particular dealer, agent, rep, gallery, publisher in this edition? Did we miss you? Send us the name, address and telephone number so we can add them to our list to be sent a questionnaire next time.

CATEGORY_____

NAME OF COMPANY

DIRECTOR

ADDRESS

CITY/STATE/ZIP

TELEPHONE

CATEGORY_____

NAME OF COMPANY

DIRECTOR

ADDRESS

CITY/STATE/ZIP

TELEPHONE

ArtNetwork
PO Box 1268
18757 Wildflower Dr,
Penn Valley, CA 95946

GET 25% OFF YOUR NEXT PURCHASE!

Recycle your out-of-date books

It's important to keep your information library current. We will be updating this book biannually, adding totally new information as well as deleting out-of-date information. To help make it easier to find the most current information quickly, we are extending this special offer of 25% off the next edition.

All you need do is cut out and mail <u>the title</u> portion of the cover of this book for the next update (1998) and you'll get 25% off the price of the third edition. We are also making this offer on *Art Marketing Handbook for the Fine Artist, Second Edition* (tentative publication date of 1996). For current prices and editions, call us at 916/432-7630 or fax us at 916/432-7633.

ArtNetwork

**Linking the fine artist
to the artworld professional**

▼

Mailing lists
Marketing books
Newsletters
Consultations
Seminars
Encyclopedia of
Living Artists

▲